DATE DUE

WOMEN ARTISTS

OF THE ARTS AND CRAFTS MOVEMENT
1870-1914

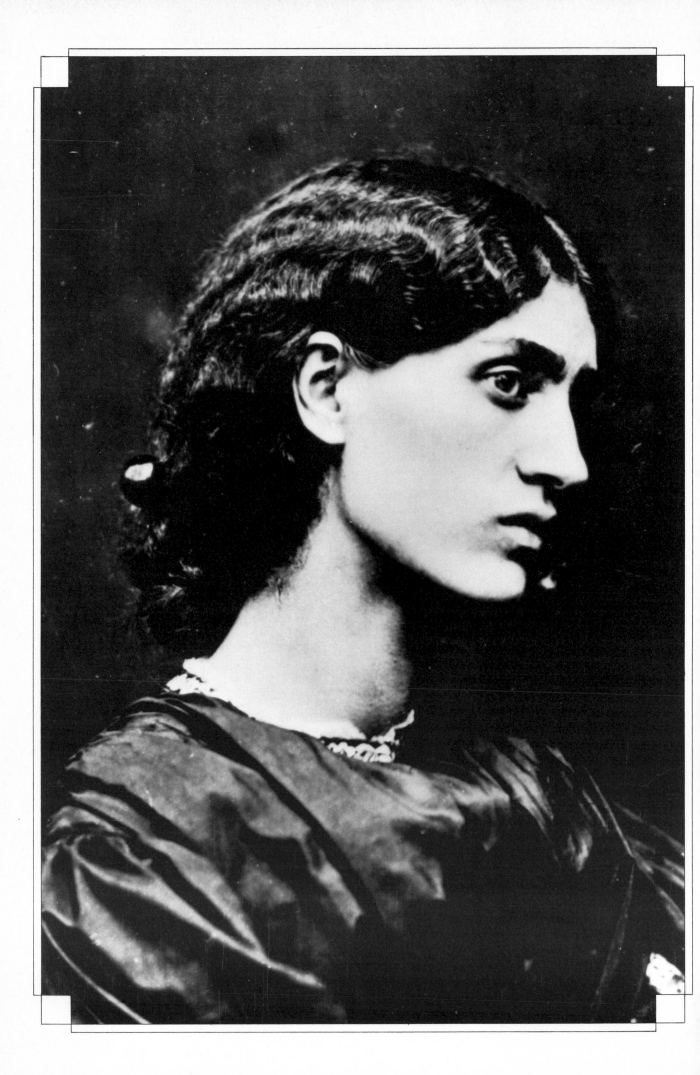

WOMEN ARTISTS

OF THE ARTS AND CRAFTS MOVEMENT
1870–1914

Anthea Callen

PANTHEON BOOKS, NEW YORK

This book is for Sheila Chesser

All rights reserved under International and Pan-American
Copyright Conventions. Published in the United States by
Pantheon Books, a division of Random House, Inc., New York, and
simultaneously in Canada by Random House of Canada Limited,
Toronto. Originally published in Great Britain as *Angel in the
Studio: Women in the Arts and Crafts Movement 1870–1914* by
The Architectural Press Ltd., London.

Library of Congress Cataloging in Publication Data
Callen, Anthea.
Women Artists of the Arts and Crafts Movement, 1870–1914.
Reprint of the ed. published by The Architectural Press, London,
under the title: Angel in the Studio.
Bibliography: p.
Includes index.
1. Women artists. 2. Arts and Crafts Movement.
I. Title.
NK1149.5.C34 1979 745 78-73646

ISBN 0-394-50667-7
ISBN 0-394-73780-6 pbk.

Manufactured in Great Britain

First American Edition

FRONTISPIECE
*Jane Morris: Photograph by Dante Gabriel Rossetti c. 1865. One of a
series of superb portrait photographs which accentuate the 'Pre-
Raphaelite' qualities in Jane Morris that Rossetti admired so much;
they tell us more about Rossetti's idea of her than what she was actually
like. A close friend of the Morris family, Rossetti had a particularly
strong emotional attachment to Jane Morris, who frequently posed for
his paintings as well as this series of photographs.* (PHOTOGRAPH: VICTORIA
& ALBERT MUSEUM, LONDON)

Contents

Acknowledgements

My first thanks go to Godfrey Rubens, who has given me many leads and references throughout my research, along with much friendly encouragement. I am equally indebted to my friend and editor Alexandra Artley who got this project off the ground, and supported and sustained me throughout its evolution. More recently, I have had the good fortune to meet Alan Crawford who, in addition to supplying me with numerous useful suggestions, has shared with a rather isolated researcher his lively erudition on the Arts and Crafts period. Alan Crawford has read several sections of the manuscript and aided me with detailed comments on my work; he has also provided me with copies of the photographs from the Birmingham School of Art. Others among my friends have given me assistance which deserves warm gratitude: Nancy Bialler gave me support and friendship in the earliest stages of the book; Griselda Pollock and Colleen Chesterman read sections from the first part of the book, contributing useful analysis both critical and stylistic; Rosie Parker read and provided valuable suggestions on the embroidery chapter. Finally my thanks go to Lindsay Miller, whose conscientious editorial work and amiable patience have drawn the book into its present consistent form.

In addition to my general appreciation which is directed at all who provided me with photographs for this book, special thanks are due to certain people who were particularly kind and helpful in my search: Miss Frances Lovering of Doulton and Co. Ltd, who showed me archive material as well as providing photographs of Doulton Lambeth Wares; Richard Dennis, who was extremely generous with his large collection of photographs of Doulton pottery; Alan Green, who very kindly lent me his photographs of the Doulton lady artists, which he made from the Presentation Volume II in the Minet Library, Lambeth; David Lloyd, Director of the Royal School of Needlework, South Kensington, who generously permitted me to photograph and reproduce material from the School's Archives; Martin Hopkinson and Pamela Reekie of the University of Glasgow Art Collections; Peter D. Cormack of the William Morris Gallery, Walthamstow; Bill Bray of The Illustrated London News Picture Library; and finally Mr Fred Hodges of School Lane, Middleton Stoney, who gave me permission to reproduce the beautiful photograph of his grandmother, Mrs Elizabeth Mills; and Ruth Pavey who allowed me to photograph her sampler.

Preface

This book reflects the choice to concentrate on women in the Arts and Crafts movement in England and America because of the particularly close links and degree of cross-currents of social and cultural influence between the two countries during the period under review. The impact of William Morris and the Arts and Crafts ideal was early felt in America through the Centennial Exhibition at Philadelphia in 1876; there the exhibit of the Royal School of Art Needlework in South Kensington included designs by Morris and his contemporaries executed by the School, which were to prove a vital inspiration to American craftswomen. It was as a direct result of this exhibit that the New York Society of Decorative Art was founded in 1877, and many American women visited London to study the new Art Embroidery at South Kensington, returning to spread their knowledge in their native land. Ceramics shown at Philadelphia were similarly influential, those of Doulton's of Lambeth and Haviland and Company of Limoges exploiting under-glaze painting techniques provided a stimulus to the development of American craft pottery.

In 1882–3 the flamboyant Oscar Wilde made his famous lecture tour of America in which he advocated the English Arts and Crafts ideals. Walter Crane visited the States in 1890, while Charles and Janet Ashbee made regular trips there from the 1890s, including in 1900 a visit to Jane Addams' Hull House in Chicago, based on, but thought more successful than, the Toynbee Hall community in London's East End. In that year Janet Ashbee visited the Roycrofters craft community at East Aurora, New York, which had been founded by Elbert and Alice Hubbard in 1895 following an inspiring meeting with Morris at the Kelmscott Press the previous year. Although Janet Ashbee found their work lacking in artistic merit, they were nevertheless responsible for popularising the Morris ideals of the craft book in America. Many Americans trained in England, like Ellen Gates Starr, founder of the craft programme at Hull House, who was taught her craft at the Doves Bindery by T. J. Cobden-Sanderson. At the beginning of this century May Morris herself toured the United States, lecturing on the Arts and Crafts and embroidery in particular. Even the more Art Nouveau oriented Louis C. Tiffany of Associated Artists, New York, was well aware of Morris's work, while his colleague Candace Wheeler visited England, gaining inspiration from the collections of the South Kensington Museum (now the Victoria and Albert Museum).

Although in Europe craftsmen like Henry Van de Velde (who worked in Weimar from 1902 and created the arts and crafts school which later became the Bauhaus) did work within an English-inspired, individualist Arts and Crafts ethos, on the whole in Germany the tendency, advocated by Hermann Muthesius, was towards a closer relationship between art and industry with a more standardised, mechanised approach to design. Elsewhere in Europe the English influence during the 1890s—particularly promoted by Samuel Bing's shop *L'Art Nouveau* in Paris and by the exhibitions of *Les Vingt* (later *Le Libre Esthétique*) in Brussels—spawned a more sophisticated, stylised offspring which came to be known as Art Nouveau and had its fullest flowering in France, Belgium and Austria. Whilst the ideals of Morris and the English Arts and Crafts movement were widely known and respected in Europe, their European progeny thus represents a new development, which owed perhaps more to the work of the Glasgow Four—Charles Rennie Mackintosh, Margaret and Frances Macdonald and Herbert MacNair—whose more European style was ill-appreciated in England and whose increasingly re-strained designs in the early years of this century looked away from the Arts and Crafts and forward to the Modern Movement.

The history of the Arts and Crafts movement has been traditionally studied and understood within the confines of the history of its leaders. The fact that the success of the movement was largely dependent upon its widespread and enthusiastic adoption by large numbers of talented but little known artists and amateurs, many of whom were women, has remained ignored and undocumented, as has the general question of the practical workings and means of dissemination of Arts and Crafts methods. Recent research, including this book, is beginning to take a less hierarchical approach to the history of this period. In particular, the important position and function of women within the history of the movement has been left unnoticed, thus reflecting general patterns within a male-dominated view of history. This book hopes to provide—for layman, specialist, historian and feminist alike—a volume of new material which will contribute to our understanding of woman's position as 'outsider' in a patriarchal culture, at the same time providing a broader knowledge of the real nature of the Arts and Crafts movement while throwing new light on the social and economic circumstances of middle-class women workers at the turn of the nineteenth century.

As a consequence of the enormous volume of unresearched material on women in the Arts and Crafts movement, this book is inevitably limited in its coverage of the activities of the many hundreds of women involved. It in no way pretends to be definitive or to provide a dictionary of all craftswomen of the period; it does, however, hope to stimulate interest and further research in the field. Any information from readers concerning individual craftswomen, or general aspects of their work or its whereabouts, would be gratefully received by the author.

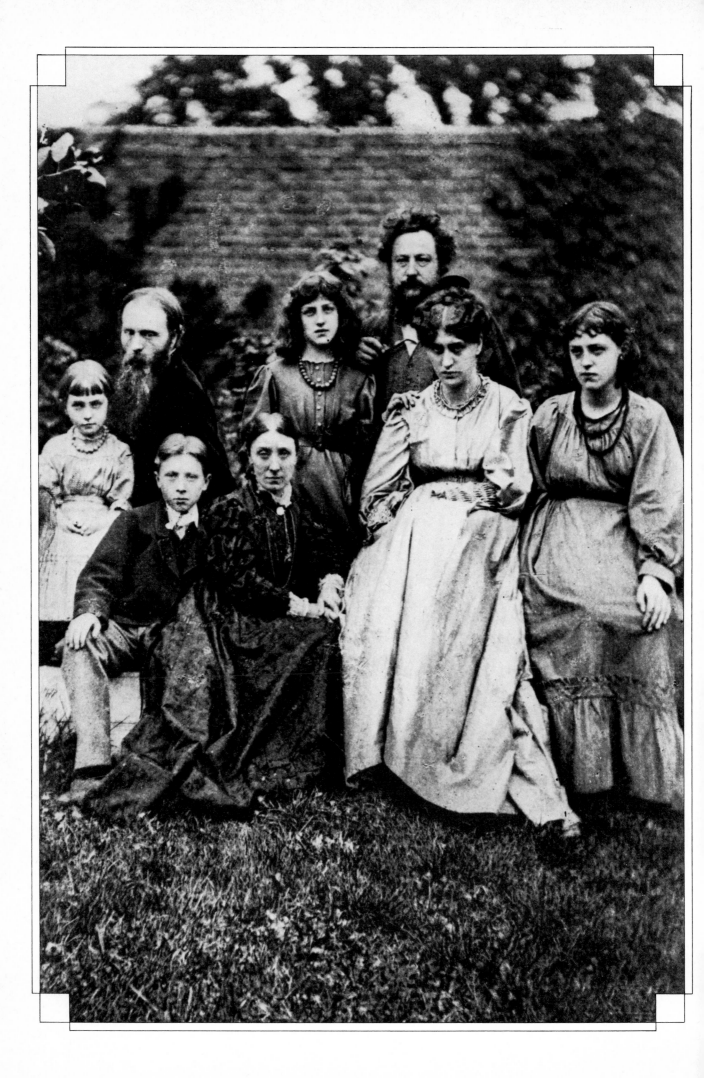

Introduction:
Class Structure and the Arts & Crafts Elite

This group photograph of the Morris and Burne-Jones families was taken in 1874 in the garden of The Grange, Fulham. From left to right, back row: Margaret Burne-Jones (Burne-Jones' daughter), Edward Burne-Jones, May Morris, William Morris; front row: Philip Burne-Jones, Georgiana Burne-Jones, Jane Morris and Jenny Morris. The photograph was taken by Fred Hollyer. (PHOTOGRAPH: WILLIAM MORRIS GALLERY, WALTHAMSTOW, LONDON)

THE ARTS and Crafts movement had its origins in a middle-class 'crisis of conscience; its motivations were social and moral, and its aesthetic values derived from the conviction that society produces the art and architecture it deserves.'[1] Thomas Carlyle was the first British writer to realise the extent to which the Machine Age was transforming English society, when he wrote in 1829:

Our old modes of exertion are all discredited, and thrown aside. On every hand the living artisan is driven from his workshop, to make room for a speedier inanimate one. The shuttle drops from the fingers of the weaver, and falls into iron fingers that ply it faster. For all earthly, and some unearthly purpose, we have machines and mechanical furtherances ... Not the external and physical alone is now managed by machinery, but the internal and spiritual also. Here, too, nothing follows its spontaneous course, nothing is left to be accomplished by old natural methods ... Men are grown mechanical in head and heart, as well as in hand. They have lost faith in individual endeavour, and in natural force of any kind.[2]

Carlyle, like Ruskin later, showed a tendency in his writings to over-emphasise the takeover of the machine from the artisan. It is now clear that hand-workshops in many trades persisted even up to the end of the nineteenth century—often side by side with a very reluctant acceptance by workers of steam-powered machines.[3] But the degradation of the labour force, and the increase in work loads and hours which resulted from the introduction of mechanisation, rather than the anticipated easing of that drudgery, are not in doubt:

... if one looks at technology from the point of view of labour rather than that of capital, it is a cruel caricature to represent machinery as dispensing with toil. High-pressure engines had their counterpart in high-pressure work, endless chain mechanisms in non-stop jobs ... The industrial revolution, so far from abridging human labour, created a whole new world of labour intensive jobs ... Working pace was transformed in old industries as well as new, with slow and cumbersome methods of production giving way, under the pressure of competition, to over-work and sweating.[4]

Against such conditions, and more particularly against the 'apotheosis of the cheap and shoddy',[5] the pioneers of the Arts and Crafts movement came out in active rebellion. The desire to improve the quality of architecture and design on every level was basic to the movement, which sought to establish a society in which creative freedom was the right of all. The ideals of Ruskin and Morris looked back to an age in which the craftsman was both designer and maker, when, before the division of labour, an artefact was the product of a single individual who saw the creative process through from beginning to end.

The Arts and Crafts movement proper was well under way by the early 1880s. The origins of its concern with the reform of design and taste lay earlier in the century with the writings and work of A. W. N. Pugin, with the establishment of the first Schools of Design in 1837, and with the work of Henry Cole, who took over the direction of the then Department of Practical Art in 1852. While many of the Arts and Crafts pioneers reacted against the theoretical, abstract approach to design of Cole and his followers, nevertheless, in his attempt to introduce design reform, and to stress the importance of conventionalised pattern as a basis of good design, he can be seen as a precursor. The movement's practical origins lay in the formation of the firm of Morris, Marshall, Faulkner & Co. in 1861, while developments during the 1870s—which included the establishment of the Royal School of Art Needlework— although by some writers associated more closely with the Aesthetic movement, were nevertheless crucial in spreading the ideals of reforming craftsmanship and quality in artistic design so central to the Arts and Crafts movement. The movement's ideological background was furnished chiefly by the ideas and writings of Ruskin, who spoke out like Carlyle against the degradation of human labour, in particular through the effects of mechanisation and the resultant division of labour, which alienated the maker from his product. Taken up and amplified by William Morris, the ideals of craftsmanship, good design, fitness of purpose, re-uniting designer and maker, and a renewed dignity of labour, found both practical and theoretical expression. His creation of craft workshops and his concern with the revival of numerous dying traditional crafts through a personal, energetic involvement, made him a figurehead and example for the majority of later developments in the movement. Thus, Morris was crucial in stimulating interest in ancient crafts and in the revival of traditional craft techniques which played no part in official art training, but with which craftspeople began increasingly to experiment.

The involvement of women in the Arts and Crafts movement, the principal concern of this book, can be divided into four main categories which also reflect the class divisions within the movement itself: first, the working class or peasant women who were organised and employed in the revival of traditional rural crafts; secondly, the aristocratic, upper- and middle-class women of comfortable means and appropriate leisure who were philanthropically engaged in the organisation both of the rural craft revivals, and of the artistic training and employment of destitute gentlewomen; thirdly, there were the destitute gentlewomen themselves, the ladies forced by circumstance to make an independent livelihood, either by waged art work in an employer's workshop or as outworkers, or freelance— usually practising discreetly from the home. Finally, the fourth category covers the élite 'inner circle' of educated middle-class women, often related by birth or marriage to the key male figures within the vanguard of the movement.

WORKING CLASS WOMEN AND THE RURAL CRAFTS REVIVAL

The first category of women's involvement in the Arts and Crafts movement included all the waged peasant women who worked in the cottage crafts in whose revival Ruskin was both actively and ideologically concerned; his ideal of the homespun found practical expression as early as the 1870s, 'when he took up the

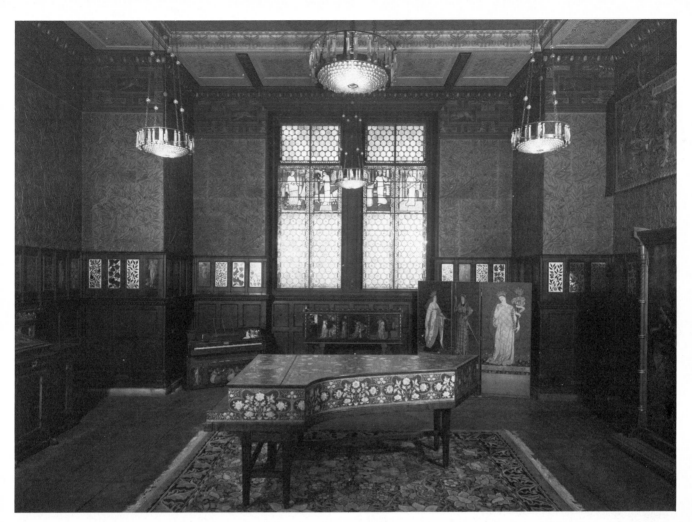

A general view of the Green Dining Room, South Kensington Museum, commissioned from Morris and Co. in 1866, probably on the recommendation of Henry Cole. This and the commission to redecorate the Armoury and Tapestry Room at St James's Palace that same year, were their first major commissions, highly prestigious for such a new firm. The design was by Philip Webb, with windows and painted wall decorations by Edward Burne-Jones; the three embroidered figures which were made into a screen in c. 1880, formed part of a frieze of twelve intended for the dining room of the Red House. Seven of these were actually executed, by Jane Morris and her sister Elizabeth Burden, by the time the Morris family left the Red House in 1865; they were not part of the original Green Dining Room decorations (see Chapter 3, Embroidery and Needlework). The grand piano in the foreground was made by John Broadwood and Sons, with decoration in painted gesso designed and executed by Kate Faulkner; it was owned by the progressive collector Ambrose Ionides who lent it to the first exhibition of the Arts and Crafts Exhibition Society in 1888. (PHOTOGRAPH: VICTORIA & ALBERT MUSEUM, LONDON)

cause of hand-spinners in the Isle of Man, acquiring a water mill for them and encouraging them to produce wool cloth of high quality, guaranteed to "last forever". In 1883, when his health was failing, he handed over the enterprise to a Huddersfield manufacturer, George Thomson, who, inspired by Ruskin's teaching, was running his woollen mill on co-operative lines'.[6] Co-operative organisation and pay were in fact extremely rare among rural craft revivals, and most of those encouraged by Ruskin in his later years, including the Langdale Linen Industry established in 1885, were run by middle-class women on a system of wages for piece-work; at Langdale the organisation was overseen by the local middle classes, but its day-to-day functions were in the hands of a literate worker, Mrs Pepper, a slater's wife.[7] A similar industry was established in 1891 under Annie Garnett, and during the 1890s hand-loom weaving workshops were set up in Haslemere, while in 1898 Katie Grassett's famous London School of Weaving was founded. Ruskin was not the only instigator of such revivals; during the 1880s rural depopulation 'had reached a peak in absolute terms and first became an important national issue'.[8] Contemporary writers linked the draining of humanity from the countryside with the increasingly drab and overcrowded existence in the cities. Public concern prompted the

upsurge of interest among politicians, businessmen, economists, social reformers and romantics alike, in the means by which rural society might be revived. The motives of these interested groups, from the businessmen and social reformers who established the Society for Promoting Industrial Villages in 1883, to the politicians of both major parties who saw a variety of advantages in the creation of small proprietorships, were often more complex than a simple desire to stave off urban squalor and revitalize the countryside. Yet their net effect was to create a widespread impression that, somehow, the English countryside must be preserved . . . The notion of revitalizing the countryside carried a powerful humanitarian and patriotic appeal. For many people the consolidation of the rural economy was seen as the ideal vehicle by which urban squalor and rural depopulation might be controlled and national vigour maintained.[8]

3

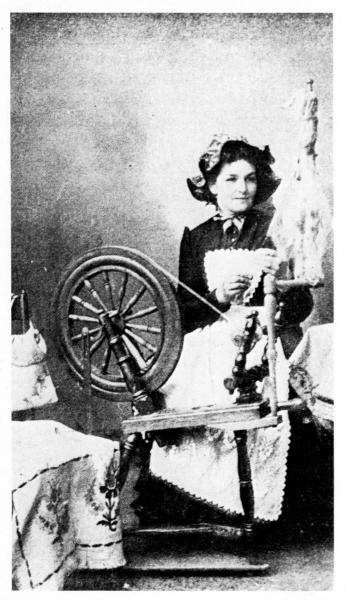

Top: *Mrs Pepper, manageress of the Langdale Linen Industry, from a photograph printed in the* Art Journal *of 1897. Mrs Pepper is seen here—in what was evidently a publicity photograph—spinning flax at St Martin's, the centre of the local outworker craft industry; her quaint rustic dress doubtless reinforced urban notions of the idyllic rural existence of peasant craftswomen.*

Above: *The Langdale Linen Industry: from a photograph of Chapel Stile and Langdale Pikes, printed in the* Art Journal *of 1897. The captions indicate that the photograph shows the local slate quarry, presumably on the left in the middle distance; Mrs Pepper's husband was a slater, which suggests that although she was manageress of the local linen industry, she came from working or peasant class origins.*

Such sentiments must have been central to the motives of the philanthropic rural gentry, with their particular vested interests in the maintenance of the *status quo* in the countryside.

Like Ruskin in his ideas for reviving cottage industries, many reformers looked to the idealised example of pre-industrial agricultural society, when craft production had been centred on the family unit and was an integral part of everyday life; the notion of a rural idyll held great attractions for a middle class disillusioned with the sordid effects of a society based upon mechanised industry. Anti-Philistinism also played an important rôle as the artistic ideals of Morris and of the Aesthetic movement began to spread and to influence a wider public; the revival of rural crafts was thus not a haphazard, inartistic venture, but on the contrary, the cult of the beautiful encouraged serious attempts to introduce good designs and promote high standards of craftsmanship.

The problem of the peasants themselves was also considered crucial; many reformers felt that erratic seasonal work left women in particular under-employed, and thus the reintroduction of craft industries could be seen both as a means towards self-help—part-time work in the home adding to the family's income—and as a way of occupying 'idle hands': the spinning wheel 'has brought increased comfort and orderliness into many a home, whose mistress is now to be found busily engaged by her own fireside, instead of gossiping beside a neighbour's'.[9] The dignity and self-respect which such philanthropy was intended to give to workers has been questioned by Brian Harrison, who suggests that worthies were not always aware of the hardships of the rural poor:

Working people disliked being visited in their homes by philanthropists who often displayed great ignorance about the problems they faced. Even had they been conscious of their ignorance, many philanthropists would not have been perturbed by it. For their aim was not to accept working-class attitudes; on the contrary, philanthropists were in the forefront of the nineteenth-century attack on popular culture.'[10]

Harrison goes on to outline a possible relationship between philanthropic activity and the Victorian fear of revolution among discontented workers.

THE LADY PHILANTHROPISTS

For numerous concerned middle-class women the revival of rural crafts provided an ideal opportunity for philanthropic work. The pervasive Victorian ideal of the 'work ethic' (against which women of enforced leisure were by no means immune), coupled with an increasing sense of guilt among the younger middle classes by the 1880s over their privileged position and 'the morality of a system which brought the unemployment and poverty which their earnest social enquiry uncovered'[11] led many such women to seek this voluntary work. Philanthropy is, however, a complex issue, and it is evident that for some it was taken up for motives often far from altruistic; it was an area of Victorian life which gave ample opportunity for social climbing, parti-

cularly since the epitome of success in any philanthropic venture lay more in securing royal patronage than in obtaining good wages for its workers. In addition, for ladies excluded from all other, male-dominated spheres of business activity, philanthropy presented a rare opportunity for power and fame, and for the pleasure of active work in managerial organisation.

A major area of philanthropic interest during this period lay in the lace associations, created to revive a dying rural craft whose products were traditionally highly prestigious, and carried the mark of wealth and social status for the wearer. Lace-making was a gruelling craft especially prone to sentimentalisation by unknowing urbanites, who saw only the quaint ivy-clad cottage and its neat worker with her lace pillow at the door; the economic realities of the craft are discussed in greater detail in Chapter 4, Lacemaking.

While it is clear that the motives of many dedicated philanthropists engaged in the revival of cottage industries were above reproach, there was, nevertheless, an occasional hint of both self-congratulation, and of attempts to highlight the sins of the poor. In a society in which poverty was considered evidence of moral failure and laziness, organised programmes of work could hardly avoid an implicit acknowledgement of moral inferiority in those organised. This type of condescension appeared regularly in contemporary writings, and an article on the Langdale Linen Industry in the *Art Journal* for 1897 is a superb example (see Chapter 3, Embroidery and Needlework). An organiser of one of the lace associations recalled in 1921 the original stimulus which had prompted her engagement in philanthropic activities, a 'genuine sympathy for the distraught workers in her village':

When I came to live here nearly 30 years ago I found the village workers in a sad state. They earned three halfpence an hour in yarded lace and a penny an hour in borders and collars. All work had to be taken to a town seven miles away, the distance often walked. Sometimes the work was bought, sometimes not. When bought, half or the whole of the value was taken out in drapery goods. I put myself in communication with a London buyer, learned to make the lace and began collecting, paying full value in cash.[12]

While the middle-class lady philanthropists tended to take a very active rôle in the organisation of craft industries, those of the upper classes and the aristocracy frequently gave only the prestige of their name and their patronage. Particularly where the lace industries were concerned, there was a long tradition of royal support through purchases of this highly desirable fabric, which then set fashions among the wealthy classes. Thus the North Buckinghamshire Lace Association by 1907 included among its patrons Queen Alexandra, the Duchess of York, the Marchioness of Milford Haven, the Princess of Wales, the Princess of Battenburg and Queen Victoria Eugenie of Spain. Its, list of thirty-two vice presidents glittered with the names of five countesses—of Howe, Jersey, Egmont, Temple and Carrington—and of the Baroness Kinloss, the Earl of Howe, the Duchess of Buckingham and

Chandos, and Lady Rothschild. This Association was run voluntarily by a committee of eighteen, at first including Lady Pauncefort Duncombe, Lady Lawrence, Lady Addington and Mr and Mrs Walter Carlysle:

They worked to a familiar pattern, each committee member supervising the work in a number of villages and encouraging local organizers to promote good quality workmanship in classical designs. For a year the Association's laces were sold privately, but by 1898 sales had risen to such a degree that it became necessary to open a store in London with a permanent sales staff. The laces ranged from cheap edgings which sold at 3d. a yard, to Berthas, fichus and scarves which sold at prices ranging from £6.6.0 to £10.10.0.[13]

Other associations, such as the Paulerspury Lace Industry in Northamptonshire founded in 1880 by Mrs Harrison, the wife of the local vicar, might choose to sell work by lacemakers through an established London organisation; Mrs Harrison found an outlet in the Ladies' Work Society in Sloane Street, London. Several of the royal names crop up repeatedly as patrons encouraging and giving status to these worthy ventures. Lace from Paulerspury was ordered by, among others, both Princess Louise and Princess Christian, daughters of Queen Victoria who were highly active in this field; both ladies also supported the movement to provide respectable artistic training and employment for gentlewomen. Princess Louise, Marchioness of Lorne, gave her name to the Ladies Work Society, many of whose embroidery designs were also from her hand; Princess Christian of Schleswig-Holstein was President not only of the Royal School of Art Needlework, but also of the Decorative Art Needlework Society.

If, from this list of auspicious names, the patronage of lace and embroidery workers may be thought of as essentially fashionable and well-publicised benevolence, by contrast, a little known but most important aspect of female philanthropy during this period lay in the establishment and running of craft organisations which were crucial in the widespread dissemination of the ideals and practice of the the Arts and Crafts movement. One organisation particularly influential from this viewpoint was the Home Arts and Industries Association, which was founded in 1884 (the same year as the Art Workers' Guild) and was largely staffed by middle-class women, with many lady organisers—some from the aristocracy. Its aims were 'to encourage the practice of handicrafts and revive old ones, more especially in villages and country places out of touch with the organisations for art and technical instruction enjoyed by large towns'.[14] Sustained by charity, its stated purpose was twofold: first to make the young artisan a better citizen by providing him with a personal hobby outside and independent from his wage-earning pursuits; secondly, if he showed talent, to encourage and develop it in the right channels. It also hoped to raise the general standard of taste of all involved. The Association did not intend to 'teach rough artisans a more "genteel" way of gaining a livelihood, nor to provide amateurs with a new way of wasting time and money';[15] it did, however, provide a vital source of training and employment for many isolated women,

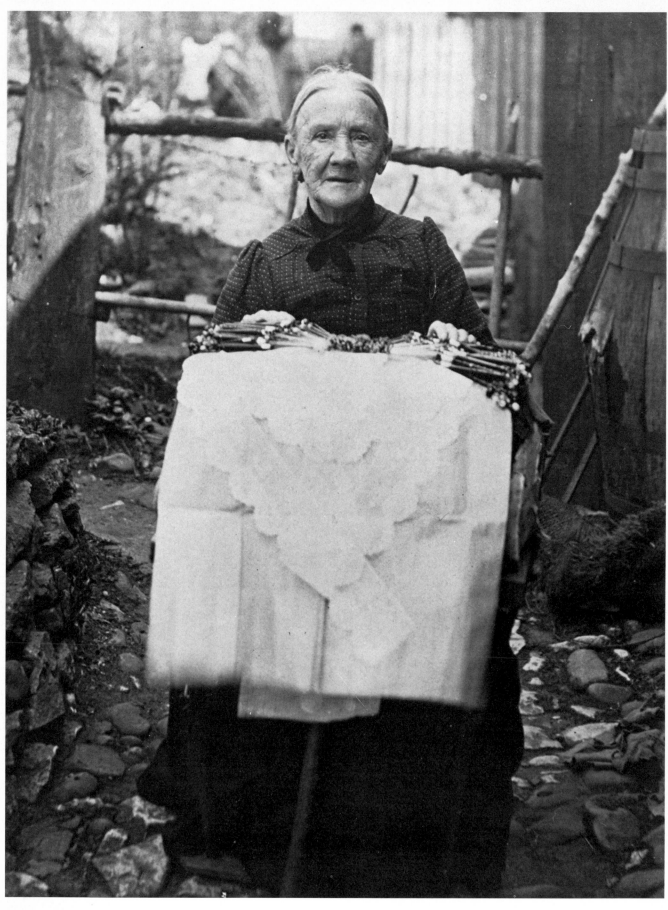

Mrs Elizabeth Mills, Buckinghamshire lacemaker, c. 1920. Mrs Mills lived and worked at Gawcott, a little village about one mile from Buckingham; she took a diploma in lacemaking and was one of the few who could do 'Old Bucks Point' lace. She made a piece of lace for Queen Victoria's Jubilee in 1887, in the shape of a diamond with 'Jubilee' worked in and the year. The large number of bobbins on Mrs Mills' *pillow confirms the complexity and high standard of lacemaking of which she was capable. According to Mrs Mills' grandson the photograph dates from around early 1920 and although her dress length would seem to indicate a date nearer 1900, the slow rate of fashion changes in the countryside may account for this discrepancy.* (PHOTO-GRAPH: COUNTY MUSEUM, OXFORD)

doubtless both middle- and working-class. A fairly characteristic range of craft teaching was offered throughout the country, particularly leatherwork, metalwork, woodwork, spinning, knitting, embroidery and sewing; exhibitions of work were held annually at the Albert Hall, London.

Instruction within the Association, often in collaboration with local councils, generally followed the same pattern:

The classes commence purely by voluntary effort on the part of those who have the welfare of the country dwellers or working people at heart. Classes are held in the homes of voluntary teachers, or in rooms let by others interested in the work. As pupils become proficient, professional teaching is engaged, and perhaps work is executed in response to local orders. The class may in time develop into an industry doing work sufficiently well to attract regular custom, and thus become self-supporting. Under this head the Windermere Industry (Miss Annie Garnett) was classed several years ago.[16]

Other developed industries included those at Dun Emer run by Evelyn Gleeson and the Yeats sisters outside Dublin, the St. Emundsbury Weavers, organised by Edmund Hunter in Haslemere and specialising in silk weaving and the Compton Industry, begun by Mary Watts, wife of the painter G. F. Watts, which produced terracotta architectural and garden ornaments of high quality. The twenty-first anniversary exhibition of the Home Arts and Industries Association was held in 1905, and 125 classes were represented, with demonstrations to encourage interest in spinning, weaving, woodcarving, metalworking, bookbinding, pottery-throwing and colour printing from wood blocks.

Although many individual instructors themselves provided designs for execution by their students (the Hon. Mabel de Grey, for example, was regularly commended for her designs in inlaid woodwork) the Association also assisted classes by the loan of designs, models and leaflets of elementary instruction. It also gave help in case of special difficulty, and provided information on the best working methods, choice of tools, materials and their cost. The central offices were at the Albert Hall, where studios were available all the year round, with the exception of the usual vacations. A 1905 list of newly affiliated classes indicated that the vast majority of instructors were women,[17] and although comparatively little is known about the proportion of women students, it is likely that this too was high. The fact that, despite frequent criticisms of inferior work, the Association received regular attention in major Arts and Crafts publications like the *Studio* and the *Art Workers' Quarterly*, gives some clue as to the importance of the Association's influence; in 1896 the *Studio* felt that this would be considerable, particularly on future generations of craftsmen. One critic noted that it was especially difficult to 'assess the merit of so many articles produced without the context of art-school or commercial criticism', and ended: 'It is a curious thing, that in tracing the source of design in the few instances of good and new work to be discerned in the gallery, in almost every case some artist of established reputation had supplied the motive power'.[18] Perhaps over-familiarity with the high-quality and high-priced work by such artists as he referred to spoiled this critic's appreciation of the simpler values expressed in the Association's aim 'to invite common use for something other than machine made articles'.[19] A major criticism of the Arts and Crafts movement, even among contemporaries, had been that its products were exclusive and outside the purchasing power of the mass market, despite its social ideals of reforming general taste and the lot of the ordinary worker. At a grass roots level, the Home Arts and Industries Association came far closer to achieving these ideals than did the more élite, more widely recognised, leaders of the movement.

In 1902 a craft encouragement group was started which had evolved from the Women's Page of the Socialist paper *The Clarion*, edited by Robert Blatchford. The Clarion Guild of Handicraft was begun and first organised by a lady under the *nom de plume* of Julia Dawson, with the newspaper offices acting as the Guild's headquarters and central offices. Within two years it was recorded that the 'membership roll is probably as large as that of all the other guilds put together'.[20] Its ideals were based on the writings of the modern humanists like Ruskin, Tolstoi, Kropotkin and Walt Whitman; high among those ideals was an heroic new form of the Victorian puritan work ethic:

The dignity of labour and its association with happiness is the keynote to the teaching of all thinkers whose work has influenced their day. It bids fair to become the characteristic ideal of the century. Nor will the fact continue to surprise us, when once we have come to realise that there can be no happiness without work, and that in order to design [good work] . . . it is not necessary to be born a genius.[20]

Significantly, the Clarion Guild came out in favour of an intelligent use of machinery to take the drudgery out of craft work, and was therefore at the forefront of the new thinking which reacted against the purist extremes of anti-mechanisation typified by Morris's early pre-socialist craft ideals. It was felt that such extreme idealism was 'beyond the reach of those who fall short of William Morris in personality and wealth', and this commentator prophesied that 'The problem will solve itself, I believe, in a working compromise, where machinery will become a useful slave instead of a tyrant'.[20] In this the Guild looked forward to the principles of the Modern Movement.

The Guild's first exhibition was held in Stafford in 1902, and by 1905 over 1,000 exhibits were gathered in Manchester. Groups were set up in many parts of the country, particularly the northern cities, and including Birmingham, Chester, Bristol, Derby, Eccles, Leeds, Bolton, Stockport, Blackburn and London. It rapidly gained the approval of the Arts and Crafts establishment: Walter Crane opened the Second Exhibition in 1903 and by invitation several prominent Arts and Crafts groups, like Ashbee's Guild of Handicraft and Godfrey Blount's Haslemere Peasant Industries, showed their work with the Clarion Guild in 1905. The Clarion Guild was 'working in harmony with all that is best among leaders of the Arts and Crafts movement

today'.[20] The fact that the Guild had its origins in the Women's Page of *The Clarion* provides an indication of the involvement in it of middle-class women; it is likely that, although intended as an urban working man's guild, many women took the opportunity to train in craftwork through its teaching network, which was similar to that of the rural Home Arts and Industries Association.

Whether for middle- or working-class women, the lace associations and the Home Arts and Industries both provided waged employment; it seems likely that the Clarion Guild, by contrast, worked in the same way as the Arts and Crafts Exhibition Society, which sold work and obtained commissions through its exhibitions, so that in effect individuals worked on a freelance basis. Waged employment for middle-class women was provided by such establishments as the Royal School of Art Needlework and the pottery firm of Doulton's of Lambeth, whose female employees were probably also drawn from the lower middle classes. The Leek Embroidery Society, which was active by the summer of 1880, expressly indicated that its middle-class lady embroiderers could not hope to earn enough to support themselves entirely:

The work was done mostly by members of the Society in their own homes. But apparently a certain number of professional embroideresses were employed, their remuneration allowing for a reasonable profit to be made on the sale of the embroideries in the open market. But it was emphasized that the work could only be undertaken by 'ladies whose time was not money to them and who did not expect to gain a livelihood by it.'[21]

Considering the fact that all the raw materials for the embroidery were obtained at cost price, because the Society and its organiser, Mrs Elizabeth Wardle, were closely associated with the successful Leek silk firm of Thomas Wardle (silk dyer and collaborator with his friend William Morris on textiles and embroidery materials) and used Wardle's materials almost exclusively, it could be argued that the Society might have afforded decent wages and was exploiting its dedicated workers.

In fact from 1883 'the Society helped to promote Thomas Wardle's own business interests. He had opened a shop in New Bond Street, London, in 1883, to sell eastern silks and other materials. In his advertising circular he stated: "We shall have associated with us the Leek Embroidery Society which is now so widely known"'.[22] The foundation of the Leek School of Art Embroidery, which was closely allied to the Society and similarly founded by Elizabeth Wardle, was applauded by Sir Philip Cunliffe-Owen, then Director of the South Kensington Museum, in a letter to Thomas Wardle in 1881:

To found the Leek School of Art Embroidery—to provide a suitable home for it, to have a foundation for the maintenance of the same, including the payment of a mistress, would be a great and good work. It would enable classes of females to attend the schools of an evening; it would afford them the example of never having an idle moment, and further would

help revive the great silk trade, and one branch of it, embroidery, which would respond to the growing taste for the same amongst all classes of society.[23]

It is thought possible that Cunliffe-Owen, in looking for a benefactor to help the School, had Wardle himself in mind—suggesting further proof of his financial stature, and therefore further possible proof of the Society's exploitation of its workers. It is apparent that the School was also intended to involve working class 'females', and Cunliffe-Owen's attitude here reflects the common notion of the peasantry as idle, and the importance of furnishing them with constructive work to fill their evenings after a day's hard labour.

WORKING GENTLEWOMEN

While committed philanthropists providing economic relief for working-class women were clearly maintaining the *status quo*, the question of creating employment for needy gentlewomen posed severe social problems in a period when 'lady' and 'work' were contradictions in terms. It was inconceivable that a lady should see earning her own living as a matter of achieving self-respect and independence, something which for men was not only taken for granted, but considered as a duty; thus Sophia Jex-Blake, who became a pioneer female medical student, recorded her father's reaction to her desire to earn money:

'Dearest, I have only this moment heard that you contemplate being *paid* for the tutorship. It would be quite beneath you, darling, and *I cannot consent to it*. Take the post as one of honour and usefulness, and I shall be glad . . . But to be *paid* for the work would be to alter the thing *completely*, and would lower you sadly in the eyes of everybody.' She argued: 'Why should I not take it? You as a man did your work and received your payment, and no one thought it any degradation, but a fair exchange . . . Tom is doing on a large scale what I am doing on a small one.' He replied: 'The cases you cite, darling, are not to the point . . . T. W. . . . feels bound as a *man* . . . to support his wife and family, and his position is a high one, which can only be filled by a first-class man of character . . . Now entirely different is my darling's case! You want for nothing, and know that (humanly speaking) you will want for nothing. If you married tomorrow—to my liking—and I don't believe you would ever marry otherwise—I should give you a fortune'.[24]

Thus the man retained absolute authority, with the ultimate power of money under his control; often women were left destitute and untrained, and even after the passing of the Married Women's Property Acts in 1882 women had little 'customary right' to their income and possessions.

In order to avoid the lowering of social status usually involved in the paid employment of gentlewomen, philanthropists seeking to find creative art work for them evolved several acceptable formulae. The most favourable were first, organised employment such as that offered by the Royal School of Art Needlework, in which ladies had only to mix with their own kind within the confines of the School's studios and workshops. Secondly, home work was encouraged, in which the main function of the organisation—like the Ladies' Work Society—was as a showplace and sales outlet for

ladies' needlework produced in the home. Anonymity was occasionally offered as a means of protecting the good name of a lady, indicating the extent to which paid work represented an embarrassing loss of status to be hidden at all costs. This common avoidance of exposure creates problems in making a thorough study of middle-class craftswomen professionally involved in the Arts and Crafts movement. For men, fame and ambition were taken for granted in the pursual of their profession, but among women it was only the more socially progressive who were able to cope with the psychological and social conflicts created by stepping outside their traditionally defined feminine rôle. It also seems clear that the majority of working ladies were isolated from any support system which might have promoted a more positive identification with their craftwork; even among men a sufficient need for common identity had been felt for them to organise the all-male Art Workers' Guild in 1884, but their exclusion of women was evidence at the highest level of the extent of women's isolation. Although a Women's Guild was founded in 1907, a minor off-shoot of the Art Workers' Guild, it was too late by then for it to fulfil the functions needed, particularly in the early, struggling years of the movement. Significantly, many of the bolder, well-known and most successful craftswomen were those trained in a sympathetic environment like the Glasgow School of Art, Birmingham School of Art and the Central School of Arts and Crafts, London, and those who worked in the numerous small clubs, guilds and

The Royal School of Art Needlework, South Kensington, London: exterior of the custom-built premises designed by the architect Fairfax B. Wade, photographed during the Opening Ceremony, April 1903. Originally founded in 1872 the School first had small apartments on Sloane Street, but rapid expansion necessitated an early move to new premises at No. 31 Sloane Street. In 1875 the School transferred to larger, temporary quarters in buildings erected for the 1867 International Exhibition; the School remained there in unsatisfactory surroundings until sufficient funds were raised to commission the building shown in the photograph, which was situated on the corner of Exhibition Road and Imperial Institute Road. When its lease ran out the School moved to the present premises, 25 Prince's Gate, in 1948; it is now known as the Royal School of Needlework. Sadly, the magnificent building in Exhibition Road, the only custom-built School of Needlework in the world when it was opened, was demolished in the 1950s. It is interesting to note that from the autumn of 1903 the top floor of this building was leased to the School of Woodcarving, which was also responsible for training many women in a craft profession. (PHOTOGRAPH REPRODUCED BY COURTESY OF THE ROYAL SCHOOL OF NEEDLEWORK)

workshops that formed the most characteristic Arts and Crafts production organisations. Thus these women benefited greatly from the support and encouragement afforded by like minds with common ideals and interests. Aside from the well-known few, the anonymity sought by many professional craftswomen has only served to speed their complete disappearance from the history of the movement, and to reinforce the common notion of the Arts and Crafts as a predominantly male arena.

The final category of women's involvement in the Arts and Crafts movement necessitates a return to its beginnings, for the example set by the Morris women and their associates was to provide inspiration for the progressive, educated women of the middle classes who followed in their path. These were the women who were in the vanguard of the movement, who achieved widespread acclaim during their lifetimes but few of whom now receive their due acknowledgement in histories of the period.[25]

From the start women were actively involved in the Morris firm, most of them being directly related through family connections or friends. At first through exploring the techniques of mediaeval embroidery, Morris's wife Jane Burden and then her sister Elizabeth were drawn into production; Georgiana Burne-Jones was soon engaged in embroidery and wood-engraving, while even Morris's housekeeper at Red Lion Square, Mary (later Mrs Nicholson) was taught to embroider; Mrs Campfield, wife of Morris's foreman, was also brought in to produce embroidery. Charles Faulkner's sisters Kate and Lucy worked for the firm from the first, painting tiles, executing embroideries and, Kate at least, designing wall-papers. Jane Alice (Jenny), the older daughter of the Morris family, was early on taught to embroider while Mary (May), the younger daughter, was trained by Morris in design and several crafts, taking over direction of the firm's embroidery department in 1885, aged twenty-three; she also designed wall-papers, and designed and executed jewellery.

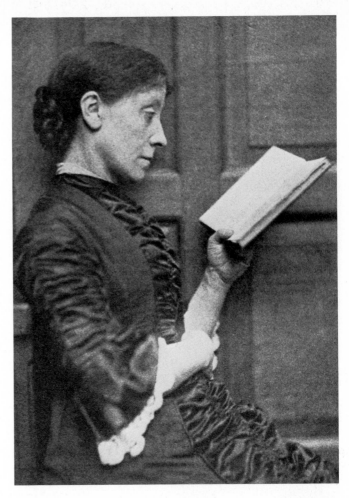

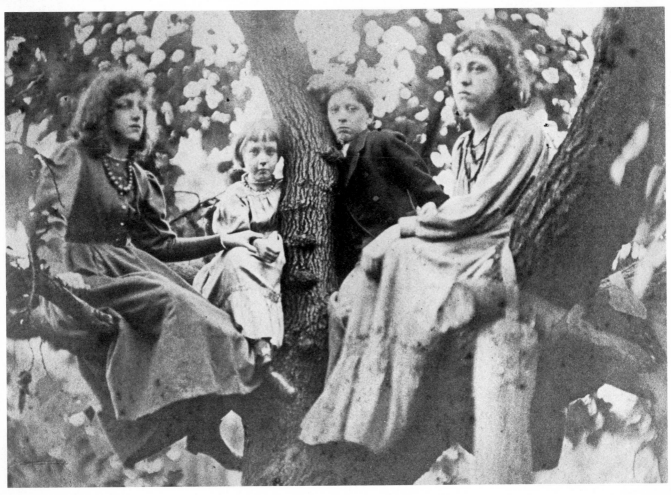

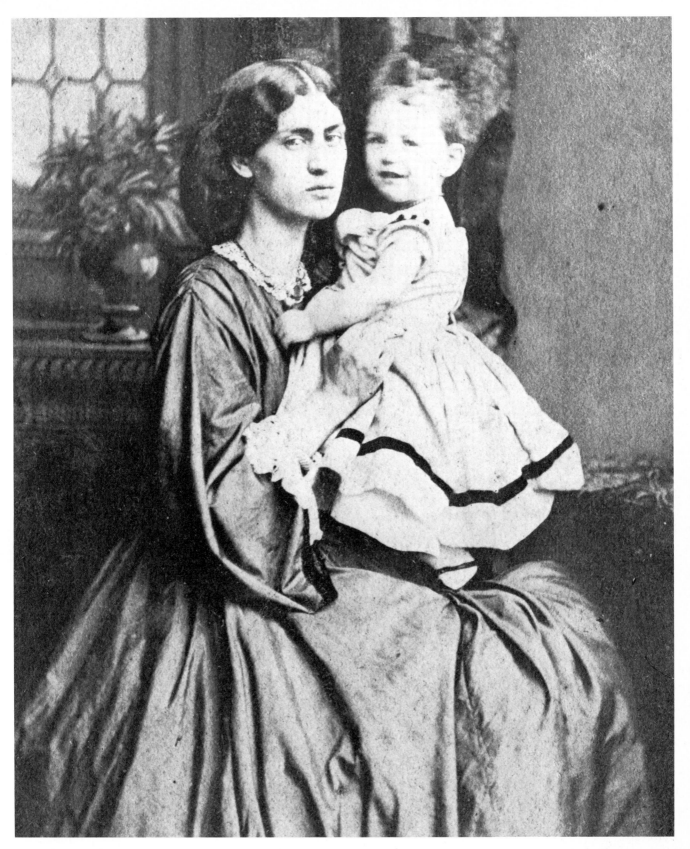

Top, left: *Georgiana Burne-Jones reading, c. 1880. Like Edward Burne-Jones, whom she married in 1860, she was closely involved in the Morris circle and took an active part in craft production, particularly embroidery in the early years of the Morris firm's existence; her strong personality comes through clearly in this photograph.* (PHOTOGRAPH: WILLIAM MORRIS GALLERY, WALTHAMSTOW, LONDON)

Left: *A less formal photograph, again by Fred Hollyer, shows the Morris and Burne-Jones children in a tree at The Grange, Fulham in 1874; from left to right: May Morris, Margaret Burne-Jones, Philip Burne-Jones and Jenny Morris. Tree-climbing for Victorian girls was clearly not prohibited either by dress or morals—at least not in the Morris circle.* (PHOTOGRAPH: WILLIAM MORRIS GALLERY, WALTHAMSTOW, LONDON)

Above: *Jane Morris holding May Morris, c. 1865. Although undated, May Morris's birthdate of 1862 gives a clue as to the date of this rare maternal photograph. Straightforward and undramatic in pose and lighting, it makes an interesting comparison with the 'arty' photographs of Rossetti.* (PHOTOGRAPH: WILLIAM MORRIS GALLERY, WALTHAMSTOW, LONDON)

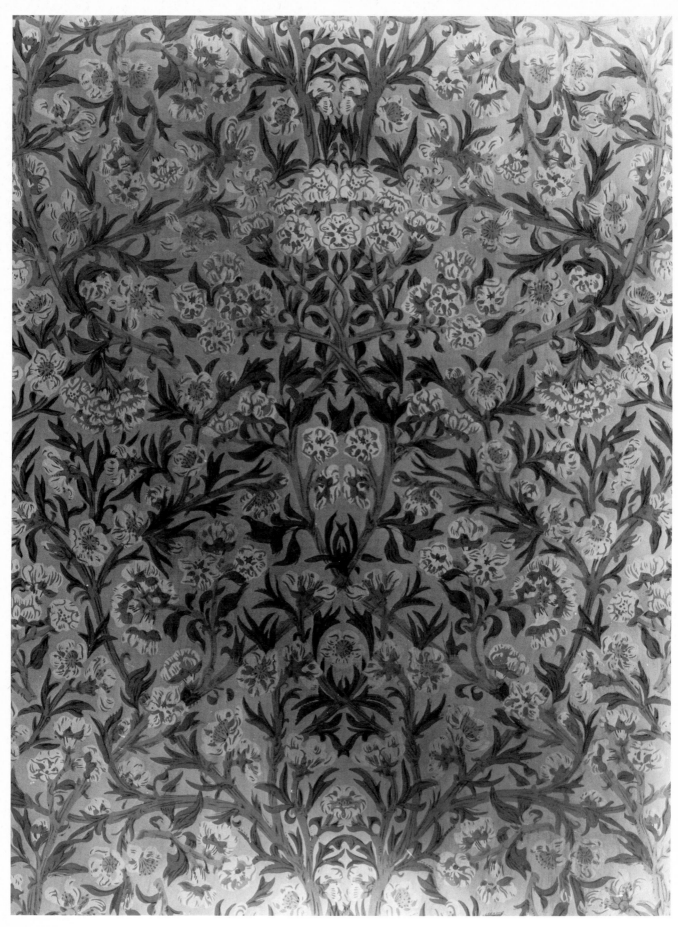

Kate Faulkner: 'Blossom' wallpaper; printed by Jeffrey and Co. for Morris and Co., England, 1885. The characteristic stylisation and flattening of natural forms into an overall flowing design, advocated by William Morris and his followers, can be seen here; the evenness of scale in the details of the design must have made it rather monotonous throughout an entire room, but this may have been overcome by a judicious use of colour combinations. Although few are now known, Kate Faulkner designed many wallpapers, both for Morris and Co., and for Jeffrey and Co. directly; she worked for the Morris firm from 1861. (PHOTOGRAPH: VICTORIA & ALBERT MUSEUM, LONDON)

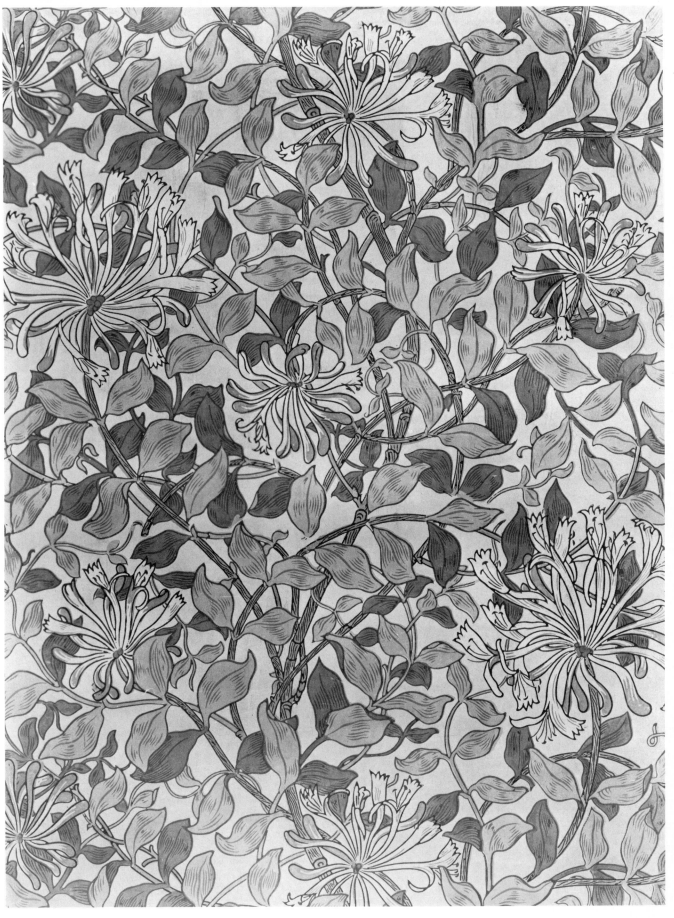

May Morris: 'Honeysuckle' wallpaper; printed by Jeffrey and Co. for Morris and Co., 1883. A less formal design than Kate Faulkner's 'Blossom', 'Honeysuckle' retains a particularly strong sense of carefully observed naturalism in the flowers, while not sacrificing the decorative two-dimensional pattern so essential in successful designs for flat surfaces. (PHOTOGRAPH: VICTORIA & ALBERT MUSEUM, LONDON)

13

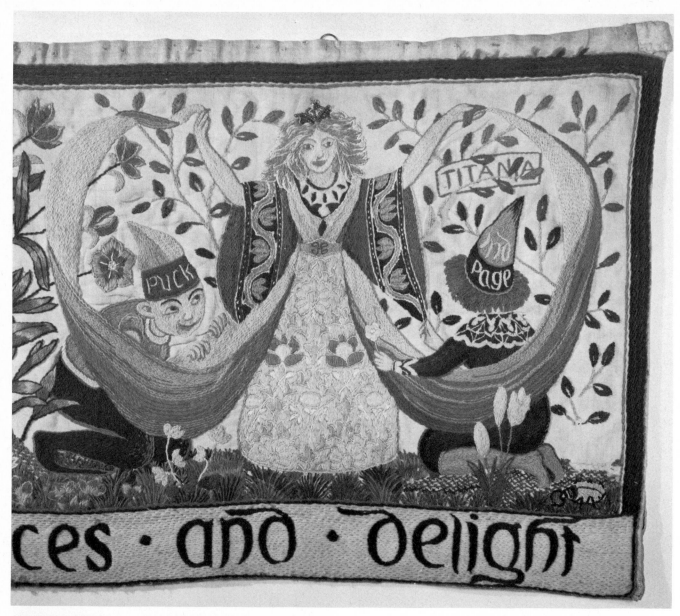

ces · and · delight

Above: 'Midsummer Night's Dream': detail of a wool embroidered frieze worked by Miss Jack, sister of the furniture designer and maker George Jack, one of the craftsmen to design furniture for Morris and Co. Few women who came into contact with the Morris firm did not take up embroidery; the delightfully 'primitive' qualities in this example indicate the hand of an amateur, although the stylish calligraphy along the bottom looks more sophisticated than that in the picture, and may have been designed by another more experienced hand. (PHOTOGRAPH: WILLIAM MORRIS GALLERY. WALTHAMSTOW, LONDON)

Left: Morris and Co.: two women weaving the 'Hammersmith' carpet design at the Merton Abbey works; from a photograph reproduced by Lewis F. Day in his article on William Morris in the Art Journal Easter Annual in 1899. This is the only photograph I have found to date which shows evidence of women employed in the Morris firm outside the embroidery department; other contemporary photographs show only men engaged in the varied departments of the firm's workshops.

Right: Jenny (Jane) Morris, photographed c.1890. Born in January 1861, Jenny was William Morris's favourite daughter because, according to Wilfred Scawen Blunt, of her intellectual faculties as a child, of which he had been proud. At the age of fifteen her development was curtailed by the onset of epileptic fits, an illness which remained with her for the rest of her life. Jenny had been engaged in embroidery from an early age, at least by 1869, but few examples of work by her survive. (PHOTOGRAPH: WILLIAM MORRIS GALLERY, WALTHAMSTOW, LONDON)

14

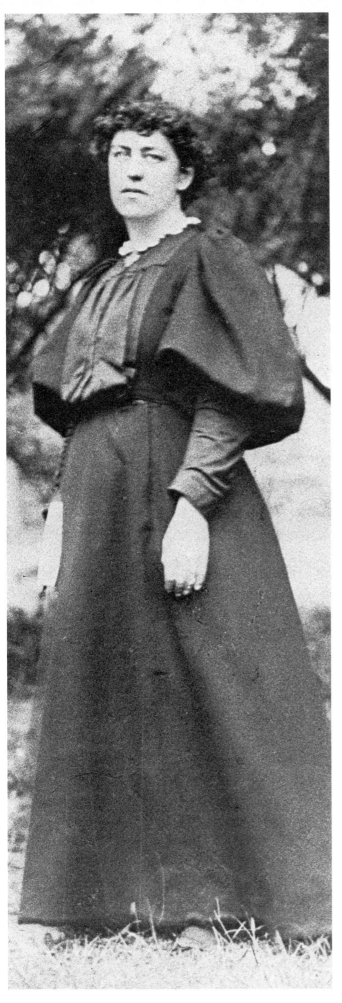

The Morris firm seems to have employed few women in its workshops, apart from the embroidery section; contemporary photographs include only one (reproduced in the *Art Journal Easter Annual* 1899), which shows two women at work, in this case carpet weaving. Thus in the main, the Morris firm's activities in which women were employed divide into two groups: first, members of the family or friends who either helped run the business and were engaged in active production more or less full time, or who, like Georgiana Burne-Jones, served as part-time, and presumably unpaid, helpers. The second group was formed by the unknown number of waged women employees who, under the supervision of May Morris, produced the bulk of the firm's embroideries. The employment of women in a traditionally 'feminine' branch of the crafts, no less than May Morris's early takeover of that department from her father, reinforced a sexual division of labour which was to be largely repeated throughout the Arts and Crafts movement as a whole. It is not clear whether May Morris was receiving payment for her work, or if she was simply supported by her father as a member of the family; it is evident that when she was planning to marry Henry Halliday Sparling she was forced to experiment with frugal living: 'May is away at Kelmscott Manor alone learning to cook & how to live on a few shillings a week. She is bent on marrying without waiting till her future husband gets employment. I have said & done all I can to dissuade her, but she is a fool, and persists'.[26] It is apparent that even at this stage she was not earning an independent income.

During the 1880s a series of key Arts and Crafts organisations were founded, including the Art Workers' Guild (formed in 1884 by the amalgamation of the Fifteen (1881) and the St George's Society (1883)) and the Arts and Crafts Exhibition Society, many of whose founder members were also in the Art Workers' Guild, and which provided an outlet through regular exhibitions from 1888. The Art Workers' Guild seems mainly to have been a metropolitan organisation which fulfilled the crucial need for an arena for discussion and the exchange of ideas among like-minded architects, designers, artists and craftsmen, thus giving its members a sense of solidarity and common identity. A major issue which remains to date unquestioned is the fact that this, *one of the most influential, élite bodies of the Arts and Crafts movement, excluded women from its ranks*. Although the Guild pursued a policy of no publicity, it is significant that by the 1890s its members were holding the most powerful jobs within the art and design educational establishment:

There is no competition, since there is no comparison, with other and similar societies, for there are none similar. We do not strive towards a definite material end. We neither seek public recognition, nor try to teach the world, nor even, definitely to teach each other; yet we are not without aims. Each member learns from each . . . So ultimately, we do teach the world and give our Professors of Art to the Ancient Universities, our Architects to be custodians of great cathedrals, our painters and sculptors to the Royal Academy, leaders and teachers to every craft and School of crafts.[27]

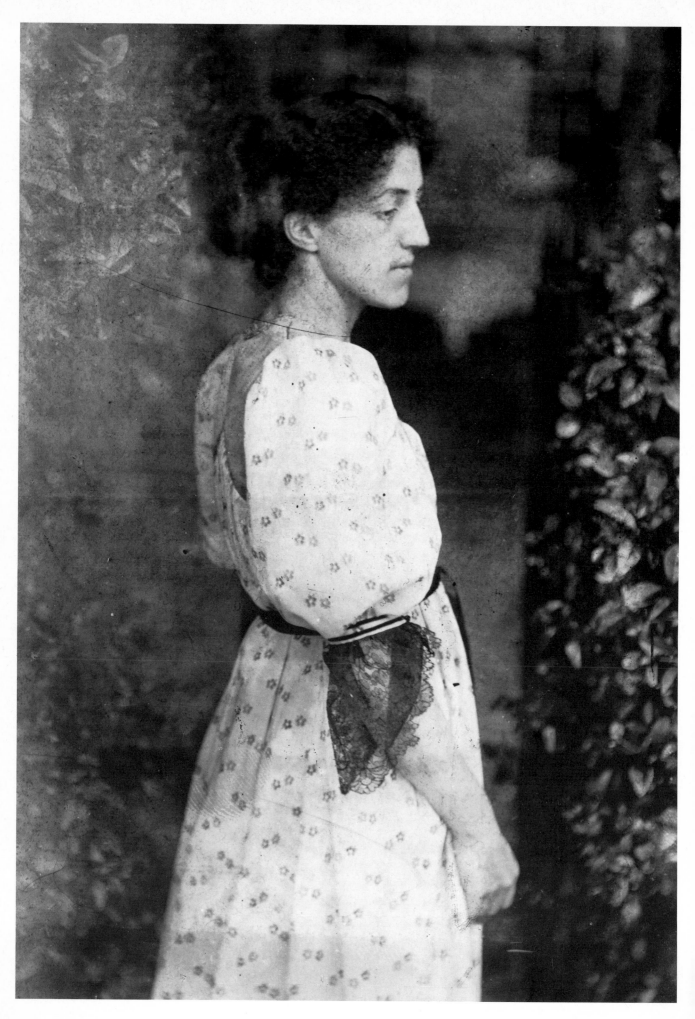

Thus these men, including William Lethaby, Walter Crane, George Frampton, R. Catterson-Smith, Anning Bell and Caley Robinson, were able to promote the ideals of the movement on a wide national scale from the level of education upwards, while at the same time innocently recreating the social power structure in which women were effectively off the map. 'Women's Evenings' were held at the Guild, but this inherent notion of their separateness as a group only served to emphasise their existence as 'other', as outside the conventionally acknowledged norm. This lack of any unselfconscious integration of men and women at such a central and influential level of the Arts and Crafts establishment was in turn echoed at almost all other levels of the movement at large. As a result, a movement with often radical social aims, which should have contained the potential for an equally radical reassessment of the personal and practical relations between men and women, turned out to be reactionary in its reinforcement of the traditional patriarchal structure which dominated contemporary society. These constricting social structures, and the evolution of formal design education for women, are the subject of detailed discussion in the next chapter.

NOTES

1. Gillian Naylor, *The Arts and Crafts Movement*, London, 1971, p. 7. This book provides a very useful introductory study of the movement.
2. Signs of the Times, *The Edinburgh Review*, 1829, quoted in Naylor, *ibid*. p. 12.
3. For an excellent re-evaluation of the importance of the rôle of handicrafts in relation to the growth of machine power, see Raphael Samuels, The Workshop of the World, *History Workshop Journal*, 3, Spring 1977, pp. 6–72.
4. *ibid*. pp. 7–8.
5. Naylor, *op. cit*. p. 8.
6. *ibid*. p. 158.
7. Naylor (*ibid*) gives 1883; 1885 was given in a contemporary article in the *Art Journal*. See below Chapter 3, Embroidery and Needlework, for further discussion.
8. Geoff Spenceley, The Lace Associations, *Victorian Studies*, vol. 16, 1973, pp. 434–5.
9. Barbara Russell, The Langdale Linen Industry, *Art Journal*, 1897, p. 331.
10. Brian Harrison, Philanthropy and the Victorians, *Victorian Studies*, vol. 9, 1966, p. 371.
11. Sheila Rowbotham and Jeffrey Weeks, *Socialism and the New Life*, London, 1977, p. 14.
12. Quoted in Spenceley, *op. cit*. p. 446.
13. *ibid*. p. 443.
14. Home Arts and Industries Exhibition, *Art Workers' Quarterly*, vol. 4, 1905, p. 143.
15. Gleeson White, The Home Arts and Industries Association at the Albert Hall, *Studio*, vol. 8, 1896, pp. 91–2.
16. Home Arts and Industries Exhibition, *op. cit*. p. 143.
17. *ibid*. p. 144. The London area included: Mrs Duncan Mackinnon: Toymaking and carving; Misses Leeson and Prior: Bookbinding, weaving, lacemaking; Miss Plater: Needlework and embroidery; Miss M. V. Lambert: Lacemaking; Mrs Lewis Lamotte: Woodcarving; Miss Bloomfield: Basketmaking; Miss Tita Brand: Weaving; Miss K. M. Coffin: Embroidery and smocking; Mrs Osburn (Norbiton): Metalwork and rugmaking; Mrs Newton (Surbiton): various. The list continued with a wide variety of classes, given mostly by women, all over the country.
18. White, *op. cit*. p. 99.
19. Home Arts and Industries Exhibition, *op. cit*. p. 143.
20. Charles E. Dawson, Clarion Guild of Handicraft, *Art Workers' Quarterly*, vol. 3, 1904, p. 45.
21. D. G. Smart (ed.), *The History of the Leek Embroidery Society*, published by the Department of Adult Education, University of Keele, 1969, p. 10 and n.1, *Queen*, 11 September 1885.
22. *ibid*. p. 9 and n. 1.
23. *ibid*. p. 7 and n. 1.
24. Margaret Todd, *The Life of Sophia Jex-Blake*, p. 72, quoted in Virginia Woolf, *The Three Guineas*, New York, 1966 (1st ed. 1938), pp. 64–5.
25. Concerning fluctuations in critical attitudes, especially since the beginning of this century, which have caused the then acknowledged contributions to art history of women artists to 'disappear', see the valuable forthcoming book by Rosie Parker and Griselda Pollock: *The Old Mistresses: Women, Art and Ideology*.
26. Letter from Jane Morris to Rosalind Howard, August 1888, quoted in Philip Henderson, *William Morris, His Life, Work and Friends*, London, 1967, p. 298.
27. Edward Warren, Guild Master in 1913, quoted in H. J. L. J. Massé, *The Art Workers' Guild*, London, 1935, p. 4.

May Morris, c. 1890: One of a series of photographs taken of her in the garden at Hammersmith, showing a more private side of her character—neither the Pre-Raphaelite caricature nor the stern former Mrs Halliday Sparling. (PHOTOGRAPH: WILLIAM MORRIS GALLERY, WALTHAMSTOW, LONDON)

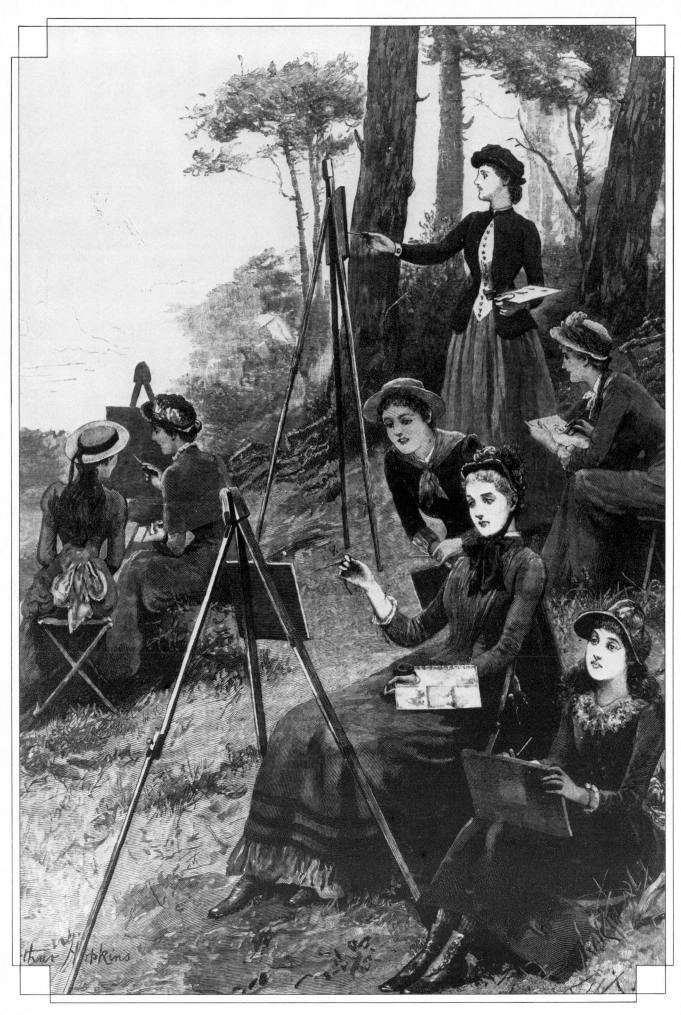

1 Design Education for Women

'A Ladies Sketching Club', The Graphic, 4 April 1885. Amateur lady artists out sketching from nature, according to the artistic fashion of the time. Creative leisure activities were still considered necessary accomplishments which enhanced a young lady's character; but professional engagement in an artistic career was even at this date frowned upon in middle-class circles. (PHOTOGRAPH: THE ILLUSTRATED LONDON NEWS PICTURE LIBRARY)

THE GENTEEL ARTS

ANY STUDY of women's education and their subsequent involvement in the Arts and Crafts movement must of necessity look first at the social and cultural position in which women found themselves during Victorian times, and the ways in which their situation conditioned their development and activities. As these forces are now so apparently distant from late twentieth-century experience, and since this study is primarily concerned to assess the role of middle-class women in their struggle for economic independence and an autonomous cultural identity, this chapter first examines the attitudes, both conscious and unconscious, with which women were imbued by social ideology in the mid-nineteenth-century.

In the Victorian era the woman's place was in the home; marriage was her sole sanctified vocation, her only means to social recognition, status and security. Home became a secular temple amidst pagan turmoil, woman its high priestess and guardian, 'The Angel in the House'.[1] As Ruskin conceived it:

This is the true nature of home—it is the place of Peace; the shelter, not only from all injury, but from all terror, doubt, and division. In so far as it is not this, it is not home; so far as the anxieties of the outer life penetrate into it, and the inconsistently-minded, unknown, unloved, or hostile society of the outer world is allowed by either husband or wife to cross the threshold, it ceases to be home; it is then only a part of that outer world which you have roofed over, and lighted fire in. But so far as it is a sacred place, a vestal temple, a temple of the hearth watched over by Household Gods . . . so far as it is this, and roof and fire are types only of a nobler shade and light,—shade as of the rock in a weary land, and light as of the Pharos in the stormy sea;—so far it vindicates the name, and fulfils the praise, of Home.[2]

Ruskin's walled garden vision of the Victorian home, the more potent for his use of quasi-biblical language, provides an incisive insight into the social and psychological forces which formed his contemporary woman. In a world of social upheaval, of ruthless business competition, she was to be the calm eye in the centre of the storm, and was endowed with ideals of virtue and wisdom, and given the spiritual and moral guardianship of her menfolk returning from the trials and temptations of an amoral commercial world. Her job was to provide in the home a haven of calm serenity, to be 'a companion who will raise the tone of [her husband's] mind from . . . low anxieties, and vulgar cares' and 'lead his thoughts to expatiate or repose on those subjects which convey a feeling of identity with a higher state of existence beyond this present life'.[3]

Within the broader social framework the rôle of middle- and upper-class women was crucial to the formal structuring of society, of social acceptability and the etiquette of social interaction. The formalities of card-leaving, call-making, dinners, balls and the whole round of the Society season—organised and ritualised by women—were central to the structural stability of a rapidly growing industrial society. Thus Society can be seen 'as a linking factor between the family and political and economic institutions. As such it proved to be an extremely flexible mechanism, useful to social groups faced with the consequences of increased population and urban growth, industrial development and political realignment which were the characteristics of the first half of the century'.[4] In the main this important social function was performed by married women, and the delegation of most domestic duties to large households of servants gave them the time and leisure to do so; thus marriage gave Victorian women their only acceptable form of social power, which it was in their own interests to protect and in society's to maintain.

As the arbiter of social taste and the protector of the virtues of homelife, there was an evident necessity at all costs to protect women from the temptations of the worldly cares seen as so damaging to moral life, and also so potentially disruptive to the social order. If women were to 'love, to serve, to save',[5] they had to be rigorously excluded from all male spheres of activity. Yet this idealisation of woman and the family left women particularly vulnerable—both psychologically and financially—when faced with lack of success in finding a husband:

We know the anxiety with which people moving in these circles look upon a daughter, as she advances towards womanhood . . . we know that satarists and novelists are never more successful than when they lament or extenuate, or sneer at the manoeuvres of some scheming, cringing, flattering mother, who is endeavouring to dispose of her daughter. But can we wonder at the efforts made, when we consider the frequent results of unsuccess? For the future, the young woman becomes a burden and a continual source of uneasiness at home.[6]

In a society where the status of middle- and upper-class women was defined by marriage, failure to do so left a stigma signalled by her lack of status; the existence of an unmarried woman was not acknowledged by Victorian Society—she had no position in the social heirarchy. Failure to do her duty in marriage was seen as a crime on her part.

The kind of upbringing and education which girls received both assumed and reinforced their exclusion from the male commercial world. Until the 1870s saw the gradual increase in the establishment of girls' schools, little or no formal education for them was customary. From the cradle onwards, life was wholly oriented towards their anticipated future rôle—that of a wife with social duties and Society aspirations; 'From the time the little girl entered the schoolroom at about the age of five until she "came out" at seventeen or eighteen, there was nothing to mark her progress in the way of promotion, certificates or even variations in dress'.[7] The lack of incentive in their early education no doubt made it difficult for women to cope later with the demands of a competitive career, but perhaps more importantly, their total isolation from early social intercourse left most women ill-equipped to handle normal social relations, if let alone to challenge

John Ruskin: a portrait photograph by Fred Hollyer, 1894. The spiritual father of the Arts and Crafts movement is captured here in old age. (PHOTOGRAPH: VICTORIA & ALBERT MUSEUM, LONDON)

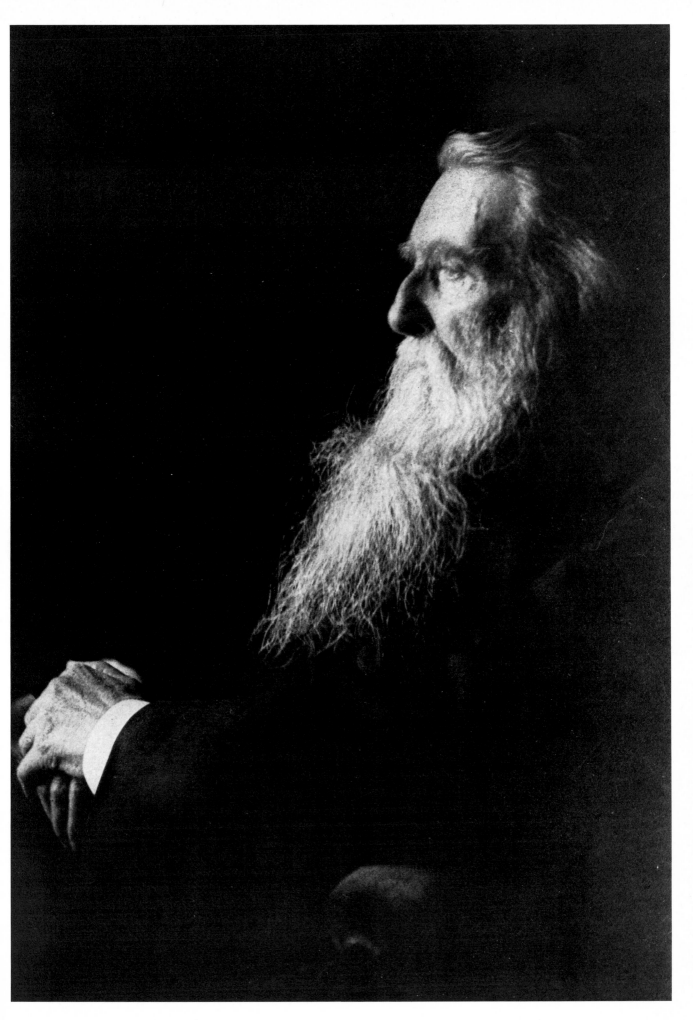

established order and attempt to make their own way in the world. Side by side with early social isolation, girls grew up experiencing constant personal companionship: from wet-nurse to nanny, to governess to chaperone, they were kept under constant surveillance, and such a lack of solitude is acknowledged as an important factor in the impediment of autonomous psychological development and a sense of self.

In discussing the possible reasons for women's inferior status and achievements in the nineteenth century, the *Art Journal* of 1872 put forward some perceptive suggestions:

It may be that woman cannot at once rise to the level on which men stand after ages of culture and conscious freedom; or, more likely, it may be that no woman is, or ought to be, able to free herself from domestic duties and associations, which, in their inevitable interruption, render almost impossible the concentration of purpose and leisure of mind essential to high success. We have here a really strong reason against the success of women in any continuous avocation, especially if followed in the home. On the master, or on the son, of the house, the library or studio door may be closed until opened by himself. But the very nature of her duties makes this difficult for the mistress who manages her own house; while, as a rule, very few mothers have sufficient sympathy with any fixed purpose of work to secure to their girls the same freedom which, as a matter of course, they give to their boys.[8]

Thus the lack of constructive solitude in childhood served as a preparation for the exigencies of Victorian marriage, while hindering individual growth. The girl's training was towards sociability, refinement, towards the acquisition of fashionable accomplishments designed to attract suitors and ensure her future security in a good marriage:

It was with a view to marriage that her mind was taught. It was with a view to marriage that she tinkled on the piano, but was not allowed to join an orchestra; sketched innocent domestic scenes, but was not allowed to study from the nude; read this book, but was not allowed to read that, charmed, and talked. It was with a view to marriage that her body was educated; a maid was provided for her; that the streets were shut to her; that fields were shut to her; that solitude was denied her—all this was enforced upon her in order that she might preserve her body intact for her husband. In short, the thought of marriage influenced what she said, what she thought, what she did. How could it be otherwise? Marriage was the only profession open to her.[9]

Beneath the Ruskinian ideal of women, marriage and the home lay contradictions which had in reality to be faced by women trained to that ideal; for marriage, although advocated as the only honourable profession for Victorian gentlewomen, was becoming increasingly less feasible. By 1851 there was 'a preponderance of half a million of the female sex'[10] and the problem of untrained ladies with no means of support was becoming acute:

What share of the ordinary avocations of life may fairly be assigned to woman, is unquestionably one of the most difficult social problems of our times, and one that, day by day, becomes more pressing for some sort of solution.[11]

From the earliest days of Victoria's reign writers had been expressing concern over the problem of destitute gentlewomen who, because of the limited rôle imposed upon them by society, were incapable of earning an independent livelihood. Even Sarah Ellis, whose works such as *The Wives of England* of 1843 helped to crystalise the Victorian ideal of womanhood, wrote sympathetically of the need to find suitable employment for the many women with no man to support them. Successive attempts were made by the Victorians to resolve this dilemma created by an over-rigid structuring of their social rôles. In view of the rôles and characteristics attached to gentlewomen, it was essential to find work that could be considered 'suitable'; contamination from the sordid commercial market was to be avoided at all costs if woman was to maintain her position as the safe haven from that world, and if man was to retain his authority in it. The work had to reflect woman's limited and 'special' feminine capabilities, and thus, on a deeper and less obvious level, minimise the competitive threat to male dominance and to the stability of the social structure as a whole.

One means of neutralising this threat and of undermining female initiative, which was in itself a social danger, was to place the plight of gentlewomen in a special category and under the umbrella of philanthropy:

Here are women demanding of us employment whereby they may earn their livelihood; what shall we give them to do? . . . surely there are pursuits other than the domestic to which woman is equal? . . . In this metropolis, thank God, Sympathy, ever warm-hearted and strong-handed, has already been considering the question, and exerting herself to answer it in the best way she is able. Already she has raised more than one temple to Misfortune . . . designed either to provide immediate and suitable employment, or the means to procure it hereafter.[12]

Such statements, here again given additional authority by being couched in a biblical and quasi-mythological idiom, emphasise the charitable, institutionalising

Top right: 'A Group of Servants', c. 1860, photographer unknown; in the Victorian middle-class household the mistress did not herself perform any of the chores, but delegated work to a hierarchical string of servants headed either by a butler or a head housekeeper. Like her husband in the 'outside' world, her rôle within the house was managerial, organisational and that of hostess to her friends and those of her husband. (PHOTOGRAPH: VICTORIA & ALBERT MUSEUM, LONDON)

Right: 'At the Ball': from a series of Victorian Domestic Scenes from stereoscopic photographs, published by James Elliott c. 1854. The impression made by a young lady at her 'coming out' year balls was crucial to her chances of success in the marriage stakes; such balls were an essential part of the Society calendar during the winter Season in London. (PHOTOGRAPH: VICTORIA & ALBERT MUSEUM, LONDON)

Far right: 'Wedding Breakfast': from a series of Victorian Domestic Scenes from stereoscopic photographs, published by James Elliott c. 1854: Such scenes show the successful fruits of a marriage campaign; it is interesting to find that Victorian stereoscopic photographers were producing reassuring images reflecting the social round and home life of the middle-classes. Stereoscopic photographs with their accompanying viewers became a standard leisure accessory in the Victorian home, having been all the rage in the 1850s and 1860s. (PHOTOGRAPH: VICTORIA & ALBERT MUSEUM, LONDON)

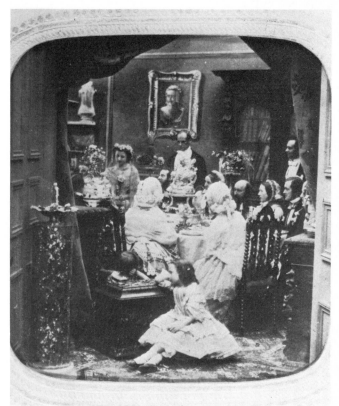

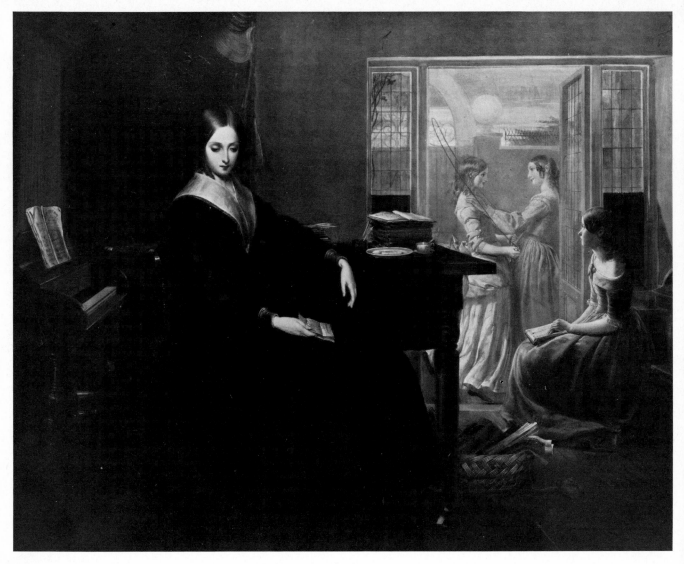

aspect of procuring work for women, diminishing the possibility of seeing work as dignified and honourable for them, and thus subtly reinforcing the Victorian view of the debasing character attached to paid work for gentlewomen: 'My opinion is that if a woman is obliged to work, at once (although she may be Christian and well-bred) she loses that peculiar position which the word *lady* conventionally designates'.[13] For a woman of gentle birth to take up employment beyond the purely charitable was considered demeaning, but to actually countenance receiving payment for such an activity was almost akin to prostitution—in itself a major side-effect and anxiety of the period.[14] In addition, for a woman to be earning money when it was not absolutely necessary was seen as a humiliating reflection on the men whose rôle it was to provide for her. It was manifestly inconceivable that a woman should see earning her own living as a simple matter of achieving self-respect and independence, something which for men was not merely taken for granted, but considered as part of their duty.

By 1872 the problem of employment for gentlewomen was still unresolved, while the numbers of the needy were steadily increasing: 'As a matter of fact, we find women in Great Britain outnumbering men by nearly a million; and we find also, in the face of the marriage theory, that three out of six million adult women

'The Poor Teacher': Richard Redgrave, exhibited in 1843. A career as a governess or a teacher was widely considered the only respectable alternative suitable for gentlewomen of straitened circumstances who failed to find a husband to support them; but pay was low and conditions difficult. The governess, although well-born and often of the same social standing as her employer, was socially isolated; as a wage-earner her social status was demeaned and she could not mix freely in her employer's social circle, but wage-earning did not make her working class, so she was ostracised by her fellow domestic servants. With the growth of provincial Art Schools many middle-class women attended art classes with a view to increasing their desirability as governesses; it was only gradually that art and design training for women became more widely accepted as a means to a career in itself. (PHOTOGRAPH: VICTORIA & ALBERT MUSEUM, LONDON)

support themselves and relatives dependent on them'.[15] In advocating art work and art education for women, the author of this article goes on to specify the class of females most needing encouragement:

In a suggestive pamphlet by Mr W. R. Greg, entitled 'Why are Women Superabundant?' we find . . . the statement that 'in the manufacturing and agricultural population, who earn daily bread by daily labour, few women remain long or permanently single.' The ranks of sufferers from want of work, and of women left dependent on themselves, are recruited from the higher classes, where work is not a duty until it becomes a necessity.[16]

As we have seen, the position for women of gentle birth was such that, if traditional means of support gave way, destitution, and often prostitution was the only future of many; concerned writers were soon making this clear to the public:

Suppose reverses or misfortunes in business, or a British Bank collapses, or Death makes a call upon the head of the family before he has made provision for it, or a guardian mis-appropriates the provision he has succeeded in making,—what is to become of her then?[17]

Paying occupations for gentlewomen were, in the 1850s, strictly limited, the main outlets being that of governess or teacher, for both of which the restricted education of women was considered an adequate preparation. However, as the numbers of single women increased during the century, competition and a growing seriousness in the general approach to education began to force the untrained woman out of the market. This was remarked upon in an important series of articles in the *Art Journal* of 1872:

Teaching has hitherto been the refuge for ladies incapable of other work: an evil always re-acting on itself, since those who do not know how to teach can only send out pupils as helpless as themselves. But even this poor refuge is fast failing, and will go, past recall. There is now a steady determination, which will cease only with success, to raise teaching, for women as for men, to its true rank as a profession, by making entrance practicable only to the duly qualified.[18]

In the search for suitable occupations for gentlewomen, art rapidly came to be recognised as one of the few areas in which women's participation could safely be encouraged; it was 'one field for female industry which hitherto has not been sufficiently surveyed, but which . . . is capable of being cultivated with high advantage at once to the labourers and the community at large'.[19] Here was an area of employment for women that could be seen as an extension of the traditional feminine accomplishments of the period, which would enhance rather than erode the rôle designated as 'natural' for Victorian womanhood. Arts and crafts could be seen to comply with Ruskin's ideal of the woman's place, and with Tennyson's 'Man for the sword and for the needle she: Man with the head and woman with the heart . . . All else confusion'.[20] They could represent merely the slightest enlargement of her accepted sphere of life:

To whom should we so confidently apply for all that concerns the beautifying of home-life as to the presiding spirit of the home? Why should not the instinctive taste and natural grace of woman be reflected in the hues and harmonies of colour and form on the walls of her rooms, on the curtains arranged by her deft fingers, on the soft carpet beneath her feet, and in the thousand forms of comfort, convenience, or elegance which surround her?'[21]

The extent of the need for, and the acceptance of art work as a suitable occupation for gentlewomen became alarmingly evident as the growth of art schools in the 1840s and 1850s gave them opportunities for training; officials were perplexed to find classes designed for females of the working and artisan class flooded by desperate gentlewomen. No-one had a precise knowledge of the extent of the problem, for these women were powerless, and had no press or political representation. Growing public awareness of the situation of middle-class women brought not only charitable sympathy, but anxiety over disruption of the *status quo*; to reassure the public that art work for women would in no way encroach on traditional male and female spheres, one writer stepped in to allay typical fears:

We may remark, at the risk of repetition, that there is here no question of the introduction of women to new employments, or of the danger of tempting them from their homes. These are points quite beside the mark. All that now concerns us is the question of fitting women to do the work well, *which they already do*, but do badly. In the consideration of new openings in Art-work we do not actually introduce any new element.[22]

This evident fear of change and anxiety over the strict division of labour between the sexes, is rarely so openly discussed with regard to the middle and upper classes; in working-class circles the fear of female competition and cheap labour was an open and recurrent theme of hostility towards women,[23] while among the more respectable classes such discussion tended to be cloaked in moral issues.

Despite the fact that work was still seen as a poor substitute for their 'natural' calling of marriage, attempts were made to see celibacy in women in a less damning light:

Marriage is undoubtedly woman's happiest vocation. But as all women are manifestly *not* 'called' to the happiest lot, it is a little hard that they should not be fitted for some other business. There may be an 'ideal' of single, as well as of married life, offering full scope for every faculty and energy, if only cultivated to the right point.[24]

The absence of the cultivation of women's faculties was seen to be a central reason why women produced inferior work. According to the *Art Journal* the key to woman's success and acceptance as an art worker was training; this was felt to be the major difference between men and women in terms of work, and a cause of women being relegated to inferior work. There was a need for women to receive a thorough training and establish a skill for themselves: 'unfortunately, till it is removed by emigration or some other equally potent remedy, we may never forget that there are too many women in England. There is, therefore, room only for skilled workers'.[25] Thus for women of the middle and upper classes who were dependent on their own resources, the increasing possibility of education to a career in the arts was a vital and rare opportunity.

The attitudes of parents were considered a major obstacle in the promotion of art education for women, and many blamed them for not providing daughters, as was automatically done with sons, with the basis of a business skill to equip them for an independent life:

Much of the fault . . . lies with the parents as well as with the girls themselves . . . If it were not a fact of daily occurrence it would seem absurd to state that we have no right to expect women to do by instinct that for which men give years of patient toil . . . The father who knows that his income is

limited or uncertain, never hesitates about his boys; at any cost they must be educated, and sent out into life armed for the struggle. At *what* cost might often be told by the sisters of these boys, if, happily, self-forgetting love were not one of the strong instincts of woman's life. There are hundreds of girls with a passion for pure knowledge and a love of study, as intense as any other power of love with which women are universally credited, who have yet to stand aside, watching an education of which no share comes to them; and, later in life, to sit idle at home, envying the activity which is denied them, until, under some sudden pressure of necessity, they find themselves rudely jostled out of their quiet corners, and breathless in the midst of a crowd of eager bread-seekers. . . . If we allow that women may undertake certain branches of work, it must follow that we grant also a system of regular training or apprenticeship for girls. For boys this is a matter of course.[26]

However, while educational opportunity for middle-class women expanded, actually earning a satisfactory livelihood still remained a major difficulty. Since the beginnings of the Industrial Revolution working-class women had been relegated to the most menial and poorly paid jobs; every circumstance, from inferior strength and slower work to the demands of child-rearing, contrived to place such women at the bottom of the work scale. The shift of production from the home to the factory, and of the onus of bread-winning from the whole family to the father had diminished the value of women's productivity within the family. Her wage become subsidiary to the man's, her lower pay and thus cheap labour a threat to his job security. By the nineteenth century 'work' came to define the activity directly related to the commercial market—the buying and selling of goods or labour for the production of surplus value; thus women's work in the home: the re-production of the labour force and the maintenance of the family, traditionally so central to the economy, became obscured and devalued within the new commercial concept of the market. It could not be seen to play any overt part in the functioning of the industrial economy, and was therefore given no recognition or reward. Working-class women's work was of course two-fold, both in the factory and in the home, and in neither was her rôle anything but secondary to that of men.

For the new middle class of the industrial and agricultural rich, leisure was a sign of success, and so women were discouraged from taking an active rôle in domestic production, which was gradually taken over by hired servants and workers. As the rituals of Society life became more complex, and involvement increasingly time-consuming, even the management of the household was often completely renounced by the mistress of the house, and delegated to a housekeeper and an efficient battery of staff. At a time when the ethic of work was raised to a pinnacle of importance among the basic codes of daily life, work ceased to play a central part in the lives of most gentlewomen.

Cheap labour and low wages for women were already an accepted fact of life when the growing influx of single, middle- and upper-class women began to establish their need for economic independence. Opposition was such that they had initially to establish the right to

decent work before they could begin to struggle for a good wage for that work:

We do not, on the whole, find that great opposition is offered by manufacturers to the wider employment of women. Indeed, even with the existing low estimate of the value of women's work, their assistance may be expected. 'There is no reason,' says one of them, 'why we should object to employ women. They work for lower wages than men.' On the score of strict justice we may possibly dispute the reasoning of such a view of things, wondering if good work, even if done by a woman, is not worthy of good payment. But we may, nevertheless, accept the position thankfully, and while we endeavour to secure the good work, leave for the present the question of its just reward.[27]

One of the most frequent arguments of the period against giving women decent wages for good work was that of the inferiority of their work to that of men. The familiar title 'amateurish' was often attached to women's work, one particularly pertinent in the context of art work, as female accomplishments in the Victorian era necessarily included the ability to embroider and to paint daintily in watercolours,[28] and when so many gentlewomen freely devoted their time to fancywork for sale in charity bazaars. Thus when such women needed to take up similar work on a professional basis they were greeted with suspicion:

It is not easy . . . for women to escape the influence of the common notions of 'amateur', as contrasted with 'professional' work, by which, in a strange confusion of meaning, we have come to understand that to do a thing *for love of it* is really equivalent to doing it imperfectly.[29]

Money had taken on such prime importance in the estimation of intrinsic value, that something not done for money was seen as of little value and of low quality. Yet the threat posed by the existence of amateurs did present serious problems for professional craftspeople, doubtless exacerbated by the more general fear of women's competition in the labour market. Charles Ashbee, writing of the problems faced by the Guild of Handicraft in 1908, acknowledged that amateurs were not exclusively female, but at the same time he criticised the lady amateur:

In the Guild's workshops our fellows are rightly nervous of this competition of the amateur, especially the lady amateur, and albeit with the utmost consideration they speak of her as 'dear Emily'. I have seen a great deal of her work in the last ten years, she is very versatile, she makes jewellery, she binds books, she enamels, she carves, she does leather work, a hundred different graceful and delicate crafts. She is very modest and does not profess to any high standard nor does she compete in any lines of work where physique or experience are desired, but she is perpetually tingling to sell her work before she half knows how to make it, and she does compete because her name is legion and because, being supported by her parents she is prepared to sell her labour for 2d. an hour, where the skilled workman has to sell his for 1s. in order to keep up standard and support his family.[30]

While it appears that by this date there was less stigma attached to a lady selling her labour, it seems that Ashbee, like many others writers, underestimated the

The Garden of the Residences of the South Kensington Museum beside Exhibition Road, 1891. The Normal, Central or Head School of Design was founded in 1837, and twenty years later moved (as the Central Training School) to new premises in the South Kensington Museum which had been established in 1852 as the Museum of Ornamental Manufactures by Henry Cole as a museum of applied art primarily intended for educational purposes. Its collection formed the nucleus of what is now the Victoria and Albert Museum. (PHOTOGRAPH: VICTORIA & ALBERT MUSEUM, LONDON)

woman within the social definition and starve, or emulate man and survive, but be left with the emotionally damaging consequences.

A major disability in women, put forward as one of the consequences of their lack of adequate training was, ironically, a want of patience and obedience: 'It is common to endow women, as natural graces, with the virtues of patience and obedience. But we think it will be generally found that when they exhibit these qualities it is either in things where they have had long practice, or else it is when they are under the influence of some over-mastering emotion which lifts them out of themselves ... we do not find the evidence ... that patience and obedience are either natural to women, or specially manifested in women's work'.[32] An adequate training both at school and afterwards in art school would, it was felt, supply a greater sense of discipline and perseverance in girls whose present education necessarily and intentionally left them with little sense of purpose or incentive to succeed.

Despite all the many disadvantages, it was thought by one writer at least that women, given the opportunity, were just as capable as men: 'There is, in reality, no lack of business power in women, as is abundantly witnessed in the great number of women at the head of large undertakings, which they manage well, without losing womanly softness or grace. But it is a power which, like other powers, requires careful cultivation'.[33] Although by no means all the Arts and Crafts women were destitute ladies, large numbers of them were middle class and thus equally subject to the social stereotype; art education offered at least the possibility of change.

PIONEER SCHOOLS: A WOMAN'S PLACE ...

Considering the negative attitudes towards the education of women, it is remarkable that as early as October 1842 a Female School of Design was established at Somerset House, London, under the superintendence of Mrs Fanny McIan, a painter of some celebrity.[34] Since the history of formal design education for women in nineteenth-century Britain is to a great extent the history of this pioneering School, an account of its development and vicissitudes under a series of Directors, beginning with the eminent painter, William Dyce, is given here in detail.

Higher education in art—and specifically in the art of design—had begun in earnest with the foundation of the Normal School of Design, London, in 1837,[35] intended for the training of male artisans in applied ornament, with the aim of improving the evident poverty of good design in English manufactures. This increasing interest in producing indigenous British designers was reflected in the provision of design education for middle-class women by the foundation of the Female School of Design, the objects of which were two-fold: 'partly to enable young women of the middle class to obtain an honourable and profitable employment, and partly to improve ornamental design in manufactures, by cultivating the taste of the designer'.[36] At the male School the emphasis was on evening classes which enabled young apprentices to study after work hours; the Female School, on the other

need of numerous unsupported women to earn their living. The caricature of the lady amateur must have created severe problems for professional craftswomen trying to establish the sincerity of their involvement, and considering the social climate and attitudes to women it is not surprising that they found it difficult to take their own work seriously, still less to expect others to do so.

Society was geared to sapping female self-confidence and initiative in any fields but the social and domestic, rendering her dependent upon men, just as it equally efficiently channelled men into the rigid patriarchal rôle. Requiring women to be professional in their work-life was to place them in a rôle which was in complete contradiction to the ideals of womanhood. Ruskin enumerated the qualities essential to the wifely rôle: 'to fulfil this, she must—as far as one can use such terms of a human creature—be incapable of error ... She must be enduringly, incorruptibly good; instinctively, infallibly wise—wise, not for self-development, but for self-renunciation: wise, not that she may set herself above her husband, but that she may never fail from his side ...'[31] Such characteristics were the very antithesis of those required in the business world, and prepared woman for a life of self-abnegation and denial, not one of self-assertion and competition. Thus she was beset with problems which are still with us today: to remain a

hand, was a day school with girls from thirteen years upwards attending three hours of official classes each day, although in practice they studied far longer; '. . . so anxious are the students to prosecute their studies, that many of them are there at 10 and 11 in the morning, and remain till six in the evening'.[37]

Unlike the male Normal School of Design, the Female School classes were packed right from the start; in the first year the students numbered forty-five, with a long waiting list for entry. By 1848 the numbers had risen to 'fifty-five persons, and there are nearly eighty applicants for admission, who are necessarily refused for want of accommodation, and superintending instruction'.[38] One of the difficulties in setting up the Female School had been the question of finding suitable accommodation; 'Fortunately the apartments in Somerset House, placed at the disposal of the Council [of Design], comprised a large room on the ground floor, formerly used for the reception of sculptures in the exhibition of the Royal Academy, and a small room adjacent, which together have proved to be well adapted for the accommodation of the Female School of Design'.[39] These rooms afforded the security of a public building, in the charge of public officers, and under the immediate inspection of the Director of the whole establishment, William Dyce. At the same time it was sufficiently distinct from the male part of the school, which was on the upper floor of the building.

During its first six years of existence the Female School achieved not only satisfactory progress but a notable degree of success, its annual shows being considered far superior to that of the male section. This success was in the main attributable to the intelligence and education of the middle-class women who attended, and to their strongly motivated enthusiasm and the high standards prompted by the demand for the limited places available. But in addition, instruction differed somewhat from the dry curriculum practised elsewhere; Mrs McIan refused, on the grounds of insufficient space, to use the casts which traditionally provided the backbone for drawing study in the round. Instead she encouraged her girls to work directly from nature. She had visited the Ecole Royale de Dessin in 1844 and 'noted how much the Parisians worked from nature and plaster models of nature';[40] consequently it was not surprising that her students received frequent praise for their drawings of plants and fruit: 'the drawings and paintings of fruit are excellent; the panels are, in many cases, original thoughts, well worked out; and there are two or three designs of which manufacturers might gladly avail themselves'.[41]

It was also wryly suggested that the comparative neglect suffered by the Female School was a factor in its superior development. William Dyce, who as Director of the School of Design had been given responsibility for the formation of the Female School, was greatly in favour of the venture and during his period of office had visited the women's class almost daily.[42] Under his aegis—though not noticeably his tutelage—the school had flourished; but upon his replacement in 1843 by Charles Heath Wilson, the Female School was left vulnerable to less sympathetic forces. Initially, Mrs McIan was left entirely to her own devices to run the school as she saw fit, and the results were admirable:

Here there have been no squabbles. It has not been here as it has elsewhere—where AB does not wish CD to make a good design because EF will obtain credit therefrom; and where GH feels that the improvement of IK will be a benefit to LM, whom he does not desire to serve. Mrs M'Ian, an accomplished and amiable lady, has had no quarrels with Councils or Directors; she has pursued her quiet way, without let or hindrance from within or without.[43]

The extent of this neglect was made public by the Report of the Select Committee on the Schools of Design, published in 1849, in which members of the then Management Committee of the Head School were forced to declare in their evidence not only that they rarely visited the Female School, but more surprisingly that they had little idea what was going on there. When questioned on the kind of designs made at the school Ambrose Poynter admitted 'I do not know that they make any; I have seen some little things; I saw some designs that had been made for an inkstand, and things of that sort, I never saw anything else'.[44] Such naive ignorance is hard to believe, and begs the question of the possible motives behind it, for, not twelve months previously the *Art Union* had published a long article on the Government School of Design in which the progress and achievements of the Female School had been applauded. 'In Mrs M'Ian's class there are now students who have produced works that have met purchasers in Messrs. Storr and Mortimer, Aspley Pellatt, Ackermann and others; and only recently an eminent artist has obtained from the school appropriate designs for porcelain.'[45]

In fact there is much evidence which points to a concerted effort on the part of officials concerned with the School of Design to hamper and discredit the work of the Female School. Dyce's successor, Charles Heath Wilson, was positively against the presence of the Female School at Somerset House; they were occupying space which could have been used for a museum. The superior success of the Female School, and its aloofness from the problematic rivalries that were crippling the male section,[46] were evidently a source of acute embarrassment to the authorities. Compared to the abusive derision directed at the male School, the Female was receiving favourable comment in the press; the *Art Union* wrote of the Annual Exhibition of the School of Design in 1847: 'From this sweeping condemnation we must, however, except the Female School . . . the "show" in [Mrs McIan's] School is at all events creditable. The female students have far surpassed those of the other sex in every branch to which they have paid attention.'[47]

Further proof of the rapid progress of the females was evinced by the necessity, during Wilson's directorship, of introducing a second set of prizes at the School of Design, to avoid the embarrassment of them all going to women; Mrs McIan recalled:

. . . I saw a large list of prizes offered to the *male* school for designs of various kinds, but the prizes alotted to the *female* school were simply for what we call class drawing; but

thinking it was rather hard to my school not to be allowed to compete for something more than that ... [she ascertained that the women were open to compete for the prizes given to the males] ... the result was most satisfactory; the council found that the designs of the female students were as superior, or shall we say so equal to the designs of the male students, that they were obliged to award a second set of prizes, because they considered that it would be *infra dig.* to the men who had studied many years that those young women should carry off the premiums.[48]

Even the highest award, a gift of eight guineas, had to be duplicated as it was obvious it would be awarded to one of the women.

Thus there can be no doubt of the strength of grounds for jealousy of the Female School on the part of those in charge of the School of Design, and the ensuing series of hostile actions perpetrated against the Female School can only be attributable to that jealousy, and to the threat of competition it presented. These crises began with the abolition in November 1847 of the directorship of the School of Design, and the reorganisation recommended by the Special Committee of 1846–7 which brought into power the new Management Committee. Of the eight members of this Committee, which took over in April 1848, the three active, artist members were Richard Westmacott, George Richmond and Ambrose Poynter.[49] They acted swiftly against the Female School: Mrs McIan was no longer to be in charge of the

The Strand, London, 1860s?, photographer unknown. The north side of the Strand, home of the Female School of Art during the late 1840s and early 1850s; the area was considered by fond middle-class parents to be dangerously close to the 'purlieus of contagion and infamy' centred around the theatrical world of Drury Lane. (PHOTOGRAPH: VICTORIA & ALBERT MUSEUM, LONDON)

selection of her own pupils; attempts were made to curtail and revise her teaching methods; and in the autumn of 1848 the Female School was abruptly removed from its rooms at Somerset House and transferred to less suitable quarters in the Strand.

For the first six years of the School's existence, Mrs McIan had had complete control over the selection of her students, and the result was that 'there has never been a pupil in the school during the time we were located in Somerset House whose object in coming into the school was not to get their livelihood; and in fact they were obliged to do so'.[50] Mrs McIan considered all her applicants—who had to declare their financial need of a training for a career—to be equally eligible, and admittance to the school was strictly on a rotation system based on date of application. Discontent soon arose when it was discovered that the Management Committee was admitting applicants with total disregard to the rotation system. Mrs McIan addressed herself to an astonished meeting of the Board of Trade, to state her grievances:

After the Christmas holidays [1848] I sent to say that I could admit 12 more students, and to my surprise 25 were sent, of whom nine had applied in 1847, and all the remainder had applied in 1848, many of them at a comparatively recent date. This has caused a great sensation among the applicants who had waited so long, who had been content to rest upon my assurance that they would be admitted in rotation; formerly there never was a single complaint made, even by those who had been waiting since July 1847; but the instant it became known that others had been admitted, who had applied only a few days or a few weeks previously, the parents of some of those who had waited so long came to the school to ascertain the cause, and some of them said it was Mrs M'Ian's partiality.[51]

The members of the Management Committee responsible—Westmacott, Poynter and Richmond, all of whom were present at the Board of Trade meeting— could provide no defence against these accusations of their partiality, and it was obvious that they were using their position to secure private interests and also to undermine the prestige of Mrs McIan. They had not counted on her confronting them, and in public, with their misdeeds; Mr Labouchere, chairman of the Board of Trade, put it on record that he considered the rotation system a just one, and hoped it would continue satisfactorily.

It seems likely that from the first Mrs McIan had invoked the Committee's disfavour by her unequivocal preference for the methods of the first director, William Dyce, whom she referred to as 'a most eminent man, and a most qualified man for the office of director'[52] even long after his removal from office. Under Dyce the females had been encouraged to work on a large scale 'as being the best mode by which we could prepare the students to make works on a small scale; for if they can paint a drawing large, they must necessarily be able to paint a drawing small with much more power and effect than if they had been taught originally to draw small'.[53] Whether or not Mrs McIan's method was the best is debatable, but at least it was producing good results.

The Management Committee, however, supported an opposite method, possibly because large scale was associated with 'high' art, and there was a longstanding fear that students in the School of Design were all harbouring secret ambitions of becoming 'fine artists', ambitions which necessarily threatened the supremacy of the Royal Academy Schools. This fear was not entirely ill-founded, for the attractions of the design profession were few, and reluctant manufacturers added little incentive at this period.

The Committee's attack on the Female School curriculum began in the form of a memorandum sent to Mrs McIan in November 1848:

... The Committee are of the opinion, that in the Female school it is not expedient to encourage painting in oil, and that all paintings on the very large scale which is adopted in this school are decidedly objectionable, not only on account of the great inconvenience they occasion in occupying so much space, but as incurring useless and unprofitable expenditure of the pupils' time and labour.

The Committee are strongly of the opinion that studies on a smaller scale, carefully executed in detail, and having reference directly to such designs for manufactures and ornamental work as can be undertaken by females, and not merely to the practice of fine art, would be far more in accordance with the essential objects and purposes of the School of Design.[54]

Contemporary preconceptions associating females with the careful, detailed execution of small-scale work, and also the assumption that there were certain (unspecified) types of work 'suited' to the feminine nature were openly indicated in this letter. The Committee went even further in its indictment of the Female School. A sub-committee, composed not surprisingly of Westmacott, Poynter and Richmond, reported on the school in January 1847. This report stipulated that it should be forced to toe the same line as the male school; not simply should its curriculum be made the same, but its entrance requirements should be similar to those of the male section—in other words, its pupils should be of a lower social class. The male School was floundering in a turmoil of mismanagement and failed ideals; the Female School was to be made to suffer the same consequences, and the most needy class, the destitute middle-class females, to be deprived of a rare opportunity of finding independence. Fortunately the Select Committee of 1849 was to expose the incompetence of the Management Committee before such action could be carried through; but from the evidence concerning their disregard for Mrs McIan's admissions system it appears they were already engaged in modifying the school's population.

The most serious of the Management Committee's actions was the removal of the Female School from its rooms at Somerset House to new premises over a soap manufacturer's shop on the opposite side of the Strand, at No. 330. This took place during the summer vacation of 1848, without the prior knowledge or consultation of the superintendent, Mrs McIan. This issue became one of the major points of contention in the Select Committee of 1849, in which Mrs McIan stated: 'I had an interview with one member of the [Management] committee ... and ... I told him that if they had desired to find a place that was ill-adapted for the school they could not have succeeded more eminently'.[55] The reason given for their removal was the lack of space at Somerset House, a problem which had dogged the School of Design for several years and which was put forward as one cause of the lack of success in the male section. The immediate pretext was the necessity of separating 'the junior class of boys from the more advanced pupils, an idea we may suppose to have originated among the many mutations of the masters' minds', as the Art Union phrased it.[56] It is significant in this context not only that this new elementary class was run by W. H. Deverell, the son of the Secretary of the School, W. R. Deverell (a fact that Mrs McIan was quick to point out),[57] but also that a class of male beginners should have been given precedence over the successful Female School. Further, it appears that the elementary class was not strictly speaking considered a part of the School of Design; the 1849 Select Committee established that it was generally the case that a boy or man attended this class 'with a view to see whether he had a knowledge of drawing lines, and was capable of being a pupil in the School of Design ... and also to carry him on to a certain extent before he is fit to be transferred to the upper school'.[58] As the Art Union stated in 1848:

The junior male pupils could have been better located out from the female class, as their studies are purely elementary, while in the other, there are many who have achieved a considerable proficiency, and whose paintings in oil, water-colour, and tempera, would reflect honour on the advanced pupils of the male division ... Independent of the enormous rental paid for the rooms now engaged, and the humiliation felt universally by the pupils, it may be asked why the other rooms formerly occupied by Mr Wilson might not have been appropriated to the junior class rather than to become the habitation of the secretary, who might be far more comfortably located elsewhere.[59]

The overwhelming problems created by the lack of elementary art schooling meant that the schools of design, far from providing an immediate higher education producing competent designers, were forced to concentrate their energy and resources on training their pupils to elementary standard. Although similar problems did exist for the Female School, many of their pupils had some experience of elementary drawing, common to ladies of the middle class, and in addition their superior, if limited, education made teaching them an easier proposition.

The new premises of the Female School on the Strand consisted of six rooms, three large and three small, situated on three different floors above the soap shop of a Mr Low. One of the small rooms was used by Mrs McIan as an office. Although the change did in fact give more space, the fragmentation of that space and its distribution on different floors made it less convenient, particularly with only one mistress in charge. A major impediment felt by Mrs McIan was the restriction on the scale of works possible in these smaller rooms; no doubt a factor in the Committee's approval of the changeover.

Drury Lane, London, c. 1875, photographer unknown. The Female School of Art was transferred from Somerset House to the 'wrong' side of the Strand during the summer of 1848, to No. 330, close to the junction with Drury Lane. Although innocently quiet in this picture, the area's reputation was clearly dubious in 1848: 'an indignant father adverts to the situation of the school on this side of the Strand, being in a house standing in a bevy of gin-palaces, old-clothes shops, pawnbrokers, etc., and with numerous ramifying alleys . . .'. Evidently the father knew what he was talking about. (PHOTOGRAPH: VICTORIA & ALBERT MUSEUM, LONDON)

In the large single studio in Somerset House there had been no limit on the scale of students' work, and supervision had posed no problems. The Strand rooms necessitated constant bustling from floor to floor, wasting time and energy trying to keep an eye on students' progress. The rooms themselves were totally unsuited to art study. In its general recommendations for the choice of art rooms the Council of Design had stipulated that 'windows should reach at least 15 feet above the floor' and that if side windows faced towards the south or west they should be 'rendered partially opaque, to prevent the passage of direct rays of the sun'.[60] However, in the Strand building the highest ceiling was only eleven or twelve feet, while the lowest was a mere eight feet; the aspect of the main studios was southerly, yet nothing apart from collected grime served to diminish the penetrating sunlight. At first no provision had been made for heating the rooms, but after an outcry, fires were arranged; ventilation was non-existent, and fainting due to lack of oxygen was a frequent occurrence.

A manufacturer, visiting the School in search of good designs, wrote at length giving his impressions of the conditions under which the women studied. Describing the main studio he wrote:

I do not know how many students were there; but the room was full to crowding. They were packed close together on forms, just like children at a Sunday School, in our manufacturing towns. The elbows, and, in some cases, the shoulders of one student touching those of her next door neighbours, on each side.... This was the junior class. They were copying from the 'flat' and the 'round' (prints or drawings, and bas-reliefs); but, though it was only two o'clock, the light was so bad, owing to the fog, and the dusty, uncleaned windows, that to distinguish anything accurately was out of the question. I asked a student why they did not have drawing-lamps, but was informed that none were allowed.[61]

A much smaller back room on the second floor, being northerly facing, was reserved for more senior students for whom a constant light was essential; here

... there was similar crowding, and with much greater injury, as the higher class of students were here; and these, frequently having large designs, were continually in each other's way. For a young lady to have a blow on the cheek, or the side of her head, from the corner of a wooden-frame—an easel upset—a cast knocked down—a freshly-painted design smeared across, or a hole knocked in a canvas, were things of almost every-day occurrence.[62]

Despite these conditions, designs were being produced for carpets, table-covers, chintz, ladies' muslin and other figured dresses, groups of flowers, fruit, paper-hangings, screens, lace, shawls and many other articles. In addition to inconveniences created by the building itself, and to the loss of rank and stature incurred by the move, the unsavoury location of the premises created a further furore:

... in one letter addressed to us, an indignant father adverts to the situation of the school on this side of the Strand, being in a house standing in a bevy of gin-palaces, old-clothes shops, pawnbrokers, etc., and with numerous ramifying alleys, leading to purlieus of contagion and infamy. Even by day, the loiterers on the pavement are equivocal, and at night the locality is one replete with pollution.[63]

Without the reassurance of the continuing presence of Mrs McIan, many respectable parents would have removed their daughters for fear of their moral safety.[64]

In spite of much protesting and adverse publicity against the offending authorities, nothing was done to improve the conditions of the Female School; forgotten were the provisos under which it had first been established at Somerset House. 'The consideration and courtesy due to the fair sex, as well as their personal comfort, can never have generated in the minds of the directing heads, or they have been so immersed in their own squabbles, that they have forgotten to exercise the respectful attention to feminine delicacy, which, as a principle, is the basis of social communication.'[65] Evidently, gentlemanly treatment of the ladies was appropriate only as long as it did not interfere with male ambition; and despite the strong evidence to the contrary, 'one person in office indeed has not scrupled publicly to emit his notion that the female class was altogether useless, if not an incumbrance'.[65]

One activity of the Female School which was generally agreed to be useless was the class for teaching practical wood engraving. The first report concerning the establishment of the school indicated that 'It is understood that females have frequently practised this kind of art, and it is obviously in many respects a suitable employment for them'.[66] Thus early on in the life of the School a class for wood engraving had been started; the fact that few people had any idea what forms of employment would be suitable for women is hardly surprising—women had had no opportunity to develop or test their skills, so 'suitability' was based on a stereotyped idea of what was appropriate for a Victorian gentlewoman. This idea evidently incorporated a strong element of the contemporary concept of the inferiority of the female mind, and so that which was considered suitable was often also manual and boringly repetitive. Wood engraving was not considered a branch of ornamental design, but a 'purely mechanical operation'; the question as to why it was being taught in a Government school of design was brought up at the Select Committee of 1849, and it was made clear that it was taught at the request of the Management Committee, being considered 'one of the means ... by which we may give employment to women in this country'.[67] It was also made clear by the Select Committee findings that, while there was a decided need for good designers, there was in fact a superfluity of good engravers; thus women were being trained in an area in which they would have difficulty finding employment. The *Art Union* had, in 1848, suggested that this obsolete class be dispensed with:

In the Female School there has been, as yet, no change ... but Mrs McIan has applied for an assistant: such aid is due to her, and is absolutely necessary. It may be had by abolishing a vain and useless part of the arrangement here—instruction in wood engraving, for which a serious charge is made, and which has led to no sort of benefit or advantage.[68]

In 1849 there were nine students in the wood engraving class, which was housed in the large attic room of the Strand premises. Here they worked on the practical side of wood engraving for two days a week, while for the other three they were engaged in drawing. Despite the observations of the Select Committee and Mrs McIan, the wood engraving class remained. In 1852 when Henry Cole took over the organisation of the art schools, and the Department of Practical Art was formed, the wood engraving class was at last transferred to a more appropriate location, Marlborough House, to join the new Technical Classes of the Central Training School— the new name for the Head or Normal School of Design.

Before his takeover in 1852, Henry Cole had been a major agitator on behalf of the Female School of Design. His magazine, the *Journal of Design*, regularly published articles concerning the progress of the school, and in particular regarding the Government's lack of action over the conditions in the Strand:

The Board of Trade is quite aware of the condition of the School. More than one petition has been prepared upon the subject; and so long back as April last, it was reported that the

prayers of the pupils would be attended to. Four months have elapsed, and not the slightest amelioration has taken place... We trust that ... our estimate of Governmental procrastination may be in excess... but we think that the neglect which for two or three years has marked the conduct of the authorities in this matter, calls for some expression of opinion ... the female classes of the Government School of Design should be established on a site where carts and omnibuses are unheard, with an aspect more calculated for the purposes of art than for the ripening of grapes, and an atmosphere that shall not require each pupil to use more than a penny loaf a-day to remove carbonaceous flakes from her drawing paper.[69]

Cole's motives however, were not entirely selfless; his desire to discredit the Board of Trade committee and those responsible for the mismanagement of the schools of design meant that the more glaring examples, like the Female School, were ideal material for his campaign: 'if ... those who have the power to assist a number of respectable young women to make for themselves an honourable occupation, and, at the same time, help to supply an urgent and important demand, should continue to refuse or neglect to furnish, what would cost them so little to supply;—the sooner the Board of Trade abandons its affected superintendence over the Schools of Design, the better it will be for the Schools and art-education.'[70]

Henry Cole's concern, however, lasted only as long as his campaign; once he had succeeded in his objective and taken command of the newly formed Department of Practical Art, and closed his *Journal of Design*, he took little more interest in the Female School than had his predecessors. In fact, a major new policy introduced by him, 'payment on results', was to prove nearly disastrous to the very existence of the Female School. However, he did arrange for the ladies to be moved out of the Strand and into new premises in Gower Street in 1852; to compensate for the cost of the move he increased the fees to double those of the Strand days, and halved the number of staff per student. At this date the School was renamed the Metropolitan School of Ornament for Females, although this name does not appear to have stuck and it gradually became known as the Female School of Art, gaining the honoured appendage 'Royal' when it formally received the patronage of the Queen and the Prince of Wales in 1862. Henry Cole's economic policy with regard to the schools of design was that they should pay their own way; this involved the gradual withdrawal of direct grants to the schools, and the introduction of payment on results to encourage art teachers to work at maximum efficiency and expand their numbers of pupils. They received in general a minimum assured salary of £70 per annum, which they then had to make up by a share of students' fees, plus rewards for prizewinning students. This turned the art schools into an industry, and the main disadvantages of the system were the tendency to standardise and produce rather mechanical work in order to satisfy the requirements of the Central School, and to eliminate creative originality, and thus the system on the whole failed to produce what was needed, namely good designers. Cole was also strongly in favour of encouraging the middle

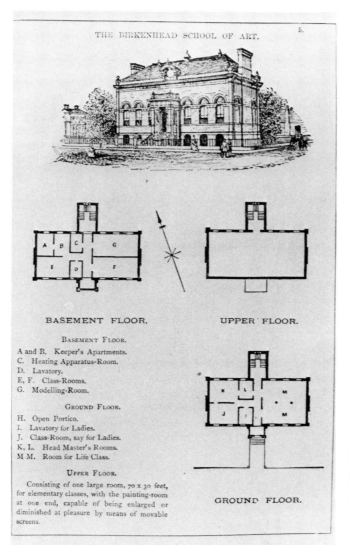

THE BIRKENHEAD SCHOOL OF ART.

BASEMENT FLOOR.

UPPER FLOOR.

BASEMENT FLOOR.
A and B. Keeper's Apartments.
C. Heating Apparatus-Room.
D. Lavatory.
E, F. Class-Rooms.
G. Modelling-Room.

GROUND FLOOR.
H. Open Portico.
I. Lavatory for Ladies.
J. Class-Room, say for Ladies.
K, L. Head Master's Rooms.
M M. Room for Life Class.

UPPER FLOOR.
Consisting of one large room, 70 x 30 feet, for elementary classes, with the painting-room at one end, capable of being enlarged or diminished at pleasure by means of movable screens.

GROUND FLOOR.

The Birkenhead School of Art—elevation and ground plans of the school, founded in 1855, reproduced in Walter Smith's Art Education *(Boston, 1873) as an example of the layout of English art schools. The inclusion, even in small provincial schools, of separate classrooms for ladies was quite typical.*

classes to patronise the art schools, an idea contrary to the original mandate whereby the schools were established for the cultivation of the working and artisan classes; however, Cole rightly realised that it was the richer classes who would make the art schools financially viable.

This was in fact already the pattern in most of the provincial branch schools, where the classes for females were monopolised by ladies either studying art as an accomplishment, or hoping to qualify as governesses and teachers. The working classes studied either free or on much reduced fees, while the higher classes paid full fees; it is thus obvious why, under the new system, teachers needed to encourage the participation of the middle classes. It is of interest to note that while art was considered an appropriate area of accomplishment for ladies in the Victorian era, for gentlemen it was thought both undignified and unsuitable; few classes for gentlemen were well attended, and many were cancelled due to lack of support. Amongst the working classes the position was reversed; promoters of art education felt it was crucial for working men to raise their skill and increase their art appreciation in order to improve the quality of English design. However in respect of working females it was felt that any education might give them aspirations above their station; even reading, writing, grammar or accounts were considered unnecessary, although education in moral habits, manners, personal cleanliness and neatness were acknowledged as essential. There was some disagreement over this question, and Earl Granville stated his opinion in a speech at the prizegiving at Manchester School of Art. Referring to girls destined to be domestic servants he said:

I believe . . . that there is no doubt the objection is a fallacy, and if you consider what Mr. Redgrave said about the sort of education which drawing confers, the precision and neatness it leads to, then the advantage of this kind of instruction must be apparent. I believe, after all, there is design in the cutting out of a frock; and a friend of mine went still further, and suggested that to lay a knife and fork perfectly parallel to one another required the sort of eye which was perfected by a drawing lesson or two.[71]

In London this question mattered less, as the large numbers of destitute gentlewomen needing an art education meant that the Female School was entirely filled by such persons. At Cole's new Central Training School, situated first at Marlborough House and later in South Kensington, there was ample provision for the instruction of working females, either in separate or in communal classes with males. From the first there was the female class in wood engraving which transferred in July 1852 from the Female School of Art, along with its instructress, a Miss Waterhouse; in March of the same year a female lithographic class began at Marlborough House, and in July a china painting class for both females and males.[72] One of the most important features of the Central Training School was the establishment of classes for training teachers of art; this was intended both for instructing newcomers, and also for bringing current art teachers up to the new required standards.

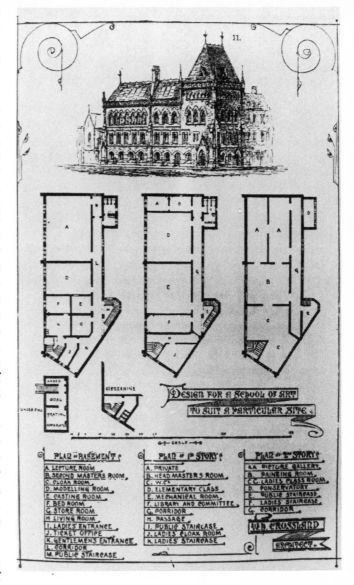

'Design for a School of Art to suit a particular site', W. H. Crossland, Architect. One of several designs for art schools proposed by Walter Smith and illustrated in his Art Education (Boston, 1873) as types which could be adopted in the United States. This one is of particular interest as it reflects the English class stratification which was common in art schools; it includes a special entrance and staircase for ladies, a gentleman's entrance and a public staircase which was clearly intended for all but ladies. Special class-rooms for ladies were installed at the top of the building, presumably to complete their segregation from the 'rougher' sorts below; their cloakroom on the floor below was also carefully shielded from the public sectors of the school.

Here both males and females had equal opportunities, and almost equal access to grants and aid with tuition.

The fact that women were automatically encouraged to take up art teaching fits in with contemporary attitudes to the profession: 'Teaching is universally admitted to be woman's special work, and we should naturally expect to find women teaching drawing or painting as generally as they teach music'.[73] To this end 'The same instruction is given to both sexes; and one distinct object of the National Art-Training School, at South Kensington, is to train Art-masters and mistresses; equal assistance being given to both. All duly-qualified students share the rich privileges of the library and museum; and scholarships are open for free competition throughout the kingdom.'[74] However,

when it came to employing women as art teachers, particularly in responsible positions, the equality ended; in contrast to the numbers of men employed, women were few and far between, and when on the rare occasions they were appointed to headships, it was only as head of one of the very few all-female schools:

It is not easy to get statistics concerning women thus employed in families, or in private schools; but it is certainly not difficult, from one's personal experience, to count up more men than women. And as regards public schools, there is no room for doubt. In Great Britain are 117 Art-Schools, where 20,133 pupils receive instruction. Of these *three* only are superintended by ladies: one in Queen Square, London, one in Edinburgh, and the Queen's Institute, Dublin. Out of 338 Art night-classes, where the attendance numbers 10,000, *five* are taught by women. Government aid is also given to 1,359 schools for the poor, containing 147,243 children who are taught drawing. There is here, in every social grade, room for the employment of women as Art-teachers. Doubtless many of the classes in the schools may be taught by women, but, if so, only in subordinate positions. This cannot be the result of want of teaching-power in women, for Miss Gann, the head of the Queen Square School of Art, stands, in 1871, *second* on the list of Art-teachers, having been *third* in the previous year. Nor is it owing to any obstacles raised to prevent women from duly qualifying themselves for this work.[75]

It is significant to note the decisive factor in this situation: from the time of his appointment in 1852 until his retirement in 1873, Henry Cole had complete personal control over the appointment of all staff in the schools of art and drawing classes in Great Britain.

Mrs McIan remained superintendent of the Female School until her retirement in May 1857, upon which she was granted a Government pension of £100 a year. Her starting salary in 1842 had been £150 a year, and following the introduction of the payment on results scheme the success of her school pushed her salary up to a guaranteed £310 a year, including a half-share in the fees of the school. Louisa Gann, who in March 1852 had been appointed an assistant teacher at the Female School on a salary of £50, with the addition after May 1853 of one tenth of the fees, was appointed superintendent of the school upon Mrs McIan's retirement. Her starting salary in this post was a mere £70 a year plus £10 allowance for her art teaching certificate; it is not clear whether or not she was to receive a share in the fees at this date.[76]

Little change seems to have taken place in the financial situation of the Female School until 1859, despite Cole's policy of pressuring the art schools into economic independence. But in December 1859 the Government withdrew all support:

The Female School in Gower Street, costs the State for rent, salary of superintendent and messenger, examples etc., above £500 a year, and is the only school remaining under the old system of Schools of Design. Female students are now trained at South Kensington, and classes for them, either general or separate, are held at the London District Schools. Rent and local expenses in Gower Street are not to be paid after next Midsummer, and unless kept open by voluntary agency, the school must be closed.[77]

There was here an obvious misunderstanding of the special nature of the Female School of Art, and of the special category of needy gentlewomen for whom it provided the means to an independent living. The problem was that the classes cited in this report, and in the schools of design in general, were intended for females other than those for which the Female School catered, and were not considered suitable by many respectable parents for the education of their daughters. Studying in classes intended for working females represented an equivalent lowering of social status for the young ladies involved. To prevent the school closing immediate steps were taken to rally public support and raise money:

At this very time . . . when the school presents every sign of increasing usefulness, the Committee of Council on Education have withdrawn the £500 per annum with which they have till now specially favoured it, and thus have left it to its own resources. The expenses of the establishment are necessarily large, and it can scarcely be expected to be self-supporting whilst fees are so low as they are at present; to augment them would, in all probability, be to diminish the number of pupils, and so lessen the usefulness of the school. Fully convinced of this, the patrons and managers appeal to the public for support. They are of the opinion that 'by saving in house-rent, which might be effected by purchasing or renting convenient premises, the expenses . . . might, by careful financial management, be brought down to a level with the receipts.' The sum required to purchase suitable and complete premises is £2000. It is . . . understood that the Science and Art Department is prepared to apply to parliament for 25 per cent on the cost of erecting the building; for the remainder they look to the public . . . Constituted as society is, no available channel for the employment of women should be closed; to lose the ground already gained by much patient industry would be a calamity. Among other means adopted for raising the necessary funds, an exhibition of paintings, drawings, sculpture and other works of Art, will be opened in early June; and afterwards a bazaar (for which contributions are solicited) will be held under most distinguished patronage, including her most gracious Majesty herself who, we have good ground for believing, takes a deep interest in the welfare of the institution. Should the appeal be successful . . . the school may be made self-supporting, and its area of usefulness . . . be definitely enlarged.[78]

The appeal was successful, and during that year, 1861, the Female School moved to new premises at 43 Queen Square, Bloomsbury, where it remained until its amalgamation with the Central School of Arts and Crafts in 1908.

From 1852 onwards, the increased fees combined with Cole's emphasis on middle-class patronage caused a gradual transformation in the student population at the Female School. Under Mrs McIan's guidance prior to 1852 the School had enforced financial need as a prerequisite for entry to training:

They are highly respectable, the whole of them; we have had the most distressing and painful cases of daughters of professional men, whose fathers have died prematurely; the young women having been brought up in great comfort, but

from their fathers leaving no provision for them are entirely dependent on their own exertions ... It is distinctly their object in coming to the school to make a means of obtaining their livelihood.[79]

Typical among the parental professions of students were medicine, the law, arts and the church. However, by the beginning of the 1860s financial necessity was no longer an essential entrance requirement, although it was still seen as a major factor in the social rôle of the Female School:

... numbers (including daughters of clergymen and medical men unexpectedly compelled to gain their living) have been enabled to support themselves and others by teaching in families and in various schools of the Science and Art Department, or by designing for the manufacturer in linens, carpets, papier-mâché etc ... At the present moment its students number 118; of these, twenty are studying with a view of ultimately maintaining themselves, and they have at their command a most excellent opportunity of preparing themselves to do so.[80]

The premises of the Royal Female School of Art, 43 Queen Square, Bloomsbury, London. First established in Somerset House in October 1842 as the Female School of Design, the School found permanent premises in Bloomsbury in 1861, the year they were granted royal patronage. Although intended to provide design training for needy middle-class women, a number of the students went on to become fine artists; Rosa Bonheur trained there, as did Laura Herford who became the first woman to be admitted to the Royal Academy Schools in 1862. The Royal Female School remained at Queen Square until 1908, when it was amalgamated with the Central School of Arts and Crafts in Southampton Row. In the photograph the custom built studios at the top of the building are still visible.

During the 1870s and 1880s reference was still made to the Female School in articles which continued to stress the need to find work for women, and in particular in the promotion of art work as the most suitable field, but the character of the school changed noticeably under Cole's administration of the Science and Art Department. Bazaars and fund-raising to keep the School going after state aid was withdrawn attracted the rich to support this worthy cause; royal patronage in the way of prizes, and purchases of students' work increased the prestige of the school, creating the perfect environment to attract dilettante students and provide a brief finishing-school for the daughters of socially ambitious parents.

The Female School continued to be successful, but the proportion of high quality, strongly motivated students seems inevitably to have dropped because of this change. The 1871 report of the School quoted a manufacturer as stating that 'pupils do not as a rule attend the school long enough to make good artists, and inundate the trade with imitations of the designs of others, at a cheap rate'.[81] Nevertheless the obvious achievements of the School cannot be ignored. In 1861 Thomas Purnell commented: 'Its success has hitherto been very considerable. Since 1852 no fewer than six hundred and ninety have entered the school; and, in the last three years, as we gather from the prospectus, its pupils have taken an average of twenty local and three national medals; at the last examination six obtained free studentships. . . .'[82]

Although the majority of women entered the teaching or design professions on leaving the School, it was not uncommon for students to gain admission to the Royal Academy Schools, when it finally opened its doors to women in 1862, or the Slade School from 1871.

During the 1870s an average of 120 students were in attendance at the Female School's Queen Square Bloomsbury premises. Fees at this date were £5 per five-month term full-time, and £4 for three days a week, with an entrance fee of 10s. to all classes. Evening classes cost £1 per term and an elementary class 10s. To these classes school-mistresses, pupil-teachers and artisans were admitted for half-payments, and teachers in schools were allowed to attend day classes for £1 per term. These fees compared favourably with those at the less auspicious Female School of Art at South Kensington, set up primarily for artisans in 1852 by Henry Cole, although the terms of study at Queen Square tended to be shorter. Courses at the Female School in Bloomsbury were similar to those taught in the Government schools of design, though they were considered superior by some:

The Female School of Art is the only one in the kingdom, not excluding even that at South Kensington, where the *principles of design* are taught as well in theory as in practice. We may mention also that lectures by a competent professor are frequently given to pupils on artistic botany. The importance of this feature, and the necessity for students in design to have a knowledge of the laws of plant growth, will be appreciated by all.[83]

This competent professor can only have been the

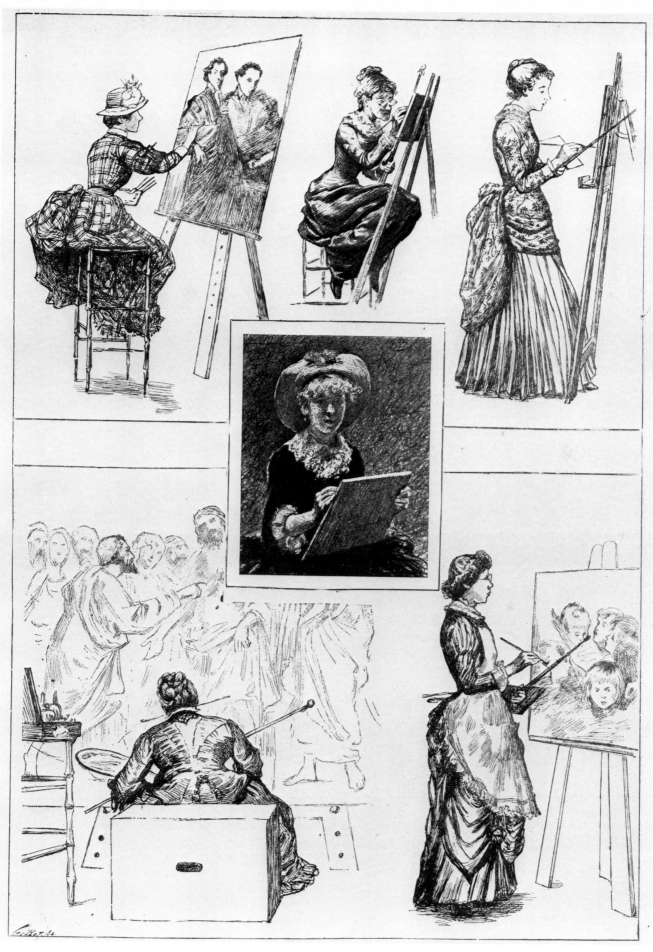

'Lady Students at the National Gallery', Illustrated London News, 21 November 1885. Copying from the old masters was an essential stage in the training of the fine artist, particularly according to the French system which became widely respected in England in the second half of the nineteenth century. At first glance providing a simple record of lady copyists, closer scrutiny indicates the degree to which this illustration reduces its subjects to a series of caricatures poking fun through stereotyped images of the 'lady artist'. Such women would have been trainee professionals rather than amateurs. (PHOTOGRAPH: THE ILLUSTRATED LONDON NEWS PICTURE LIBRARY)

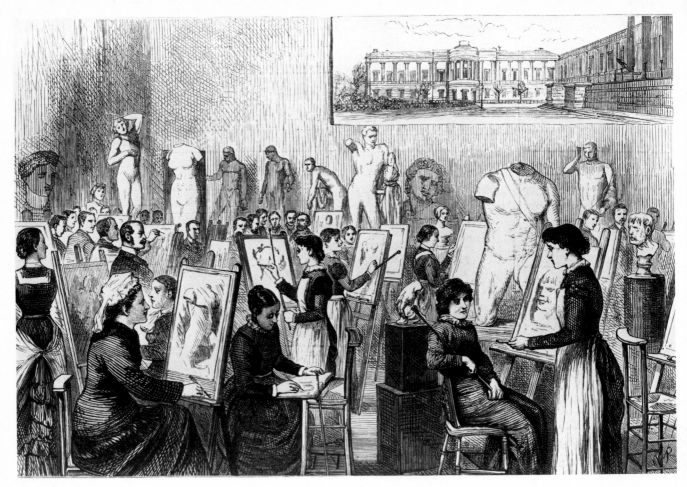

Slade School of Fine Art, University College, Gower Street: Mixed Antique Class, from an engraving in the Illustrated London News, *1881. The Slade School, which took women from the first, was opened in 1871 under the directorship of Edward Poynter.* (PHOTOGRAPH: ILLUSTRATED LONDON NEWS PICTURE LIBRARY)

botanist and designer Christopher Dresser, who lectured in both subjects at the Female School during the 1860s and 1870s. Dresser in fact also taught at South Kensington, and was the most progressive designer and thinker in that circle; his designs stand favourably beside Bauhaus ones in their clean simplicity and lack of ornament. His ideas and teaching must have had a strong influence on the quality of design work at the Female School; he stressed fitness of purpose in design, and proposed that 'the material of which an object is formed should be used in a manner consistent with its own nature and in that particular way in which it can be most easily worked';[84] sentiments very close to those of Morris and the Arts and Crafts movement in general.

Although it was mainly run on private funds, the Female School nevertheless had close links with the Department of Science and Art, its students competing for the state scholarships, prizes and medals which the Department offered annually. In addition, the school was able to award several independent prizes, donated by benefactors.[85]

By the 1870s the proliferation of art schools and classes in London, the provinces, Scotland and Ireland meant that opportunities for women to train for an artistic profession were increasing. However, prejudice was still rife and advocates still urged the importance of art education: 'if . . . women are compelled to work, they would be made happier as well as more useful, if trained to do their work properly'.[86] Art school training in certain areas had strong links with local industry; thus at Stoke and particularly at Lambeth in London the emphasis even early on was upon design for the ceramic industry and china painting, with local art schools providing both new talent and retrained craftsmen for the trade. Women were accepted alongside men in most art and craft classes, except for study from the nude and for certain crafts considered specifically 'male', or for certain trades which engineered the exclusion of women from their classes.[87] Despite new opportunities in education, the number of women accepted into professional posts of responsibility was limited; in many instances women worked free-lance from home, or joined special workshops and studios providing work specifically for women. A chromolithographic studio attached to the Female School of Art, Bloomsbury, was established in the 1880s for female students trained there, and where they executed paid work and commissions. Similarly, the Royal School of Art Needlework, founded on a philanthropic basis in 1872 under royal patronage, provided both training and employment for needy gentlewomen. In the art pottery industry Doulton's of Lambeth found it expedient to employ women from the local art school as designers and decorators to meet the growing demand for hand-made ware, while Minton's set up an art pottery studio next door to the government art school at South Kensington, with the specific and state-funded aim of providing employment for female students there.[88] This bulk of evidence emphasises the reluctance of employers to hire

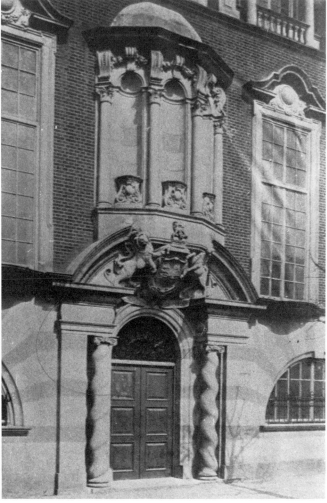

Top: *Royal School of Art Needlework: Embroidery studios in the new School building on the corner of Imperial Institute Road and Exhibition Road, c. 1905. From an illustration in* Lady's Realm, *1905.* (PHOTOGRAPH REPRODUCED BY COURTESY OF THE ROYAL SCHOOL OF NEEDLEWORK, LONDON)

Above: *Royal School of Art Needlework: Entrance Hall of the custom-built School building on the corner of Exhibition Road and Imperial Institute Road, 1903; the building was demolished in the 1950s.* (PHOTOGRAPH REPRODUCED BY COURTESY OF THE ROYAL SCHOOL OF NEEDLEWORK, LONDON).

Left: *Royal School of Art Needlework: the façade of the new premises on Exhibition Road, designed by Fairfax B. Wade and erected in 1903.* (PHOTOGRAPH REPRODUCED BY COURTESY OF THE ROYAL SCHOOL OF NEEDLEWORK, LONDON)

women artists except when it was found financially expedient to do so, and the extent to which finding suitable work for women was seen as a charitable and problematic affair.

In the mid-1890s, fees at the Female School of Art were on a par with the numerous private London art schools which offered classes, usually emphasising artistic accomplishments for genteel ladies. By 1895, although it did provide a more respectable professional education, the Female School was charging fifteen guineas for a session of two five-month terms, with evening classes at one, two and three guineas per term, fees being halved for artisans. By comparison, the government-run South Kensington schools charged £5 for a five month term for both day and evening classes. The aim at South Kensington was art training for industry:

Although amateur artists find certain classes at South Kensington admirably suited to meet their requirements, the School should on the whole be looked upon as an industrial training school. There is a great number of students who study here as paying pupils, but the evident tendency of the School is to be without these, and to become a college for training, without payment, men and women who mean to earn their living as designers or as teachers of art students in schools throughout this country and abroad. Even those students who are not working with a view to becoming Art Teachers are expected to pass the Art Department's exams.[89]

Under Cole's administration the stress was on 'applied' ornament and on the importance of training students in draughtsmanship and copying ornament from the antique; the payment on results scheme had fostered designing by rote and hindered the growth of natural creativity. A major gap in creative design education, which by the 1890s began to be filled, was practical workshop training. Few students had familiarity with the possibilities and limitations of the material for which they were designing, let alone the demands of industrial production which would necessarily modify their designs. However, attention was increasingly turned towards seeking solutions to these problems. Following in the footsteps of Ruskin, Morris and the crafts revival, many artists and craftsmen were attempting to close the gap between fine art and the crafts. Dissemination of these ideas on a broad educational level was achieved mainly through the efforts of members of the Art Workers' Guild, which was founded in 1884, and which, by the 1890s was providing the bulk of craftsmen-designers to teach and organise in the art schools—as for example Walter Crane, first Principal of the Royal College of Art in 1898, and William Lethaby, appointed Principal of the Central School of Arts and Crafts on its establishment in 1896.[90] Although craft classes were introduced at South Kensington by Crane, who lectured and demonstrated there from the mid-1880s, the Central was the first school established on specifically craft-training principles, where students received practical as well as theoretical training.

From the beginning of the session 1908–9 the Royal Female School of Art amalgamated with a reluctant Central School at its new premises on Southampton Row. The committee of the Female School had handed over responsibility to the London Council in February 1908, apparently for economic reasons: the Queen Square buildings were in dire need of repair, being so deteriorated due to lack of funds as to be almost uninhabitable. In addition, the committee had the previous year dismissed the headmistress of over fifty years' standing, Miss Louisa Gann, for reasons not entirely clear from the records, but apparently for financial reasons, and possibly because of her age and her reluctance to agree to the council's takeover. She brought an action against the committee of the School for wrongful dismissal, and in January 1908 the council paid her £150 in settlement on behalf of the committee, following an agreement in November 1907, when 'The Council decided to relieve the Committee of the school of all liability of the action brought against them by Miss Gann for wrongful dismissal, subject to the Committee at once handing over to the Council'.[91]

The council was unwilling to foot the bill of £2,500 necessary for restoration of the Queen Square premises when adequate room and superior facilities were available for the Female School at Southampton Row. Instead, the council wished to adapt the Queen Square School to provide much-needed space for trade classes for girls and women, for which an estimated further £1,360 would be required. It seems also that the Female School had by this date become something of a dinosaur; although the council were 'fully aware of the excellent work done in the school in several branches of art and [were] desirous that there should be no break in its continuity',[92] nevertheless it was evident that cheaper and better-equipped courses were widely available elsewhere, and the need which the Female School had been established to fulfil was no longer so desperate. It is evident from the records that interest in craft classes, which had been set up and funded by the council at the Female School, was waning; in 1906 classes in embroidery, lacemaking and writing and illumination had been closed because of insufficient attendance; bookbinding, with an average attendance of seven, was the only craft class to survive. These crafts were being taught more effectively and professionally at larger schools like the Central. Attendance at the Female School had dwindled to around seventy by the time of its transfer to Southampton Row.

The Central School was horrified at the prospect of being joined by the ladies; the strong trade orientation of the Central, with its specialist craft workshops, meant that staff and students viewed the Female School as a bunch of dabblers; although many of the women were amateurs, others were equally serious and dedicated, and yet the association of women with amateurism and poor quality work still continued. The Female School was renamed the Day School of Art for Women, and in fact it interfered little with the Central's programme, as most of the trade and craft classes were held in the evenings and were intended to supplement workshop practice and not to teach trades. The Prospectus for 1908 indicates the new aims of the Female School, and also a softening in the stringent Central regulations:

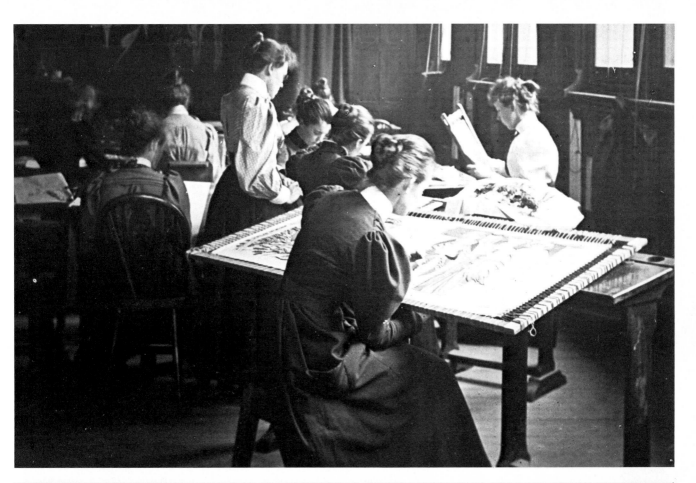

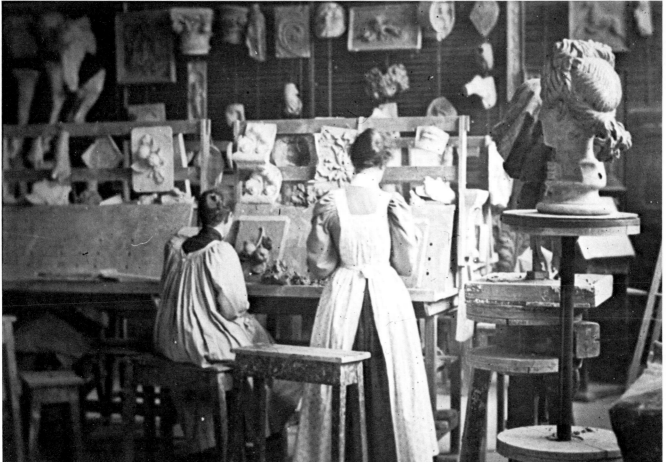

Top: *Birmingham School of Art, c. 1900. Needlework class with embroideries in the process of both design and execution.* (PHOTOGRAPH: COURTESY OF ALAN CRAWFORD, BIRMINGHAM SCHOOL OF ART)

Above: *Birmingham School of Art, c. 1900; women students relief modelling.* (PHOTOGRAPH: COURTESY OF ALAN CRAWFORD, BIRMINGHAM SCHOOL OF ART)

Admission to the School is, within certain limits, only extended to those actually engaged in Handicraft, and every opportunity is given to students to specialize in relation to their own particular calling. The School is intended to supplement rather than supersede apprenticeship, by affording students engaged in the typical London art industries opportunities for design and practice in those branches of their craft which, owing to sub-division of process of production, they are unable to learn in the workshop.[93]

This situation was fine for male students, but for women presented a series of problems; many of the trades excluded women and actively boycotted their entry into apprenticeships and, as many of the Central's classes were restricted to trade pupils, it followed that these classes were also closed to them, making training and qualification in certain crafts impossible for women. Those who could afford it took private classes, or alternatively were limited to crafts which were considered suitable for women, which did not involve competition with men for jobs, and for which day classes were laid on. Other women struggled against this male domination of trades and jobs.[94] Trades particularly notorious for the exclusion of women were bookbinding (women were only acceptable, ironically, as binding sewers) and gold and silversmithing; more obviously, women were discouraged in furniture-making and wrought-ironwork and were virtually unheard of in glass-blowing. In the artistic professions architecture in particular was considered an all-male province. It seems that women were acceptable as manual workers in the lowest echelons of craft industries where little pay or skill was the norm and competition minimal; as designers and craftswomen in fields considered suitable for and restricted to women; and otherwise, in broader skills, only in the comparatively limited progressive circles of the artistic and social élite. Most women in the latter category were working freelance in communal studio-workshops with craftsmen husbands, fathers or friends.

Symptomatic of this pressure for women to enter 'feminine' crafts is the range of teaching employment in which women were most commonly found. At the Central School when it opened in 1896 no women teachers were listed. In 1897 a class in embroidery was started for which a woman teacher, Miss Maggie Briggs, was appointed, and May Morris was listed as a visiting teacher. In 1899 May Morris took over direction of the class, with Miss Ellen Wright replacing Miss Briggs as instructress. Life classes for women only began in 1899, for which Miss Muriel Alexander was appointed. No further women were appointed until 1905, when three new courses were opened: the prospectus lists Miss E. Richey to take classes in lacemaking, Miss Ethel M. Williams for miniature-painting, while the third class, dressmaking and costume, lacked an appointment at the date of going to press. However, the Central was evidently so confident that a woman would be chosen to teach this course that the staff listing merely leaves a gap after the title 'Miss' beside the appropriate class. The 1906 prospectus confirms this conviction in its nomination of Mrs F. Burgess – the only error of prophecy being her marital status.

All these craft classes—embroidery, lacemaking, dressmaking and costume, miniature-painting, even the life class for women, fall predictably within the category of traditional socially-sanctioned female accomplishments. A further appointment in 1908 simply reinforces this pattern, that of Miss M. Hindshaw, a pupil of Alfred Powell, to teach china-painting and design. The evident advance here for women is that at least we find competent artists and designers being employed in responsible posts in a major London Art School—a huge step from the era of using art training to become a governess.

All the staff of the newly transferred Day School for Women were female. Subjects taught reflected the type of craft openings available to women, which beside life and perspective classes, included study in black and white intended for employment in illustration, fashion drawing and general design. These classes were, however, supplemented by attendance at the craft classes run by the Central.

Most progressive of the provincial schools in their craft teaching were Birmingham and Glasgow. Birmingham pioneered craft classes in jewellery and precious metalwork in 1890—work strongly linked with local

May Morris: A Page of Lecture Notes on Embroidery, undated. These notes may relate to May Morris's teaching at the Central School of Arts and Crafts, London; in 1897 she was appointed a visiting lecturer, and two years later took over direction of the course on embroidery there. In the early years of this century May Morris made a lecture tour of the United States, but these notes seem too informal to date from that occasion. (PHOTOGRAPH: WILLIAM MORRIS GALLERY, WALTHAMSTOW, LONDON)

industry, but nonetheless progressive in its approach. Glasgow rapidly made a name for itself in the 1890s, producing a series of brilliant students and staff, including Margaret and Frances Macdonald, Ann Macbeth and Jessie Newbery, and a very individual style of Art Nouveau design. Manchester was another school which, under the direction of Walter Crane in the early 1890s, attempted to wrest itself from the rigidity of the old formal applied ornament training. Although he had little impact on the curriculum at this date, his personal influence on both staff and students sowed the seeds of change.

THE AMERICAN RESPONSE

In terms of art education, the situation for women in America was not dissimilar to that of Britain, though for rather different reasons; women were increasingly dependent upon their own resources due to the growing drain on available men caused by emigration to the West. In order to help resolve this problem Mrs Sarah Worthington King Peter, a prominent citizen of Philadelphia, campaigned for the establishment of art training for women. Through her efforts the Philadelphia School of Design for Women, the first school of

design in America, was set up in 1844. The reasons put by Mrs King Peter to the Committee of the Franklin Institute in support of her idea were remarkably similar to those for which the Female School in London was founded:

For our men, there are now, and there must continue to exist, so many more direct and more easily to be attained avenues of fortune, that high excellence in the industrial arts of design can rarely be expected from them. Our women, on the contrary, are confined to the narrowest possible range of employment; and owing to the unceasing drain, by emigration to the west and elsewhere, of young and enterprising men, we have a constantly increasing number of young women who are chiefly or entirely dependent upon their own resources, possessing respectable acquirements, good abilities, sometimes even fine talents, yet who are shut out from every means of exercising them profitably for themselves or others. To such as these the establishment of a School of Design opens at once the prospect of a comfortable livelihood, with the assurance of a useful and not ignoble career.[95]

Birmingham School of Art: Woman student metalworking, c. 1900. (PHOTOGRAPH: COURTESY OF ALAN CRAWFORD, BIRMINGHAM SCHOOL OF ART)

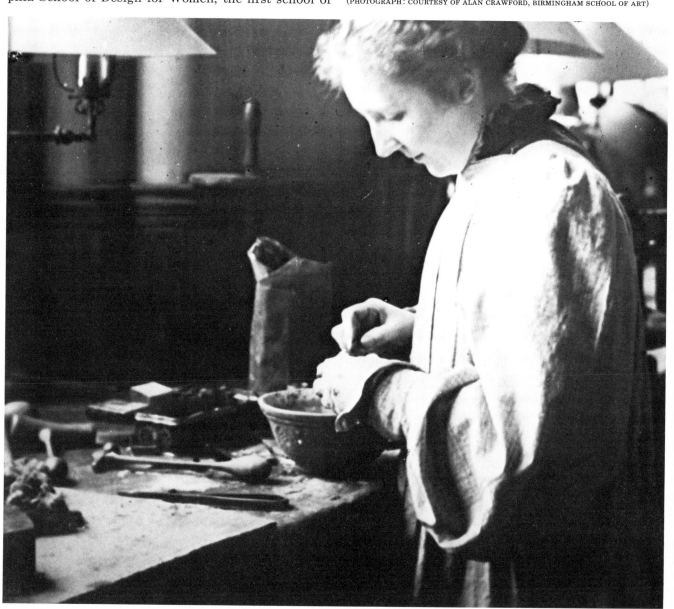

The committee responded with due appreciation to Mrs King Peter: 'The person who points out a new field for the employment of female industry, must be looked upon as a public benefactor; and any mode by which such a field may be rendered accessible to necessitous women, recommends itself strongly to society as a powerful agent in the advancement of our civilisation, and the relief of suffering.'

In general, however, design education and the training of art teachers developed rather later in America than in Britain. A major advance took place when, in 1871, Walter Smith arrived from England to take up his appointment as Director of Drawing for the Boston Schools, and Massachusetts State Director of Art Education. Smith had been headmaster at Leeds School of Art, achieving great success in spreading art education in Yorkshire by his itinerant teaching, and his pupils were among the best in Britain. He resigned following a local change of policy which would have required him to give up his fruitful itinerant work. The Massachusetts post was to offer him greater freedom to develop his ideas on art teaching, something inconceivable within the tight structure of the centralised British system.

The Massachusetts State Normal School in Boston was established in 1873 and was perhaps the first public school of art in the United States. Art education had been receiving increasingly urgent attention in America for similar reasons as it had earlier in England, particularly the need to produce indigenous designers and so cut the cost of importing foreign designs. Some art schools were already in existence attached to the academies of New York and Philadelphia, and a School of Fine Arts at Yale had been endowed by Augustus Street; but these were aimed at teaching fine art rather than industrial design. The State Normal School was intended to furnish the evident lack of qualified industrial design teachers, and had a much greater emphasis on the technical and industrial arts than its British counterparts.

Walter Smith's attitude to art education for women was progressive and forthright; in his book *Art Education* (1873) he wrote: 'There is an unworked mine of untold wealth among us in the art education of women. In the field of general education here I am informed that nine-tenths of the teachers are women; and some explanation of its excellence may be found in that fact. I have discovered in my experience that the peculiar phases of mind and disposition which are absolutely necessary for the possession of teaching-power are more frequently to be found in women than in men'.[96] Although this reflects Smith's English experiences and preconceptions, the American evidence echoes the British attitudes. He goes on to say: 'This would point in the direction of utilizing much human life now not profitably occupied, by employing ladies as teachers of art.' The Victorian preoccupation with the necessity for a profitable occupation influenced life on many levels.

Smith further advocated design careers for women, expressing an earnest desire that new American art schools should show no discrimination against females:

There are also many branches of art workmanship, requiring delicate fingers and native readiness of taste, which could be better performed by women than men. It seems to me that an infinite amount of good would be done by opening up the whole field of art instruction and art workmanship to the gentler sex; and I do hope ... there shall be absolutely no distinction made concerning the eligibility or disqualification of sex in the students.[97]

Smith saw art education as one area in which positive efforts could be made to erode traditional destructive attitudes and foster a greater equality between the sexes; at a time when the subject was causing increasing controversy, his opinions appear to be unusually progressive:

My own fear has been, and now is, that hitherto women have been treated as pets and playthings, to be indulged and delighted in, but not to be held responsible for any thing; have been educated with the view that all should become merely the ornaments of society and not its essentials, and the important half of its structure; that, finally, men have come to regard women with a patronizing feeling, in which there is an infinite amount of good nature in some cases, but no justice in any case ... we educate women superficially, and then smugly say they have no minds; we withhold reasoning processes from them, and then say they cannot argue, but jump to conclusions; we train and grind up our boys in athletic sports, in Euclid and conic sections, and the differential calculus, and our girls in Berlin-wool work, in waltz-playing, and the Paris fashions, and then proclaim that men can reason, women only perceive, men can create, women only appreciate ... half of the troubles we find in the world arise from, and are a just judgement upon, our presumption in making distinctions between them, in fostering the self-conceit of the one, and sacrificing the independence of the other. Let the same education from the first to the last, physical and mental, be furnished for both sexes. ...[98]

Other contemporaries seemed to feel the situation for women was worse in England than in America. Despite the flow of men emigrating to the West there was thought to be less disparity between the sexes in America than in Britain, and for some this reinforced the argument that woman's only career should be marriage, and that women should be discouraged from pursuing an education and a professional career apparently just for the sake of it. Late marriages were common in Victorian England, particularly among the middle classes, where an adequate income to provide a stylish life was considered on essential prerequisite. Thus in England, the possibility of marrying either late or not at all meant that there was a good chance that a woman would make use of an acquired skill before any future husband took over responsibility for her maintenance. However in America it was argued that since, potentially, there was more opportunity for a woman to marry, and especially because wages in America were higher, there was little value in educating women for an artistic career when men could afford to marry young and support a family. As in England, little thought was given to the hazards of fate, and the likely necessity of a widow (or even a married woman) having to support herself and her dependents; still less was there any

consideration of woman's personal desires for economic independence. As the secretary of a New York art school opined in the early 1870s: 'as most women marry, and when married are supported by their husbands, they do not find it necessary to learn arts requiring long training'.[99] This was given as the reason for the absence of women in industrial art work in America at that time.

But if wages in America were generally higher, it did not automatically follow that women's pay there was relatively any different from that of women in England; they were still at the bottom of the scale. Walter Smith claimed that the only fields of work he knew in which men and women received equal recompense were book writing and painting, both of which were popular among nineteenth-century women on both sides of the Atlantic. The beguiling simplicity of Smith's claim, which masks the whirlpool of complex social forces and double standards informing women's creative work, does not however diminish the importance of his basic argument:

In every other avocation that I know, the same work, performed in the same manner and with equal skill, is paid for

NATIONAL ACADEMY OF DESIGN, NEW YORK.

Ground plans and elevation of the National Academy of Design, New York, illustrated in Walter Smith's Art Education *(Boston, 1873). Here no separate rooms for women's classes are indicated; the school, which concentrated on fine art training, had been founded in 1826, and gave free education in day and evening classes to both men and women. Life classes for women, if permitted, would of course have been segregated.*

at an entirely different rate. This is especially the case in education . . . If a woman and a man were by their industry to raise two barrels of potatoes, and each took a barrel to the market, the market price of a barrel of potatoes would be given to both for their goods. If a woman and a man by their industry and training grow the ability to teach, and take their goods to sell in the educational market, both being of the same quality, tried by every test, the man will be paid by the purchaser nearly fifty per cent more than the woman; and the latter is of necessity obliged to take the unrighteous offer.[100]

He goes on to discuss the effects of this undervaluing of women's work, advocating 'sound practical education, good, healthy work, and fair treatment' as a means of curtailing 'pestilent' American female agitation. Despite the prejudice of this last comment, and a lapse into puritanical anti-Jewish extremism, Smith was perceptive of the effects of the sexual imbalance:

For every portion of that half of the work which men withold from women, men have to make up by additions to their own half; and for every dollar witheld from them for work done, men have to pay them in some way, directly or indirectly, as a question of sentiment or charity; which destroys self-respect and independence in women, and develops in them slavishness and timidity, distrust in themselves, and absence of self-reliance and self-helpfulness.[101]

In practical terms Smith encouraged the acceptance of his ideas by advocating equality of opportunity in art education; and in his recommendations on the setting up of art schools in America advised against separate classes for males and females. By 1873, however, there were already a number of art schools specifically for women. The Philadelphia School of Design for Women had by this date been in operation for nearly thirty years; the course of art instruction was similar to that at South Kensington under Henry Cole, but included the study of landscape. As at the Queen Square Female School of Art, professional craft and design courses were also taught, but the American students were not allowed to enter these until they had passed through both preliminary and advanced stages of the general course. Practical classes covered almost identical subjects in both schools: designing (patterns for calico and oilcloth printers, etc.), wood engraving, lithography, drawing and painting (figure drawing and painting from the antique and from life and landscape painting in oil and water colours) and art teaching.[102] Art teacher training in London was the province of the Head School at South Kensington.

The aims of the Philadelphia School were stated in the prospectus:

The courses of instruction pursued in the school have for their object the systematic training of young women in the practice of art, and in the knowledge of its scientific principles, with the view of qualifying them to impart to others a careful art education, and to develop its application to the common uses of life, and its relation to the requirements of trade and manufactures.[103]

The education it provided was not free; fees in 1870 were $40 for the elementary course and $20 each for figure

and landscape in oil, in both cases for an academic year which ran from mid-September to mid-June, with two weeks Christmas vacation. The elementary course, consisting of preliminary and advanced stages, was considered essential, whatever the intended career:

The stages in the Elementary Course, with lectures, have been arranged solely in view of developing a knowledge of form, the laws of light and shade, colour and perspective, none of which can safely be dispensed with, whether in the practice of the 'Fine' or 'Applied Arts'; . . . The course lasts from two and a half to four and a half years, depending upon the industry of the student.[104]

If women could not afford to pay the fees, there were other art schools which provided free training, for example the Lowell Institute in Boston which provided drawing lessons for women on two afternoons a week; male classes were on two evenings, thus implying that men were assumed to be working, the women not. Applicants were received who could 'furnish the best evidence of good moral character, of general intelligence and ability, of industry and skill, together with a taste for design and drawing'.[105] The National Academy of Design in New York, which was run on similar lines to the Royal Academy Schools in London and so gave a fine art training, also took women. 'The schools of the Academy, which have been in operation, *free*, day and evening, male and female, for forty-seven years, embrace, at present, an Antique (or Statuary) School, Life (nude) School, School of Anatomy, and also of Perspective. Schools of Painting and Modelling will be supplied as required.'[106] The Cooper Union Female School of Art was another which provided free art education: 'This department of the Cooper Union has been established by the Trustees in accordance with the provisions of the trust deed, for the purpose of affording free instruction in the arts of design to females, who, having the requisite taste and natural capacity, intend to apply the knowledge acquired in the institution to their support, either by teaching or pursuing art as a profession'.[107]

In spite of the increasing opportunities in art education for women, Kate Gannett Wells reported in 1880 that with regard to art there was 'little concerted action among women. They rent studios together, and form classes for mutual criticism and admiration'.[108] Although women were making advances in the art world on a minor scale, she felt little had been done by them on a large, organised scale. However, she commented favourably on the opportunities for women in art education, particularly in stone and wood carving:

The school for carving and modelling in clay, plaster, and wood in Boston is unique. A girl can graduate there as plasterer, stone-cutter, designer or carver . . . In 1864 the Cincinnati ladies induced the trustees of the McMicken University to open a school of Design, and to this were donated their paintings and statuary. . . . and at last, through Mr Pitman, resulted the woodcarving department. Encouraged by the great success of that school, the Wheeling School of Art in this country, and the Sheffield School of Design in England, the Women's School of Industry, St. Louis,

the Rochester, New York, and Portsmouth, Ohio, Woodcarving School have arisen; whilst the Catholic Sisters of Notre Dame and Ursuline Sisters of Brown County, Ohio, are teaching their own pupils and worshipping amidst their own carvings.[108]

As in England, needlework was a strong area of craft involvement for women, both as an accomplishment and pastime for the upper classes, and as a valuable means of earning a living for the less fortunate. The revival of art needlework in the 1870s provided a particularly good outlet for higher class women in need; headed by the Royal School of Art Needlework at South Kensington, the movement was rapidly taken up in America. American women visiting London took courses at the South Kensington school, and returned home to spread their knowledge; in turn, many English needlewomen left the Royal School to teach in America, where art needlework schools and societies flourished almost everywhere. 'Opposed to *utility* stitches are the art needlework schools that have branched out in many directions from New York . . . The impulse that led to their formation was derived from South Kensington, England, and affords a striking instance of the ramifications of [a women's] organisation.'[109]

Pottery, too, was an important field for craftswomen in America, again with art schools providing training and links with local craft industries. Several of America's most prominent and influential art potters were women, and one of the first and most important craft potteries—the Rookwood Pottery in Cincinnati, Ohio, the centre of the American craft pottery revival—was founded and run by a woman, Maria Longworth Nichols Storer. The Newcomb College Pottery of New Orleans, which was set up in 1895 in Newcomb College, the women's division of Tulane University, with the aim of providing training and employment for young women, is an example of the efforts made in America to find honourable work for needy women. Women were, in the main, responsible for the growth and promotion of art pottery in America; societies founded by them appeared in most major cities in the last decades of the century, encouraging appreciation, offering training and mounting exhibitions.

NOTES

1. Coventry Patmore's renowned poem on ideal Victorian womanhood, 1854–56.
2. John Ruskin, Of Queen's Gardens, section 68, in *Works*, E. T. Cook and A. D. O. Wedderburn (eds.), London, 1902–12, vol. 18, p. 122; quoted in W. E. Houghton, *The Victorian Frame of Mind*, London 1957, p. 343. This volume's chapter, Love, deals in greater detail with the Victorian attitude to women.
3. Mrs Sarah Ellis, *The Wives of England. Their Relative Duties, Domestic Influence, and Social Obligations*, London, 1843, pp. 99–100; quoted in Houghton, *op. cit.*, p. 351. The similarity between this description and ideas of the priesthood are significant.
4. Leonore Davidoff, *The Best Circles*, London, 1974, pp. 14–15. Page 103, n. 5 provides a useful definition of the distinction between Society and society, which I have tried to follow here.
5. Baldwin Brown, *The Home Life; in the Light of its Divine Idea*, London, 1866, quoted in Houghton, *op. cit.*, p. 351.

Arrangements for drawing from models and objects, Cooper Institute, New York, illustrated in Walter Smith's Art Education *(Boston, 1873). This shows a female student at work; careful, precise drawing is indicated by her use of a mahl- or leaning-stick to support her drawing hand.*

6. Thomas Purnell, Woman and Art, *Art Journal*, 1861, p. 107; the use of the word 'uneasiness' hints at the humiliation involved in not marrying, as does the word 'unsuccess' used here rather than the less euphemistic 'failure'.

7. Davidoff, *op. cit.*, p. 51. Concerning a characteristic lack of ambition for personal recognition, see Virginia Woolf, *The Three Guineas*, New York, 1966 (1st ed. 1938), p. 76. Regarding the lack of status of unmarried women, see Davidoff, *op. cit.*, p. 50, 'As a note it should be added that an unmarried gentlewoman, no matter how old, could not chaperone; she was still nominally unattached to the system.'

8. Art-work for Women II, *Art Journal*, March 1872, p. 102.

9. Woolf, *op. cit.*, p. 38 and n. 32, p. 157.

10. The Female School of Design, *Journal of Design*, vol. 6, 1851, p. 31.

11. Purnell, *op. cit.*, p. 107.

12. *ibid.*, p. 108.

13. Letter to the editor of *The Englishwoman's Journal*, vol. 8, 1866, p. 59; quoted in Davidoff, *op. cit.*, p. 95.

14. Prostitution was one of the sins gentlewomen were expected to correct; see Houghton, *op. cit.*, p. 352 and no. 31. Sheila Rowbotham in *Hidden from History*, London, 1974, gives a brief survey of the subject in Feminism and Rescue Work, pp. 51ff.

15. Art-work for Women II, *op. cit.*, p. 103.

16. *ibid.*

17. Purnell, *op. cit.*, p. 107.

18. Art-work for Women I, *Art Journal*, 1872, p. 66.

19. Purnell, *op. cit.*, p. 108.

20. See John Ruskin, Of Queen's Gardens, in *Sesame and Lilies*, London, ed. 1904, pp. 106–10 in particular and Tennyson, from *The Princess*.

21. Art-work for Women I, *op. cit.*, p. 65.

22. Art-work for Women III, *Art Journal*, 1872, p. 130; italics are from the original text.

23. See for example B. L. Hutchins and Harrison, *History of Factory Legislation*, London, ed. 1903.

24. Art-work for Women II, *op. cit.*, p. 103.

25. Art-work for Women I, *op. cit.*, p. 66. Not too few men!

26. Art-work for Women, II, *op. cit.*, p. 102. See also Lewis F. Day, The Woman's Part in Domestic Decoration, *Magazine of Art*, 1881, pp. 457–63, for a similar and equally interesting discussion.

27. Art-work for Women I, *op. cit.*, p. 66.

28. It is not within the scope of this book to make a general study of the many professional women artists of the period, but it is important in the context of 'professional' and 'amateur' to emphasise the operation of double standards of criticism. The type of subject matter in art, and the areas considered suitable for women to tackle were, on the whole, very different from those for men; in addition, criticism centred strongly around the importance of women's artwork exhibiting those qualities of gentle sentimentality and feminine softness which came within the accepted expectations of a lady. Thus good painting was often 'good for a woman' rather than good within the general terms of male critical appraisal. See Germaine Greer's article on double standards of criticism in *The Times Literary Supplement*, 26 July 1974 pp. 784–5.

29. Art-work for Women III, *op. cit.*, p. 130.

30. Charles Ashbee, *Craftsmanship in Competitive Industry*, London, 1908, pp. 37–8.

31. Ruskin, Of Queen's Gardens, in *Sesame and Lilies, op. cit.*, p. 109.

32. Art Work for Women II, *op. cit.*, p. 102.

33. Art-Work for Women III, *op. cit.*, p. 130.

34. S. Macdonald, *The History and Philosophy of Art Education*, London, 1972, p. 134, gives the date of the start of the female class as March 1842; Q. Bell, *The Schools of Design*, London, 1963, p. 136, gives October 1843. The *Report of the Council of the School of Design 1842–3 (Reports, Commissioners*, vol. 29, pp. 173–96, 1843) states (Report, p. 6, para. 11, School for Females) that 'This branch of the School opened in October last', implying that the female school actually opened in October 1842.

35. For the general background to the history of the schools of design, see Bell *op. cit.* and Macdonald, *op. cit.*, The Normal School of Design changed its name as follows: Normal, Central or Head School of Design (Somerset House) from 1837, Central Training School (Marlborough House) from 1852, (South Kensington) from 1857, National Art Training Schools from 1863, Royal College of Art from 1896 (see Macdonald, *op. cit.*, p. 383).

36. Purnell, Woman and Art, *op. cit.*, p. 108.

37. *Select Committee Report on the School of Design*, 1849, evidence of Mrs McIan, p. 117, 1392.

38. The Government School of Design, *Art Union*, vol. 10, 1848, p. 366.

39. *Report of the Council of the School of Design, 1842–43*, London, 1843, vol. 29, p. 6.

40. Macdonald, *op. cit.*, p. 135.

41. The Government School of Design: Its Annual Exhibition, *Art Union*, vol. 9, 1847, p. 309.

42. *Select Committee Report, op. cit.* p. 115, 1350.

43. The Government School of Design: Its Annual Exhibition, *op. cit.*

44. *Select Committee Report, op. cit.*, p. 56, 631.

45. The Government School of Design, *op. cit.*

46. Discussed in full in Bell, *op. cit.*, and Macdonald, *op. cit.*

47. The Government School of Design: Its Annual Exhibition, *op. cit.*

48. *Select Committee Report, op. cit.*, p. 120, 1435.

49. See Bell, *op. cit.*

50. *Select Committee Report, op. cit.*, p. 120, 1434.

51. *ibid.*, p. 121, 1448.

52. *ibid.*, p. 115, 1350.

53. *ibid.*

54. *Select Committee Report, op. cit.*, p. 391, Appendix, Female School at Somerset House (letter from Mr J. W. R. Deverell to Mrs McIan).

55. *Select Committee Report, op. cit.*, p. 116, 1357.

56. The Government School of Design, op. cit.

57. *Select Committee Report, op. cit.*, p. 121.

58. *ibid.*, p. 15, 155, evidence of (Sir) Stafford Northcote.

59. The Government School of Design, *op. cit.*

60. *Report of the Council of the School of Design, 1842–43, op. cit.*, Appendix, p. 23, para. 41. The actual room sizes of the Female School were given in the Appendix to the *Select Committee Report of 1849*, p. 391:

Comparison of Rooms for Female School:

Dimensions of Lower Room, Somerset House:

| 30 × 25 feet | area—750 feet |

Dimensions of Rooms at 330, Strand:

3 front rooms 17 × 19 feet each	area—969 feet
2 back rooms 16 × 11 feet each	area—330 feet
4 closets for examples, books etc.	
9 × 6 feet each	area—216 feet
	Total—1,515 feet
area Somerset House Room	750 feet
	difference—765 feet

Besides the above Mrs McIan has a separate room for her own use, as at Somerset House.

61. The Female School of Design in the Capital of the World, *Household Words*, March 1851, p. 579.

62. *ibid.*

63. The Government School of Design, *op. cit.*

64. *Select Committee Report, op. cit.*, p. 116, 1359.

65. The Government School of Design, *op. cit.*

66. *Report of the Council of the School of Design, 1842–43, op. cit.*, p. 6, para. 11.

67. *Select Committee Report, op. cit.*, p. 117, 1373–4.

68. The Government School of Design, *op. cit.*, p. 31.

69. The Female School of Design, *Journal of Design*, September 1851, p. 30.

70. *ibid.*, p. 31.

71. Department of Science and Art: Distribution of Medals at Manchester, *Art Journal*, 1857, p. 353. For further information on the classes of people attending art schools see Macdonald, *op. cit.*, Chapter 7, pp. 143 ff.

72. *Précis of Minutes of the Science and Art Department*, Ed. 84. 35. Records of the Victoria and Albert Museum, held at the Public Records Office, London.
73. Art-work for Women I, *op. cit.*, p. 65.
74. *ibid.*
75. *ibid.* For further information on the general training of art teachers, see Macdonald, *op. cit.*, pp. 159–66.
76. *Précis of Minutes, op. cit.*, Ed. 84. 35. Changes relating to shares in the fees are frequent and complicated at this period. It appears, for example, that by April 1856 Mrs McIan's salary was no longer guaranteed, and that she was then to receive '8/20ths instead of 6/20ths of the fees' (E. 165, 5.4.56), indicating that her share of the fees had already been cut from 1/2 to 6/20ths.
77. *Précis of Minutes, op. cit.*, Ed. 84. 35., 1.12.59.
78. Purnell, *op. cit.*
79. *Select Committee Report, op. cit.*, p. 120, 1434.
80. Purnell, *op. cit.*
81. Art-work for Women III, *op. cit.*, p. 130.
82. Purnell, *op. cit.*
83. *ibid.*
84. C. Dresser, *Principles of Decorative Design*, London, 1876, p. 22; quoted in Macdonald, *op. cit.*, p. 249.
85. The following scholarships had been created by 1895: The Gilchrist Scholarship, tenable for two years (£50); The Queen's Scholarship (£60); The William Atkinson (£5); The Mercer's (£30); The Brightwen (£15) and the Clothworkers' (£15). All these were tenable for one year. See Tessa Mackenzie, *Art Schools of London, 1895*, London, 1895, p. 35.
86. Art-work for Women II, *op. cit.*, p. 103.
87. Further discussion of this problem, and specific examples of the exclusion of women from trade classes will be found in Chapter 7, Hand-printing, Bookbinding and Illustration.
88. For detailed discussion of these topics, see the chapters devoted to each craft below.
89. Mackenzie, *op. cit.*, p. 75. For fuller information on the government art classes, see Macdonald, *op. cit.*
90. See Macdonald, *op. cit.*, Chapter 17, pp. 291 ff.
91. *London County Council Education Committee Minutes*, Polytechnics and Evening Schools Sub-committee Reports, 23.1.08; 139–40. The Board of Education was to take over all liabilities and expenses of the Royal Female School, in exchange for the freehold property of the School at Queen Square.
92. *ibid.*, 1.7.08; 5, p. 2127.
93. Central School of Arts and Crafts and Day School for Women, *Prospectus*, 1908, p. 4.
94. See note 87 above.
95. *The Art Journal*, 1850, p. 362. Mrs Peter also promoted an association for the advancement of tailoresses, and founded art museums and convents.
96. Walter Smith, *Art Education*, Boston, 1873, p. 28.
97. *ibid.* p. 29.
98. *ibid.* pp. 163–5.
99. Art-work for Women II, *op. cit.*, p. 103.
100. Smith, *op. cit.*, pp. 166–7.
101. *ibid.*, p. 169.
102. *ibid.*, p. 380, Appendix IV.
103. *ibid.*, p. 378.
104. *ibid.*, p. 379.
105. *ibid.*, p. 377.
106. *ibid.*, p. 370.
107. *ibid.*, p. 372.
108. Kate Gannett Wells, Women in Organisations, *Atlantic Monthly*, September 1880, p. 363.
109. *ibid.*, p. 361.

2 Ceramics

Minton vase decorated with naturalistically painted flower sprays, date c. 1871–5; one of a pair. This vase probably came from the Minton Kensington Art Pottery Studio, and was thus almost undoubtedly decorated by one of their many anonymous women artists. Remarkably few examples of work executed by women at the Studio are known; they were employed mainly in producing ware designed by directors like William Coleman rather than their own original work, despite the thorough training the women had received at the National Art Training Schools. (PHOTOGRAPH: THE FINE ART SOCIETY, LONDON)

T HE CERAMIC INDUSTRY was one of the first to respond to the growing demand for hand-crafted, individually designed and therefore unique objects, which were a feature of the Arts and Crafts movement in England and the United States.

Although pottery, as an aspect of woman's rôle as domestic provider before the break-up of the family economy, was a traditional women's craft in pre-mediaeval society, lack of evidence and the anonymity of craftspeople then, make it difficult to establish the extent of their involvement in it. By the nineteenth century all common knowledge of such practices was lost:

Amongst the long and noble record of early English potters who made this industry their profession, certainly not one woman's name can be traced, the only way in which the potter's wives assisted their husbands having been, apparently, to carry to market and there disposing of the pots, jugs, etc., fashioned in the various small potteries throughout the country.[1]

While in itself no mean feat, the vending of wares is here reduced by the writer to insignificance; but such 'doctoring' of history, however unconscious, is a characteristic of Victorian society, in which sex rôles were limited and seen only within the confines of what was then acceptable in terms of femininity and masculinity. Guild training and organisation also increasingly excluded women, as full-time participation in a craft became crucial to the expansion of the economy and capitalist competition, and thus removed trades from the home and family base to the factory with fixed hours, fixed tasks and division of labour; the craft of pottery was no exception.

This Victorian writer's assessment of the historical situation is also inaccurate with regard to more recent developments, for, while pointing out that a 'few ladies . . . painted flowers at the Sèvres manufactory during the latter half of the eighteenth century', any mention of women's involvement in pottery at a managerial level is omitted. Yet by this date women often participated in this way, rather than on the practical side for which they had no training; a typical situation was that of a widow who would take over the running of a husband's business after his death. The early history of the firm of Doulton's of Lambeth, London is an excellent example of this: the pottery in which John Doulton ventured his life savings of £100 in a partnership in 1815, in Vauxhall Walk, Lambeth, was being run by a widow, Martha Jones. It is likely that during her potter husband's lifetime she had kept the books and was familiar with the business side of this small firm, and though apparently lacking in practical training she was able to continue running it with the help of a foreman, John Watts. Martha Jones had planned to hand over to her son Edward when his apprenticeship was complete, so it is clear that she saw herself as standing in for a man, rather than automatically assuming entire responsibility and ownership herself. However, following a tangle with the law Edward disappeared to South America, and at this point, in 1812, John Doulton joined the firm, soon after finishing his seven year apprenticeship. Three years later when she was sure her son would not return, Martha took Watts and Doulton into partnership, and little is known of her practical activities in the firm afterwards; she withdrew from the partnership in 1820, probably to retire.[2]

By the mid-nineteenth century, a new tradition of woman's rôle in the ceramics trade had become firmly established. In the new mechanised pottery factories in the Stoke-on-Trent area of the English Midlands, women were hired and trained as decorators of china. The art of china painting was considered a more suitable employment for women than for men, though the elevated class of designers were usually male. Here again we find women limited, by the pressure of the mass of organised male workers, to non-competitive 'feminine' skills which required the manual dexterity by which women's work was characterised. However, even the training of women in the potteries' art schools and their introduction to this trade caused violent hostility among the male workers. The problem was brought up in the *Report on the Schools of Design* in 1849, in which Herbert Minton gave evidence to the Select Committee regarding progress at the potteries' art schools. There was widespread fear that the women would take the men's jobs:

There was a great deal of jealousy on the part of the men, at first, at the women being educated. Several of the parents even objected to their children going, because they thought the women would do work which ought to belong to the men. That was one objection to it. But now the women are attending, and the young girls are making great improvements.[3]

The Stoke-on-Trent Art School had been established in 1847, and two years later Herbert Minton was able to report that one quarter of his factory staff attended evening classes, after a ten-hour working day. Each of the local schools ran one female class at this date, and Minton praised their success: 'There are some drawings now done by the girls in the school, of such merit, that I do not believe there is one woman in the whole district of the potteries could have drawn those things six years ago.'[4] Although Minton again emphasised the jealousy felt over women entering the schools, he himself was very anxious to encourage the admission of young girls, feeling that their progress was quite satisfactory. Female labour was of course, cheaper than male. When asked in what particular branch of designing the females chiefly excelled, Minton answered that 'Their instruction is generally in flower painting; scarcely anything else.'[5] Minton would have been unable to answer in any other way, as the women were so severely restricted to flower painting that their talents in other fields were unknown.

Evidence of the rivalry between men and women at the potteries was given in Minton's account of the men's exclusion of women from certain privileges. The Committee Chairman questioned Herbert Minton:

'Am I correct in the information I have had, that in painting flowers the females are not allowed to use the rest for the arm?'

'Yes, the men have the rest, but the women have not.'

'Can you give the Committee any reason for that?'

Howell and James: Illustration of paintings on porcelain by various women, reproduced from the Art Journal Catalogue of the Paris International Exhibition, 1878. The elevated social class of many of the lady entrants into the annual competitions organised by Howell and James of Regent Street furnishes proof of the widespread approval accorded by this date to porcelain painting as a new leisure accomplishment for middle- and upper-class ladies. For the less fortunate gentlewomen, it did however provide the possibility of a means to an independent income which could be earned from home; Howell and James's Galleries functioned as an invaluable outlet for the work of such women. The examples shown here were the prize-winning exhibits displayed in Paris, and later in the Regent Street Galleries. Among the works illustrated appears, at the lower left as No.4, a landscape-painted plaque depicting blackberrying, executed by Catherine Sparkes, wife of John Sparkes the outstanding and progressive head of Lambeth School of Art who was responsible for encouraging its association with Doulton's of Lambeth, and later head of the National Art Training Schools at South Kensington from 1876. Catherine Sparkes had evidently undergone training at Lambeth herself, and in addition to work submitted to Howell and James's competitions, she produced an enormous tile panel painted on Lambeth faïence which was exhibited by Doulton's at the International Exhibition at Philadelphia in 1876. She worked freelance for Doulton's during the 1870s and possibly later, and assisted John Sparkes particularly in his efforts to develop faïence at the Doulton Pottery, Lambeth. Catherine Sparkes was a talented, all-round artist.

'It is an arbitrary rule; just the same as another rule, that women are not allowed to use gold to gild.'

'By whom is that arbitrary rule enforced?'

'By the workmen entirely; by the gilders.'

'What has suggested such an ungallant proceeding?'

'I cannot say; it is a most tyrannical thing; but such is the fact.'

'Do you not think there is a little contradiction between, on the one hand, asking for assistance from the government, and on the other hand, allowing arbitrary rules of this sort to interfere with the beneficial operation of the school?'

'It may be inconsistent; but in years gone by there has been an attempt to upset it, and the men have turned out, and people considering their own private interests, have rather given way than contest the point. There has not been any attempt for the last 15 or 20 years to renew the question; the women are so accustomed that they never think of using the rest; they are not brought up to it.'[6]

In addition to admitting his convenient powerlessness in this situation, Minton is acknowledging that the women were forced to do a more tiring and demanding job than the men, a tactic no doubt intended to protect the men's jobs by excluding all but the strongest and most determined women. This trivial prejudice also provided the men with the assurance of a different job status from the women, avoiding any connotations of the indignity of being identified with women's work.

As late as 1872 the refusal to allow women the use of armrests for china painting was still prompting discussion, but finally it was noted that conditions had improved: '. . . for the last five years, in most manufactories, women use the hand-rest equally with the men, where they do any painting at all.' This same article emphasised the suitability of this craft:

there is perhaps no branch of Art-work more perfectly womanly and in every way desirable than painting on china. The character of the designs brings them within the reach of even moderate powers, and it must be admitted that painting flowers and birds and pretty landscapes, or children's heads, is work in itself more suitable for women than for men. The same may be said of its sedentary character, since men suffer more than women do from want of activity.[7]

Considering this enlightening statement, the author then attempted to discover the reasons why so few women were engaged in china painting:

Among the exhibitors of china in the last International Exhibition we find only two ladies. Of these, one exhibits with Messrs. Minton; the other, Mrs Ipsen, a Danish lady, had a case of her special work . . . which is so deservedly popular in Copenhagen. Doubtless other work had been done by ladies, but here the execution of original designs gave a right to special distinction.

In fact it was not that few women were engaged in the craft, but rather that women, relegated to the most menial tasks, rarely reached a sufficiently elevated position in the hierarchy to receive recognition for their work. Generally speaking it was the designer, usually male, who received acclaim for his creativity while the executant of his design, usually female, remained anonymous; this anomaly was partially corrected by the advent of greater respect for craftsmanship with the Arts and Crafts movement proper, and will be discussed in full with regard to embroidery. 'In the potteries, as a rule, where women are employed in painting, it is in a strictly subordinate position. Daughters assist fathers, or wives husbands, to fill in outlines, put in sprigs.' The majority of women were employed in drudgery similar to that reserved for boys, who, having less physical strength than men, were only worth low wages; these women, despite the optimism voiced by men like Herbert Minton, remained uneducated. However, by 1872 gilding work in the ceramic industry was more commonly associated with women than men: 'Gilding and burnishing gold is work generally done by women, as is also transferring for the printer.'

The female china painters in the Minton potteries at Stoke were of the working and artisan class, but they nevertheless set the pattern for women's careers in general in the ceramic industry, the main difference being that the women in the higher classes received greater acknowledgement for their work than their poorer sisters. In this craft industry it is again typical that delicate colouring work should have been considered the most suitable outlet for ladies' talents, and that they should have not merely been encouraged in this field, but excluded from all others, which were traditionally reserved for men. With the spread of Arts and Crafts movement ideals and the increasing concern over finding suitable employment for middle-class women, art pottery decoration rapidly became seen as a dignified means to a lady-like independence. Social sanction was awarded by the growing popularity of the craft as a hobby among the upper classes.

Thus the 1870s saw a veritable explosion of interest in art pottery decoration and painting on china. At the amateur level this interest developed to craze proportions as ladies all over England took up the craft; for a while it outstripped the popularity of embroidery as a pastime. An advertisement inside the front cover of the *Magazine of Art* for February 1880 indicates the enthusiasm for the craft: 'Messrs. Howell and James Art Pottery Classes . . . [They] have opened a studio at their Art-galleries where classes for ladies are held daily, Saturdays excluded, in China Painting.' The classes were under the direction of Miss Florence Judd, who had been employed at Minton's Art Pottery Studio in Kensington Gore. Classes were from 11 am to 1 pm, and 3 pm to 5 pm, a course of ten lessons of two hours each costing £3.3.0d, six lessons £2.0.0d, three lessons £1.0.0d. Four years later, an article on this 'Royal Academy' of china painting justified the honorary title used by its author on the basis that, while the small almost private school could offer no royal diplomas, yet it had been given a large measure of royal approval and support. By 1887 the principal of the school was stated in *Queen* as being Miss Mary Salisbury.

In 1876, Howell and James opened their new, especially erected Art Pottery Galleries at 5 Regent Street, and from that year on an annual exhibition of women's work was held there: 'During the season there will be held . . . an exhibition of painted china plates and

'Di Vernon—A Round': Charlotte H. Spiers. A painted portrait on porcelain exhibited at the Ninth Exhibition of Paintings on China, Howell and James's Gallery, Regent Street, 1884; From an illustration in the Magazine of Art *of the same year. The magazine commended her work as among the best, noting that she chose to depict healthy, handsome, natural faces, both gentle and refined. Her design was considered to be on the severe side, occupied in thought; she produced beautiful work, 'thoroughly English and pure, and masterly also, if such an epithet can be applied to designs which are feminine in the best sense of the word'.*

plaques, of strictly original design. To the successful competitors—whether artists or only amateurs— will be awarded money prizes and medals, and Messrs. E. W. Cooke, R.A., and E. J. Poynter, A.R.A. have consented to act as judges.'[9] The new art was considered 'Not only harmless and charming' but it 'opened out a congenial career to hundreds of women.'[10] It was made clear from the start that the new galleries were intended to encourage professionals as well as amateurs:

While varied in merit, there were many that indicated great ability, giving assurance of that which is so greatly needed—a remunerative market for the sale of ladies' work, and, moreover, a safe and dignified depôt in which their productions may be placed to be seen and disposed of. We hope, therefore, that Messrs. Howell and James will repeat the very satisfactory experiment, and that another season will produce even better results. This long established firm is doing much to advance the interest of Ceramic art.[11]

The recurrent references to the 'season' stress the social milieu under discussion here. At the same time Howell and James were advancing the interest of needy women, exhibiting that year 550 works; 'several prizes were awarded to lady amateurs, as well as to those who are "professionals".'[12] Finding a satisfactory outlet for their work was a major problem for isolated craftswomen attempting to establish a career from the home, particularly with the need for social respectability placing restrictions on women of gentle birth.

By 1881 over 2,000 pieces were being exhibited at Howell and James' Galleries, and 243 diplomas of merit,

in three classes, were awarded that year. Increasing numbers made it both possible and advisable to raise standards, and the following year fewer works were accepted while diplomas awarded numbered only ninety. This new rigour of the judges meant that gradually the distinction between amateur and professional work diminished.

The initial surge of interest in art pottery began as a response to the efforts of two famous ceramic firms, Minton's and Doulton's, to produce popular, artistic hand-crafted ware on a large commercial scale.

MINTON'S: THE KENSINGTON ART POTTERY STUDIO

Following a particularly successful collaboration between Minton's and some of the ladies of the National Art Training School in the execution of a tile decoration, designed by Edward Poynter, for the Grille Room at the South Kensington Museum (1868–9), the authorities began to consider the possibility of setting up an art pottery studio in London. Its main purpose would be to 'provide employment for such lady students of the Training School as desired it. This was one of numerous schemes which were mooted at the time for the employment of women of the middle and upper classes.'[13] As one contemporary writer observed:

In the establishment of this London studio Messrs. Minton have met the great difficulty attendant on the employment of women in china-painting; although the fact of their having a lady-artist at Stoke, whose position is equal to that of the gentlemen there, proves that this difficulty is not insuperable. It is urged that young ladies could not go to live at the potteries. But young ladies do constantly leave home as governesses; and it is not easy to see why a little community, under proper matronly supervision, might not . . . well exist at the potteries, doing pleasant work there . . .[14]

This draws attention to the practical problems of providing work for ladies, because of the restriction imposed upon their movements by the necessity for constant chaperoning. Also implied here is the interesting notion that the majority of needy gentlewomen resided in or near the metropolis; many others would have had relatives in London, making centralised aid for women the most effective.

Minton's were approached by the South Kensington authorities, and a seven-year lease was granted them by the Commissioners of the 1851 Exhibition on a plot of land advantageously situated close to the Royal Albert Hall, 'immediately between the Royal College of Music, which was then in the process of construction, and the conservatory of the Royal Horticultural Gardens.'[15] Minton's had the land at a 'merely nominal ground-rent',[16] and with Kensington Gardens close by to provide natural forms for designs, and the South Kensington Museum with its collection of antique pottery examples, a more appropriate location for the new studio would have been hard to find. The building constructed on this site and opened in the spring of 1871 was a simple two-floor affair; a contemporary report in the *Art Journal* described a series of studios and storerooms, the largest studio taking up practically the whole of the upper floor. There were two kilns, one large

and one small, at least one of which was said to have been designed to consume its own smoke. 'The studio was established under the happiest auspices. No project surely was ever launched with greater opportunities. It soon became one of the show places of London and was visited by a number of the most highly placed personages.'[17] William Stephen Coleman, the 'first English artist of reputation to devote himself to the production of original works on pottery',[18] was appointed Art Director of the studio. His task was to 'select a few skilled painters from Stoke and students from the National Art Training Schools at Kensington, and conduct a class for practical china painting ... it is hoped that, with its facilities, eminent artists (ladies especially) may be induced to paint upon porcelain and majolica'.[19]

Two years later the *Art Journal* recorded the progress of Minton's studio, where:

a number of ladies, whose Art-education has qualified them for the work in which they are engaged, are comfortably located with all the necessary models and designs around them, calculated to inspire and stimulate them in whatever they undertake. There are from twenty to twentyfive educated women, of good social position, employed without loss of dignity, and in an agreeable and profitable manner. All have received the necessary Art-instruction, either at the Central Training Schools at South Kensington, or at the schools at Queen's [sic] Square, or at Lambeth.[20]

A class in painting on china, for both sexes, had been established at South Kensington by 1852, and as early as 1848 writers on the success of the Female School noted that the students there were producing good designs for porcelain.[21] Thus by the 1870s there can have been no lack of talent to staff Minton's studio. Biscuited wares were transported to London from the Stoke factory, ready for decorating and glaze firing in the studio kilns. Underglaze decoration on the biscuited clay, which is extremely porous and absorbent, had to be rapid and confident, requiring a broad and unfaltering touch. Overglaze painting, which tended to produce more brilliant, pure colours, was also used, and combinations of the two processes, often requiring several firings, were common practice at the studio. Occasionally works had to be returned to the Stoke factory for the glaze firing, a procedure which inevitably increased the risk of breakage; however, all overglaze firing and work on fragile pieces was carried out at the London premises.

Ornamental treatment on both earthenware and porcelain bodies was intentionally direct and simple in character, with strong colour. Rapid execution demanded a decorative approach, and the avoidance of more traditional effects of pictorial art which necessitated the use of chiaroscuro modelling, which was contradictory to the studio's aim of producing good decorative art. Thus the works 'depend for their expression on good outline, with well-distributed masses of detail and harmonious colouring'.[22]

One of William Coleman's most significant contributions to the renaissance of English art pottery was his powerful and individual sense of colour: 'He ... set the pot painter's palette anew, and showed the way to a richer, juicier scheme of colour, which was yet essentially ceramic in character'.[23] Two of Coleman's sisters, both of whom were well-known china painters, seem to have shared his exceptional ability in the use of colour. It is not known whether both sisters worked at Minton's studio, but an article in the *Art Journal* of 1872 records that at least one of them, possibly Helen, was there at that time; 'it is this very freedom of handling which gives such charm ... to the floral subjects by his sister, Miss Coleman, whose success in this direction is remarkable'.[24] Certainly both Rebecca and Helen Cordelia Coleman (Mrs Angell) decorated Minton wares, probably on a free-lance basis after the closure of the studio in 1875, and both were amongst the best professional class of exhibitors at the annual china painting shows at Howell and James' Galleries. Rebecca Coleman's death was remarked upon in the *Magazine of Art* review of the 1884 show: 'The loss which this branch of china painting has sustained by the death of the latter is not easily overestimated. In skill of handling, in the bright purity of her tints, she was unequalled. The last work of hers which I have seen was like a rainbow'. Studies of heads was the branch of china painting in which Rebecca Coleman excelled.

Hannah Bolton Barlow, one of the most widely renowned of all women art pottery decorators, was one of the few female artists who worked at Minton's studio whose presence there is supported by documentary evidence. George W. Rhead, one of her fellow artists at Doulton's Lambeth Pottery, was later to record her brief stay with Minton's. Rhead gives no precise dates, but a recent study of Doulton's Art Pottery states that 'After a short period at Minton's decorating studio in Kensington Gore, she did some free-lance work for Doulton in 1870 and early the next year began to work for him full-time.'[25] As the Minton studio did not open until the spring of 1871, Hannah Barlow cannot have worked there before this date; however it is quite likely that she may have done free-lance work for Doulton before her appointment at Minton's, or even at the same time. Her stay at Minton's must have been very brief indeed, for the records of 1882 indicate that by June of 1871 she was employed by Doulton;[26] a more accurate dating for her stay at Minton's can therefore be calculated to a probable maximum of three months, between March and May of 1871.

Before considering the Doulton Art Pottery in detail, it is interesting to consider the reasons why this venture proved so successful and why, in contrast, Minton's failed. At first sight remarkably similar in aims and ideals, a closer examination reveals marked differences, particularly in the two companies' approach to the individual creativity of their artists. Even during the most creative period at Minton's, under Coleman until his resignation in late 1873, the highly trained artists and designers were engaged mostly in executing the designs of others, especially of Coleman himself, who comes over in the literature as a man preoccupied with his own talent; perhaps he was a man who could not bear to have others of talent around him. Edmond G. Reuter, another artist at Minton's, received due

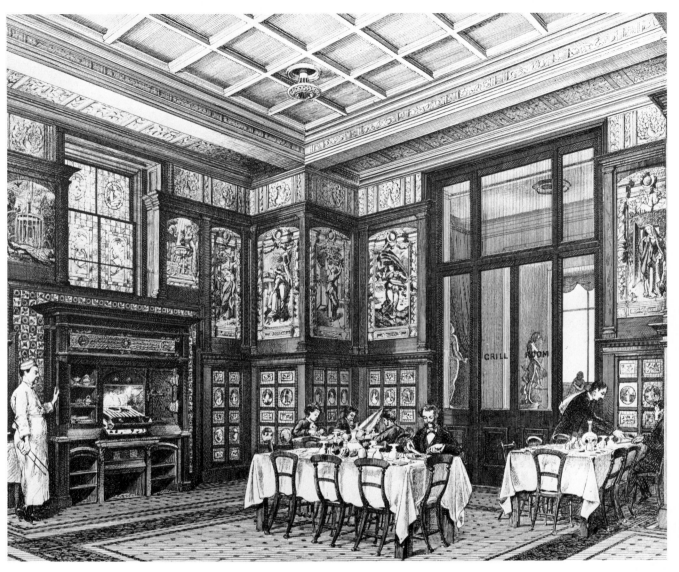

Above: *John Watkins (d. 1908): The East Dining or Grille Room, South Kensington Museum (now the Victoria and Albert Museum), c. 1876; pen and ink, $11\frac{1}{4} \times 17\frac{1}{2}$ in. The designs for the interior tile panels were commissioned by Henry Cole from Edward Poynter in 1868. The tiles were painted by the women students of South Kensington and fired by Minton's; this collaboration led to the establishment of the Minton's Kensington Art Pottery Studio in 1871, which was staffed mainly by women from the nearby National Art Training School, thereby finding them suitable employment.* (PHOTOGRAPH: VICTORIA & ALBERT MUSEUM, LONDON)

Left: *'Dora—A Round': Rebecca Coleman. A painted portrait on porcelain exhibited at the Ninth Exhibition of Paintings on China, Howell and James's Gallery, Regent Street, 1884. By the time this work was exhibited, Rebecca Coleman was dead; the* Magazine of Art *which illustrated the portrait head—her forte—wrote: 'The loss which this branch of china-painting has sustained by the death of the latter is not easily overestimated. In skill of handling, in the bright purity of her tints, she was unequalled. The last work of hers which I have seen was like a rainbow' (p. 249). Rebecca Coleman and her sister Helen Cordelia Coleman were both professionals, and at least one of them worked at the Minton Kensington Art Pottery Studio (which was for a time under the management of their brother William Stephen Coleman). The sister whose work at Minton's was commended specialised in flower studies, and was therefore probably Helen Cordelia.*

recognition only much later because of:

a remarkable instance of entire lack of perception of a great firm, or organisation, to turn to account the material to hand, and to make the most of it. We have here an instance of a man of unique capability employed during a long period, upon the merest trivialities, work which could have had no possible interest for him, hoping against hope, and finally losing all heart and interest in his daily occupation.[27]

The responsibility for this state of affairs lay squarely with Coleman, rather than with Colin Minton Campbell who, unlike his predecessor Herbert Minton and his rival Henry Doulton, was not a practical potter but a businessman and an employer of labour. Coleman's lack of practical knowhow, and his irregular supervision made him ill-equipped to criticise or interfere in the workings of the studio. Thus the division of Minton's between Stoke and Kensington Gore created difficulties which did not exist for the London-based Doulton firm.

Above all, it is clear that to run an organisation as an outlet for the talents of one individual to the detriment of all others involved was a recipe for disaster. Given insufficient opportunity to exercise their individual creativity, the artists of the studio became unpractised in using their own initiative, and over-dependent on the succession of inefficient managers who followed in the wake of Coleman. One such manager, excessively keen on increasing productivity, sectioned off the large studio space into tiny individual cubicles, intended to cut out distractions and time-wasting discussion among the artists. Thus, from being a show-piece of artistic industry, an ambitious fore-runner of other similarly exciting ventures, the studio dwindled to an embarassingly imitative workshop. It was a relief to all concerned when fire destroyed the premises in the summer of 1875.

By contrast, Henry Doulton encouraged the creative talents of all his artists; there was a much greater sense of growth and continuity as all had both practical and artistic training, and every worker had the opportunity to rise from Junior to Senior Assistant, and from there to the coveted Artist status. Attention was given to the ideas of all personnel, from artist to thrower. There was also direct, personal supervision at Doulton's, by an employer and practical potter rather than by a manager. Although there were artistic directors at Lam-

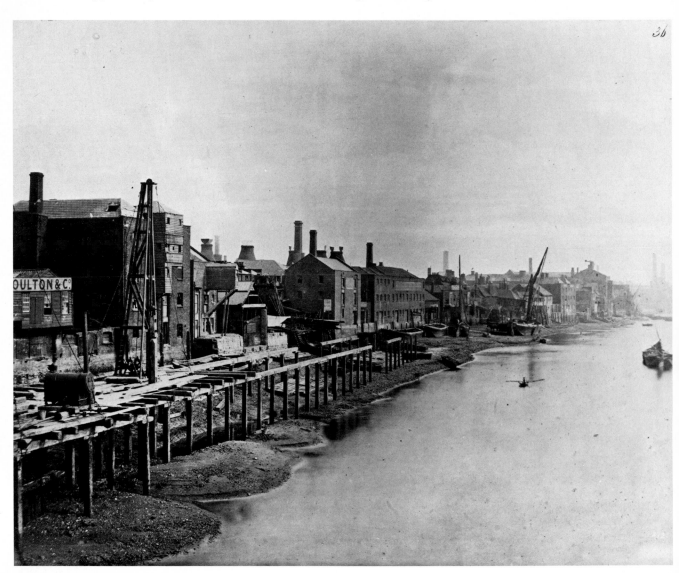

The Lambeth Riverside before the construction of the Albert Embankment in 1861. This photograph shows the old ramshackle loading stages overhanging the River Thames which were replaced in 1861 by docks *under the Embankment itself; part of the old Doulton buildings are clearly indicated to the left.* (PHOTOGRAPH: VICTORIA & ALBERT MUSEUM, LONDON)

beth, a strong sense of collaboration and co-operation existed between all involved. Perhaps it is wrong to draw too many conclusions from the slim documentary evidence of the brief existence of the Minton Art Pottery Studio, but it seems predictable that the surviving information deals almost entirely with the managers of the establishment, such as Coleman, leaving lost to anonymity the large numbers of other artists, both male and female.

DOULTON'S: THE LAMBETH ART POTTERY

George W. Rhead, who was for many years one of the few male artists employed at the Lambeth Art Pottery, later wrote that one of the most important results of the Minton studio initiative was that it 'most probably, we may say certainly, provided the incentive to Messrs. Doulton to take up art work in pottery. It was the pioneer in London, although Messrs. W. B. Simpson had already been doing most excellent work, chiefly, however, in tiles'.[28] It is interesting to note that Simpson's too were making a point of hiring female artists; the *Art Journal* of 1872 reported that 'two more students' from the Female School 'had obtained permanent engagement in tile-painting at Messrs. Simpsons, who now employed six students from the school'. To return to Rhead's statement, it does seem likely that Minton's example was decisive in encouraging Henry Doulton to expand his art pottery concern, but it is clear from the records that the Lambeth Art Pottery was well under way some years before the Minton experiment began in 1871.

The first item of art pottery produced by Doulton was a rather insignificant reproduction of a sixteenth-century Rhenish salt-cellar, made at the instigation of Edward Crecy, an architect and friend of Henry Doulton. This piece was shown along with the firm's industrial ceramics at the International Exhibition held in London in 1862. There it was noticed by John Sparkes, head of Lambeth School of Art, who had for some years been nurturing the idea of a creative partnership between school and pottery. When first approached, Henry Doulton had been against the suggestion, but following this exhibition, and with the encouragement of Crecy, he gradually became more enthusiastic until early in 1863 he became one of the Committee of Management for Lambeth Art School. In 1864 a commission from Doulton, designed by John Sparkes, for a series of large terra-cotta heads to decorate the façade of an extension to the pottery, marked a new stage of co-operation between the two establishments. Two years later George Tinworth, one of Sparkes' most promising students, entered employment at Doulton's as a pottery modeller, and began designing a series of stoneware vessels which he then decorated in the raw clay state with raised bosses, beaded runners and incised concentric lines which he filled in with brown or blue colour, or partially dipped in blue glaze. These items—jugs, vases and tankards—were then submitted to the same single high-temperature salt-glaze firing as the industrial wares for which Doulton's were already famous.

Doulton's had traditionally produced a variety of

Hannah Barlow: Photograph from Presentation Volume II, given by the lady artists in his employment to Henry Doulton in 1882.
(PHOTOGRAPH: MINET LIBRARY, LAMBETH, LONDON)

non-industrial wares such as spirit bottles, toby jugs and commemorative pieces, but here for the first time a talented artist was being employed especially to create unique, ornamental pots. The result of Tinworth's efforts was an exhibit of some thirty artistic pots which were shown alongside Doulton's main production at the Paris Exposition Universelle of 1867, and critical response was sufficiently positive to warrant Henry Doulton's increasingly enthusiastic commitment to the new enterprise. In preparation for the following International Exhibition at South Kensington in 1871, Henry Doulton began to commission works from students at the Lambeth School. On Sparkes' recommendation two of his most talented students, Hannah and Arthur Barlow, began in 1870 to produce free-lance designs for the firm; by June of 1871 they were both permanently employed at Doulton's. At first there was no special studio provision for the artists; they were installed in a corner of the main Lambeth showroom, inadequately protected from the prying eyes of customers, who 'persistently intruded on the privacy of the artists by craning their necks over the screen'[29] which separated them from the work area.

Hannah Barlow was the first and one of the most important lady artists to work for Henry Doulton. She and her brother Arthur and her two sisters Florence and Lucy, who all worked for Doulton for varying lengths of time, and were all associated with the rise to fame of his artistic pottery, belonged to a large family which had the good fortune to grow up during the middle years of the century 'in idyllic unspoiled country surroundings, first at Little Hadham in Hertfordshire and later at Hatfield Broad Oak in Essex'.[30] Theirs was a comfortable middle-class background, and one apparently with little time for the niceties of society rituals. Rather they were encouraged to study natural history and to take full advantage of the abundant and varied wildlife which surrounded them. Country rambles in search of flowers, plants and fossils and a growing knowledge of

59

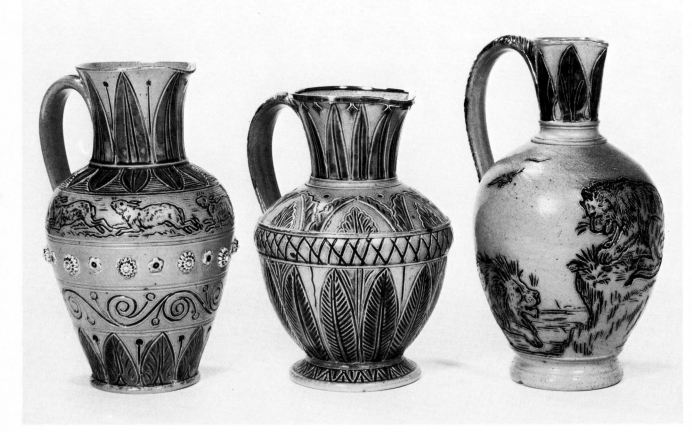

animal life and the seasonal round characterised their early years. In addition to their father's position as a bank manager at Bishop's Stortford, he owned a 250 acre farm, on which were kept horses, ponies, sheep, cows and goats, plus a collection of pigeons, doves, peafowl and other poultry. The Barlow children's own pets included various breeds of cats, dogs and rabbits, a lamb, a tame jackdaw and 'a remarkably sociable pet partridge'.[31] Their early pastimes were to provide crucial inspiration for later artistic pursuits.

The first impulse towards the ceramic arts came to Hannah Barlow when, at the age of seven, she witnessed 'the coming of a travelling man with a potter's wheel to the village where I lived as a child'.[31] This early memory of her first glimpse of the thrower's art was never to leave her. However, although 'Hannah showed great talents in delineating animal life whilst quite a child, it was not until after family reverses and the death of her father occurred that she thought of art professionally, and entered the Lambeth School of Art and Design'.[32] Thus Hannah's introduction into an artistic career followed the typical pattern of a young lady of middle class origins forced to support herself because changes in family circumstance deprived her of the economic security which she was brought up to expect. In 1868 she was the first of her family to enter art school; she was introduced to John Sparkes by the daughter of a well-known woodcarver, George Alfred Rogers (this was Edith Rogers, who also later worked as an artist at Lambeth) and there Hannah 'practised painting, modelling and general design, including the beginnings of the incised or *sgraffito* method of decorating pots which was to become her *forte*'.[33] It has been suggested

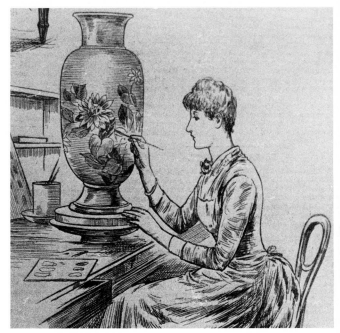

'Doulton's of Lambeth: Pottery Work and China Painting—Miss Roger's Studio', from an engraving reproduced in Queen, *1887. Although there were several Miss Rogers at Lambeth, this was probably Miss Edith Rogers (daughter of the wood carver Alfred Rogers) a versatile artist who designed and decorated Doulton Ware, Silicon Ware, Carrara Ware and Impasto; here Impasto painting of a floral design is in progress. Developed in the late 1870s, Impasto was a good technique for artistic impressions. An earthenware body, like that used for Lambeth faïence, provided the base, but the colour was applied to the raw clay, 'so thickened by the vehicle by which it is incorporated, that it models the form as well as paints it. [It had] . . . 'all the advantages that opaque tempera, or oil painting, possess: it reflects light from its surface'. (John Sparkes, Head of the Lambeth School of Art, writing in 1880.)*

that she may have been influenced by the French landscape painter and stoneware potter Jean-Charles Cazin, who succeeded Alphonse Legros as a teacher at Lambeth in the early 1870s. After she began working at Doulton's, Hannah continued studying at Lambeth in the evenings, as did the majority of John Sparkes' students:

A recreation room, with piano etc., is also at the disposal of those workers who may wish to spend there the interval of time elapsing between the closing of the workrooms and the opening of the Lambeth Evening School of Art, the proximity of which to Messrs. Doulton's establishment affords excellent opportunity for study, apart from that purely appertaining to the art of the potter, and it is, therefore, taken much advantage of by the potters.[34]

Hannah Barlow's particular strength lay in her naturalistic representation of animals set in an appropriate landscape; her succinct and articulate drawings, whether on paper or incised into damp clay, required only the minimum of lines for maximum effect. Her simplicity of line is reminiscent of certain Japanese masters, and it is surely no accident that the renewed interest in artistic pottery coincided with a cult for the art of the Orient, a cult which was in general a key factor in the revival of all the crafts of the period, pointing the way to an ever more daring and stylised treatment of ornament, with a decorative flattening of design. But for Hannah it must have been the concise calligraphic quality of Oriental brushwork which proved attractive, and which she sought to transform through her own personal, essentially realistic, vision of nature.

Far left: *Hannah Barlow: Three early Doulton salt-glazed stoneware jugs. From left to right: with incised stiff leaves, scrolls, and a frieze of rabbits, with a band of applied flower heads on a buff ground, c. 1872, 7½ in high; with incised stiff leaves filled with blue and brown slip on a buff ground c. 1872, 6¾ in high; with incised lions in a landscape, filled with dark blue slip on a light buff ground, c. 1872, 8 in high. Incised lines were made into the wet clay; the raised flower motifs would be applied when the clay was leather hard, but still unfired.* (PHOTOGRAPH: COURTESY OF RICHARD DENNIS)

Above left: *Florence E. Barlow: A massive vase, salt-glazed Doulton stoneware, the buff ground impressed overall with small circles, painted in green and white pâte-sur-pâte with garden birds amongst branches and numerous ducks among rushes, the base with brown and blue panels decorated with bead work, c. 1880, 26¼ in. Florence Barlow regularly preferred to work on a large scale, producing fitting designs for the bigger size and often showing a marked interest in Japanese-style motifs which were then widely popular. Her decorative use of reeds and foliage here shows a distinct Japanese influence, both in design and execution. Florence Barlow, like Hannah Barlow, specialised in work on stoneware, but her treatment of birds was far superior to that of her sister; tacit agreement led to each concentrating on their individual forte, with Hannah leaving birds to Florence who created them in both incised and painted decoration.* (PHOTOGRAPH: COURTESY OF RICHARD DENNIS)

Above centre and right: *Edith D. Lupton: Two salt-glazed Doulton stoneware pieces.* Centre: *vase with painted flower and foliage decoration and incised borders, signed in full: 'Edith D. Lupton, Lambeth School of Art', 1878, 11¼ in high;* right: *mug with incised stiff leaf decoration, 1881, 5½ in high. The vase was evidently executed while Edith Lupton was studying at Lambeth School of Art; many of the Doulton artists trained at Lambeth, and most continued to do so at evening classes even after they had taken up employment. Some artists began designing and decorating ware for Doulton's on a free-lance basis before leaving Art School.* (PHOTOGRAPH: DOULTON & CO. LTD.)

Above: *Hannah B. Barlow: A page from a sketch book dated 1872. Hannah Barlow made hundreds of such studies from nature, using them as the basis for her free-hand incised line drawings in clay. At her country home in Wraysbury, Berkshire, she kept a veritable zoo of animals both common and unusual, which provided her with a constant source of material and inspiration.* (PHOTOGRAPH: DOULTON & CO. LTD.)

Right: *Hannah Barlow: buff terracotta panel with animals modelled in high relief, 1890, 10×7 in, in an ebonised frame; one of several pieces exhibited at the Royal Academy between 1881 and 1890, this panel was exhibited in 1890, and entitled 'So near and yet so far'.* (PHOTOGRAPH: COURTESY OF RICHARD DENNIS)

After about 1877–8 Hannah concentrated almost entirely on the depiction of animals, while her sister Florence, who probably joined Doulton's in February 1873, specialised in painting birds. At her home in the country, Hannah kept a small private 'zoo'; the *Lady* reported in 1887:

In a general way Miss Barlow keeps from 12 to 16 animals to study from; and amongst them at the present time are a splendid Scotch deerhound, a black mountain sheep answering to the name of 'Lady Gwen Morris', and a pet goose, over eight years with her mistress. A little while ago a beautiful little Shetland pony, a donkey, and a fallow deer would have been found among the list. The latest addition is a little fox, just brought from South Wales, which was at first very savage, but is now both tame and gentle, and follows Miss Barlow about as quietly as a well-trained dog ... He is not yet quite accustomed to his fellow pets, for he will insist upon teasing a large Russian cat—the same which the Prince of Wales so much admired on his visit to Miss Barlow's studio at Lambeth last Christmas.

Her animals were invaluable to her art studies, and she also frequently visited the London and other zoological gardens to study the animals. Although Hannah made hundreds of pencil drawings from life, she was never known to use these for copying from onto the clay; she would sometimes observe the animals' movements for hours on end, and would then reproduce them from memory. 'She knows the anatomy and ways of animals by *cumulative experience* and scratches the forms onto the clay ... a method demanding a precision of touch

rare even among artists of distinction.'[35] Tom Taylor of *Punch* said of Hannah Barlow: 'Her art is a living art, derived from close and sympathetic study of life, and having life in it, so working freely, joyously and profusely as all life works—not in dead, dull and formed fashion, as mechanical dexterity works.'[36]

Many Doulton artists, including Hannah, regularly produced works for show in the major art exhibitions, enhancing both their own reputations and that of the Doulton company:

Miss Barlow, although so much occupied with her Doulton etchings, still finds time to prepare a few works annually for exhibition in the Royal Academy, Dudley Gallery, Society of British Artists, the Walker Art Gallery (Liverpool), and various provincial exhibitions ... Many water-colour and black and white drawings have also been exhibited since Miss Barlow's professional début in 1874.[37]

Most popular among her exhibited works were her terra-cotta sculpture groups such as *Mother's Darlings* (ass and foal), *The New Play Fellow* (child, dog and tortoise) and *On Guard* (deer and fawn).

Continuing successes enabled Doulton to enlarge his group of artists and by the end of 1873 there were thirteen ladies on the staff. Apart from Florence Barlow these included Eliza S. Banks, Eliza Simmance and Louisa J. Davis. Eliza Banks was one of the first Lambeth exponents of the famous *pâte-sur-pâte* method of decoration, which had been brought to England from the Sèvres porcelain factory when the artist Louis Marc Solon left there and came to work for Minton's.

Experiments in this technique at Lambeth were taking place during 1876–7. It involved the slow build-up of an image in low-relief using coloured slips; with expert handling an effect of modelling could be achieved by varying the thickness of slip and thus allowing the body colour to show through the thinner areas in a chiaroscuresque manner. Other specialists in this technique at Doulton's included Florence Barlow and Eliza Simmance. John Sparkes said of Eliza Banks in 1880 that she 'has invented and executed some excellent designs on a larger and more picturesquely ornamental scale than anyone else. Her work is recognisable by a certain freedom of brush work which occasionally verges on the natural side of the line that is conveniently held to divide nature from ornament'.[38]

Before Florence Barlow began working in the *pâte-sur-pâte* technique, with which she was particularly clever at achieving a sense of light and shade, she used the incised method of decoration for which her siblings Arthur and Hannah were especially famous. Most of the artists tended to find a certain technique which suited their work, and then to remain with it for most of their careers, but Eliza Simmance was a notable exception. At first somewhat overshadowed by the Barlow sisters, her unusual versatility gradually set her apart from the others. She was a particularly original designer and decorator, her work with Doulton Wares and Silicon Wares being especially notable. In her fifty years at Doulton's she produced an enormous number of highly varied pieces. She was one of the few women artists in touch with and influenced by changing trends in the art

Louisa J. Davis: Three salt-glazed Doulton stoneware pieces. Left to right: *silver-lidded jug, the brown ground with impressed flower motifs and incised pointed green, blue, and brown panels, 1876, 6 in high; vase, the buff ground with painted Y motifs, and incised long lovat leaves, brown foliage, and blue flowers, 1877, 9¾ in high; vase, the white ground with an incised spiral band of foliage with blue flowers, 1877, 11¾ in high. Louisa J. Davis worked at Doulton's from c. 1873 until the mid-1890s, specialising in the naturalistic treatment of leaves and grasses, and in Persian- and Indian-derived stylised decoration; her designs were strong and individual.* (PHOTOGRAPH: COURTESY OF RICHARD DENNIS)

world, her work in the Art Nouveau style being among her most exciting and original. Skilled at most of the decorating techniques in practice at Doulton's, she would often combine several to great effect on a single pot. Although her fine incised work and *pâte-sur-pâte* painting were particularly beautiful, she also did carving, perforating, applied relief-figuring, bold modelling and incising through coloured slips. John Sparkes emphasised the surprising volume of her ideas:

First among those who have thrown their whole energy into their work is Miss Eliza Simmance. Her work is not only designing with the stylus but especially she excells in painting the *pâte-sur-pâte* patterns. There are examples of her work which are so eminently graceful and well-drawn as to emulate the same qualities in the work of the Italian ornamentists. She, too, has so many ideas to spare—more than she can work out by herself—that she keeps a staff of rising artists occupied in carrying out her instructions.[39]

By the mid-1870s the need to find proper studio space for the Lambeth artists had become urgent. Henry Doulton decided that a series of houses built many years

63

previously for the use of workmen, but which had subsequently fallen into disuse, would provide perfect small studios for his design staff. The rooms were too small for general use, but when renovated and made comfortable, proved ideal as individual or shared studios. A further wing was added in 1881 to house workrooms and studios for the sixty new female staff taken on in that year alone. This wing contained 'fifty separate studios, in many of which three to four assistants and trainees worked under the supervision of a principal designer. Some of the designers had their own private studios; others, like the Barlow sisters, preferred to share a studio with one or two others'.[40] This respect for privacy was felt to enhance the originality of the individual artists:

Each artist is encouraged to perfect her own individual predilections ... The encouragement given to the individual artist, the avoidance of any suggestion of a stereotyped character in the work turned out, is exemplified by the number of small rooms where artists of individual distinction carry out their own ideas.[41]

Henry Doulton always gave his artists enthusiastic encouragement, emphasising that no-one should be allowed to interfere in or direct their work, but that they should be left to develop in their own creative ways. As Hannah Barlow herself stated in a letter to Sir Edmund Gosse, written after Henry Doulton's death in 1897:

Sir Henry was always so encouraging I could not help but enjoy my work ... In all the many years I have worked at Lambeth, I have never felt that I was working for money. That has been one of the great charms of my work there. Sir Henry's enthusiastic interest in my work always made me feel roused to do better work![42]

It is significant that Hannah should have stressed that she never felt she was working for money, a reflection of the attitude of distaste and dishonour attached to remunerative work for ladies by contemporary society; this attitude is implicit in her statement, both in the lack of pride at being independently self-supporting, and in Doulton's creation of a work environment the atmosphere of which promoted such sentiments.

One personal account book does in fact survive (in the Archives of Doulton's, Pall Mall) to give an indication of the wages earned by women artists at Doulton's during this period. Written in the hand of Miss Earl, it could be the wages record of either Florence or Alice Earl, both of whom were Senior Assistants in 1896, the year the book is dated. The class of work was given as 'Daywork' and the record begins in the week ending 30 January 1896, and continues to 30 July 1897. Each week the number of hours worked was listed, with the type of work, given as either 'Supervision' or 'Repeated'. These classifications may refer to the supervision of Junior Assistants, and the repetition of the designs created by the lady artists. The account

Left: *Four salt-glazed Doulton stoneware vases. Left to right: Eliza S. Banks: vase with carved panels of blue foliage surrounded by painted white flowers, the dark blue ground with incised green leaves, with assistant's monogram—Annie Gentle, 1882, 8¼ in high. An original and effective artist, Eliza S. Banks produced strong, broad designs in pâte-sur-pâte painting as well as carved and incised work. Elizabeth Atkins: vase, the buff ground with an incised scale pattern and four panels, two with ears of corn and two with blue flowers, 1883, 7 in high. Elizabeth Atkins' stay at Doulton's is variously given as c. 1876 to between c. 1883 and 1899. Margaret Aitken: one of a pair of vases, the white ground with painted cream lattice-work and incised flowering foliage painted in green and white pâte-sur-pâte, with assistant's monogram—Florence Hunt, 1881, 8 in high. Margaret Aitken: one of a pair of vases with incised and carved brown and blue leaves on a hatched ground with applied shell motifs, with assistant's monogram—Georgina White, 1882, 7¼ in high. Margaret Aitken's working life at Doulton's is variously given at c. 1881–c. 1882, and 1875–1883.* (PHOTO-GRAPH: COURTESY OF RICHARD DENNIS)

Above: *Eliza Simmance: Four Doulton stoneware pieces. Left to right: one of a pair of cylindrical vases incised through the pale blue glaze onto the white body with garden birds and flowering trees, also assistant's monogram—Emily Chandler, 1879, 6¾ in; jug with incised green and blue leaves with white diaper, 1875, 8 in high; tazza, surface with an incised blue and brown leaf pattern on a dark blue ground, the underside and base with stiff pale blue leaves and white bead work, also assistant's monogram—Rosina Brown, 1877, 6½ in high; vase with an incised foliate design in pale green and dark blue, further decorated with bead work, also assistant's monogram—Emma Martin, 1876, 7¼ in high.* (PHOTOGRAPH: COURTESY OF RICHARD DENNIS)

book records that the woman worked a six-day week, with an average of forty-one hours per week until 16 July 1896; thereafter the average was about fifty-five hours a week until the end of November following which it dropped to around fifty-two. At the beginning of the record her wages were 5¾d. per hour, giving a wage of 19s. 8d. for a forty-one-hour week; for the fifty-seven-and-a-half hours worked in the week ending 8 October 1896, Miss Earl earned £1.7s.7d. In the week ending 7 January 1897, her wages rose to 6d. per hour, yielding a weekly income of £1.0s.6d. for a forty-one hour week. Wages for both 'Supervision' and 'Repeated' work were paid at the same hourly rate. Thus the wages paid to women artists by Doulton's were comparable to those paid to the skilled embroiderers employed by Morris and Co. in the early 1890s (see Chapter 3, Embroidery and Needlework), which were well above the national average for skilled working class women. Charles Ashbee notes in *Craftsmanship in Competitive Industry* (1908) that a weekly wage for skilled craftsmen was £2.10s.0d. per week; this is markedly higher than that for comparable craftswomen, despite the fact that Ashbee's figures are ten years later than those recorded in the Doulton archives.

The results of Doulton's supportive attitude to individual creativity proved the value of his policy: thousands of completely original and idiosyncratic wares were produced, which found a growing popular market. In fact demand was so great that by the early

Eliza Simmance: Three Doulton stoneware pieces. Left to right: jug painted with stylised vine leaves and purple grapes against a pink ground, 1910, 8½ in high; vase painted with pink roses, the stems brown against a pale pink ground, 1910, 11 in high; jug with incised yellow leaves and impressed brown berries against a mottled blue ground, 1909, 9 in high. Eliza Simmance was a highly original artist, whose style changed and developed during her long period at Doulton's between 1873 and 1928. Her early, finely incised work was perhaps overshadowed by the work of the Barlow sisters, but Eliza Simmance gradually evolved a bolder, very personal Art Nouveau style—particularly after 1900, when all her products were signed individual pieces. She specialised in pâte-sur-pâte decoration of flowers and blossom which, although deriving from nature, became more conventionalised under the influence of Art Nouveau. The three pieces shown here are examples of this Art Nouveau style work; the central vase in particular seems to exhibit an awareness of the Glasgow style and makes an interesting comparison with the work of Margaret and Frances Macdonald in the late 1890s, and with the embroidery designs in appliqué by Anne Macbeth. (PHOTOGRAPH: COURTESY OF RICHARD DENNIS)

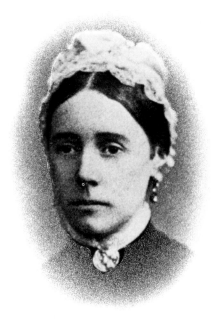

Florence E. Barlow: Photograph from Presentation Volume II, given by the ladies in his employment to Henry Doulton in 1882. (PHOTOGRAPH: MINET LIBRARY, LAMBETH, LONDON)

Eliza S. Banks: Photograph from Presentation Volume II, given by the lady artists in his employment to Henry Doulton in 1882. (PHOTOGRAPH: MINET LIBRARY, LAMBETH, LONDON)

1880s Doulton decided to reproduce certain lines in limited editions of usually no more than 2,000; this allowed a wider and less exclusive public access to craft pottery. However, even these repetitive pieces were both hand-thrown and hand-finished to the design of a leading artist, and in copying the decoration the assistant worked always from the original to maintain the greatest possible accuracy. Thus the series retained a greater degree of originality than the typical run of mass-produced ceramics.

Doulton's art pottery became increasingly familiar to the public through frequent exhibitions; Howell and James, in addition to annual displays of ceramics designed and painted by women, of which many were Lambeth wares, also regularly showed Lambeth pottery. 'The New Art-Pottery Galleries, erected by Messrs. Howell, James, and Co., of 5 Regent Street, are now open to the public. They are devoted more especially to the exhibition of Lambeth Faience, to which we drew the attention of our readers a few months ago.'[43] The International Exhibitions of the period also provided an excellent opportunity to publicise the work of the Lambeth women, such as that of Philadelphia in 1876, where Catherine Sparkes, 'wife of the man who has done more than any other artist or teacher in England to develop art painting on china',[44] showed a major work. Made in Lambeth faïence, this was:

Above: *'Doulton's of Lambeth: Pottery Work and China Painting— Painting Doulton Ware', from an engraving reproduced in* Queen, *1887. Here two women are at work decorating two very large scale pots of the type of prestige examples shown at the major international exhibitions of the period.*

Below: *Hannah and Florence Barlow's Studio, 1887, from an illustration in* Queen *of 1887. On the left, Hannah Barlow applies the painted decoration to a leather-hard pot onto which she has already incised a frieze of animals; on the right Florence Barlow paints a sculpted group of birds which rests on a turntable to facilitate work. Artists at Doulton's often chose to share studios, but they were permitted to work on their own if they preferred; accomplished artists were regularly assisted by younger apprentices, whom they helped train.*

A large tile panel painted by Catherine Sparkes . . . [which] aroused immense interest. Consisting of 252 tiles, 6 inches square, it depicted the Pilgrim Fathers standing in strong relief against an evening sky, bidding farewell to their friends and relatives in England. 'Her large and effective drawing and fine sense of colour,' wrote John Forbes-Robertson, 'make every piece of Lambeth faïence which comes from her hand an art object worthy of the cabinet of the most fastidious connoisseur'.[45]

Another piece of Lambeth faïence, exhibited at the Chicago Exhibition of 1893, was thought to be the largest vase ever made at Lambeth; painted by Florence Lewis, a leading artist in this field, it measured over six feet high and two and a half feet in diameter. Exhibition pieces for important international exhibitions tended to be rather extravagant and necessarily eye-catching.

China painting represented a major area of both employment and creative craft work for women. Although still concentrated within a specialised area of work considered appropriate for ladies (lady throwers or turners, for example, were rare, Hannah Barlow being one of the few women capable of throwing pots to her own design, rather than decorating ones produced by skilled male throwers), at Doulton's the women were given a remarkable amount of creative freedom within their discipline. Training for most women consisted first in a period at art school, often at Lambeth, followed by a trial month at Doulton's when their talents for the work were assessed. If accepted into permanent employment a woman would become a Junior Assistant, serving the equivalent of an apprenticeship at her craft under the guidance of the Art Director and a skilled artist. Between 1878 and 1899 the Art Director William Rix trained over 1,000 students; in March 1899 he stated 'when you remember that seven years is considered necessary before a student can be considered competent, some idea may be gained of the work accomplished'.[46] Of course not all the women completed their seven years, although many stayed far longer, and most of them arrived with an excellent initial training from Lambeth Art School, which John Sparkes continued to supervise even after his appointment as Director of Art Studies at South Kensington in 1876.[47] In fact of the 250 art staff employed at Doulton's by 1885, according to John Sparkes all but 10 had been students at Lambeth. Their studies were further encouraged by the arrangements made for their leisure at Lambeth Pottery; 'a well-stocked library of books on art; a music room; recreation rooms; and a dining suite were at the artists' and assistants' disposal'.[48]

Doulton's were widely applauded for their promotion of opportunities for women; 'the liberal spirit and enterprise which first determined them to permanently enlist [women's] aid, and thus establish on a firm basis an occupation so well suited to women, has unquestionably been repaid to them tenfold'.[49] Such repayment was in fact in terms of prestige and world renown rather than financial gain, for the art pottery side of Doulton's firm was apparently never profitable, and was subsidised by Henry Doulton himself.

The number of women at the Lambeth Art Pottery

Florence E. Lewis: Photograph from Presentation Volume II, given to Henry Doulton by the lady artists in his employment in 1882. (PHOTO-GRAPH: MINET LIBRARY, LAMBETH, LONDON)

Hannah B. Barlow at work in her studio, c. 1913. Taken just before her retirement, this photograph shows the artist working on a vase. She holds the sharp tool for making incised lines in the wet clay; these lines were then filled with colour and the whole submitted to a single salt-glaze stoneware firing. Hanna Barlow had worked briefly at Minton's Studio in 1871 and when she joined Doulton's she was the first of many lady artists to be engaged by the firm. Trained under John Sparkes at Lambeth, she had a very personal, idiosyncratic style which was little affected by changing artistic taste; she specialised in so-called sgraffito work in the raw clay, depicting animals from memory. Many of her low-reliefs and terracotta sculptures of animals were shown at the Royal Academy during the 1880s. (PHOTOGRAPH: DOULTON & CO. LTD.)

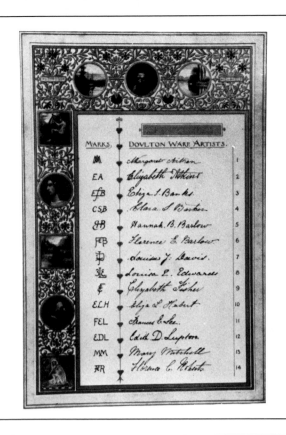

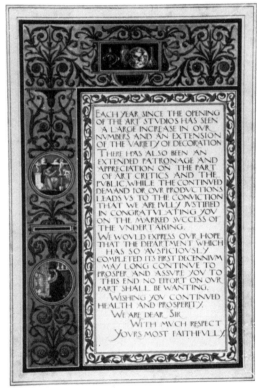

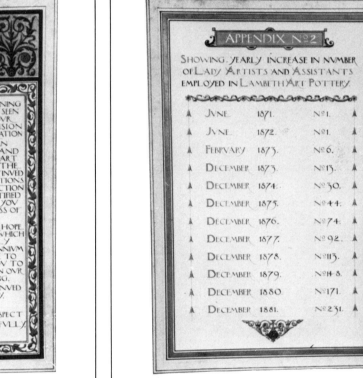

Top left: *Sample page from Presentation Volume I, 1882, showing the signatures and marks of the total of 228 ladies who signed the dedicatory letter, this first page containing many of the most famous of Doulton's lady artists.* (PHOTOGRAPH: COURTESY OF RICHARD DENNIS)

Above and top right: *Dedicatory letter from Presentation Volume I, 1882, given by the lady artists in his employment to Henry Doulton. The tone of the letter clearly indicates the paternal role adopted by Henry Doulton, and the element of philanthropy in his creation of work for women with their correspondingly self-effacing sense of obligation.* (PHOTOGRAPH: COURTESY OF RICHARD DENNIS)

Above: *Appendix 2 from Presentation Volume I, 1882, showing the yearly increase of lady artists and assistants employed in Lambeth Art Pottery from 1871 until 1881, the year the two volumes were compiled. Volume I included the dedicatory letter, the signatures and marks of all the lady artists and assistants then employed at Doulton's, appendices including a list of male artists and assistants (total twenty), the present growth chart, a list of awards obtained by Lambeth Art Pottery, and a list of distinguished visitors to the studios and showrooms of the pottery. Volume II contained vignette photographs of all but one of the lady signatories of Volume I, some of which are reproduced here.* (PHOTOGRAPH: COURTESY OF RICHARD DENNIS)

rose rapidly during the early years; Hannah Barlow was the only woman there for her first eighteen months, but after February 1873 the concern expanded to six, and by 1890 there were three hundred and forty-five lady artists and assistants at Doulton's. After Henry Doulton's death in 1897, when Lambeth wares were at the peak of their popularity, social changes and economic conditions necessitated a gradual decrease in production. Purely ornamental pottery was struggling against a shrinking market, as the crowded, cluttered rooms of the Victorian era gave way to the more restrained and functional interiors of the Edwardians. There was, however, no need to make women redundant at Doulton's; as artists left or retired they were simply not replaced, although some of the earliest to join were also the last to leave: Hannah Barlow in 1913 and Eliza Simmance in 1928. This decrease in job opportunities for women in china painting came at a time when other possibilities were at last opening up for women, and when rigid feminine rôles were being somewhat loosened, so that it did not create serious problems for those in search of dignified work. The Doulton Lambeth Art Pottery continued in production until 1956, and while staff numbers were minimal, the tradition of high quality women artists was maintained by such art potters as Vera Huggins and Agnete Hoy.

Few women were involved in the small craft or artistic potteries that grew up as a result of the Arts and Crafts movement; these potteries, such as that of the Martin Brothers who trained at Lambeth under John Sparkes, were run and staffed by men. In the Morris firm, during the early days, tile painting was in some cases undertaken and practised by women; Kate Faulkner, sister of the firm's partner Charles Faulkner, was involved in tile painting, but William De Morgan soon took over the ceramic section of the Morris output, remaining independent and setting up in workshops close to Merton Abbey in 1882, sometimes using female assistants. Women in English ceramic industries remained predictably at the level of decorators, and, before the advent of the studio pottery in the twentieth century, were rarely concerned with the production of pottery from raw clay to finished product. In other words, they were employed in potteries where a division of labour was practised, although on an artistic basis. But by the turn of the century individuals were emerging, like Dora Billington who trained at the Central School and later taught ceramics there, establishing a new and more completely integrated reputation for women potters.

Kate or Lucy Faulkner: Ceramic tiles designed and probably executed by 'Miss Faulkner'—possibly Kate rather than Lucy Faulkner—for Morris and Co., no date (early 1880s?). From a photograph reproduced by Lewis F. Day in 'William Morris and his Art', Art Journal Easter Annual, 1899, p. 19. Kate Faulkner and her sister worked for Morris, Marshall, Faulkner and Co., from its earliest days; their brother Charles was one of the company's founding directors. During the early years of Morris and Co. the firm produced all its own tiles, the blanks being imported from Holland and then painted by Charles, Kate and Lucy Faulkner; they were then fired in a kiln in the basement of 8 Red Lion Square. From the 1870s Morris worked in collaboration with the ceramicist William De Morgan, who gradually took over much of the tile production for the Morris firm, even moving his workshops to Merton Abbey to be near Morris in 1882.

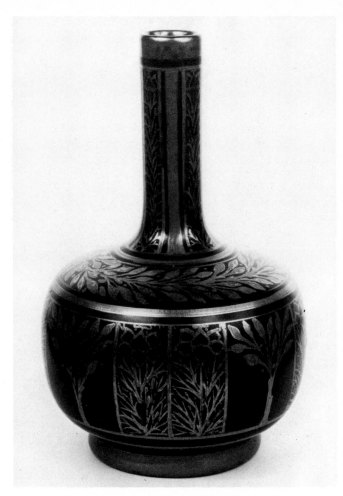

Gwladys Rogers: Vase decorated with gold, silver and ruby lustre on a dark blue ground, 1908, 5 in high, manufactured by Pilkington's. Gwladys Rogers was one of four lady artists who worked at Pilkington's, specialising in superb lustre glazes which unfortunately lose much in photographic reproduction. Their designs tended more towards restrained abstract geometry which exploited the glazes. A photograph of Gwladys Rogers at work is reproduced in Abraham Lomax, Royal Lancastrian Pottery 1900–1938 (1957), plate 31. (PHOTOGRAPH: FINE ART SOCIETY, LONDON)

Left: *Phoebe and Harold Stabler: Group of a boy and girl, stoneware, decorated with coloured glazes, 13¼ in high, 1916. Illustrated in colour in the* Studio *magazine, Vol. LXIX (1917), p. 75. Phoebe and Harold Stabler moved to their Hammersmith studio c. 1906, and this piece, designed and executed by them both, bears a painted mark of The Bull, Hammersmith.* (PHOTOGRAPH: FINE ART SOCIETY, LONDON)

Below: *Kate Faulkner: Dish, white-glazed earthenware, painted in dullish blue-green, with an impressed stamp of 'Pinder, Bourne & Co.'; made by Pinder, Bourne & Co., of Burslem, 1880, 17⅜ in diameter. It is clear from this example that Kate Faulkner did free-lance work in china painting outside the Morris firm, and other references to her working free-lance confirm it. Henry Doulton had bought a share in Pinder, Bourne & Co. in 1877, and then in 1882 entirely took over the Burslem firm. Kate Faulkner may at that time have been working indirectly or even directly for Doulton's, as some blanks made by and stamped with the Pinder, Bourne & Co. mark were decorated by Lambeth artists during these years.* (PHOTOGRAPH: VICTORIA & ALBERT MUSEUM, LONDON)

Edith Rogers: Three Doulton pieces. Left to right: jug, the silicon body painted with rust and blue, with a spray of white flowers growing from copper lustre and gilt tendrils, with assistant's monogram—Mary Davis, 1884, 7¼ in high; vase with incised blue flowers heightened with white, the ground over-glazed in dark grey, with assistant's monogram—Mary Aitkin, 1883, 7¾ in high; vase with finely incised blue flowering plants, the ground over-glazed in brown, with assistant's monogram—Emily Mayne, 1883, 8 in high. Edith Rogers was a versatile and original artist, perhaps best known for her finely incised, detailed work. (PHOTOGRAPH: COURTESY OF RICHARD DENNIS)

Above: *Louisa E. Edwards: Photograph from Presentation Volume II, given by the ladies in his employment to Henry Doulton in 1882.* (PHOTOGRAPH REPRODUCED BY COURTESY OF THE MINET LIBRARY, LAMBETH, LONDON)

Left: *Louisa E. Edwards: Salt-glazed Doulton ware vase with incised, impressed and applied decoration, in blue, brown, green and fawn tones, 1879, 11 in high. Louisa Edwards was one of the artists commended by John Sparkes in his 1880 Report to the Royal Society of Arts; her work showed the influence of Middle-Eastern conventionalised design and pattern.* (PHOTOGRAPH: DOULTON & CO. LTD.)

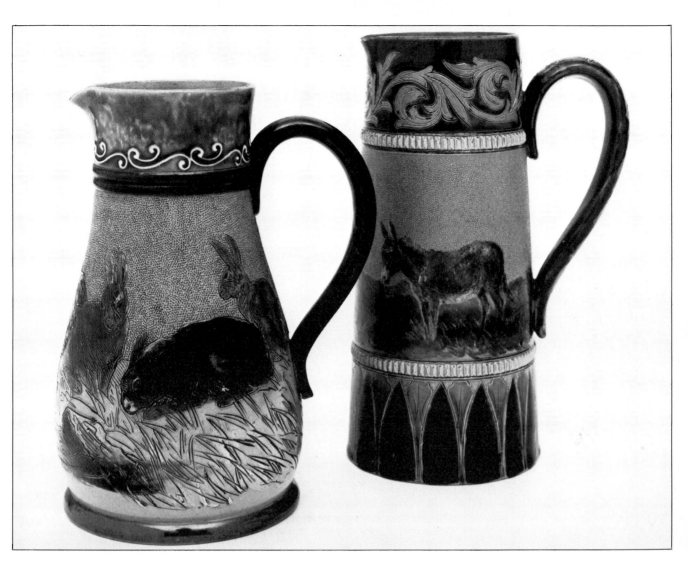

Above: *Hannah Barlow: Two salt-glazed Doulton ware jugs. Left: incised decoration of rabbits with stamped background and incised border, c. 1884, 8¼ in high; right: straight-sided jug incised with frieze of donkeys, incised stiff and flowing leaf borders, also has Lucy A. Barlow's monogram, c. 1884, 9¼ in high. Lucy Barlow worked only briefly at Doulton's c. 1882–4, and apparently only as an assistant adding decorative details and borders, often to her sisters' work. Hannah Barlow's best work is acknowledged to date from the 1870s and 1880s, when her hand and eye were freshest and her ideas most inventive; her style did not change with the times, but rather became stale and less powerful as she grew old. She worked for Doulton's for forty-two years.* (PHOTOGRAPH: DOULTON & CO. LTD.)

Left: *A monumental Doulton stoneware clockcase in shades of blue and brown with carved and incised details and applied bead work, the supporting cherubs moulded and glazed, the back with overall incised yellow and blue foliage on a lovat ground. Artist's monogram—JB, with assistant's monogram, Mary Thomson, 1879. 15¼ in high. Although 'JB' may be the monogram of Jessie Bowditch, it is more likely to be that of John Broad, one of the few male artists at Doulton's.* The artist would probably have been responsible for the overall design and the modelling of the cherubs, while the assistant would have worked on the decoration. Doulton's produced a number of clockcases, in addition to numerous domestic items.* (PHOTOGRAPH: COURTESY OF RICHARD DENNIS)

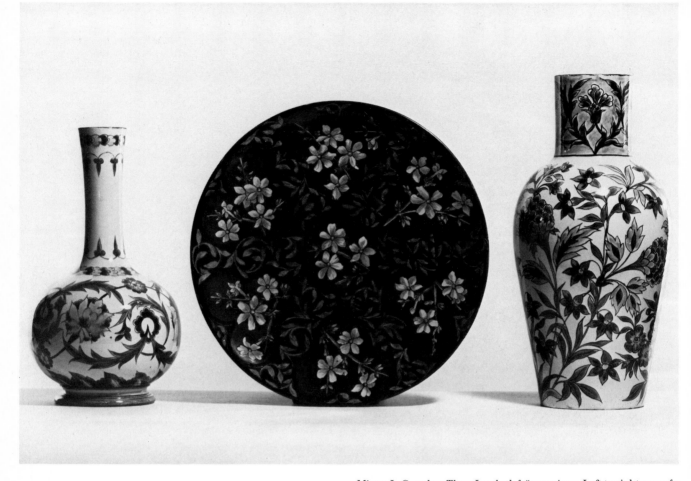

Minna L. Crawley: Three Lambeth faïence pieces. Left to right: *one of a pair of vases each painted in the Isnik style, with turquoise, blue and brown flower-heads on a cream ground, 1879, 11¼ in high; dish painted with yellow blossom on brown panels divided by blue bands with green foliage, diameter 12½ in; vase painted with purple, blue and brown stylised flowers on a cream coloured ground, 1877, 13½ in high. Lambeth faïence—an earthenware body in any colour other than white—was developed at Doulton's in 1872; while with the salt-glazed stoneware the painting was executed before the piece was fired, with faïence the decorations were painted onto the highly porous, biscuit-fired surface of the pot. Because of the limitations this created, excessive detail was avoided, and general harmony of colour and tone was the effect aimed at, although a wide variety of styles were used. John Sparkes wrote of Minna Crawley's work in 1880, '[she] has made an important section on her own. She early studied Persian and Rhodian ornament, and now produces these beautiful examples of similar style to the great originals just mentioned, with clear drawings and excellent colour and distribution'.* (PHOTOGRAPH: COURTESY OF RICHARD DENNIS)

Minna L. Crawley: Photograph from Presentation Volume II, given by the lady artists in his employment to Henry Doulton in 1882. (PHOTOGRAPH: MINET LIBRARY, LAMBETH, LONDON)

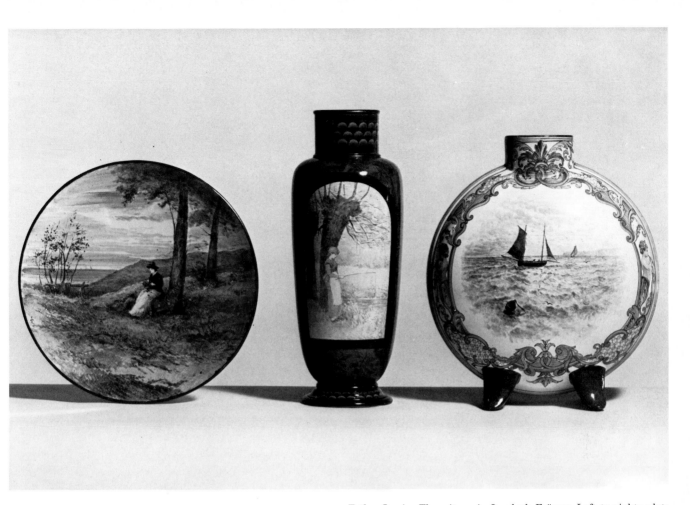

Esther Lewis: Three items in Lambeth Faïence. Left to right: *plate entitled 'On the hills', painted in polychrome, 1878, diameter 10¾ in; vase painted with a girl fishing in an arched panel, the green ground with rose sprays, 1883, 13 in high; flattened circular flask with four bracket feet, one side painted with a coastal scene by Esther Lewis within a border by Ada Dennis and Josephine Durtnall, the reverse with a renaissance panel by Mary Denley, 11¾ in high. Esther Lewis was one of the professional artists to exhibit regularly at Howell and James's annual exhibitions of china painting at their galleries in Regent Street; the* Magazine of Art *gave fulsome praise of her talents in 1884, although her work had not been shown since 1880; she created 'amongst the most notable effects in decorative representation of scenery by an English lady at these exhibitions . . . Works of this class have depended mainly on the genius of French china painters'.* (PHOTOGRAPH: COURTESY OF RICHARD DENNIS)

Esther Lewis: Photograph from Presentation Volume II, given by the lady artists in his employment to Henry Doulton in 1882. (PHOTOGRAPH: MINET LIBRARY, LAMBETH, LONDON)

Florence E. Lewis: A large vase in Lambeth Faïence painted with hibiscus and a startled jay on a yellow ground with blue foliate patterned borders, 1883, 29½ in high. This superb large piece provides ample evidence of Florence Lewis's skill and breadth of handling. In *addition to Lambeth Faïence, she worked in Crown Lambeth and Marqueterie, playing an important part in the development of these wares through her training of around seventy young women as painters.* (PHOTOGRAPH: COURTESY OF RICHARD DENNIS)

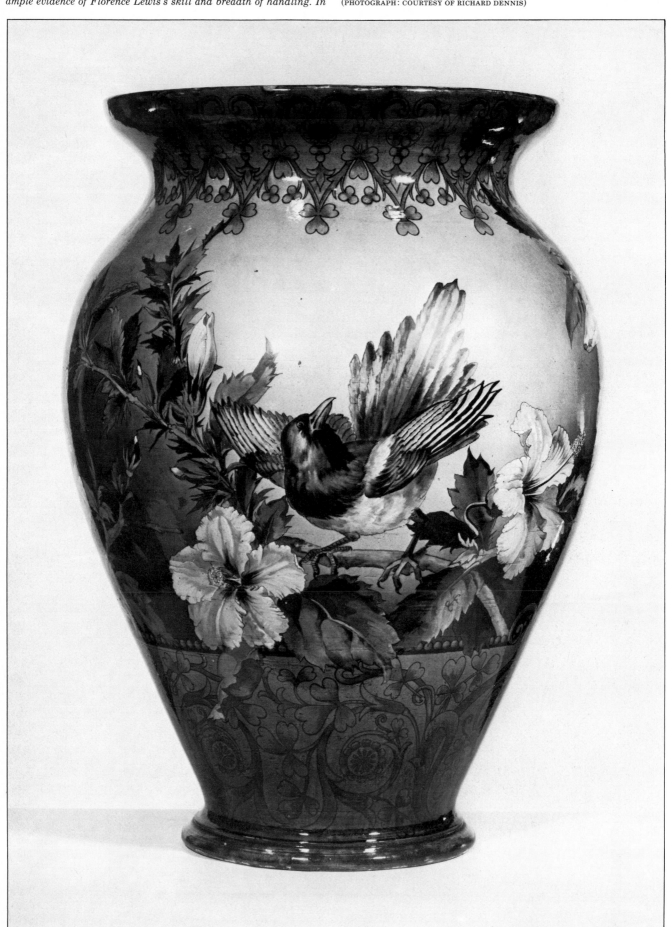

Linnie Watt: Photograph from Presentation Volume II, given to Henry Doulton by the lady artists in his employment in 1882. (PHOTOGRAPH: MINET LIBRARY, LAMBETH, LONDON)

Linnie Watt: A large framed wall plaque in Lambeth Faïence painted with a young woman wearing a blue costume and sitting in a rocky

landscape, painted c. 1876 and illustrated in a Doulton catalogue of that year, titled 'Lambeth Wares', 20 in diameter. Linnie Watt's work was widely exhibited and admired, particularly at the annual exhibitions of china painting at Howell and James's galleries in Regent Street. (PHOTOGRAPH: COURTESY OF RICHARD DENNIS)

Margaret E. Thompson: Two plaques and a vase in Lambeth Faïence. Left to right: framed plaque painted with a girl wearing a yellow robe and walking beside a yew hedge, reading a book, 10 × 15 in; one of a pair of vases each painted with two girls walking in a rose garden against a blue sky, 14 in high; framed plaque entitled 'Spring', represented by a girl wearing a yellow dress, running through a field of bluebells, framed by painted purple irises, 10 × 15 in. Margaret Thompson seems to have been at Doulton's between around 1889 and 1926; she specialised in painting mural tile panels with scenes inspired by legends, nursery rhymes and children's stories, often designed as mural decorations for

hospital wards. While the simple, restrained style of painting seen in the left-hand plaque clearly shows Margaret Thompson's links with the Art Nouveau style, thought to have its origins, in her work, in the illustrations of Kate Greenaway and Ralph Caldecott, the more flamboyant, sophisticated curvilinear style of 'Spring' shows stronger connections with European Art Nouveau graphics and poster art, examples of which were regularly to be seen on and inside the covers of Studio magazine. Margaret Thompson's work was itself shown in the Studio (see for example Volume XXIV, page 260). (PHOTOGRAPH: COURTESY OF RICHARD DENNIS)

77

One group of women to receive special commendation at the exhibitions of china painting at Howell and James' Galleries, was the Cincinnati Pottery Club. Critical appraisal in the *Magazine of Art* of 1884 emphasised that while the English ladies excelled in pictorial representations on china, they had much to learn from their American sisters in terms of pure decoration. One of the main criticisms directed at English women was that the amateurs in particular seemed unable to differentiate between the characteristics peculiar to ornamental decoration and those of picture making. Their work tended to ignore the indigenous qualities of the materials rather than enhance them; it was:

decorative in the sense of providing effective bits of decoration for a room, but not purely decorative in the sense of decorating pieces of china. The china has been treated mainly as a thing to be hidden, not beautified—as a piece of paper, in fact, or a canvas . . . [the] tendency of them has . . . been rather towards the pictorial than ornamental side, and in many works, especially in landscapes and figures, they have pushed as far towards the complete imitation of nature and the suggestion of human sentiment as the materials allowed.

The English ladies tended to create 'pictures' with light and shade and atmosphere, and showed little enthusiasm for the construction of flat ornament by the arbitrary arrangement of forms suggested by natural growth. Many of their works fell between the two, creating a hybrid which was neither picture nor plate.

The American women were from the start more seriously professional; they had much to teach the English women in the decorative treatment of china painting and in addition, they had 'proved that underglaze painting is not out of the reach of the amateur. The president of the [Cincinnati] club, Miss Louise McLaughlin, has, indeed, published a capital little book on the subject'.[50] In England underglaze painting and also conventionalised design had both been considered the province of the professional and an impossible sophistication as far as amateurs were concerned. The American women were far more adventurous in their approach to the art, and set out to prove that nothing was beyond them. Cincinnati was the major centre of early interest in art pottery and the decoration of china by women in America. As early as the summer of 1874, Ben Pitman (brother of Sir Isaac, inventor of the shorthand system) brought back to Cincinatti from the East Coast of America a number of china painting colours, and invited the lady members of his woodcarving class at the School of Design to participate in a china painting class. Marie Eggers, a young German lady who had learnt something of the craft in her native country, was hired by Pitman, out of his own pocket, to instruct them. The pupils were enthusiastic and the class expanded and became increasingly serious; the course was not intended to train working women for a career, but was specifically aimed at socially prominent women who wished to perfect a pastime, but which nevertheless in several cases inaugurated highly successful careers as ceramicists. Among the pupils at

M. Louise McLaughlin. (Photograph: from a reproduction in E.A. Barber, The Pottery and Porcelain of the United States, *1909)*

the start were Clara Chipman Newton and Mary Louise McLaughlin, daughter of the city's leading architect, who was to become one of the most influential and innovatory of the Cincinnati china painters.

At first only able to use the overglaze painting technique, the Cincinnati women were nevertheless sufficiently advanced by 1876 to decorate fund-raising china for a Centennial Tea Party; they were also ready to send a display of their work to the Women's Pavilion of the Philadelphia Centennial Exhibition later that year, where it was favourably received. In turn, this exhibition proved crucially influential for a number of women through its foreign ceramic entries, particularly that of oriental pottery which, although known in America, achieved wide appreciation through the Centennial Exhibition. Maria Longworth Nichols, the future founder of the Rookwood Pottery, while not herself an exhibitor, was strongly influenced by the Japanese exhibit, having already become interested in the art of the orient both through her husband and from some books of Japanese designs which a friend brought to her from London in 1875. The women, particularly Louise McLaughlin, were also impressed by the French barbotine ware, a type of underglaze painting with coloured slips that had been developed by Ernest Chaplet at Bourg-la-Reine and then used by him at the Haviland factory at Auteuil.

Soon after seeing the Philadelphia Exhibition, Louise McLaughlin began experimenting with underglaze

painting, searching for the secret of the Haviland method. She was already aware of the basic principles involved, and as early as 1875 had experimented with underglaze cobalt blue (similar to that used initially at Doulton's) on porcelain blanks fired at Thomas C. Smith and Sons' Union Porcelain Works at Greenpoint, Long Island. On the basis of this experience she formulated a theory, which while naive was not inaccurate, as to the technique used at Haviland. In fact she developed a method slightly different to theirs, which created some technical problems which she eventually surmounted. She mixed her mineral colours with an unfired clay slip used on a damp body, while at Haviland they used finely ground fired clay made into a slip and then applied to a thoroughly dry piece. It is significant in view of later disagreements about the origins of the underglaze technique in Cincinnati, that all the local potteries, including the Rookwood Pottery, used Louise McLaughlin's method rather than the French one, thus proving conclusively from whom it had originated. In 1877, having achieved her first success in underglaze blue using a stoneware blank from the Frederick Dallas Pottery, she pursued the underglaze faïence technique. Her experiments began in September 1877 at the P. L. Coultry Company, which produced commercial wares; she used a common yellow ware teapot without its spout and handle and she painted it while moist with her coloured clay slip. Although this piece was not a success, as when drawn from the kiln it was evident that the slip had been applied too thinly, it did establish that her technique could produce effects similar to those of Haviland. In January 1878 her first fully successful pieces were drawn. They appeared for the first time at the Women's Art Museum Association Loan Exhibition of that year, and then in New York and at the Paris Exposition Universelle, where she was awarded an Honourable Mention.

Louise McLaughlin's discovery rapidly attracted followers, and on 1 April 1879 she founded the Cincinnati Pottery Club, with herself as president and Clara Chipman Newton as secretary. Maria Longworth Nichols, whose invitation to join the Club apparently never reached her, felt herself snubbed and refused to join, thus starting a rivalry with the Club in general and Louise McLaughlin in particular which was to have lasting repercussions. Maria Nichols found her own working quarters at the Hamilton Road Pottery of Frank Dallas. Ironically, in the second half of 1879 the Cincinnati Pottery Club also moved to the Dallas Pottery, when Louise McLaughlin discovered that at her previous base, the P. L. Coultry Pottery, her secrets were being leaked and Mr Coultry had gone into partnership with Thomas J. Wheatley, who was claiming to have originated the underglaze method himself in New York in 1877. Despite the fact that he even took out a patent on the method in June 1880, no-one believed him, and there were records to prove that Louise had produced her underglaze decorated pots in the autumn of 1877, while his earliest pieces dated from April 1879. Following a fruitless attempt in the autumn of 1880 to prevent both Louise McLaughlin and Maria Nichol's Rookwood Pottery from using the method, he soon

M. Louise McLaughlin: Pilgrim jar, porcelain, 10⅜ in high, 1877. Painted with an underglaze slip decoration of a branch of rose blossoms in pink, black and grey. This piece was the first successful example of Limoges ware done in Cincinnati, executed in late 1877, and drawn from the kilns in January 1878; it was the result of Louise McLaughlin's experiments to discover for herself the Limoges underglaze technique. The jar was exhibited with the Cincinnati Women's section at the Chicago World's Fair of 1893. (PHOTOGRAPH: CINCINNATI MUSEUM OF ART, OHIO)

dropped his claim. Thus from the autumn of 1879 both women were using the Frank Dallas Pottery. The Club quickly discovered that the harsh fires of the 'granite-ware' kilns were fatal to the delicate underglaze colours, and Louise McLaughlin had a special kiln built to order at her own expense for the underglaze firing. Working quite separately from the Club, and not to be outdone, Maria Nichols (who was working with Jane P. Dodd) built a kiln for overglazed pieces, said to be the largest in the country.

Apart from Maria Nichols and Jane Dodd, and the women working in the Clubroom at the Dallas Pottery, many others sent their work to be fired there; they were not only from Cincinnati, but all over the state, and many came from miles away for classes. Work was sent from as far afield as New York, Kentucky, Iowa, Michigan, Indiana and Minnesota; their numbers totalled over two hundred, all but two of whom were women. The *Harper's New Monthly Magazine* recorded the popularity of the new art:

It is curious to see the wide range of age and conditions of life embraced in the ranks of the decorators of pottery: young girls of twelve to fifteen years of age find a few hours a week from their school engagements to devote to over or underglaze

work, or to the modelling of clay; and from this up through all the less certain ages, 'til the grandmother stands confessed in cap and spectacles, no time of life is exempt from the fascinating contagion. Women who need to add to their income, and the representatives of the largest fortunes, are among the most industrious workers; and it is pleasant to know that numbers of these self-taught women receive a handsome sum annually from the orders for work, from sales, and from lessons to pupils.[51]

Maria Longworth Nichols was the grand-daughter of 'Mr Longworth, one of the Fathers of Cincinnati, who founded the great Vine Culture of the Western States, and only daughter of Joseph Longworth',[52] who was a great patron of the arts in Cincinnati and whose money, gained in highly successful real estate ventures, was often freely given towards encouraging the spread of culture. In keeping with this tradition Maria, with a 'profound artistic sense, and that hardihood and daring conception which belongs to the New World ... determined to use her own gifts to start a beautiful industry that should be absolutely local'.[53] She had first

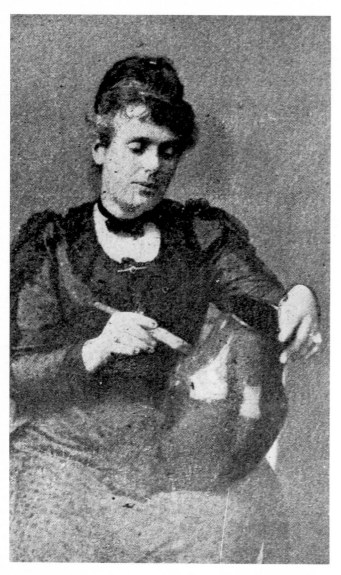

Maria Nichols at work. (Photograph: from an undated photograph reproduced in E. A. Barber, The Pottery and Porcelain of the United States, *1909)*

become interested in the art of china painting in the summer of 1873, when a young neighbour, Karl Langenbeck, who was later to become the first ceramic chemist in America when he was employed by the Rookwood Pottery in June 1884, received a set of china painting colours from an uncle in Frankfurt, Germany. Maria Nichols and another neighbour Mrs Learner Harrison, greatly taken with this new amusement, borrowed Langenbeck's colours until they were able to import their own. Maria Nichols began painting in the overglaze technique, and recalled later the importance of the Japanese influence, dating from the gift of Japanese design books in 1875:

This was almost my first acquaintance with Japanese Art of the imaginative and suggestive kind. It prepared me for the wonderful beauty of the Japanese exhibit at the Philadelphia Centennial Exposition of 1876. It was there that I first felt a desire to have a place of my own where things could be made; and I wanted to import a complete Japanese pottery, workmen and all. My father laughed at the impracticability of this undertaking when I proposed it to him—but the idea of my making pottery interested him.[54]

However, it was not until 1879 that Maria Nichols was able to begin working seriously and pursue her aims; in that year she heard that a lady was already painting in underglaze colours at the Dallas Pottery, using a high-fired 'graniteware' which necessitated a kiln heat sufficient for her own requirements. Thus she obtained permission to make experiments at the Dallas Pottery herself, and to have pieces made in the clay and fired for her. Like Doulton's in their early days of art pottery manufacture, she found it difficult to produce colours which did not disappear in the intense heat of the firing. But from the evidence of the large overglaze firing kiln which she had built for her, it is clear that she was also using that method of decoration at this time. Maria Nichols later recalled her early difficulties:

I was constantly discouraged by the fact that the hard fire of the graniteware kilns destroyed nearly every colour I used, except cobalt blue and black. Mr. Bailey ... added a dark green, and I found a claret brown that would stand the heat. Lastly we obtained a light blue and a light green: but we had no red and no pink or yellow, and the effects were cold and hard.[54]

Seeing her enthusiasm and her problems, her father offered Maria premises of her own, to be fitted out as she chose, and this was the beginning of the famous Rookwood Pottery, founded in the spring of 1880 and first in production the following November. Although Mr Joseph Bailey, Frederick Dallas' superintendent, refused to leave his employ through loyalty, he recommended his son, Joseph Bailey Jnr. who was hired by Maria Nichols to supervise the new venture; the old Mr Bailey nevertheless gave her much assistance and advice concerning the setting up of the pottery.

The advantage of her family's wealth, her father's sympathy and her own social standing meant that Maria Nichols was able to do what would have been impossible for most women of her time: to establish her own craft industry. Social restrictions on a lady's

The Rookwood Pottery, Mount Adams, Cincinnati, from an illustration in the Art Journal *of 1897. At first established in an old school house at 207 Eastern Avenue, by the 1890s the Pottery had moved to these new, spacious premises overlooking Cincinnati. The buildings seen in this photograph were later extended (compare the photograph reproduced in Paul Evans* Art Pottery of the United States, *1974, p. 255).*

pastimes were generally less rigid in America, allowing her more freedom, but again Maria Nichols' wealth held her above criticism, and her work could be seen as charitable both artistically and morally for she 'follows the traditions of her family in devotion to the well-being and advancement of her native place';[53] sentiments close to those used to justify the social work of moral rehabilitation expected of English middle- and upper-class women. However, such questions were not uppermost in Maria Nichols' mind; her principal object in starting the Pottery was, as she stated publicly, 'my own gratification'.[55] It is also evident that philanthropy in the provision of suitable employment for needy ladies was not a consideration in the foundation of Rookwood; even the provision of facilities for lady-amateurs waned rapidly. During the early years of Rookwood, the Pottery Club moved from Frank Dallas' premises and rented space there. Most of the early decorative pieces were produced by amateurs, and in October 1881 Maria Nichols started the Rookwood School of Pottery Decoration which offered classes in over and under-glaze painting and in carved and modelled work and which she intended to be a support to the Pottery, both financially and by providing trained and experienced artists. But it was soon evident that women who could afford the school's weekly fees of $3 would hardly then take up employment at Rookwood for the same amount in wages. The average weekly wage there was $5, but that was for men; women were usually paid at the lower rate. An exception was Maria's old friend and school-mate Clara Chipman Newton, who began work at Rookwood in April 1881 under the general title 'sec-

retary' at a salary of $27 a week. Her rôle was very much that of personal assistant to Maria Nichols, and she was also a talented decorator, having begun china painting in the first class under Ben Pitman in 1874. She undertook the School's classes in pottery decoration, while Laura Ann Fry, who was among the first full-time paid decorators at Rookwood, hired in 1881, taught modelling and Limoges work.

The Rookwood School had but a brief life; in 1883 Maria Nichols employed an old friend, William Watts Taylor, to take over the administration and organisation of the Pottery, and to set it on an economic footing. Prior to his arrival and for several years after, the venture was supported by funds given by Joseph Longworth. Taylor, who had little sympathy with the lady amateurs, felt that the School, with its over-generous discount on wares, was a waste of money, and closed it down after his arrival in the spring of 1883, with Maria Nichols' permission. Later that year, and similarly with Maria Nichols' consent, Taylor summarily evicted all the lady amateurs, including the Pottery Club, from Rookwood's premises. He did not intend the Pottery to be used as an 'outlet for genteel ladies with artistic leanings'[55] nor to nurture potential rivals, like Louise McLaughlin, under his very roof. His intolerance and high-handed methods caused much resentment among the women affected, and Clara Chipman Newton eventually resigned from Rookwood in 1884, her allegiances to both the Pottery Club and Rookwood proving incompatible. Taylor further hindered the growth of pottery as the women's craft it had begun as, by his attempts to replace the women decorators at the Pottery with men; and again Maria Nichols supported Taylor, as she was sure that Rookwood could not rely entirely upon women for its decorators. 'Replying to criticism from the ladies, she insisted that the opportunity was there, but there were simply not enough women with "the proper artistic ability and sufficient energy to come day after day and

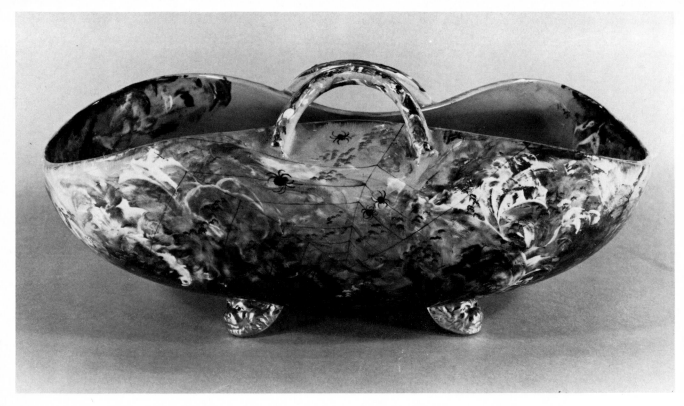

Rookwood pottery basket, executed by Maria Longworth Nichols, with a painted underglaze decoration of spiders in a web, in beiges, black and white, with gilt overglaze, 8¼ in high, 1882. Maria Nichols' early interest in Japanese motifs is seen in her use of typically Japanese spiders, dragonflies, and even dragons. The gilt lions' head, feet and the un-oriental basket shape indicate the stylistic eclecticism typical of the period. (PHOTOGRAPH: CINCINNATI ART MUSEUM, OHIO)

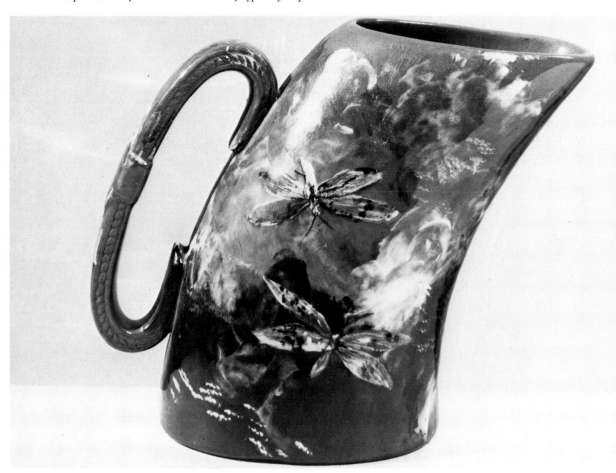

Clara Chipman Newton: Horn pitcher, with painted underglaze decoration of dragonflies (on the side shown) and bamboo branches (on the other side), in browns, blues, black and white, with gilt overglaze, 6½ in high, 1882. This pot was decorated while Clara Newton was working at Rookwood as the Pottery's secretary; it shows the influence of both the Japanese and the French (Rookwood artists were aware of the work by Emile Gallé at Nancy). (PHOTOGRAPH: THE BROOKLYN MUSEUM, NEW YORK)

do a day's work".[55] In fact, many of the decorators at Rookwood were women and some, like Laura Fry, were decisively important in their contribution to its development. However, they were cheaper to hire than men, and this was no doubt an important factor in Taylor's continued use of some women at the Pottery.

Until the exclusion of women amateurs from the Pottery, Maria Nichols had provided the women of the Pottery Club with their unfired pieces ready for underglaze decoration, and then fired them afterwards. Rookwood, like Doulton's, used skilled men for throwing and turning the wares, which was a separate activity from the decorating. When these facilities were no longer available, artists such as Louise McLaughlin were forced to return to simpler, overglaze methods of decoration, which thus simultaneously eliminated serious competition with Rookwood. From independent studio work mostly by amateurs, Rookwood developed into a professional firm of art pottery decorators which by 1889 had evolved a cohesive style and purpose. Its style emerged gradually during the 1880s and while a variety of different techniques were tried, the original Limoges-style ware, using Louise McLaughlin's underglaze method, held sway. The early grotesque Japanese-inspired motifs of dragons and serpents, so characteristic of Maria Nichols' first pieces, and the use of gilding, gave way to a simpler, more naturalistic treatment of plants and animals, while the underglaze painting process itself was further refined thanks to the inventiveness of Laura Ann Fry:

The painting, which at first was as coarse as the French ware, became suaver and more delicate. Most important was Laura Fry's introduction in 1883 [*sic* 1884] of an atomizer to create smoother color transitions for the background. This ware, which was to become known as 'Rookwood Standard', showed remarkably subtle changes from dark brown to orange to yellow and green, thus prompting the description of 'Rembrandtesque tones'.[56]

Prior to 1884 all the backgrounds had been laid in with the brush, which achieved nothing of the even subtlety of the atomiser. Laura Fry was both an employee at Rookwood and an original, honorary member of the Pottery Club doing independent work as well. Some of her work has similarities with that done in the incised line technique by Hannah Barlow at Lambeth. Laura Fry was one of the few women at Rookwood to design shapes as well as decorate them. She left the staff at Rookwood in 1887, although she continued to do occasional free-lance work for them. Following the advice of William Watts Taylor she applied for a patent on her atomiser, which was granted in March 1889. During the early 1890s she joined the staff of the Lonhuda Pottery in Steubenville Ohio, which will be discussed below.

It was only after the Rookwood Pottery received a Gold Medal in the Paris Exposition of 1889 that 'America awoke to the extraordinary merit of this beautiful "Home Art",'[57] but after that date the commercial success of the undertaking was guaranteed. With the exception of Kataro Shirayamadani, a Japanese artist who worked at Rookwood from 1889, by

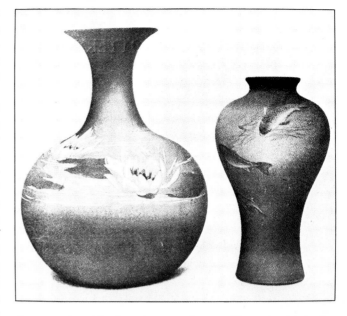

Two examples of Rookwood pottery, from an illustration in the Art Journal, *1897, p. 342: 'Waterlilies' and 'Fish' ('Sea Green'). The subtle background glazes on these superbly shaped pots would have been applied using Laura Ann Fry's airbrush; the Japanese influenced decorative motifs of waterlilies and fish would then have been painted on and the whole item glazed and fired.*

*Laura Anne Fry: Pitcher, Cincinnati Art Pottery Club. Incised decoration of ducks and waterlilies picked out in blue glaze, $8\frac{5}{8}$ in high, 1881. Laura Fry was both a member of the Women's Pottery Club and an employee at Rookwood. This piece, although executed on a Rookwood blank, was decorated independently, the style and shape imitating the type of stoneware being produced at the Doulton factory by women decorators such as Hannah Barlow.† (*PHOTOGRAPH: CINCINNATI ART MUSEUM, OHIO)

1897 all the artists there were American, and most of them had been trained at the Art Academy of Cincinnati. A thorough training and education in drawing were considered an essential supplement to basic talent before admittance to the Pottery, when a fresh education would begin. Maria Nichols herself emphasised:

The greatest artist living would only make daubs of Rookwood decoration unless he took time and infinite patience to learn the methods. Not only each colour has to be studied, but every dilution and every mixture of colours—making an endless multiplication of effects and possibilities.[58]

In addition to their training, some of Rookwood's artists were given paid leave to go to Europe and elsewhere for study and improvement of their work; it is not clear whether or not women artists were included in this scheme; obviously their safety and chaperonage would have presented great problems.

In 1885 her first husband, Colonel George Ward Nichols, died, and the following year Maria Nichols married the prominent Cincinnati attorney and rising politician Bellamy Storer Jnr., who had been one of the suitors for her hand in her youth. From that date her active interest in Rookwood began to dwindle, particularly since she knew it to be in the capable hands of William Watts Taylor. She maintained a studio at Rookwood for her own work and her researches were increasingly concerned with developing rich, lustrous glazes in copper-red colours. Her interest in Japanese motifs became more subtle and refined as she saw them no longer simply as a repertoire of painted monsters, but began to absorb the Japanese lesson in terms of a more sophisticated appreciation of the intrinsic values of colour and texture. In addition, by the late 1890s she started working in bronze, creating decorative objects, often as supports or additions to her pots, and it was more on these that she continued to exploit the dragon motifs. In 1900 she won a Gold Medal at the Paris Exposition Universelle for her pottery and metalwork. However, after her marriage to Bellamy Storer, Maria spent an increasing amount of time following her husband's political career, which included long spells abroad; but she found time to study painting at the Cincinnati Art Academy under Thomas Noble from 1887 to 1891, and in 1893 her work was shown in the Cincinnati Room of the Women's Pavilion. After her husband's election to Congress in 1890 they established a home in Washington D.C., and from 1897 she accompanied him to Europe where he was posted as ambassador in turn to Belgium, Spain and the Austro-Hungarian Empire.

By 1885 Mary Louise McLaughlin had abandoned her 'Cincinnati Faïence' because of lack of facilities. Frederick Dallas had died in 1881, and the majority of his skilled workers had been hired by the Rookwood Pottery, leaving the Pottery Club without the means to continue in underglaze work. During the following ten years Louise McLaughlin worked at overglaze china painting, and did some design work for the Kensington Art Tile Company of Newport, Kentucky. In 1893 the storm of rivalry with Maria Nichols Storer (as she now was) broke publicly, prompted by a description in the

Maria Longworth Nichols Storer: Vase with modelled decoration of three sea-horses, dark red glaze with slight iridescence, 7 in high, 1897. An example of Maria Nichols Storer's later work, when she had moved away from painted decoration to concentrate on relief decoration and increasingly subtle new glazes. (PHOTOGRAPH: CINCINNATI ART MUSEUM, OHIO)

M. Louise McLaughlin: Porcelain vase, Losanti Ware, c. 1903, 5 in high. Decorated with a modelled design of conventionalised leaves. After 1901 Louise McLaughlin began using carved instead of painted decoration, and her designs reflect an awareness of European Art Nouveau, although the quiet restraint with which she used the style reflects also her belief that it could not be followed without reason or moderation. The forms of her pots also became increasingly simple and classical, as this example shows. (PHOTOGRAPH: WORCESTER ART MUSEUM, MASSACHUSETTS)

catalogue of the World's Columbian Exposition in Chicago of the activities of the Cincinnati Pottery Club:

Miss McLaughlin, the President of the Club, is the discoverer of the method of decorating under the glaze that is still used as the foundation principle of the work at the Rookwood Pottery. The same method was used at the other Art Potteries of Cincinnati during their existence.[59]

On seeing this quite truthful statement, William Watts Taylor reacted quickly on Maria Storer's behalf, requesting its deletion from the catalogue on the basis that he felt sure that Rookwood was only indebted to Maria Storer for its methods. Feeling this to be a denial of her just due, Louise McLaughlin wrote directly to Maria Storer in support of her claim. An acid and belated reply from Maria Storer, who had been in Europe, made it clear that she had conveniently forgotten the early history of the Cincinnati underglaze method, and she refuted Louise's claim. In subsequent editions of the catalogue the paragraph quoted above was deleted, and it was not until amost fifty years later that the American Ceramic Society officially acknowledged the debt to Louise McLaughlin as originator of the method. It was only in 1895 that Louise McLaughlin resumed full-scale ceramic work, when she began testing a new method of decoration which she patented in 1894 and called 'American faïence'. This process involved the painting of a decorative pattern in coloured slips on the interior surface of a plaster mould, the vessel then being cast in a different coloured clay. When the piece was removed from the mould the design was embedded into its surface, producing an inlaid effect. Unable to control the whole process, she was forced to abandon this work as well.

Her third and most important process was begun in 1898, and was perhaps a development of interests inspired by the Porcelain League of Cincinnati, founded in 1894 by members of the disbanded Pottery Club. As with her earlier work she proceeded on an experimental basis, searching for a means to produce hard-paste decorative porcelain. Unwilling to be reliant yet again on others, she had a special kiln constructed at her home premises on Eden Avenue, Cincinnati. It was a long and difficult task: by 1900, when she had found a suitable body composition, no less than eighteen different ones had been tried and around forty-five accompanying glaze formulas developed. Although experimental pieces were shown at the Cincinnati Museum of Art in 1899, the most successful did not appear until 1901, when several were shown at the Pan-American Exposition at Buffalo, where they were awarded a Bronze Medal. Her new ware, which she named 'Losanti' after the original name of Cincinnati, Losantiville, was produced by a single high firing and was creamy-white and translucent. After perfecting the body, she concentrated on developing its decoration. One method she used to exploit the translucency of the body was to carve out the design in the clay and fill the openings with glaze, her range of which she expanded to include delicate blues and old-rose tints with touches of light green, almost bordering on a peachblow.[60] In 1906 she finally abandoned entirely her work in ceramics, devoting herself to other interests.

It is significant, by comparison to the English scene, that a large number of American women set up independently to explore the possibilities of art pottery. Two of the most important of these, apart from Louise McLaughlin and Maria Nicols Storer, were Adelaide Alsop Robineau and Mary Chase Perry. Most of these women began their careers as china painters and then became fully-fledged ceramicists as they delved more deeply into the secrets of the craft. Adelaide Robineau was no exception: she painted on china and taught the subject in Minnesota until her marriage to Samuel E. Robineau in 1899. In May of that year the Robineaus bought a magazine, the *China Decorator* in Syracuse, New York, which they brought out under the new title *Keramic Studio* (later *Design*). Through the editorship of this magazine, Adelaide Robineau became a prominent national figure. Soon, with the encouragement of her husband, she began making her own earthenware, and her earliest pieces were exhibited in 1901; by 1903 she was experimenting with porcelain. Her first pieces were mainly cast from moulds, but she soon began throwing all her own work, a comparatively unusual phenomenon among women potters at this date.

Her work after 1900 showed the influence of Art Nouveau ceramics, with a respect for conventionalised forms. In 1902 the Robineaus obtained a treatise on porcelain by the Sèvres artist Taxile Doat, who later came to the University City Pottery in Missouri with which Adelaide Robineau was associated after 1910. Samuel Robineau translated the treatise, which included detailed instructions for making the ware, and formulas for the porcelain paste and glazes, and this served as a basis for Adelaide's experiments in the medium, although she had to find compatible local materials for her own use. She took several weeks of classes under Charles Binns at Alfred University, New York, and then began to develop her own porcelain body and glazes suitable for high-fired ware. Her work was shown at the 1904 St Louis Exposition, where she exhibited hand-thrown and carved pieces decorated with unique matt glazes of a finish and texture only obtainable on high-fired porcelain. Later in the same year she showed brilliant crystalline glazed wares at the Art Institute of Chicago, with colours varying from blue to copper-green, yellow-brown and pearly yellow. The Robineau Pottery briefly attempted to mass-produce wares, but this proved both unsuccessful and dissatisfying, although between 1905 and 1910 they continued to produce porcelain door-knobs with a variety of glazes, which provided the economic mainstay for Adelaide's limited, original pieces. Her work was particularly renowned for its delicate incised decoration and superb glazes. She was especially proud of the matt examples, which by 1907 included soft browns, dark and light green, a dark blue, pale blue, orange-red, creamy white and black, some of which were difficult to control and came out streaked or brilliant.

In 1909 Taxile Doat came to America at the start of the new University City Pottery in Missouri, and the Robineaus joined him on the staff there. Some of

Adelaide Alsop Robineau: Porcelain lantern with reticulated and excised decoration, matt glazes of titanium, 8⅜ in high, 1908. Adelaide Robineau prided herself most on her minutely carved and modelled vases with matt glazes like the present example, for although she developed some brilliant crystalline glazes she perhaps felt her carved work to be more personal and individual. (THE EVERSON MUSEUM OF ART, SYRACUSE, NEW YORK STATE)

Adelaide Alsop Robineau: Poppy vase in porcelain with incised design and inlaid porcelain slip decoration, 6¼ in high. This example dates from 1910 when Adelaide Robineau was working at the University City Pottery; it was there that she and her husband Samuel E. Robineau perfected the technique of excising, and developed a glaze of semi-opaque texture which retained its translucence without being too brilliant. (THE EVERSON MUSEUM OF ART, SYRACUSE, NEW YORK STATE)

Adelaide Robineau's most important work was done in the eighteen months she spent there, including the famous Scarab Vase which took over a thousand hours of carving. Together they also evolved a new semi-opaque textured glaze which retained translucence without being too brilliant. The peak of her career was her exhibition of fifty-five pieces at the International Exposition of Decorative Art in Turin in 1911, when she was awarded the Grand Prize, the highest award possible. She also received the Grand Prize at the San Francisco Exposition in 1915 and was the same year appointed a medalist in the Arts and Crafts Society of Boston. The Robineau Pottery, in which she was assisted by Samuel Robineau in the preparation of glazes and in his supervision of the firings, never produced large numbers of pieces, but sought perfection in its limited output. Production declined during the First World War and in 1920 Adelaide joined the staff of Syracuse University to give instruction in pottery and ceramic design, and her kiln was given to the University and maintained by them. She continued with her own work, though on less complex pieces than previously, until a year before her death in 1929.

Mary Chase Perry was also a specialist in glazes, and 'Like Mrs Robineau, Miss Perry . . . made the important change from china painter to ceramicist. It was a step from talented lady painter (with its implied dilettantism) to professional craftsman—a challenge to which only a few rose.'[61] Originally from Michigan, Mary Chase Perry received her art training in Cincinnati and New York. She moved from china painting to clay sculpture and in Detroit borrowed the use of a neighbour's dental enamel kiln to fire her china. She and her neighbour, Horace Caulkins, together evolved a new gas-fired kiln which they sold under the name 'Revelation Kilns'. Among the formative influences in the development of her ceramic career was Charles Binns, with whom, like Mrs Robineau, she had studied briefly at Alfred University, New York. The collection of oriental pottery owned by her acquaintance Charles L. Freer, the Detroit millionaire, provided her with an excellent source of inspiration.

Until 1903, when she founded the Pewabic Pottery in Detroit, Mary Perry's work went under the name Revelation Kilns; it was initially a small concern, in which she was assisted by Horace Caulkins and one male thrower. Her early work displayed the influence of William H. Grueby, who was responsible for introducing matt glazes into American art pottery, and of European Art Nouveau ceramics, often through the intermediary of American exponents of the style such as Louis Tiffany. Her vases were decorated with conventionalised natural forms and matt glazes, but gradually her interest centred upon the effects of glazes, and of necessity the forms of her pots became simpler in order to show off the rich colours and lustres. In fact the major portion of her career, which ended only with her death at the age of 94 in 1961, was spent in exploring iridescent and lustre glazes. She evolved deep blues and burning gold, among many others, and her late work is characterised by subtle overlays of dripping colour and

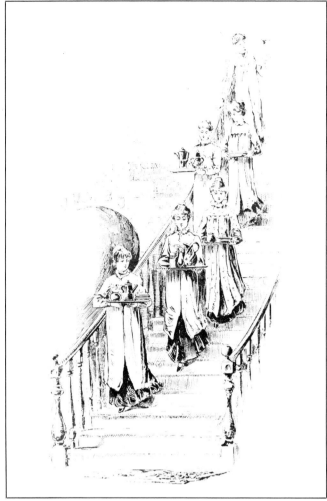

Left: *Mary Chase Perry: Pottery vase, Pewabic Pottery, Detroit, Michigan. Decorated with iridescent glazes in tones of gold, purple, grey and green, 10 in high, c. 1914. The rich, decorative qualities of Mary Chase Perry's glazed surfaces are sadly lost in black and white reproduction.* (PHOTOGRAPH: THE NEWARK MUSEUM, NEW JERSEY)

Above: *'Women going to stack a kiln', illustration from Susan Stuart Frackelton,* Tried by Fire, *1886, p. 69. The large numbers of women active from the first in the revival of art pottery in America meant that their pioneering role was taken for granted in a way not found in England, where they tended not to participate so fully in all stages of pottery production.*

a sparkling iridescence that made her glazes quite original for the period, and ensured her importance in the development of American ceramics.

The Frackelton Pottery of Milwaukee, Wisconsin, was established by 1883 by Susan Stuart Goodrich Frackelton. It was a substantial enterprise, employing professionally trained artists and with an average weekly production of from 1,500 to 2,000 pieces. She was the daughter of a brick-maker, and, like so many of her enterprising sisters, she trained as a china painter. Susan Frackelton's contribution to the history of American art pottery is of special interest because of her development of mineral painting, and her introduction of a portable gas kiln for china decorators. She is also known for her 'extensive experimentation with local Wisconsin clays and her work with high-fired stoneware, especially of the salt-glazed variety'.[62] By 1892 she had organised the National League of Mineral Painters, which aimed to foster a national school of

ceramic art, and to provide a link between china painters throughout the country. By 1900 the League had around five hundred members among whom was Adelaide Robineau. Susan Frackelton developed the Frackelton Dry Water Colours, gold and bronzes for painting on china, which were 'awarded medals by Leopold II, King of the Belgians, in the competition at Antwerp in 1894. Related to this was the publication by D. Appleton & Company, New York, of the enlarged third edition of Frackelton's *Trial by Fire*, which was copyrighted in 1885'.[62]

Susan Frackelton's china painting was awarded a Gold and Silver medal as early as 1881 at the International Cotton Exposition in Atlanta, and at the Columbian Exposition in Chicago in 1893 she showed her first art stoneware, and was awarded a Gold Medal. The salt-glazed pieces that she sent to Chicago were designed exclusively to show the quality of the local clay, and were not intended for commercial purposes,

although some art work was done commercially by her. Unlike in Britain, there was little work in America which used common salt-glazed stoneware for artistic purposes, and apart from some produced by the Graham Pottery, Susan Frackelton was the sole exponent of this type of ceramics in America. 'Her success demonstrated that salt-glazed stoneware need not be confined to utilitarian objects ... but could be fashioned into artware objects which could hold their own in any competition.'[62] Like the early work at Doulton's, Susan Frackelton used cobalt blue colouring, with incised and applied decoration. As with so many of her sister ceramicists of the period, Susan Frackelton had serious difficulties due to the lack of suitable facilities for her work, particularly for firing. By 1904 she had abandoned her pottery making and moved to Chicago, where she continued to give public lectures on a variety of subjects until her death in 1932.

The Lonhuda Pottery was mentioned above in relation to Laura Ann Fry, who joined the staff there in 1892 after working at Maria Nichols' Rookwood Pottery in Cincinatti. The Lonhuda Pottery was located at Steubenville, Ohio, and was founded by William Long, W. H. Hunter and Alfred Day, the name of the Pottery being formed from the first letters of their surnames. They began the production of artistic pottery on a large scale in 1892, adopting the use of the atomiser for the application of grounds which had been invented by Laura Fry in 1884. This type of ware became the standard line, called Lonhuda faïence, and because of its similarities was in direct competition with Rookwood's products. Because Laura Fry's method had been patented, there was an attempt in 1893 to stop the Rookwood Pottery using it; but the court case was greatly delayed and in 1898 ruled against Lonhuda, on the basis that although this was a new use for the particular tool, the process was not new. Nevertheless, Laura Fry's method was of crucial importance and was rapidly taken up almost universally in American potteries as the method for the application of both underglaze grounds and the glaze itself.

Although Laura Fry had left the Rookwood Pottery in 1887, she still did occasional freelance work for the Pottery. In 1891 she accepted the position of Professor of Industrial Art at Purdue University in Indiana. Between 1892 and 1894 she worked at Lonhuda, resettling in Cincinnati in 1894, and resuming her involvement in the ceramic movement there. The Porcelain League, an outgrowth of the Cincinatti Pottery Club, was organised at her studio on 10 January 1894, with Clara Chipman Newton as secretary. By the 1890s the intense public interest in the women's decorative arts movement, which had begun in Cincinnati in the early 70s, decreased very rapidly, and finding it more difficult to make a living as an independent artist, Laura Fry returned in 1896 to her post at Purdue University, and remained there until her retirement in 1922. Among the other artists at Lonhuda was Jessie R. Spaulding, who executed some of the Pottery's most outstanding work.

Several of the art potteries in America in this period had close links with local art schools; of particular note with regard to women were the Nashville Art Pottery,

Mary G. Sheerer: Pottery vase incised and painted with motif of iris flowers and leaves in tones of blue, cream, pink and yellow, with glossy glaze, 10¼ in high; blue glazed pottery stand 1¾ in high, 1898 (not shown). An early, unusual example of Newcombe College pottery; Mary Sheerer was design instructor there from the Pottery's inception in 1895, having trained at the Cincinnati Art Academy. Mary Sheerer's talents as a ceramic artist are clear from the simple, direct aptness of this conventionalised but empirically observed flower design. (PHOTOGRAPH: CINCINNATI ART MUSEUM, OHIO)

Nashville, Tennessee and the Newcomb College Pottery of New Orleans. The Pottery at Nashville was associated with the Nashville School of Art which was directed by Bettie J. Scovel, who went to Cincinnati in 1882 to observe the school there and also the Rookwood operation. In 1883 she took over the McGavock building in Nashville, which provided sufficient space for modelling, claywork, plaster-of-Paris and pottery work, and for a kiln. Early the following year the first kiln was fired, and in 1885 work expanded to include a pottery and a fireman to take on the heavy work. All the moulds and modelled forms were made by Bettie Scovel, and were noted for their artistic shapes; red earthenware was used first and later a white body, and as with so many of the American potteries, experiments with local clays were carried on. Up until 1888 a brown glaze was used, but in that year two original glazes were introduced: 'goldstone' was a rich dark brown glaze over a red body and had a brilliant golden appearance because of high firing; 'pomegranate' had a white body decorated with a red-veined effect on a mottled pink and blue-grey ground which was also produced by high firing.[63]

The Newcomb College Pottery of New Orleans was a particularly good example of American initiative in helping women in need of a career. William Woodward, an instructor in painting and drawing at Tulane University, New Orleans, was responsible for promoting this cause in the city; he led a women's pottery club, the Baronne Street Pottery, which was run by the women who decorated china, very like the Cincinnati Club. Out of this grew indirectly the Newcomb College Pottery. Newcomb was the women's college of Tulane University, and was founded in 1886; in 1895 a pottery was started there and William Woodward's brother Ellsworth was made its director. 'Operated in conjunction with advanced art and design courses, it was to serve as a laboratory where art and science could be blended and where students could obtain practical information as to a method of earning a living through the training offered.'[64] Mary Sheerer, who had trained at the Art Academy of Cincinnati and had been associated with the women who assisted in the development of the Rookwood Pottery, was appointed as design instructor and to supervise the women; she was herself a highly skilled china painter. As at Rookwood and Doulton's of Lambeth, the women were trained principally as decorators, while male specialists were hired to produce the wares for them. Joseph F. Meyer, the first of these, worked with Mary Sheerer to produce the Pottery's bodies, glazes and decorative methods during the early days.

The venture aimed at exploiting things indigenously Southern, as Mary Sheerer stated: 'The whole thing was to be a southern product, made of southern clays, by southern artists, decorated with southern subjects.'[65] Motifs used included magnolia, live oak, palm trees and wisteria. At first necessarily a modest enterprise, some of the materials were obtained from an abandoned porcelain factory, suitable clay was found at nearby Biloxi, and a simple kiln was built by them in part of a boiler room. The first decorators at Newcomb were 'girls working as undergraduates, who usually took their work home with them. They were basically artists applying decorations to ware made and finished by other hands. As the pottery developed it had a regular decorating group of about five women who worked at the pottery on a permanent basis, usually after their graduation from the school.'[64] But the character of the pottery changed after 1918, and from being a semi-commercial set-up it evolved into an educational laboratory in which graduate students could experiment, and where they were concerned with the entire creative process from start to finish, more in the style of twentieth-century studio pottery. Thus in its early period the Newcomb Pottery provided both a craft training and, for some women, employment after graduation, while in its later years it provided a specialist ceramic training for women artists.

Paul E. Cox, who was the ceramicist at Newcomb between 1910 and 1918, later recalled three of the most important of the Pottery's many women decorators:

Miss Sadie Agnes Estelle Irvine was the greatest of the decorators in the history of the enterprise. A prolific but less

Sadie Agnes Estelle Irvine: Pottery vase, Newcombe College Pottery, New Orleans. Decorated with a design of stylised blossoms in blues and greys with a semi-matt glaze, 6⅞ in high, probably after 1910. Sadie Irvine joined the Newcombe College Pottery some time between 1910 and 1912, and was one of their three most important artists. The Pottery's most stereotyped decorative motifs were the oak tree and the moon, both attributed to Sadie Irvine who recalled 'I was accused of doing the first oak-tree decoration, also the first moon. I have surely lived to regret it. Our beautiful moss-draped oak trees appealed to the buying public but nothing is less suited to the tall graceful vases—no way to convey the true character of the tree. And oh, how boring it was to use the same motif over and over and over, though each one was a fresh drawing (no Newcombe pot was ever duplicated unless the purchaser asked for it)'. Quoted in Paul Evans, Art Pottery of the United States, *p. 187.*
(PHOTOGRAPH: CINCINNATI ART MUSEUM, OHIO)

inspired designer was Miss Fanny Simpson . . . Miss Henrietta Bailey never gave all of her time to pottery decoration but more of her ware went into prize-winning shows than her general average of work would predict. These three women have been the 'standbys' of the Pottery.[66]

Women instructors after Mary Sheerer, who designed most of the Pottery's simple, soberly shaped vases, were Miss Juanita Gonzalez and Miss Angela Gregory.

The Pauline Pottery in Chicago, Illinois, and after 1888 in Edgerton, Wisconsin, was established by Pauline Jacobus, who began as a china painter giving instruction in her Chicago home. Her interest broadened to art pottery and she went to Cincinnati to study the workings of the Rookwood Pottery. In 1883 she began commercial production from a workshop in Chicago with one small kiln and only two decorators.

Pauline Jacobus: Covered jar, Pauline Pottery, Edgerton, Wisconsin. Light buff earthenware with clear glaze over handpainted decoration with some gold embellishment, 6¼ in high. (PHOTOGRAPH: STATE HISTORICAL SOCIETY OF WISCONSIN)

By 1886 the concern was sufficiently successful to open a second plant and, like many other art potteries, one of their retail outlets was Tiffany's in New York. The Pottery moved to Edgerton in 1888 to make use of the local clays there and to avoid having to transport clay from Ohio; the number of kilns in use by this date was six. During its busiest periods the Pottery employed about fourteen women to decorate art pottery. Underglaze painting was at first the most popular method of decoration, but Pauline Jacobus also produced a majolica-like ware. In 1893, the death of her husband coincided with the failure of his business and the Pottery folded as a result of the subsequent bankruptcy proceedings. It was re-formed the following year as the Edgerton Pottery; when this failed in 1902 Pauline Jacobus kept one of the original kilns and erected it at her home in Edgerton, where she resumed her work on a small scale with the help of summer student assistants. The bisque wares produced in the summers were then decorated during the winter by her and occasionally her daughter. After 1902 Pauline Jacobus was increasingly involved in experiments with low fired glazes on a near white body, producing crazed surfaces. She also worked at blending glazes, the best of which was 'peacock', a deep blue and dark green blend. The Pottery ceased production in 1909 and two years later Pauline's home and studio were destroyed by fire.

Three potteries involving women from after 1900 which should be mentioned are the Paul Revere Pottery of Boston, the Poillon Pottery, Woodbridge, New Jersey and the Overbeck Pottery of Cambridge City, Indiana. The Paul Revere Pottery, so called because of Revere's historical association with the area in which the

Pottery was established, grew out of the Saturday Evening Club or 'S.E.C.'. This Club was an association of young, mostly immigrant workers who, despite their Club's title, in fact worked an eight hour day at the Pottery. It 'not only furthered the artistic training of its young workers, but also used its financial rewards to complement their education in other areas'.[67] The Club's patron, who initially encouraged them to take up pottery and helped provide their first small kiln in 1906, was Mrs James J. Storrow; in 1908 they moved to new premises in Hull Street. There they had a four-storey building with clubrooms and a complete pottery, with an apartment on the top floor for the Pottery's director and designer, Edith Brown. The decorators worked to pre-established patterns, and most of their products were functional rather than ornamental. They were usually girls straight from school, who:

after a year's training were able to undertake the more skilled aspects of the work such as the incising of designs on the ware in the biscuit stage or the application of colors. It was intended that those who were interested in permanent work should also learn the potter's art—not only those aspects of it requiring skill of hand and ripe judgement in the management of materials, but those involving the chemistry and art of original designs both of form and decoration. Prior to 1915 a designer, two girls, one boy, a skilled potter and a man responsible for the firing of the kiln were employed.[68]

In 1915 the Paul Revere Pottery moved to a new building, designed by Edith Brown and given by Mrs Storrow, in Brighton, Massachusetts. From that date larger facilities created ideal conditions, and the number of workers varied from fourteen to twenty. Although its aims were successful, the Pottery was never a financial success and it needed heavy subsidies to remain in production. Nevertheless, its products were popular and highly acclaimed, mostly thanks to the work of Edith Brown. 'To Miss Edith Brown is due a large part of the credit for the quality of the work produced. A distinctive character has been maintained both in design and technique, and too high praise can scarcely be awarded to the wares.'[69] After her death in 1932 several directors followed, but none were able to solve the Pottery's economic problems, and it closed in 1942.

The Poillon Pottery of Woodbridge, New Jersey was established around 1901 by Clara Louise Poillon and Mrs Howard A. Poillon, and their first wares were shown at the December 1901 exhibition of the New York Society of Keramic Arts. Clara Louise Poillon was the central figure at the Pottery, producing a series of glazes which were considered a great accomplishment. The earthenware body used was decorated with her gold and orange lustres, matt and high-gloss glazes of which the blue, green and yellow were especially noteworthy. After 1904 the Pottery placed increasing emphasis on the production of ornamental garden ceramics and kitchen utensils, including inexpensive but well-designed tea and coffee pots. Clara Poillon retired in 1928 and died eight years later.

The Overbeck Pottery was opened in 1911 by four sisters of that name, Margaret, Hannah Elizabeth and

Elizabeth Gray Overbeck, photographed c. 1910? The Overbeck Pottery was established in 1911 by Elizabeth Gray Overbeck and her three sisters; she took charge of technical matters, including the development of glazes and clay mixtures, as well as the building and throwing of wares. (PHOTOGRAPH: AMERICAN CERAMIC SOCIETY, COLUMBUS, OHIO)

Mary, from their home in Cambridge City, Indiana. The workshop was in the basement and the studio on the ground floor while their Revelation kiln, made by the Pewabic Pottery of Mary Chase Perry, was set up in a separate building behind the house. Margaret, 'who had been an art teacher at De Pauw University, Greencastle, Indiana, died the year of the pottery's opening. She had studied at the Cincinnati Art Academy and at Columbia University under Arthur W. Dow. A keen student of china painting at the turn of the century, she received numerous awards in *Keramic Studio* competitions, in whose pages her designs can regularly be found.'[70] The second sister, Hannah, was an invalid for many years prior to her death in 1931, but she also produced designs for *Keramic Studio* and for decorating the Pottery's products. Elizabeth Gray:

studied ceramics in 1909–10 at the New York State School of Clayworking and Ceramics, Alfred [University], under the renowned Charles F. Binns. At the pottery she was in charge of the technical part of the operation, including the development of glazes and clay mixtures, as well as the building and throwing of ware. Overbeck work under her guidance was awarded an Honorable Mention at the 1934 Third Ceramic National Exhibition at Syracuse, New York; in March 1937, just nine months prior to her death, she was made a Fellow of The American Ceramic Society.[70]

The youngest of the four, Mary Frances, had like her sister Margaret been a student of Arthur Dow at

Columbia University, and she then became a public-school art teacher. Before the death of Elizabeth, Mary was in charge of the artistic side, but she then took over the entire production, although on a smaller scale. The pottery was acclaimed for the originality of its designs, particularly the hand-made products of Elizabeth Overbeck. Before here death two main types of decoration were in use there, glaze inlay and carving. The glazes developed by Elizabeth, which were at first of the popular matt variety and later brighter and glossy, included three of particular merit: 'hyacinth', 'turquoise' and a creamy yellow. The Pottery's production gradually decreased after 1936 until Mary's death in 1955, when it closed completely.

Two potteries were established at the beginning of the twentieth century in conjunction with centres for the treatment of early cases of tuberculosis in working women, aiming to combine occupational therapy with artistic but commercial pottery production. These were the Marblehead Pottery, New England, started by Dr H. J. Hall in 1908, and the Arequipa Pottery, founded on the basis of the success of the former, which was set up in Fairfax, California in 1911. The problems involved in reconciling the two aims of these potteries, particularly in view of the high turnover of patients which affected the standards of decorative work, proved insurmountable. At Marblehead a successful attempt was made to separate the pottery from the medical establishment, but at Arequipa the changeover was not successful and the Pottery remained linked to the sanatorium, finally closing in 1918. One of the early instructors at Arequipa was Agnes Rhead, wife of Francis H. Rhead; they both left the Pottery in July 1913. Despite the difficulties posed by these two ventures, they are interesting in their attempt to provide work for sick, wage-earning women, while at the same time training them in a new and no doubt useful skill.

NOTES

1. The Work Table: Women's Industries. Pottery Work and China Painting, *Queen*, 1 October 1887, p. 403.
2. See Desmond Eyles, *The Doulton Lambeth Wares*, London, 1975, Chapter 2.
3. *Select Committee Report on the School of Design*, 1849, evidence of Herbert Minton Esq., 16.5.49, p. 242, 2718.
4. *ibid.*
5. *ibid.* p. 248, 2800.
6. *ibid.* 2801–2805. Compare the discussion in Chapter 3, Embroidery and Needlework, where in mediaeval times gold thread work was the province of the men only.
7. Art-Work for Women I, *Art Journal*, 1872, p. 66. Contradictions in this writer's discussion at times allow for a more active female disposition, frustrated by inactivity; cf. II p. 102: women 'have yet to stand aside, watching an education of which no share comes to them; and, later in life, to sit idle at home, envying the activity which is denied them . . .'.
8. *ibid.*
9. *Art Journal*, 1876, p. 222.
10. Cosmo Monkhouse, The 'Royal Academy' of China Painting, *Magazine of Art*, 1884, p. 246.
11. *Art Journal*, 1876, p. 255.
12. *ibid.* The quotation marks used here for emphasis are in the original, indicating a certain awkwardness in referring to women as professionals.
13. G. W. and F. A. Rhead, *Staffordshire Pots and Potters*, 1906, p. 351.

14. Art-Work for Women, *op. cit.* p. 66. The lady artist mentioned here was Ellen Montalba, see illustration in *The Art Journal Catalogue of the International Exhibition*, 1871, p. 40.
15. Rhead, *op. cit.*, p. 351. This source gives the lease length as five years, while a contemporary source (*Art Journal*, 1872, p. 100) gives seven years. Rhead may be confusing the studio's duration with the lease period.
16. Minton's Art-Pottery, *Art Journal*, 1872, p. 100.
17. G. W. Rhead, who had worked in the Kensington studio, quoted in G. A. Godden, *Victorian Porcelain*, London, 1961, pp. 97–8.
18. Minton's Art-Pottery, *op. cit.*
19. *Art Journal*, December 1870, p. 381.
20. Minton's Art-Pottery, *op. cit.*
21. The Government School of Design, *Art Union*, 1848, p. 366; 'only recently an eminent artist has obtained from the school appropriate designs for porcelain . . .'.
22. Minton's Art-Pottery, *op. cit.*
23. *Art Journal*, 1887, quoted in Godden, *op. cit.*, p. 97.
24. Minton's Art-Pottery, *op. cit.*
25. Rhead, *op. cit.*, p. 355 and Eyles, *op. cit.*, p. 91.
26. These records are in the form of two presentation volumes given to Henry Doulton by the lady artists in his employment, on 26 April 1882 (now in the possession of the London Borough of Lambeth, Minet Library). Volume I contains the signatures and pottery marks of all the 'Lady Artists and Assistants of the Lambeth Pottery', and an enumeration of the increase in their numbers from 1871 to 1881, herein illustrated. The first date listed, June 1871, gives one lady artist, Hannah Barlow; the months cited in the list are not consistent, so there is every reason to believe that June 1871 was the first month in which Hannah was in permanent employment at Doulton's.
27. Rhead, *op. cit.*, p. 355.
28. *ibid.*, p. 362.
29. Quoted in Eyles, *op. cit.*, p. 27 (no source given).
30. *ibid.*, p. 89.
31. Quoted in *ibid.*, p. 91 (no source given).
32. Lady Artists: Miss Hannah Bolton Barlow, *The Lady*, 24 March 1887, p. 215.
33. Eyles *op. cit.*, p. 91. The information in Eyles concerning the Rogers is contradictory, p. 91 he cites a woodcarver W. G. Rogers; it seems safe to assume that the daughter who introduced Hannah to Sparkes was herself a student at Lambeth, and as a student of Sparkes and a daughter of a woodcarver it seems likely that she would end up working at Doulton's. An Edith Rogers is listed by Eyles (p. 103) and given as the daughter of a woodcarver, *Alfred* Rogers; the man in question must have been the renowned George Alfred Rogers, Artist in wood to Queen Victoria.
34. The Work Table: Women's Industries, *op. cit.*, p. 404.
35. C. Lewis Hind, quoted in Eyles, *op. cit.*, p. 92.
36. Quoted in *ibid.* (no source given).
37. Lady Artists: Miss Hannah Bolton Barlow, *op. cit.*, pp. 215–16. The date 1874 is given in error here, unless it is meant to relate specifically to her debut as an exhibitor; but since works by her were shown by Doulton's at the International Exhibition of 1871, this seems unlikely.
38. John Sparkes, On the Further Development of the Fine Art Section of the Lambeth Pottery, *Journal of the Society of Arts*, 12 March 1880, p. 350.
39. *ibid.*
40. Eyles, *op. cit.* p. 54.
41. Contemporary report in *Queen*, quoted in *ibid.*
42. Quoted in *ibid.*
43. *Art Journal*, 1876, p. 62.
44. Monkhouse, *op. cit.*, p. 247.
45. Eyles, *op. cit.*, p. 42.
46. Quoted in *ibid.* p. 55.
47. 1875 is sometimes given, but the *Art Journal* of 1876, p. 319, which carries the report, would suggest 1876.
48. Eyles, *op. cit.*, p. 55.
49. The Work Table: Women's Industries, *op. cit.*, p. 404.
50. Monkhouse, *op. cit.*, p. 242. The book by Louise McLaughlin referred to is probably her *Pottery Painting Under the Glaze*, 1880.

51. Quoted in Herbert Peck, *The Book of Rookwood Pottery*, 1968, p. 7.
52. Rose Kinsley, Rookwood Pottery, *Art Journal*, 1897, p. 342.
53. *ibid.*
54. Quoted in *ibid.*
55. Quoted in *The Ladies, God Bless 'Em*, Exhibition Catalogue, Cincinnati Art Museum, 1976, p. 12.
56. Robert Judson Clark, (ed.) *The Arts and Crafts Movement in America 1876–1916*, Exhibition Catalogue, Art Museum, Princeton University and the Art Institute of Chicago, 1972–73, p. 119. The date of 1883 for the invention of the atomiser by Laura Fry is a typographical error for 1884 which was made in Peck, *op. cit.*, p. 29, and repeated by writers since then; the correction is noted in Paul Evans, *Art Pottery of the United States*, New York, 1974, p. 141, p. 144 n.9.
57. Kinsley, *op. cit.*, p. 343.
58. *ibid.* p. 346.
59. Quoted in Peck, *op. cit.*, p. 47.
60. Information from Evans, *op. cit.*, pp. 147–8.
61. Clark, *op. cit.*, p. 173.
62. Evans, *op. cit.*, pp. 105–6 and p. 107.
63. *ibid.* p. 178.
64. *ibid.* p. 182 and 183.
65. Mary G. Sheerer, Newcomb Pottery, *Keramic Studio*, vol. 1, 1899, pp. 151–2; quoted in Clark, *op. cit.*, p. 144.
66. Quoted in Evans, *op. cit.*, p. 185.
67. Clark, *op. cit.*, p. 180.
68. Evans, *op. cit.*, p. 214.
69. C. F. Binns, evaluating pottery in America in *The American Magazine of Art*, vol. 7, February 1916, p. 135; quoted in Evans, *op. cit.*, p. 216. C. F. Binns was Director of the New York College of Clay Working and Ceramics at Alfred University, New York.
70. Evans, *op. cit.*, p. 203.

NOTES TO CAPTIONS

*See Richard Dennis, *Doulton Pottery*, Part II, 1975.
†Martin Eidelberg, 'Art Pottery', *The Arts and Crafts Movement in America 1876–1916*, 1972. This piece is discussed and illustrated in by E. A. Barber in *The Pottery and Porcelain of the United States*, 1893, pp. 282–3, and by K. E. Smith in 'Laura Ann Fry', *American Ceramic Society Bulletin*, Vol xviii, 1938, pp. 369–70 and p. 372.

3 Embroidery
and Needlework

Jane Morris and Elizabeth Burden: Three of the completed embroidered panels, embroidery silks on serge, made c.1860 as wall-hangings for the dining room at Red House. The design of the figures, based on Chaucer's 'Illustrious Women', has been variously attributed to William Morris and Edward Burne-Jones. These three panels have survived in the form of a screen which was made up for Lady Carlisle c.1880. (PHOTOGRAPH: VICTORIA & ALBERT MUSEUM, LONDON)

EMBROIDERY above all other crafts, was traditionally associated with women; an association at first maintained with pride and dignity at a period when the Opus Anglicanum was famed throughout the known world, it was gradually trivialised as the status of women changed in a rising capitalist society:

In the Middle Ages English embroidery was considered to be equal if not superior to painting and sculpture; the embroiderers (both men and women) played an important part not only in the cultural but also in the economic life of the country. As society 'progressed', embroidery became an almost exclusively female activity, and over the centuries this relationship has been mutually destructive. Embroidery suffered from being categorised as women's work. The same characteristics were ascribed to both women and embroidery; they were seen as mindless, decorative and delicate—like the icing on a cake, good to look at, adding taste and status, but devoid of significant content.[1]

The middle of the thirteenth century was a watershed in the history of English embroidery, for until that date it was mostly in the hands of women scattered about England; after then, as the importance of the product increased, its production became concentrated more and more in London workshops:

Recorded payments were no longer made to individual workers but to masters of workshops who were mostly men. Although the names of women do figure in royal records. There was Rose de Burford whose workshop embroidered a cope for Edward II and Mabel of Bury St. Edmunds who was commissioned to make a cope for Henry III. Both men and women sewed in the workshops, the women usually sewed the coloured thread and the men the gold.[2]

As with gilding in the ceramic trades, embroidered work with gold was considered a job carrying a particular status and was thus reserved for men; it was also very tough on the embroiderer's fingers. In addition to embroidery produced for the courts, the church was a great patron of the art, and many monks and nuns worked both at embroidery and illuminated manuscripts; after the Reformation put a stop to this, there was no marked activity in ecclesiastical embroidery until its renaissance in the nineteenth century.

At a period in English history when home and workshop were usually under one roof, there was no problem for women, who could participate in a trade while at the same time carrying on their domestic chores. Children were considered adult as soon as they were old enough to wield a needle, and their apprenticeship and education took place as they grew up in this workshop-home environment, where they played an active role in the family production unit:

Generally there were no frontiers between professional or business life and private life. These activities all tended to go on in the same living/working area. This integration of work and home contributed to the fact that it was not necessary to regard the socialisation of children as one of the most important functions of the family. Children were not seen as a special group—once they were past infancy they were absorbed into the adult household . . .[3]

However, the source of women's changing status and that of embroidery were already present in this pre-capitalist social structure, as Rosie Parker argues:

The root of embroidery's later history, I believe, lay in the class and sex division which existed amongst medieval embroiderers. Although both men and women worked in guilds and ecclesiastical workshops, amateur embroidery was the province of noblewomen. Queens from Emma, queen to King Canute, through to the 18th century Queen Anne have been dedicated embroiderers, making it an integral part of an aristocratic woman's existence. As England became a richer, more settled country under the Tudors, the wives of the wealthier merchant men began to imitate the lifestyle of the aristocracy, and there was a dramatic rise in the number of amateur women embroiderers.[4]

In the fifteenth and sixteenth centuries the expansion of trade led to many embroidery commissions from the new wealthy city companies, while at the same time merchant's wives were expected to reflect their newly-acquired status by a withdrawal from active trade participation, and increased leisure. While embroidery on the amateur level was thus increasingly encouraged among these women, their professional involvement in the craft was simultaneously discouraged. The greater demand for status-giving embroideries brought with it a stiffening of regulations concerning its production; 'in 1516 Elizabeth I re-founded the embroiderers' guild. All members were men.'[5] Among less wealthy landowners and farmers the productive employment of the needle by women was common until well into the seventeenth century; their talents were needed to clothe the family and provide household linen, but here embroidery as such played a minor rôle, and would only have been found on special items such as those for a woman's trousseau. Women in this social sphere were trained by their mothers in the art of the needle for purely practical, economic reasons, like the making of clothes and the embroidering of names and dates on the family linen, which was also often spun and woven by her.

During the eighteenth century, the agrarian revolution and enclosures brought about a commercial rather than domestic cultivation of the land. As a result the wives of new wealthy farmers sought a more leisured life in emulation of the upper classes, and at the same time developments in the textile industry relieved such women of many of their former duties in the production of household linens. Embroidery was taken up by them as a leisure activity and female accomplishment, at the same time as needlework ceased to be a productive employment in the home and indeed soon disappeared.

The woman's traditional needlework training began with the sampler, a small piece of canvas or linen on which girls of six or so practised a wide variety of stitches, making simple designs and usually letters and numbers. Many of the verses thus handed down to posterity reflect the moral training which girls received; others were gifts of friendship, or had religious, commemorative or political themes. Some expressed the frustration and misery of their executants: 'Polly did it and she hated every stitch,' 'Jane King will be happy

Sampler, dated 1848, a typical example by a young Victorian girl; moralising verses such as these were commonly given to girls to incorporate in their sampler, and formed part of the training towards a dutiful adult life. (COURTESY OF RUTH PAVEY, LONDON)

when Christ shall make her free,'[6] indicating that some girls fitted unwillingly into the rôle prescribed for them by society. The moralising most frequently evinced in sampler verses emphasises subservient obedience to family and God, and the importance of the worthwhile employment of time:

When I was young and in my Prime
You see how well I spent my time
And by my sampler you may see
What care my Parent took of me[7]

and:

Is there presumption in my heart
Search glorious Lord and see
Or do I act a haughty part
Lord I appeal to thee

I charge my thoughts be humble still
And all my carriage mild
Content my father with thy will
And quiet as a child

The patient soul the lowly mind
Shall have a large reward
Let saints in sorrow lie resign
And trust a faithful Lord.[8]

After completing her first sampler, the young girl's childhood was then 'structured by a series of embroidery projects'; Rosie Parker cites an education typical of the seventeenth century, but equally common later:

Aged 8 she finished her first sampler and signed it with pride, Martha Edlin 1668. It took her another year to complete her white work sampler, then she had to begin an embroidered casket which she signed in 1671. Her final task was to embroider a jewel box and she finished it in 1673, aged 13, when her training was considered complete and she set herself her own work.[9]

A critic writing in the *Studio* at the end of the nineteenth century, with the influence of the Arts and Crafts revival at his heels, was able to discuss the originality of many old samplers, which were in fact often based on earlier models with the motifs creatively rearranged. However, much amateur embroidery done by ladies as a pastime, particularly from the eighteenth century on, was greeted as unoriginal, and merely interpretative, and the term 'amateur' came to be synonymous with bad and tasteless workmanship, lacking in original creative thought. This was reinforced by the appearance in the latter half of the eighteenth century of magazines designed to provide ladies with ready-made embroidery patterns; this took one creative aspect of the work out of their hands, and one that was frequently considered the only original part of embroidery, the execution being relegated to a level of virtually mindless manual dexterity. Even Lady Marian Alford, an expert on needlework writing in 1886, had to struggle with herself to concede a small element of creativity to the executant of embroidery:

The individual genius of the artist works first in design, though his work is for the use of craftsman or artisan, his collaborator; for the two, head and hands, must work together, or else will render each other inoperative or ineffective. The artisan, by right of his title, claims a part in the art itself; the craftsman, by his name, points out that he, too, has to work out the craft, the mystery, the inner meaning, of the design or intention.[10]

This split between 'head and hands', so common since the gradual introduction of a division of labour in craft industries, and so customary in particular in Victorian attitudes to applied art, was one which writers from Ruskin on had sought to diminish in their advocation of a good artistic training for artisans and a good practical training for artist-designers. In practice this split often turned out to be a division on sexual lines, with man as the 'individual genius', the designer, and woman as the 'hands', the executant of the designer's ideas. This fitted perfectly with contemporary notions of women as irrational, mindless creatures incapable of thought, and reinforced the position of men in the creative, dominant and active rôle. Despite attempts by men such as William Morris to close the gap between designer and executant, and to reinstate pre-capitalist integrated labour, where one person or communal effort saw the creation of an object in its entirety, from start to finish, in practice it proved difficult in all but the most small-scale ventures.

The imitation of the aristocracy by the new middle classes, which had first caused the rise of the amateur embroiderer 'took on new dimensions in the late seventeenth and eighteenth centuries. Embroidery totally dominated middle-class women's lives, it became more of a sexual characteristic than a craft. "It is as scandalous for a woman not to know how to use a needle as for a man not to know how to use a sword," wrote Lady Mary Wortley Montague.'[11] Although many women of necessity continued to work as professional embroiderers, it is not always clear whether or not they come from the middle classes. One clear-cut case is that

of Mary Lamb, wife of Charles Lamb, who worked for eleven years as a professional embroiderer:

In 1815, she submitted an extraordinary article, *On Needlework*, to a women's magazine. Ostensibly discussing embroidery, she wrote a stinging comparison of men's and women's lives and work. Women, she said, should embroider for money or not at all, only then would they see their work as 'real business' and allow themselves 'real leisure'. Moreover, by embroidering for love women were taking work away from professional embroiderers, and embroidery was the only employment open to women.[12]

As we have already noted, for a lady to accept payment for her 'work' meant a loss of status unacceptable among the middle and upper classes in the nineteenth century, so the view put forward by Mary Lamb was radical for that date. But for most Victorian ladies destitute or in need of financial support, embroidery represented one of the few feasible outlets for which they had any training; thus she had to ply her needle and sell her work in secret if her name was not to be dishonoured.

The revival of artistic embroidery in the second half of the nineteenth century, which came in part as a reaction to the machine-made product, stimulated by the efforts of the Morris family, and in part as a side-effect of the religious revivals, had a complex effect on women involved in the craft. On the one hand it provided a much-needed avenue for ladies seeking an income, but on the other it prompted an overwhelming response which flooded the market with hand-embroidery, often causing prices to drop, and certainly causing standards to rise. While the latter was not a bad thing, it nevertheless pushed many inadequately trained and helpless women out of the market.

According to one source in 1859, machine embroidery had not taken the place of hand-made, but:

Contrary to what might have been expected, the production of these machine embroidered trimmings stimulated a general interest in embroidery to such an extent that the demand for hand embroidery increased. In 1849 in London there were apparently 2,000 people obtaining their living by embroidery who had not done so before, and in Scotland and the North of Ireland some thousands of females were employed not in factories, but in their own homes as outworkers.[13]

The writer here is of course referring to lower- rather than middle-class women, and the hand embroidery involved was not art embroidery but repetitive copy work, embroidering stamped designs of sprigs and borders on machine-made point net or muslin, work which machines could not then do. In fact this type of embroidery, done by women outworkers, was one of the worst kinds of sweated labour; they were no longer within the supportive, productive family unit of earlier centuries, but simply over-worked, under-paid and isolated in a way which made it impossible for them to organise themselves and agitate for better pay and conditions. The only way to earn a reasonable wage at this trade was to be a pattern setter or designer, and this was always a man's job. The women's low wages were further reduced by the number of middlemen involved, work being given out at the warehouse to mistresses or agents who not only employed young women in their homes, but also gave it out to others in neighbouring villages, so that work often passed through several hands with each extracting their profit, and leaving little for the actual embroiderer.[14] In some cases women worked in a group, paying children 1d a week to keep their needles threaded and speed up their work.

This division between male designers and female embroiderers was already apparent in the earliest developments of the trade; for example: 'In 1798 an Italian named Luigi Ruiffini set up a workroom in Glasgow where girls of 6 or 7 years old embroidered flowers on muslin while young male apprentices were sent to train as pattern drawers at the Glasgow Trustees' Academy of Design.'[15] Although it was during the nineteenth century that children really began to be treated as a special group separate from adults, most working-class children continued to work until well into the twentieth century. Despite the shocking findings of the Children's Employment Commission in 1843 and the few attempts by women embroiderers to improve their own lot, conditions remained unchanged; but hand embroidery was gradually eliminated as more sophisticated machinery was invented.

By contrast to the situation of working-class women, destitute women of the middle classes received an extraordinary amount of attention and organised assistance during the nineteenth century. The alternatives for both classes were not dissimilar: inadequate wages or no work when it was needed usually resulted in prostitution for either class of women. But for the Victorian worthies, the plight of the 'decayed gentlewoman' was more immediately under their noses; she:

attracted a great deal of sentimental interest and inspired considerable charitable effort. It was not that governesses were the most numerous or the most depressed class of women workers in the country, but unlike women workers in factories and fields, they were highly 'visible' to the middle and upper classes, being familiar figures in their own homes.[16]

While this particular discussion refers specifically to the problem of governesses, it is equally true of needy gentlewomen in general; there was hardly a family which did not have a lady relative who was forced to support herself, and was thus a constant reminder to the family of its own insecurity and potential downfall. In these circumstances charitable concern and provision for gentlewomen were both a practical and psychological protection against similar distress befalling every middle-class household.

As has been noted, one of the greatest difficulties faced by ladies attempting to find remunerative employment was the inadequacy of their education in fitting them for a career, and the limited means available for obtaining a suitable training. In the field of artistic embroidery, much effort was put into augmenting the average lady's childhood instruction to raise it to professional standards. While embroidery as such does not seem to have been taught at the Female School of Design in its early years, designing for both lace and embroidery was common there:

Royal School of Art Needlework: Students and workers in the studios of the custom-built premises of the School erected on the corner of Exhibition Road and Imperial Institute Road in 1903; the photograph dates from the 1920s. (PHOTOGRAPH REPRODUCED BY COURTESY OF THE ROYAL SCHOOL OF NEEDLEWORK, LONDON)

'We believe we are correct in referring for instance to . . . a lace-scarf by Urling & Co., and an altar-cloth by Reginald Cox Esq. [designed by students of the Female School and exhibited at the Great Exhibition of 1851; and] the designs for cards, lace and porcelain show an elegance of taste, which, not many years ago, would have been hopeless to expect even from persons who professed themselves to be practised designers'.[17]

Up until the 1890s most government Design Schools taught only the theoretical aspects of design, and not the practical side. The London County Council Minutes for 1906 indicate that by 1905 both practical embroidery and lacemaking were included in the curriculum of the Female School, but that low attendances for these classes (an average of three and four girls) caused them to be abandoned at Easter 1906. It is likely that more demanding courses were available elsewhere by then, for example those at the Central School of Arts and Crafts.

The most important early institution for the training of ladies in professional secular embroidery was the Royal School of Art Needlework, which was founded in the autumn of 1872 'under the presidency of H.R.H. Princess Christian of Schleswig-Holstein and an influential committee of ladies for the two-fold purpose of supplying suitable employment for gentlewomen, and restoring ornamental needlework to the high place it once held among the decorative arts.'[18] Among the founders was Lady Welby, herself an accomplished embroiderer, who:

had the courage to face all the difficulties of such an undertaking. A small apartment was hired in Sloane Street, and Mrs Dolby, who was already an authority on ecclesiastical work, gave her help. Twenty young ladies were selected,

and several friends joined heartily in fostering the movement . . . The School grew so fast, that for want of space for the work frames, it had to remove into a larger house, No. 31, Sloane Street, and finally in the year 1875 it found its present home in Exhibition Road, when the Queen became its Patron. In 1878 the Association was incorporated under the Board of Trade, with a Managing and Finance Committee, and a salaried manager to overlook the whole concern.[19]

From 1875, between a hundred and a hundred and fifty ladies were employed at the School; 'their claims were poverty, gentle birth, and sufficient capacity to enable them to support themselves and be educated to teach others.'[20] An article written ten years after the School's foundation for the *Magazine of Art* described the workings of the School and its successes:

The first purpose of the founders—that of providing suitable employment for gentlewomen—has been accomplished to a very great extent. A hundred and twenty ladies on the average are constantly employed in the School; some in embroidering, some designing patterns, some in drawing the patterns on material, and thus preparing work for amateurs; others in making up the finished work for sale at the school, others in selling the work and materials in the show-rooms, others as clerks, book-keepers, and so forth. The regular course of instruction at the school—which costs the learner £5— consists of but nine lessons of five hours each. At the end of

this course the learner is considered a 'qualified worker of the school', and may 'under the direction of the lady manager', take her place in the large and well-lighted work-rooms at the back of the show-room, where the workers are expected to sit at their frames for about seven hours a day. No applicant is admitted to the course of instruction until there is a vacancy.

One of the most useful sources of information concerning the School is the Report presented by the Vice-President, Lady Marian Alford, to H.R.H. the President and Council in 1875. The degree to which women's welfare was their concern was shown by their choice of printer—The Ladies Printing Press (for the Tuition and Employment of Necessitous Gentlewomen). In her report, Lady Alford described the progress of the school: 403 orders had been received in the executive department that year, and 1,065 re-orders had been prepared in the work department. Work had been sold to the value of £1,382 while the guarantee fund, or capital, stood at £4,300; at the beginning of 1875 there were 88 workers and 12 staff in the school, but by the end of it numbers had risen to 110 workers and 20 staff. The School itself consisted of four main departments, with a Head of Department and a Forewoman or Assistant in charge of each. The first department was the large general workroom, where an 'accomplished lady over-looks the execution of varied work in all materials and styles from the most delicate to the most effective'. The second department was devoted to appliqué and gold work, under the supervision of a lady 'who has learned her craft in the best Foreign Schools'; the third was the 'Artistic Room' which specialised in embroidery in crewels from the most eminent designers, such as Burne-Jones, Morris and Crane. The last and most financially successful department was that concentrating on the preparation of work to be completed by amateurs in their own homes; here ladies were busy composing, altering, tracing and pricking the designs.

In 1875 a Higher School of Art was formed within the Royal School of Art Needlework, where lady workers were advised and instructed by prominent artists like Lord Leighton, Val Prinsep and the architect G. F. Bodley, who had commissioned ecclesiastical embroideries from the Morris firm as early as 1862. In addition to the workrooms, the school possessed a large, permanent showroom where examples of all the different types of embroidery by the school could be viewed by the public. The 1875 report noted a satisfactory development in this respect: 'Mr. Norman Shaw's show-rooms will shortly be connected with our show-room by a passage. He has promised to employ the embroideresses of our School, for his decorations, and will grant us the use of his Show-room, for our Council to sit in, with closed doors.'[21] As at Doulton's of Lambeth, the facilities provided for the lady workers at the South Kensington School were good: 'Besides several comfortable and airy work-rooms, there is a kitchen and refreshment room, and a small room where any over-tired worker may rest in a comfortable chair, and refresh herself with a book from the library or a cup of tea from the kitchen.'[22]

It was a principle of the School to try to provide

Miss Nellie Whichelo, designer, in the design room of the Royal School of Art Needlework, circa 1890. (PHOTOGRAPH REPRODUCED BY COURTESY OF THE ROYAL SCHOOL OF NEEDLEWORK, LONDON)

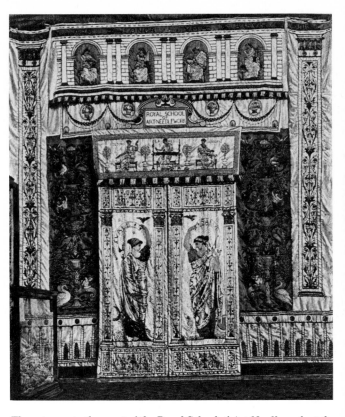

The entrance to the court of the Royal School of Art Needlework at the Philadelphia International Exhibition of 1876, designed by Walter Crane and worked by the School; from an engraving illustrated in the Magazine of Art, *1880. The School's exhibit of art needlework in Philadelphia had a profound impact on American needlewomen, and stimulated the beginnings of the art needlework revival there.*

constant and regular employment for its staff of qualified lady workers; even during holiday periods work was often given out to them to do at home. While staff not doing embroidery were recorded as being paid weekly and their salaries were continued throughout the vacations, there is conflicting evidence concerning the payment of embroiderers. The *Magazine of Art* for 1882 stressed that embroiderers were paid by the piece and that their earnings thus depended upon individual industry; another source by contrast states that their rates of payment 'varied from tenpence an hour for the most skilled work to fourpence an hour for the least skilled.'[23] Thus wages for a seven-hour, five day week would have amounted to £3.10s. (£3.50) for the most skilled, down to £1.8s. (£1.40) for the least skilled, making their income greatly above the national average and above even the highly-paid Morris and Co. embroiderers (see below). Perhaps the School aimed to maintain its workers in a style suited to their station. The seven-hour day was unheard of in industrial circles (it still is), and was evidently a concession to the ladies, whose eyes it was thought would not be able to stand the strain, which indeed often blinded their poorer working-class sisters.

In addition to designs produced by the women themselves, the embroiderers were frequently provided with large prestige designs by such artists as Edward Burne-Jones, William Morris, Walter Crane and Selwyn Image. This link may well have been forged by the presence of Elizabeth Burden, sister of Morris' wife Jane, as a teacher at the School during the 1870s. Elizabeth Burden was responsible for introducing into the School a special variety of cushion stitch which she had used in the unfinished Red House dining room figure, and which was used for the large figure panels designed by Walter Crane for the School's exhibit at the

The Showroom of the Royal School of Art Needlework when it was situated at the Albert Hall end of Exhibition Road, in temporary premises originally built for the International Exhibition of 1867. The photograph, which probably dates from the 1880s, includes a spinning wheel in the left foreground; spinning and lacemaking were taught at the School as well as all types of embroidery. (PHOTOGRAPH REPRODUCED BY COURTESY OF THE ROYAL SCHOOL OF NEEDLEWORK, LONDON)

Philadelphia Centennial of 1876, which were worked at the School under her direction. Philadelphia was the first major showing of the School's work, and £2,000 was spent in preparing it, with designs from Morris and G. F. Bodley also included. The School's special pavilion measured about twelve feet square, and each wall was hung with embroidered panels, while the doors had portières and the windows curtains on both sides. Walter Crane's designs were for figure embroideries representing Music, Painting, Architecture and Poetry, and a valance showing the Three Fates: Clotho spinning her thread, Lachesis at her loom and Atropus wielding her spears. Lastly, two allegorical figures, of 'Salve' and 'Vale' and some arabesque panels in green and gold completed the set of hangings, all of which were worked in crewel wools. Bodley contributed a set of mediaeval designs of roses and leaves worked in silk with appliqué borders in dull red silk and velvet. The most costly designs were from Morris: 'The dado-hanging is a deep band of dull green, over which runs a well conceived vine pattern, in which the bunches of fruit, the leaves &c. are so deftly mingled, that while each part retains its individual vigour, it contributes largely to the general harmony. Gorgeous peacocks spread their feathery glories among the vines and their brilliant hues relieve the work of undue sombreness'.[24] These hangings, worked entirely in silk, cost £50 a square yard. Other designs by Morris included an

elaborate book-case curtain executed by the Hon. Mrs Percy Wyndham, and curtains based on a design for his 'Honeysuckle' chintz. H.R.H. Princess Christian, the School's President, exhibited a screen embroidered by herself and based on a design which was Japanese in character. The huge success of this exhibit, which was given the highest possible award, a Certificate of Award, justified the time and expense involved in its preparation; it marked, through its influence, the beginning of the revival of the craft in America. The International Exhibition in Paris two years later saw a further display of the School's work, which was again well received, and achieved for them a Silver Medal.

Despite the example of the famous craftsmen who provided designs for the School, it was nevertheless criticised for its excessive use of floral designs:

those who visit the School year after year grow weary and depressed over the monotony of the designs. Honeysuckles and roses, lillies and irises, sunflowers and daffodills are assuredly a goodly sight in themselves; but is it not just possible to get too much of their portraits worked no matter how faithfully on tissues however exquisite? We shall, no doubt, be told there is a greater demand for floral designs than for any others; but a School of Art-needlework professing high aims should do its utmost to educate and enlarge the public taste by a constant supply of new and effective design. A very slight acquaintance with Oriental needlework will prove how narrow and comparatively poor are our ideas of decorative design. These must be enriched and enlarged; and however expensive the best and rarest patterns may be, it is the duty of the School to provide them.[25]

This discussion is significant in view of the lack of formal training at the School in design methods; while most government schools of design were devoted entirely to theoretical design instruction, institutions such as the Royal School taught only the practical side. It was not until the turn of the century that design teaching was introduced at the School, and only then upon the insistence of the Technical Education Board, who gave the School a grant of £150 per annum for that purpose. Mr Paulson Townsend was appointed to give two evening classes a week of two and three-quarter hours each, and a second instructor, Miss Parson, took two others. Mr Paulson Townsend's reputation and sex entitled him to fees of £1.1s. (£1.05) per class, while Miss Parson received only 5s. (25p) for the same work. In 1908 she was, however, recommended for a rise: 'As regards the evening classes, Miss Parson is reported to be an excellent teacher, who should receive a fee of at least 7s.6d. (37½p) an attendance, and we think it should be made a condition of the Council's grant that her rate of pay should be raised accordingly.'[26] Thus it was only after many years of unfavourable criticism of their designs that design classes were set up in the School.

Items embroidered by the School ranged from large prestige and exhibition pieces and sumptuous household drapes down to the most popular 'oddments' which made ideal presents:

Curtains in creamy-white satin inwrought with delicate wild roses, the colour of pink shells; curtains of gold and silver and many-coloured silks on yellow satin, or dark green or blue velvet; curtains, and these are not the least effective, worked with crewels in simple outline on serge linen. Among the table-covers is one made of brilliant red plush, with a sun in the centre richly embroidered in raised gold amidst a radiance of gold rays, and with the same design, reduced, in each of the four corners. Many of the folding screens, too, are vast and beautiful enough to be classed with the larger designs. The demand, however, is chiefly for minor fancy articles, of which there are always a great number and variety on view. With many articles of dress, there are screens, table-covers, chairbacks, cushions, couvre-pieds, tidies, fans, sachets for gloves and handkerchiefs, hand-bags, purses, blotters, and envelopeboxes, menu and photograph cases—cases, in short, for everything that the heart of man or woman can desire.[27]

Apart from the use of inferior designs, the major criticism directed at the School was that its products were too expensive:

It has been said sometimes that the prices of the finished needlework as well as the materials on sale at the South Kensington School are higher than elsewhere. But it must be remembered that the enterprise is not merely commercial. It is also, avowedly, if not primarily, one of social beneficence. The prices are, in fact, carefully fixed on the lowest scale which experience shows to be compatible with the maintainance of the institution.[28]

This patronising attitude not only contains the degrading notion that even when practising a profession ladies had to be given tolerant charitable assistance in order to make a decent living, but it also implies an awareness that, if allowed to compete on the open, lower-class embroidery market, ladies would be forced back into the state of destitution they sought to escape because of the inadequate wages offered to working-class embroiderers. But at least such philanthropy enabled the ladies to feel suitably grateful, and guilty for their failure to marry well or keep their husbands alive; and it spared them from the feelings of pride and achievement usually associated with satisfying work and the resultant self-made financial independence. The writer above continued:

Admitting that the School can be undersold by other and private establishments conducted for a purely commercial purpose, its prosperity must depend on two things: on the amount of sympathy with its special aims which can be awakened among the purchasing classes; and on its securing and maintaining a pre-eminent position for excellence and originality of design, and for soundness as well as beauty of material. To a very great extent the School has achieved this already.[28]

Consistently we find the importance of design stressed, with quality of materials a poor second. The importance of execution, and the variety of talent and personality in this aspect of the art, are rarely mentioned, yet again emphasising the artificial split between intellectual and manual activities.

The origins of the embroidery revival in England in the nineteenth century lie in the aftermath of the Catholic emancipation of 1829, and the resultant burst

of church building that followed it. These churches needed furnishing and decorating and, stimulated by A. W. N. Pugin's call for a return to a Gothic style of architecture, a wide interest was aroused in a revival of mediaeval styles of embroidery. Thanks to Pugin's concern for the subject, high artistic standards in the medium were part of this revival; he wrote on the theme:

At present the generality of [ladies'] productions, covered as they are with hearts, rosebuds and doves, stand forth in all their *prettiness* like valentine letters on a large scale ... But we must most earnestly impress on all those who work in any way for the decoration of the altar that the only hope of reviving the perfect style is by strictly adhering to the *ancient authorities* ... We cannot yet hope to revive the expression and finish of old work, but we may readily restore its general character.[29]

In 1848 the Ecclesiological Society published a volume of twelve plates of working patterns of flowers drawn full-size from medieval vestments and furnishings;

Embroidered Curtains from Fanham's Hall, executed by the Royal School of Art Needlework, c. 1905. (PHOTOGRAPH: VICTORIA & ALBERT MUSEUM, LONDON)

called *Ecclesiastical Embroidery*, its drawings were made by Agnes Blencowe, whose idea the publication was, and it is likely that George Edmund Street, the Gothic Revival architect with whom William Morris first studied the profession in 1856, helped select the examples. Agnes Blencowe and George Street's sister together founded the Ladies Ecclesiastical Embroidery Society in 1854 to 'supply altar cloths of strictly ecclesiastical design either by reproducing ancient examples or by working under the supervision of a competent architect.'[30] The collecting of ancient embroideries was coming into vogue at this date, led by the example of the Queen and the royal family, and the South Kensington Museum was developing a collection from which most serious embroiderers worked. While such enterprises as the Ladies Ecclesiastical Embroidery Society were important in the revival of interest in artistic, high-quality embroidery, they did not provide paid work for middle-class women; this church work was done free by women of comfortable means, and the Society merely charged the churches for the cost of materials. One interesting aspect of such middle-class women's organisations was the desire expressed by the women themselves to work together with other women on communal projects because of the comfort and support that such communication offered to otherwise fairly isolated women, in addition to the creative satisfaction.

Nevertheless, women like Agnes Blencowe, while advancing the cause of art embroidery, were also reinforcing traditional ideas of the amateur status of women embroiderers (a status upon which their social position depended in this period), and at the same time depriving working women of much-needed employment. In 1863 the Society joined forces with the Wantage Church Needlework Association, which consisted of the Exterior Sisters and Friends of St Mary's House, Wantage, Berkshire, and they also undertook the production of church embroidery with the prime aim of raising funds for the Home. The fact that the nineteenth century revival of embroidery was initially linked with the church was no coincidence; its origins lay in the church and embroidery had long-standing religious overtones; 'because of its religious roots, embroidery was seen as a pious act, and the subject matter of embroidery was frequently biblical'.[31] Even George Street, writing on ecclesiastical embroidery in *The Ecclesiologist* of 1863, ended with advice to lady embroiderers on the spiritually elevating nature of their work: he reminded them of the 'happiness which must result from employing their fingers and their eyes upon something fair and beautiful to behold instead of upon horrid and hideous patterns in cross-stitch, for foot-stools, slippers, chair-covers, and the like too common objects'. He also had rather clear-cut ideas about the type of embroidery which *was* spiritually elevating.

Although William Morris only stayed nine months in the offices of George Street, the architect's ideas were to be crucial for him: 'Street believed that an architect should not be just a builder, but a blacksmith, a painter, a fabric worker and a designer of stained glass. In this he was the original inspiration of Morris and [Philip] Webb and the whole of the Arts and Crafts movement.'[32]

Street had been greatly involved in his sister's embroidery, writing to her to describe mediaeval examples he had seen, and making sketches from them for her. He also made original designs for her to work, and this involvement must have communicated itself to Morris. Morris' move with Edward Burne-Jones to 17 Red Lion Square in London in the winter of 1856 saw the beginning of his activities as a designer and decorator when, failing to find tolerable furniture for their rooms, he set about designing some, and had it made by a local carpenter and, with Burne-Jones, decorated the results with mediaeval-style paintings. Morris' early interest in embroidery must have been stimulated by the enthusiasm of Street and Webb for the craft, for it appeared before his move to Red Lion Square. He may also have known Agnes Blencowe through Webb, of whom she was a close friend. Thus according to Morris' wife Jane Burden, he had an embroidery frame made as early as 1855, and some worsteds dyed to his taste by an old French couple; 'The experimental piece of embroidery done at this time used to hang in Red House, Bexley Heath. The design was a repeating pattern of a tree with birds and a scroll bearing the motto "If I can".'[33]

Once having become interested in the craft, it was typical of Morris that he should then begin studying it in detail and executing works in his own hand. Jane Morris later recalled how, after their marriage in 1859, Morris initiated her into the art:

He taught me the first principles of laying the stitches together so as to cover the ground smoothly and radiating them properly. Afterwards we studied old pieces and by unpicking, etc., we learnt much—but it was uphill work, fascinating, but only carried through by his enormous energy and perseverance.[34]

Not only did he teach Jane Morris to embroider, but he seems to have instructed in the art every woman he came into contact with, including Mary (Mrs Nicholson) who kept house for him at Red Lion Square, Mrs George Wardle (Madeleine Smith) wife of Morris' manager at Red Lion Square, Elizabeth Burden and Georgina Burne-Jones. The latter three and Jane, with several women working under them, executed embroideries for the firm on cloth and silk. After the first experiments, Jane Morris worked a series of hangings for the bedroom in the Red House, which was designed for Morris by Philip Webb in 1859. Although these hangings no longer survive, Jane Morris described work on them:

The first stuff I got to embroider on was a piece of indigo dyed blue serge I found in a London shop . . . and he was delighted with it and set to work at once designing flowers—these we worked in bright colours in a simple, rough way—the work went quickly and when we finished we covered the walls of the bedroom.[35]

A letter about Jane Morris from Henry James to his sister, written after a visit to the Morris family in 1869, gives an insight into the attitude to women prevalent in

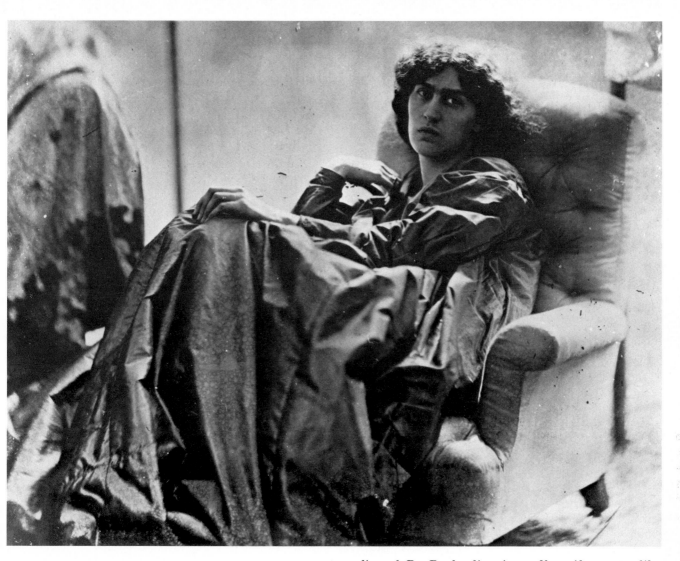

Jane Morris: Photograph posed by Dante Gabriel Rossetti c. 1865.
(PHOTOGRAPH: VICTORIA & ALBERT MUSEUM, LONDON)

artistic circles at this period:

A figure cut out of a missal—out of one of Rossetti's or Hunt's pictures—to say this gives but a faint idea of her, because when such an image puts on flesh and blood, it is an apparition of fearful and wonderful intensity. It's hard to say whether she's a grand synthesis of all the Pre-Raphaelite pictures ever made—or they a 'keen analysis' of her—whether she's an original or a copy.[36]

Many of the women in the Morris circle, including Jane Burden herself, were from working-class backgrounds, who found themselves taken up by this group of intellectuals and aesthetes for their sultry beauty and earthy sensuality. However, the Victorian code of morals, here overcast with strains of mediaeval chivalry, meant that any direct sensual relationship was abandoned for a distant pedestalisation of these women. It was evident that sex and marriage were incompatible, as Swinburne so aptly intimated in his letter to Edwin Hatch of 17 February 1858, when he said that he liked to think of 'Morris having that wonderful and most perfect stunner of his to—look at or speak to. The idea of his marrying her is insane. To kiss her feet is the utmost men should dream of doing.'[37]

Against this barrage of Victorian and quasi-mediaeval, Pre-Raphaelite views of her rôle, women like Jane Burden must have found it extremely difficult to maintain a balanced, realistic view of themselves. Apparently more attracted to Rossetti (who was himself committed to marrying the working-class Lizzie Siddal), she allowed him to persuade her to marry the love-sick Morris, ostensibly in order to keep her within the group as a model. But Rossetti's infatuation for her, and her unsatisfactory marriage to Morris who was evidently paralysed by his other-worldly vision of her, provided the basis for the tragic frustration which underlay the relations of the group. The educating and 'raising' of working-class women, permissible only in artistic circles, by such men as Morris and Rossetti, had strongly paternalistic overtones, and although potentially these women were more free from the moral restrictions of the period than their middle-class sisters, they were in fact being encouraged to abandon their own culture for a bohemian no-man's-land. Placing working-class women on a pedestal was in itself a contradiction in Victorian terms, and Jane Burden was thus doubly caught, between her own origins and instincts and the conflicting demands of the ideal imposed upon her. Morris himself was unable to get beyond his own fantasy of her, to deal with the real woman.

Seen in terms of this family background, Jane Burden's involvement in the craft activities initiated by

William Morris, her hours of patient embroidery, must have provided her with essential relief from emotional stress, but even this rôle of embroiderer itself had mediaeval overtones, harking back to the Arthurian ideal of the Lady in the Bower, and the noble princess passing her time at the embroidery frame. Like the majority of women in this circle, Jane worked almost entirely under Morris' direction and from his designs. This pattern of rôles is again traditional, and despite the novelty of purpose is reminiscent of the most conventional sexual divisions of labour since mediaeval times. In addition, although she worked actively for the Morris firm from its founding in April 1861, there is no record of any direct payment made to her for her work. At first Morris received a salary of £150 a year as manager, and presumably when the profits came it was he and the firm's directors who controlled them. While thus not exactly embroidering for love, Jane must herself have questioned the status of her work.

The wall-hangings for the dining room at the Red House were designed to look like tapestry, and were based upon Chaucer's *Illustrious Women*. Although only seven of the embroidered figures were completed by the time Morris left the house in 1865, there were to have been twelve, each with trees in between and a running band of flowers at their feet. They were worked mainly in crewel wools with some silk and gold thread, on coarse linen; 'the figures were then cut out and applied to a blue woollen ground which had previously been embroidered with a simple coiling floral pattern in chain stitch. The flower-strewn band at the base, which united the figures and trees, recalls the verdure of medieval tapestry'.[38] The ceiling was covered in floral designs, painted by Morris and Jane, and Lizzie Siddal helped with the decorations.

The first prospectus for the firm, under the general heading of furniture, included embroidery of all kinds. G. F. Bodley was the first architect to commission church work from the company, and one of their earliest important projects which included embroidery was for his church St Martin's-on-the-Hill, Scarborough in 1862. In the same year the firm's work was seen publicly for the first time at the International Exhi-

Above: *Detail of a superfrontal designed by Philip Webb and executed by May Morris, 1897, in silk and gold thread on linen with cross motifs interspersed with vines and oak leaves, with a border of strawberries and oak leaves. Much of the work produced by the Morris firm's embroidery department was for ecclesiastical purposes, and their earliest commissions were for church decorations.* (PHOTOGRAPH: VICTORIA & ALBERT MUSEUM, LONDON)

Right: *Wall hanging, designed by Henry Holiday and executed by Catherine Holiday c. 1887. Catherine Holiday collaborated with William Morris on a number of prestige and other embroideries, selecting the threads and the colours in which they were to be dyed; she was considered one of the most talented embroiderers of the period.* (PHOTOGRAPH: THE FINE ART SOCIETY, LONDON)

bition in London, and the exhibit included large embroidered wall-hangings similar to those made for the Red House dining room. They were highly praised by the jury, and the firm was awarded a Gold Medal; Christopher Dresser described them as: 'a series of quaint fabrics that have the pattern wrought upon them in thick worsted thread of many colours which is sewn to the surface'.[39]

In addition to his immediate family, Morris had enlisted the help of other women around him: 'Embroidery, including figure panels of the Red House type, altar cloths and hangings, were worked by Morris himself, Jane Morris, and her sister Miss Burden, Mrs Campfield, the wife of the foreman, and Georgiana Burne-Jones.'[40] Georgiana, wife of Edward Burne-Jones, later recalled the Red House period: 'Oh, how happy we were, Janey and I, busy in the morning with needlework or wood-engraving, and in the afternoon driving to explore the country round by the help of a map of Kent.'[41] As soon as Morris' daughters were old enough, they too joined in the collective embroidery work, in the manner of the mediaeval system Morris admired so much. Henry James recorded that Morris 'works it stitch by stitch, with his own fingers, aided by those of his wife and little girls'.[42] The eldest, Jenny was at this date (1869) eight years old, while May was seven, so their involvement in the craft had evidently begun at a very early age.

One of the women whose embroidery work impressed Morris a great deal, and with whom he established a

Left: *William Morris: 'Artichoke', design for embroidered hangings for the dining room of Smeaton Manor, the home of Mrs Godman, who executed this repetitive pattern. Morris's particular talents in designing for flat decorative surfaces (like wallpapers and printed fabrics) were in conflict with his ideals as a craftsman; thus he could produce superb two-dimensional designs like the present example, which were however exceedingly boring to execute in embroidery, so destroying the creativity involved in working the design. Drawing reproduced by Lewis F. Day in 'William Morris and his Art',* Art Journal Easter Annual, *1899.*

Above: *Margaret Bell and Florence Johnson: Figure of 'Hate' from the 'Pilgrim in the Garden of Vices', part of the Romaunt of the Rose embroidered frieze designed by William Morris and Burne-Jones for the Bells' home, Rounton Grange; the designs were made c. 1874, and the embroidery, done in coloured silks, wools and gold thread on linen, took Margaret Bell and her daughter eight years to complete.* (PHOTOGRAPH: WILLIAM MORRIS GALLERY, WALTHAMSTOW, LONDON)

working partnership in the 1870s, was Catherine Holiday. Catherine Holiday's husband Henry was a life-long friend of Morris, and a painter and designer of stained glass, mosaic and illustrations. When Morris first saw Catherine Holiday's embroidery his reaction showed the importance he placed on quality of execution; he suggested designing for her on a commercial basis, with the finished work to be sold by the Morris firm:

Morris supplied the designs but the colouring and technique were entrusted to Mrs Holiday . . . Although, according to her husband's memoirs, Morris was prepared to back her 'for heavy sums against all in Europe in embroidery', he was not afraid to criticise and advise. An example of his practical advice occurs in a letter written in March 1877, concerning some cushion squares she had worked: 'I thought the sort of work rather too *frail* for the purpose and propose the quilting down of the long stitches with hair lines of silk, even at the expense of losing some of the beauty. I think also I might find some better designs for cushions for you: In fact I have one which I will send you if you please to do as you will with [it] as to colour and style of work: with caution however that durability is necessary for such things; especially when the work is as beautiful as you make it.'[43]

Like all of Morris' materials, the embroidery silks used by Catherine Holiday were specially dyed for her to her own specifications; she would send him a small sample of the colour she wanted matching, and these were produced by the expert Thomas Wardle with whom Morris did all his experiments in the field of coloured dyes, and who printed most of Morris' fabric designs. 'The elaborate portières and coverlets worked by Mrs Holiday were necessarily expensive and a customer might have to pay as much as £120 for one of them. Even so, Morris' profit margin on these items was small for he regarded them as prestige pieces, and relied on small articles such as cushion covers to make the project pay.'[44]

Many of the firm's early embroideries were designed as special commissions for private houses, such as Rounton Grange, Northallerton, which was built for Sir Lowthian Bell by Philip Webb, and for which a hanging was designed by Burne-Jones in 1874 depicting scenes from the *Romaunt of the Rose* by Chaucer. Although designed by the firm this, like many other embroideries, was worked by lady amateurs, in this case Bell's wife Margaret and their daughter Florence Johnson. It 'was worked in wool, silk and gold thread on linen . . . with as much patience as any two medieval ladies in a bower. It took them eight years to complete, being a frieze three feet deep completely covered by fine stitchery.'[45] Another hanging designed *c.* 1880 by Morris for Rounton Grange was completed in wool on linen, probably by Margaret Bell; two other versions of this design exist, both worked in silk. Another commission for a private house was that of Mrs Godman, who asked Morris for a design for her dining room at Smeaton Manor in 1880; the design, 'Artichoke', was a repeat pattern, dull to execute:

The finished hangings, which covered the four walls of the

May Morris, c. 1890. From a series of informal photographs taken of her in the garden in Hammersmith. (PHOTOGRAPH: WILLIAM MORRIS GALLERY, WALTHAMSTOW, LONDON)

huge dining room, were worked in crewel wools on linen. It is impossible to estimate the number of patient hours Mrs Godman spent in completing this task. To some extent she must have relieved the monotony by varying the colours slightly from repeat to repeat but the general effect is still pretty uniform . . . It is strange that Morris, with his insistence on the joy of creative labour, should consider that repeating patterns were suitable for embroidery.[46]

In addition to embroidery ready marked up and usually begun for clients, which was sold with wools or silks specially dyed for the pattern, the workshop of the Morris firm produced much completed embroidery. Several women worked under the supervision of Morris or Jane, and in 1885, when she was twenty-three years of age, Morris gave complete charge of the embroidery workshop to his daughter May. From this date the importance of the section increased, and while designs by Morris were still used, most new ones after 1881 were by May Morris or J. H. Dearle, chief assistant and later manager of the Merton Abbey works, to which the firm moved in November 1881. Although Dearle's designs have often been confused with those of Morris, so thoroughly did he absorb the master's style, the work of May is noticeably distinct from her father's, even though she was trained and doubtless influenced by him:

Her designs are stiffer and less flowing, with a broader, simpler treatment, and less intricate detail. A characteristic example of her work is the 'Orchard' portière . . . This was one of the most popular of her designs and the Day-book of the embroidery section of the Morris firm (now in the Victoria and Albert Museum) shows that no less than five versions of it were made in the year 1893 alone. One 'Orchard' portiere represented about fourteen and a half weeks' work and cost £48 when it was sold fully completed.[47]

The Day-book records the sale of a traced and possibly started Fruit Garden ('Orchard') portière on lined silk, to a Mrs Middlemore; ordered on 4 April 1893 it was supplied eleven days later, at a cost of £9. Elsewhere in the Day-book a detailed break-down of time and costing was given for a 'Kelmscott' hanging: in addition to six hours of design work on the border by May Morris, fifteen and a half hours of marking were needed, and seventeen and a quarter of tracing. The embroidery work time was estimated at a total of twenty-four and a half weeks. The embroidery itself was divided among three workers, identified only by their initials:

L.Y.—two and a half weeks	£3.7.6d [£3.37½]
E.W.—eight weeks	£7.8.0d [£7.40]
M.D.—fourteen weeks	£12.5.0d [£12.25]

The cost of the weeks' work noted gives an indication of the various wages paid to women workers weekly by the Morris firm: 'L.Y.', presumably doing the most skilled work, received the highest wage at £1.35 a week, the next highest was 'E.W.' at 92½p a week, and the lowest paid (who also worked longest) was 'M.D.', at 85p a week. The average weekly wage for working-class women in 1891–2 was 11s.5d (57½p), while more skilled trades such as jewellery and watchmaking paid 12s.2d (61p) a week.[48] The wages at Morris' firm were thus well above the average, although the women employed were highly trained and skilled. It is not clear whether or not they were middle class; May Morris, as an employer, would certainly have been considered as such.

In the wake of William Morris' revival of artistic embroidery and the foundation of the Royal School of Art Needlework, many new organisations sprang up with the dual aim of producing high-quality needlework and aiding needy gentlewomen. Two of the earliest such bodies were the Ladies' Work Society and the Decorative Art Needlework Society, which were both discussed in the *Magazine of Art* for 1880. The former took over the premises at 31 Sloane Street which had been occupied by the Royal School before its move to Kensington, while the latter was to be found in George Street, off Portman Square. The Ladies' Work Society was established (*c.*1875) under the patronage of H.R.H. Princess Louise, Marchioness of Lorne, the sculptress daughter of Queen Victoria, who made many of the designs herself. It aimed almost entirely at obtaining commissions for needlework of all kinds, both decorative and plain, to be executed by members of the Society in their own homes:

The society, through its officers, exercises a considerable surveillance of the designs and their execution in embroidery; and, as far as customers permit, tempers the taste of the commissions. Arrangements can be made for the giving of lessons. The society's chief object, however, is to provide work of a useful, artistic, and elevating character for ladies who are dependent on their own exertions.[49]

A contemporary register of embroidery societies for ladies noted that, in order to raise the standards of artistic embroidery 'the Committee find it necessary to accept such work only as they consider good both in design and execution . . . There is greater demand for plain and useful work than for fancy articles, unless the latter are artistically and tastefully executed'.[50] Each member was permitted twelve articles for sale at a time, and the commission charged on all work sold was particularly high, at 2½d per shilling or twenty-five percent, when the average was 1d; perhaps the wide reputation of the Society justified such charges.

The Society exhibited work at the Philadelphia International Exhibition of 1876, including a frieze with Japanese-style vegetation and a heron motif designed by Thomas Jeckyll. For the Paris Exhibition of 1878:

the society wrought a set of elaborate hangings for a room in the pavilion of the Prince of Wales. The work was principally of the appliqué class. In the design, mixed in character, at times vivacious like a Japanese composition, at others betraying a tendency to lumpy mediaevalism, were depicted scenes of 'sporting life', shooting, fishing, and such-like. The society also produces work very much in the style of those from the Royal School of Art [Needlework].[51]

The Decorative Art Needlework Society 'owes its existence, in the first place, to Lady Welby Gregory, who had a great desire to find out whether decorative art needlework could be made commercially profitable as a business'.[52] Although only a small amount of capital sufficed to start the undertaking, it was in all respects a success when it was described by the *Magazine of Art* in 1880:

All branches of decorative needlework are done by the society, and lessons are given to amateurs. The society has been particularly successful in restoring and copying antique needlework. The President of the Royal School at South Kensington has extended her patronage to this society, and in this sense the society may be regarded as linked to the parent school at South Kensington.

The 1883 register of ladies' needlework societies stated that the Decorative Needlework Society was established by ladies 'who have until recently held leading positions in the Royal School of Art Needlework, for the production, at moderate cost, of the highest classes of decorative needlework'. Despite the close ties between the various institutions, the *Magazine of Art* for 1880 emphasised that each was distinct from an administrative point of view; 'If there be any tie of connection, it is to be found in the common cause which all the Art Needlework Schools have at heart'.

Like the Royal School, the Decorative Art Needlework Society trained all its own staff. 'Lady workers are employed, who, on first joining, go through a course of instruction, and are then eligible to become members when a vacancy occurs. The work is all done at the

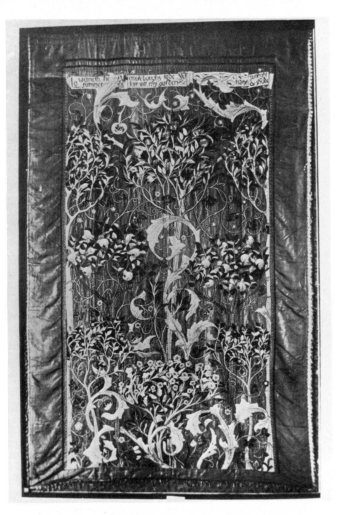

Above: 'Orchard': Portière, designed by May Morris and executed in coloured silks by Mrs Theodosia Middlemore. Mrs Middlemore seems to have executed two 'Orchard' portières, one of which was recorded in the Morris firm's Day Book: 'Fruit garden portière on silk (lined) 4 April 93. 15 April 93. £9.0.0'. This may have been for lining the finished portière, as there was no reference to starting it. Barbara Morris (Victorian Embroidery) reproduces a second version worked by Mrs Middlemore in coloured silks on linen, 1894, 108 × 69 in, now in the collection of Robert Bartleet Esq.

Right: Ecclesiastical banner, designed and worked by the School of Mediaeval Embroidery; from an engraving reproduced in the Magazine of Art, 1880.

rooms. Private lessons are given to amateurs either at their own residence, or at the rooms of the Society.'[53] Unlike the Royal School, which only trained professionals if there was a vacancy in the workrooms, this Society evidently trained more than it needed, presumably creating competition for workroom places when they became available. Payment of the ladies was probably made on the same lines as the Royal School, and 'Special attention is paid to the faithful restoration of antique embroidery.'[53]

While these two societies concentrated on secular embroidery, another institution, the School of Mediaeval Embroidery, run by the sisterhood of St Katherine in Queen Square, Bloomsbury, specialised in ecclesiastical needlework. The Magazine of Art recorded in 1880:

There are at present fifteen workers in this school, who undertake the execution of orders for embroidered stoles, orphreys, chalice veils, maniples, chasubles, banners, altar frontals, etc., for those churches in the Church of England in which such accessories of ritual are used. The scale of fees for persons desiring to be initiated into the cunning of the delicate stitchery used in ecclesiastical embroidery is a guinea for a single lesson in the less difficult stitches, and two guineas for a lesson in embroidery applicable to the reproduction of human faces, etc.

In a banner worked by the School and illustrated in the Magazine of Art showing the Virgin in a vesica of glory, the engraved and small-scale reproduction did not show clearly how the work had been carried out:

The effect of the stitchery in the original nearly approaches

Berlin Wool Work Picture: 'The Talisman', taken from the novel by Sir Walter Scott; worked by Mrs Billyard of Cheshire, circa *1860.* (PHOTOGRAPH: VICTORIA & ALBERT MUSEUM, LONDON)

that of painting. In the face and the hands, with much ingenuity the stitches are taken so as to impart a variety of surface and modelling to the flesh, which appears to be superior, as an approximation to painting, than the more formal stitchery of the Middle Ages.

This decisive question as to the decorative or realistic roles of embroidery was one which had provoked heated discussion over several centuries. This author went on to define the problem: 'it may well be argued that the embroiderer should not attempt to emulate the life-like results of the painter. Needle and silks are not so freely handled as brush and paints, nor could the greatest skill produce any but a far-off imitation of painting'. In mediaeval times there were, of course, both links and similarities between the stylistic 'primitivism' exhibited in embroidery and painting. At this period, before the discovery of oil painting and with it the ability to achieve a high degree of pictorial realism, paintings were in the more limited media of tempera or fresco, in which rapid drying and a matt, opaque paint surface restricted the degree of realism obtainable. Realistic depiction of depth and the illusion of space were best achieved through the transparent, glazing properties of oils, which enabled the artist to build up light and create shadow with chiaroscuresque modelling. With the perfection of oil painting in the Netherlands in the early fifteenth century, and its subsequent adoption throughout Europe, a new attitude to truthful realism spread and by contrast needlework, with its differing

technical powers, looked as awkward and naïve as did the 'symbolic' pictorial representation of pre-Renaissance paintings.

Although by the sixteenth century the status of embroidery as a work of art had increased, Rosie Parker argues that:

Even when embroidery was divorced from functional objects and hung on walls it could not compete with painting as an investment. John Berger explains why oil painting became a status commodity: 'Oil painting often depicts things. Things which in reality are buyable. To have a thing painted and put on canvas is not unlike buying it and putting it in your house. If you buy a painting you buy the look of the thing it represents.' An embroidered picture can never achieve the slick trompe-l'oeil effect of an oil painting. Moreover, embroiderers on the whole had no access to training in representational techniques.[54]

Thus, at least in part because of the increasing demand for illusionistic representation, embroidery became associated with the minor arts, while painting was seen as high or fine art. Embroidery's association with women only emphasised this categorisation:

Painting was labelled Art because it was considered to express the skills, knowledge, ideals, personality and power of the

person who held the brush. Embroidery remained a craft because it was considered to express little beyond manual dexterity. Women held the needle and by the 18th century, women were not considered capable of injecting thought or personality into their work. 'To model well in clay is considered strong minded and anti-feminine but to model badly in wax or bread is quite a feminine occupation.'[55]

Before the nineteenth-century revival of ecclesiastical embroidery women had already tried to introduce a more sophisticated realism, reminiscent of oil painting, into embroidered work. Needle painting had become increasingly fashionable in the second half of the eighteenth century, with ladies like Mary Linwood gaining widespread renown. 'In 1787 an exhibition of over a hundred of her glazed, framed embroidered pictures opened at the Hanover Square Rooms in London and subsequently toured the provinces.'[56] One critic wrote:

The Ladies of Great Britain may boast in the person of Miss Linwood an example of the force and energy of the female mind, free from any of those ungraceful manners which have sometimes accompanied strength of genius in a woman. Miss Linwood has awakened from its long sleep the art which gave birth to painting.[57]

Her embroidered copies of the old masters were given approval only in the accuracy of their imitation of oils, and not as creative works in their own right; however she bowed to traditional attitudes herself in making

Left: 'Vine': Embroidered portière, designed by William Morris c. 1878 and worked here by May Morris and her assistants in silks on yellow silk; it was shown at the Arts and Crafts Exhibition Society, 1890. The Morris and Co. Day Book for the Embroidery Department (now in the Victoria and Albert Museum, London) records that two examples of the 'Vine' portière were traced and begun for clients in 1893; the cost of this service and the linen and silks for completing it was £6.10s (£6.50), as against approximately £45–£50 for a comparable completed portière. (PHOTOGRAPH: VICTORIA & ALBERT MUSEUM, LONDON)

Above: 'Musica': designed by Edward Burne-Jones and worked in brown crewels on linen by the Royal School of Art Needlework, from an illustration in the Magazine of Art, 1880, where the writer commented: it is 'seen to far greater advantage, since the linen . . . is strained in a screen frame'.

such copies, rather than finding her own means of expression, better suited to her individual creativity and to the demands of embroidery. Nevertheless, her works were highly valued, and she received an offer of £3,000 for one which, because of her cherished amateur status as a lady, she gave instead to the Queen.

By the nineteenth century, a bastardised form of 'realistic' needlework was widely popular in the form of Berlin wool work. Worked in wools on a canvas backing, this type of embroidery was usually done from ready-drawn patterns and involved the minimum of talent or creativity. The single stitch used was uniform and predetermined by the weave of the backing canvas;

the designs were often realistic in a rather vulgar way, depicting vivid parrots and garish cabbage roses or sometimes religious themes. Occasionally the embroiderer would add an extra touch of realism with knotted or looped wool which could later be cut to imitate an animal's fur. It was against such excesses as these that the artistic embroiderers reacted; May Morris, in her book on embroidery of 1893, argued forcibly against the use of such contrivances in needlework: 'Such "effects" ... are, to my thinking, in bad taste and out of place in embroidery; where, even in the pictorial side of the art, natural objects should be interpreted by bold and skilful drawing, and no attempt at faithful copying be made.'[58]

Even Walter Crane's figure designs for the Royal School of Art Needlework in 1876 were criticised by the *Magazine of Art* as being unsatisfactory, and it was questioned as to whether, despite the ancient tapestries, figure subjects were suitable for finished needlework; 'It should never be forgotten by designers for needlework that the art, however beautiful, is a limited one, and that it is useless to make it co-extensive with painting.'[59] William Morris' more abstract, decorative wall-hanging designs were applauded for their truth to the embroidery medium.

May Morris was thus among the majority of creative craft thinkers of this period, who rejected the slavish copying of natural objects in artistic decoration; even in pictorial embroidery she advocated the avoidance of techniques like making textured knots to evoke sheep's fleece. She maintained that a 'realistic' imitation of nature led to a caricature-like result, and emphasised that few amateurs were capable of a successful treatment of pictorial embroidery:

The more important and pictorial side is usually left in the hands of professional workers of experience and skill, but the decorative and more popular work is quite within the scope of amateurs, and is indeed often more beautiful as mere ornament, though its intellectual value may not be so great.

This identification of 'intellectual' value with the 'pictorial' element deserves some discussion. May Morris here makes a strictly traditional value judgement about the relative intellectual content of pictorial versus decorative embroidery; at the same time she has in effect reiterated the broader schism between painting (realistically pictorial) and embroidery (stylised and decorative). She defines in detail these two separate categories of embroidery: first, *pictorial art*, where the material serves as a surface or ground to be entirely covered with embroidery, 'like the canvas of a picture'; secondly, *decorative art*, where woven stuff is ornamented with borders and designs more or less elaborate, but where the textile is less subordinate than it is in the pictorial type. Ironically, the decorative type seems by its very nature an embroidery at once more integrated and whole in its balance between stitched pattern and ground, and in its commitment to a decorative design conforming to and complementing its two-dimensional surface. The pictorial type by contrast, in its imitation of the realism of painting immediately suggests a greater degree of removal, or abstraction, from the

Decorative Needlework.

Fig. 17.—Suitable for Appliqué.

May Morris: Design for embroidery, illustrating a design suitable for appliqué work, from her book Decorative Needlework, 1893. The simple, rather stark geometry of her conventionalised flower in this drawing is typical of her work.

inherent properties of the materials used in embroidery. Thus because of its association with painting the pictorial type of embroidery was seen as having a higher 'intellectual' content, while the decorative type was seen as inferior. In effect, May Morris uses the word 'intellectual' to define the content of an art-form alienated from its basic roots. Similar criticisms regarding the misuse of pictorial treatment in decorative art had been made against amateur lady china painters, but here, where there was no ancient tradition linking the craft to oil painting, nothing was found to recommend it.

In her dedicatory note May Morris made clear the aims of her book:

I have tried to show that executive skill and the desire of and feeling for beauty, realized in a work of definite utility, are the vital and essential elements of this as of all other branches of art, and that no one of these elements can the embroideress neglect or overlook. If she pursues her craft with due care, and one might even say with enthusiasm, however, she will not only taste the keen pleasure which everyone feels in creative work, however unpretending, but the product will be such as others will be careful to preserve: this in itself being an incentive to good work.

Her emphasis on utility is a logical product of the Arts

and Crafts ethic, which came as a reaction against the non-functional applied ornament of the Victorian heyday, and had its origins in the writings of Ruskin and her father, combined with the contemporary adherence to the protestant work ethic. Eighty years after Mary Lamb's virulent criticism of 1815, the lack of distinction between work and leisure in a lady's life is no clearer, although May Morris is evidently discussing the amateur needlewoman.

By 1883 the number of organisations for the assistance of needy lady embroiderers had expanded enormously, with eighteen listed in London and twelve in the provinces. Many did not offer training, but merely acted as agencies or depots for the women's work. They were often linked with employment agencies for gentlewomen, like the one in Torquay:

Mrs. Geyselman's Depôt for Ladies' Work, 2 Lower Uncroft, Torquay, with which is incorporated an agency for governesses and ladies who give lessons in Torquay. Subscription 10s.6d. annually, and 2d. in the shilling commission on all work sold, or orders given for execution. A worker may send six articles at a time to the depôt, which may be replaced when any are sold; low prices are urged to induce a ready sale. All plain work must be hand sewn, well executed, and pretty useful patterns. Orders taken for work of any kind.[61]

None were as blatant as this agency in their demand for cheap work, and few in the provinces had such high subscription and commission charges. Most depôts required references, often from clergymen, proving financial need before they would accept a lady's work, and some guaranteed anonymity to protect the ladies from public knowledge of the remunerative nature of their work, and thus save them from dishonour. The Ladies' Work Society was one such, whose lady workers were referred to in the books by numbers only. Depôts in the provinces were to be found at Torquay, Brighton, Surbiton, Bristol, Leamington Spa, Liverpool (two), Manchester, Southport, Leeds, Bath, Reading and Plymouth, with one in Dublin, the Irish Ladies' Work Society. The Royal School of Art Needlework itself had several branches in the provinces, mostly established in leading department stores of major towns; by 1880 there was a school in Glasgow, and agencies in Liverpool, Manchester, Leeds, Norwich, Birmingham and Newcastle. The *Furniture Gazette* of 1880 recorded the opening of the Newcastle branch in August of that year:

Finding that the scheme was so much appreciated in London, the committee, with a view to carrying the operations of the school into other parts of the country, determined to open agencies in several large towns ... A lady teacher has been sent down to give lessons in the various classes of work, and already several classes have been formed, which meet in a large room at Messrs. Bragg & Co.'s.[60]

A large exhibition was held to inaugurate the opening at Messrs. Bragg's store, 93–5 Pilgrim Street, with ancient Middle Eastern embroideries and 'three rooms ...filled with specimens of modern work sent down from the school at South Kensington, and this portion of the Exhibition will most likely be of great service to ladies who propose attending classes, and in fact to all who

wish to improve their knowledge and taste in art needlework'. The whole enterprise was under the patronage of eminent local ladies such as the Duchess of Northumberland, the Countess of Ravensworth, the Countess Percy, Lady Ridley and Mrs Albert Grey. Other provincial depôts were linked to London societies, such as those of Bath and Reading, which were branches of the Association for the Sale of Work of Ladies of Limited Means at 47 Great Portland Street, W.:

This society is really a charity, and is intended solely for gentlewomen by birth and of very limited means. Workers must be presented with a nomination from a member. Honorary members subscribe one guinea each per year, and a donation of £10 constitutes an honorary member for life. Working members, nominated and approved, pay a subscription of 2s.6d. [12½p] each annually, and the work is subject to a deduction of 1d. in the shilling for expenses. £5 of work may be on view at a time in the show rooms.[61]

Two other institutions offered particular services; the London Institute for the Advancement of Plain Needlework, 40 Upper Berkeley Street, Edgware Road, advised:

The objects of this institution are, first, to teach teachers how to teach needlework; second, to give diplomas to persons who have passed a good examination in four courses of plain needlework, viz., ability to do good plain needlework, knitting and netting, darning and mending, and cutting out. Lessons in needlework, 2s.6d. [12½p] each lesson ... The possession of a diploma enables the owner to give lessons in demonstration and simultaneous teaching of needlework.[61]

The Ladies' School of Technical Needlework and Dressmaking, 42 Somerset Street, Portman Square, provided another directly functional training:

The Committee offer free instruction in dressmaking to young ladies who give their time for twelve months. They also offer training to teachers and ladies who have some previous knowledge, and wish to improve themselves in dressmaking. Classes are held for instructing amateurs in cutting out and making up dresses, and teachers can be sent into the country. A manual has been prepared for use in schools, for teaching cutting out dresses by geometric measurement. Lessons are also given in plain needlework and art embroidery.[61]

In offering a full twelve months of training, this establishment differed from most of the pure embroidery schools, whose courses tended to be quite brief. Connected with the School was a centre, The Church Heraldic and Artistic Work Depôt which, although it did not receive work for sale, gave lessons in and took orders for every kind of ecclesiastical and artistic work, thus providing steady work for at least some of the School's trained embroiderers. While both the London Institute and the Ladies' School of Technical Needlework are perhaps a far cry from the sophisticated art embroidery world of the South Kensington establishment, such instruction must nevertheless have provided many gentlewomen with the possibility of an independent income which could be gained from the home.

Only one of the organisations listed in 1883 seems to have been intended for women of the lower classes:

The Co-operative Needlewomen's Society is an association to benefit the poorer class of workers by securing to them better wages than they could receive by the ordinary system of paid needlework, and at the same time offers the advantage to the purchaser by presenting genuine work at the lowest possible prices. The workers assemble day by day in rooms set apart for the purpose. Every kind of plain needlework is undertaken.[61]

Under the guise of improving the conditions of the poor, this establishment seems to have operated by the exploitation of its labour force. Compared with the high, charitable prices asked by the Royal School, its charges must have been competitively low; something of women's conditions under the ordinary system which produced these low prices has already been discussed. The final sentence in this advertisement, however, indicates that the type of work done by the Co-operative was extremely simple by comparison with that of the more well-known institutions, and therefore it was probably not a real threat. As here, it is evident that some embroidery establishments organised their workers together under one roof, while many others gave out orders to women working from home or received for sale work initiated by home-workers.

 While the majority of these embroidery schools and depôts insisted that their workers be both gentlewomen and in financial difficulties, in the provinces the revival of artistic needlework seems to have provided an opportunity for philanthropic ventures directed at poverty-stricken working-class women, and numerous attempts were made to revive old local crafts. In Ireland, the two classes of women were combined in an embroidery society founded by Mrs Ernest Hart in the early 1880s. A famine in Donegal at that time, caused by a series of bad harvests, prompted Mrs Hart to set up the Donegal Industrial Fund, on the basis of public support, to assist the starving people of Northern Ireland:

Her first efforts were devoted to the revival of local weaving industries and the production of hand-woven Irish tweeds and knitted goods. The yarns were hand-spun and hand-dyed with dyes produced from the local heather, wild plants, mosses, roots, leaves and bog-products. The next step was the setting up of classes for teaching embroidery to village girls. Sixty to eighty poor Irish ladies were employed in teaching the local girls as well as executing finished work themselves. The idea rose from Mrs Hart's discovery that a number of Irish ladies 'of culture and distinction were starving like peasants'.[62]

The ladies, with their traditional knowledge of embroidery, passed on their skills to the working women, and at the same time themselves earned money to survive. The particular type of embroidery developed in Ireland by Mrs Hart became known as Kells Embroidery, as its designs were based upon the illuminations in ancient Celtic manuscripts. Hand-spun and vegetable-dyed wool or 'Galway flannel' and linen were used as the bases for the embroidery, which was worked in polished, waxed threads of linen which had a lustrous shine almost equal to that of silk:

The designs featured curious dragons and writhing serpents, combined with typical Celtic interlaced ornament. Large curtains and portières were a feature of Kells embroidery, and

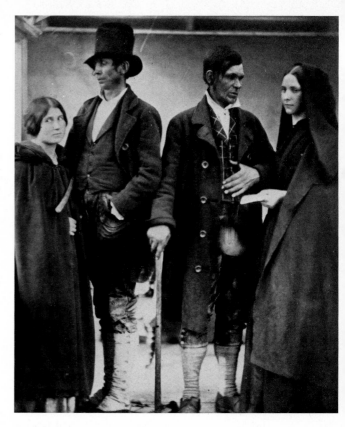

Irish Peasants, from a photograph dating from the 1860s. (PHOTOGRAPH: VICTORIA & ALBERT MUSEUM, LONDON)

the designs, contrary to the usual practice, had the heaviest part of the ornament at the top, with the pattern broken up and scattered as it neared the floor.[62]

In addition to producing curtains for the Queen at Windsor Castle, the Donegal Industrial Fund also designed and executed curtains for the Associated Artists, the organisation established in New York by Candace Wheeler (see below) and Louis Tiffany. The Fund received public recognition in 1887 when the government granted £1,000 to Mrs Hart for teaching purposes; a small committee including Lord Leitrim, Archbishop Logue and Mr Woodhall, M.P., was set up to administer the grant. A shop was opened at 31 New Cavendish Street in London for the sale of goods, and work by the Fund also appeared at the Arts and Crafts Exhibition of 1888.

 Another important art needlework industry which trained and employed working-class women, and was organised by wealthy, philanthropic ladies, was the Langdale Linen Industry. This industry was established in 1885 to help impoverished women of the dales in the two hamlets of Great and Little Langdale, and in nearby Elterwater and Chapel Stile, near the lakes of Coniston and Grasmere in the Lake District. It began with the revival of the traditional cottage spinning industry:

It is in homes such as these that the spinning-wheel was once the most noticeable object, and into which ... through the energy and wisdom of Mr Albert Fleming and the ladies who rallied round him, it was reintroduced with the hearty co-operation of the women themselves. After careful consideration, flax-spinning, and not wool, was started, there being more demand for the former, which also presented less

difficulties both to spinner and weaver. So far, all the flax used has been imported from Ireland, its cultivation in the district, though possible, seeming unnecessary in these days of easy transport. An old woman who had spun in her youth was discovered, and, though much crippled with rheumatism, she became the instructress of Mr Fleming and his helpers in the forgotten art.[63]

The whole industry became known as 'St. Martin's' after it was put under the patronage of that saint, and its headquarters, a white seventeenth-century cottage in Elterwater village, was also called St. Martin's. By 1897 the management of the spinning, and much of the actual weaving and experimental work was in the hands of Mrs Pepper, the wife of a slater, and herself one of the first pupils and by then the best spinner and weaver in the whole district:

She and her mother (one of those to whom the industry has been a real blessing, enabling her to keep her tiny home together without becoming a burden to anyone) are at St. Martin's all day, weaving, bleaching, attending to the correspondence, and sale of the embroideries and linen always on view there; or giving lessons in spinning, weaving, and embroidery to all comers.[64]

From this headquarters all the flax and silk was given out to the spinners, who came twice a month to return their bobbins of thread, to take back more flax, and receive their wages. The wheels were the property of the industry, being lent to the women so long as they continued to spin for St. Martin's. Once a year in summer a 'Spinners' Tea' was held, at which every woman was interviewed separately by the lady who superintended the whole industry, and asked whether she had any complaints, was tired of her work, or wished to give up her wheel. The work was all paid for by the piece, the price varying with the quality of the spinning. Some good spinners could earn as much as 6s. a week for the finest silk and linen thread, but the average wage was usually no more than 4s. By comparison to the embroidery workers at Morris and Co. this wage seems nominal, and no details were recorded of the relative wages of embroiderers at Langdale; however, even by comparison to the national average for women workers at this date, Langdale's skilled craftswomen were being paid over sixty percent less than their sisters elsewhere. It is evident that their wages must have been seen as a supplement to a husband's income, although many single women were employed at spinning. There was little specific discussion of the problems of single women, save to point out that their industry, in true work ethic style, made their lives more joyful:

Certainly, no one who had ever talked to a lonely woman about her spinning . . . could doubt for a moment that it was an industry worth encouraging, if only for the joy and interest it had put into lives so destitute of all that goes towards making life enjoyable. The married women are equally enthusiastic; and, perhaps better proof still, the husbands are more so, for the wheel has brought increased comfort and orderliness into many a home, whose mistress is now to be found busily engaged by her own fireside, instead of gossiping beside a neighbour's.[65]

It can be seen from this the extent to which paternalistic moralising crept into contemporary discussions of working-class craft industries for women; in similar writings on the middle- and upper-class women it is prevalent, but not so strongly. Women of the higher classes were no doubt expected, through the influence of their breeding and upbringing, to be less subject to moral deprivation than their poor sisters. This theme, and the importance attributed by the Victorians to the value of work and art in raising the moral standards of the working classes, were further stressed by Barbara Russell (writing in 1897):

It is hardly necessary to point out the great value of such an industry in any neighbourhood, as the increased comfort in cottage homes speaks for itself; but perhaps it may be necessary even now, though so much has been written as to the need of improvement in our Art industries, to state the value of such work as an educational factor.

When cottage mothers are engaged in the production of really beautiful fabrics, the whole family must benefit thereby, learning unconsciously to appreciate beautiful things, and also receiving a much-needed training in conscientious work, no mean advantage in these days of scamping. Beauty has always a refining influence, and the power of producing it markedly increases the self-respect of the worker. For this reason alone lovers of their country should require no urging to support such industries as that of Langdale, particularly when, as in this case, the work produced is no mere experiment, but has an intrinsic value of its own to all who can appreciate beauty of texture, colour and fine needlework. It is, therefore, not merely a duty owners of wealth owe to their fellow-countrymen, but a means of adding to the beauty and interest of their own surroundings, by adorning them with such fabrics.[66]

Once the spinning at Langdale was completed the thread was distributed for weaving; the spinners did not do the weaving, except for the manageress Mrs Pepper, who wove some of the silk, mixed silk and flax for dress fabrics at St. Martin's, while the remainder was done by Bell of Ambleside. All the sheeting and canvas for embroidery was sent to a Scottish weaver. In addition to the successful experiments in the rearing of silkworms and the subsequent use of this good quality thread from c. 1896 for spinning and weaving, Mrs Pepper supervised developments in pattern-weaving and vegetable-dyeing. Up until the 1820s wool-spinning for weaving and knitting had been a feature of the district, with the local 'Silas Marner' from near Keswick coming at regular intervals to collect the yarn from the women, returning it later in the form of blankets or cloth, according to order. Vegetable dyes were then used to colour the wool: logwood for black, lichen which they gathered among the rocks for brown, and heather from the fell for green. These plants, and others, were again used by Mrs Pepper in her experiments at St. Martin's with flax and silk dyeing.

Once the linen was woven it was then given out to another large band of women, 'chosen with the greatest care by one whose own exquisite taste is only equalled by her skill in producing embroidery . . . Under her supervision, these workers decorate this homespun

Langdale Linen Industry: Square of punto-a-reticella, *or Greek Lace;* '*of all the various methods of ornamentation attempted, none is of greater beauty or interest than the* punto-a-reticella *or Greek lace, of which St. Martin's has made a speciality. Indeed, some of its workers excel all other English lace-makers in its production . . . This lace is worked entirely with the needle in either silk or linen thread, and being very durable, is one of the best decorations for linen ever devised. It was much used throughout Europe for church linen and vestments, some of the old Italian pieces still extant being most elaborately wrought in heraldic devices or figures of men and animals*'. (*Art Journal, 1897, from which the reproduction is also taken.*)

linen with embroidery worked from patterns of some of the best designers of the day'.[65] Among the items embroidered were quilts, cushions, cloths and, reputedly the most successful and popular, wall-hangings, in both simple and elaborate stitchery. Of all the various methods of embroidery attempted by the Langdale group, the most interesting and attractive was the Greek lace or *punto-a-reticella*, which became its speciality. This 'lace' was produced entirely with the needle, using either silk or linen thread, and as it was very durable it was eminently suited for decorating linen. Other types of embroidery carried out at Langdale were darned work on a netted ground and cut work; embroidery proper was executed using every variation of stitch, from solidly worked silken figures to the delicate Louis XV 'powderings' of tiny bouquets or garlands.

The Langdale Industry and its success inspired craft revivals elsewhere:

it has already become the parent of other similar industries . . . In the district itself, both Keswick and Windermere now employ many spinners; and Winterslow, near Salisbury, now busily engaged in producing homespun woollens, owes all its present earnings to Mrs Poore's satisfaction with the results achieved in Langdale. A spinner from Winterslow taught the Sandringham women at the special request of H.R.H. the Princess of Wales; and Mrs Brownson, of Compton Greenfield, who had learnt to spin at Windermere, has already gladdened the hearts and increased the earnings of a large number of

Gloucestershire wives by the introduction of wheels and needle-lacemaking into their cottages.[66]

While with most organisations for the promotion of artistic needlework the class of women workers involved was usually quite evident, particularly when the aims cited were philanthropic as well as artistic, some, like the Leek Embroidery Society, do not provide a clear indication of the social standing of their workers; however, from the mainly artistic and economic aims attributable to the Society, it is likely that working-class women were both trained and employed in addition to the amateur and semi-professional lady workers. The Society was founded in 1879 by Elizabeth, wife of Thomas Wardle, 'the President of the Silk Association of Great Britain and Ireland, whose efforts on behalf of British Silks are well-known and appreciated, and whose dyed and printed fabrics, in accordance with the style developed by the aesthetic movement are so well-known'.[67] The home of the Society was in Leek, and nearly all the materials required for the embroidery were manufactured by Wardle himself; 'although the aim of the Leek Embroidery Society was to improve the general standard of embroidery, its aims were not entirely disinterested for most of the work promoted by the Society was worked on printed tussore silks, printed by Wardle at his own works, and in embroidery silks specially dyed at Leek'.[68] Of the various types of embroidery popular at this period, the Leek Society specialised in embroidery on printed or brocaded grounds, until the original print or woven design was partly or wholly obliterated by the applied stitches. The traditional method was to work on a woven ground, so that the use of a printed ground was a new development; appliqué work was also done, but again using printed grounds as a base.

Leek embroidery was particularly noted for its richness, colour and beauty of design. Some of the designs, like the 'Ajunta' adapted from Indian art, were by Thomas Wardle, others were from well-known designers such as the architects J. D. Sedding and R. Norman Shaw; 'other specimens of [the Society's] work owe their beauty of arrangement to the artistic knowledge and skill of Mrs Wardle'.[67] The domestic output of Leek included embroidered hangings, screens, curtains, mantel borders and falls, cushions, bags, bedspreads and table centres. However, in 1893 the Society was better known for its ecclesiastical embroideries.

Appliqué work was a particular feature of the Haslemere Peasant Industries, founded by Godfrey Blount in 1896, and organised by him, his wife Ethel Hine (the daughter of the landscape painter Henry George Hine) and his sister-in-law, Mrs Maud Egerton King, 'with the aim of reviving and encouraging the simple applied arts that could be found in villages and out of the way places'. M. H. Baillie Scott writing on the subject of embroidery in the *Studio*, was rather cynical of the organisation, saying that it 'is sometimes called *peasant embroidery*, probably because it is seldom practised by peasants and cannot be strictly described as embroidery. In this the outline is made a feature of the design and like the lead in a stained-glass window,

M. H. and Mrs Baillie Scott: Two panels in cotton with appliqué on linen, designed by M. H. Baillie Scott and embroidered by Mrs Baillie Scott in coloured silks and gold and silver braid, and glass beads, c. 1896. Baillie Scott was a furniture designer and craftsman who also designed for and wrote on the art of embroidery (see Studio, *XXVIII, 1903, 'Some Experiments in Embroidery', pp. 279ff); most of his designs were executed by his wife.* (PHOTOGRAPH: VICTORIA & ALBERT MUSEUM, LONDON)

Top: *May Morris: Left half of a frieze designed and embroidered on linen.* (PHOTOGRAPH: WILLIAM MORRIS GALLERY, WALTHAMSTOW, LONDON)

Mary J. Newill: 'Una and the Red Knight', two embroidered and appliqué wall hangings, a second version of the hangings originally designed and executed by her for the dining room of E. Butler's house, Top o' the Hill, and for the Paris Exhibition of 1900. The left of these two repeat panels remained unfinished. (WORCESTER COUNTY MUSEUM, HARTLEBURY CASTLE, WORCESTERSHIRE)

separates the different materials'.[70] Another writer in the *Studio* was more enthusiastic:

At Haslemere many years of wisely directed work on the part of Mrs Joseph King and Mr and Mrs Godfrey Blount have resulted in a 'developed industry' of spinning, weaving, and embroidery which, for the quality and variety of its output, may now compare with anything of the kind in this country. The workers have a very real sense of the beauty in texture, colour, and ornament, and their work has the charm and freshness of being deliberately and intelligently done . . . The linen and woollen hangings, household tapestries, and dress goods are as pleasing as ever; and the *appliqué* embroideries show many novelties in design without departing from the breadth and simplicity which have marked them from the first.[71]

In addition to woven and embroidered goods, Haslemere also produced pottery, simple hand-made furniture, baskets, repoussé copper-work, and leatherwork. The embroidery included portières, hangings, bedspreads and banners, many of which were designed by Blount himself.

The work of many women embroiderers was seen at the regular exhibitions of the Arts and Crafts Exhibition Society, whose first show opened in September 1888 at the New Gallery in Regent Street, London. May Morris, who was herself a member of the Society, was a frequent exhibitor, though her designs had often been executed by another hand. Another member of the Arts and Crafts Exhibition Society, closely linked with the Bromsgrove Guild of Handicraft, was Mary J. Newill. She was a skilled embroiderer and designer, a painter and black and white illustrator and designer of stained glass. Her embroidery designs were usually pictorial, and intended for wall-hangings and curtains. She executed several important ecclesiastical embroideries, including a series of panels for a reredos, exhibited in 1896 at the fifth Society Exhibition, the central panel of which was illustrated in the *Studio*. Other designs for church embroideries were illustrated in the same magazine in 1895–6, but while these designs show the influence of Burne-Jones, both in the treatment and choice of large figures, here of angels, Mary Newill's reredos panel shows greater originality. In a contemporary discussion of her work, her embroidery was applauded, for in it:

Birmingham School of Art, Embroidery Class, c. 1900? Mary Newill both trained at Birmingham and, like several of her fellow-students, ended up teaching there; embroidery was one of her specialities. It is interesting to note the designs and instructions on the blackboard at the top of the photograph: the wording mentions constructing with the help of geometry and the arrangement of masses. (PHOTOGRAPH: COURTESY OF ALAN CRAWFORD, BIRMINGHAM SCHOOL OF ART)

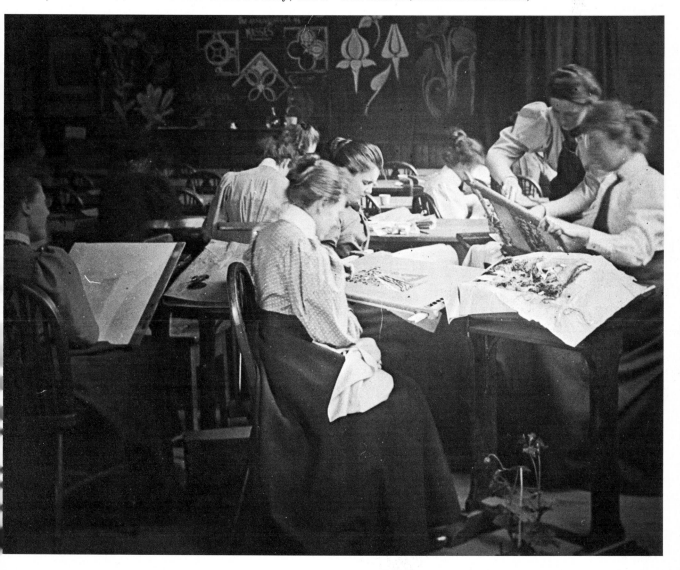

we see that an artist has employed the material simply and with a full sense of its own importance, so that you do not feel that it is a copy of a picture, burlesqued in stitches, but a genuine achievement in the art of embroidery, which by virtue of a fine sense of design happens also to include some pictorial qualities. The panel of an angel . . . is a feast of colour, no less than a most pleasant arrangement of line and mosaic, yet as you study the actual work you are tempted to believe that it grew under the worker's hands almost without reference to previous studies in pencil or colour. This apparent ease is in itself a charm, and when the whole work reveals no careless-

ness in its design or manipulation, the straight-forward impression it gives adds to it an irresistible flavour.[72]

Phoebe Anne Traquair was another important embroiderer to show her work at the Arts and Crafts Society exhibitions, and also in Europe and America. She was born and received some early art training in Dublin, and subsequently travelled abroad. In 1872 she married Dr Ramsay Traquair, and settled in Edinburgh on her husband's appointment to the Natural History Department of the Royal Scottish Museum. Phoebe

Traquair's interests covered an exceptionally broad range of artistic crafts, for in addition to her embroidery she did mural paintings, oils on gesso, metal work and enamelling, bookbinding and illumination. She was a particularly original embroiderer, and her 'most ambitious effort' was a four-fold screen which she began in 1895, completed in 1902 and first exhibited at the Arts and Crafts in 1903:

The four embroideries are the 'Denys' Series. They represent, in an allegorical way, four stages in the spiritual life of man, inspired by the account of Denys L'Auxerrois in Walter Pater's *Imaginary Portraits*. The first panel represents the happy stage of hope and enthusiasm, with innocence and ignorance of the realities of life. In the second, the forces of evil make their appearance and begin to destroy all that is cherished and held dear. In the third, frustration, disillusionment and despair have gained the upper hand. The fourth panel represents ultimate salvation by the grace of Higher Powers rather than by the merits of the individual.[73]

The four panels were individually monogrammed and dated: 1895 *The Entrance*, 1897 *The Stress*, 1899 *The Despair* and 1902 *The Victory*. 'The linen ground is completely covered by fine stitchery in coloured silks and gold thread, and the execution is of an extremely high standard.'[74]

One extremely important group of women designers and embroiderers which, although only indirectly connected to the Arts and Crafts movement proper by most historians, had a crucial impact not only on design for embroidery, but also on methods of teaching it, was that of the Glasgow School of Art. From 1885 the Glasgow School of Art was under the able direction of Francis H. Newbery, trained as a painter at South Kensington but committed to the decorative arts. Under his guidance the School was to achieve an international reputation greater than any other by the end of the century. During 1893 he organised a series of lectures on the decorative arts and inspired by this a group of students gathered under the leadership of Charles Rennie Mackintosh and prepared an exhibition of their products in 1894. Such was the distinction in style and character of their work that it soon became known as the Glasgow Style; more conventionalised in style than most Arts and Crafts designs, and purer in form than Art Nouveau, the Glasgow Style had an underlying geometric structure to its pattern, often relating to a grid format of verticals and horizontals, which was more 'classical' and functional than either of

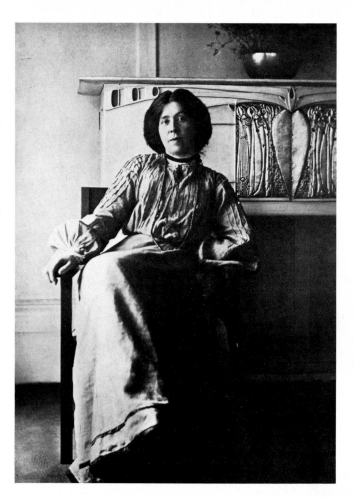

Margaret Macdonald, c. 1900? She is surrounded by Glasgow Group furniture and metal work. (PHOTOGRAPH: ANNAN AND SONS, GLASGOW)

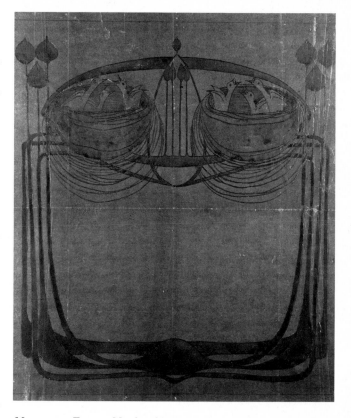

Left: *Phoebe Traquair: Numbers one and four of four embroidered panels in her 'Denys' series, an allegorical representation of the four stages in the spiritual life of man, inspired by the account of Denys l'Auxerrois in Walter Pater's* Imaginary Portraits. *The first panel represents the happy stage of hope and enthusiasm, with innocence and ignorance of the realities of life; in the second, the forces of evil make their appearance and begin to destroy all that is cherished and held dear. In the third, frustration, disillusionment and despair have gained the upper hand. The fourth shows the ultimate salvation by the grace of Higher Powers rather than the merits of the individual. Embroidered in silks, each is signed with an embroidered monogram and dated, (1) 1895 (4) 1902.* (PHOTOGRAPH: NATIONAL GALLERIES OF SCOTLAND, EDINBURGH)

Margaret or Frances Macdonald: Design for embroidery, 'Fledglings'; pen and watercolour on tracing paper, 22½ × 24½ in. (PHOTOGRAPH: UNIVERSITY OF GLASGOW, MACKINTOSH COLLECTION)

123

the other two, more organic styles. The Glasgow colour schemes were original too, using pearly-greys, silvers and lilacs 'set off by marked contrasts of black and white, far removed from the greenish blues and olives of the "aesthetic" movement'.[75] Distinctive lettering was another feature of the style, and was freely used in the embroidery.

Among the women at Glasgow, four were of particular importance with regard to embroidery; the two Macdonald sisters, Margaret and Frances, worked closely with Mackintosh and Herbert MacNair, becoming known as the 'Four'. As a group they were most central to the evolution of the Glasgow Style; Frances and Margaret in particular made designs for embroidery, which were often intended as integral parts of a whole decorative scheme, like those decorating the walls and casement curtains of Mackintosh's famous Cranston Tea Rooms in Glasgow. But the major impetus behind the development of this new style of embroidery was due to the work of Jessie R. Newbery, who married Francis in 1889, and Ann Macbeth. A review in the *Studio* of the Glasgow International Exhibition of 1901, which achieved widespread fame for the style, stressed their originality:

In the Applied Art Division of Women's Industries are exhibited specimens of tapestry and art embroidery from schools of needlework and private individuals . . . Mrs Francis Newbery and other ladies connected with Glasgow School

Fra and Jessie Newbery: Photograph c. 1900? Jessie Newbery trained at Glasgow School of Art, where she met her future husband; she went on to teach embroidery there. (PHOTOGRAPH: GLASGOW SCHOOL OF ART)

have likewise sent to this section work of great charm of design and skill of execution. Up-to-dateness is not usually a feature of designs intended for embroidery, but much of the work on exhibition shows a distinctly modern feeling.[76]

Jessie Newbery, when Jessie Rowat, had been noticed early on as a medallist at South Kensington, and had herself been a student at Glasgow. In 1894 she started a needlework class at Glasgow School of Art, where she continued teaching until 1908. In an article in the *Studio* of 1898, she elaborated on her artistic creed:

I believe in education consisting of seeing the best that has been done. Then, having this high standard before us, in doing what we like to do: *that* for our fathers, *this* for us.

I believe that nothing is common or unclean; that the design and decoration of a pepper pot is as important, in its degree, as the conception of a cathedral.

I believe that material, space, and consequent use discover their own exigencies and as such have to be considered well . . .I like the opposition of straight lines to curved; of horizontal to vertical; of purple to green, of green to blue . . . I specially aim at beautifully shaped spaces and try to make them as important as the patterns.

I try to make most appearance with least effort, but insist that what work is ventured on is as perfect as may be.[77]

Jessie Newbery's designs, which were particularly well suited to the materials used, were conceived initially in terms of colour harmonies, and dealt with problems of balance of colour. Many of them did not involve the endless hours and even years of embroidery that had characterised the more heavily ornamented, large-scale productions of the 1870s and 1880s by the Morris family and their followers. They were simple and direct but also fresh and novel; 'designers will soon discover that their apparent simplicity is the result of real power; their gay and harmonious colour the evidence of an inborn sense of beauty. Above all . . . they preserve the best traditions of the art, and yet never directly imitate early work; and therefore it is possible to praise them very highly, without once over-stating the case, and still less without regarding them patronisingly as a woman's work.'[77]

As here with the work of Jessie Newbery, in discussing women's art writers were constantly faced with the problem of a double standard of criticism, since traditionally women's work was criticised by more lenient standards than those used for men, as they were felt to be incapable of equal quality. In the nineteenth century in particular this seems to have been complicated by calls for a 'womanly' art, necessarily distinct from man's because of all that society attributed to the sex in terms of softness and sentimentality. It is evident that there was a strong sexual division of labour in the Arts and Crafts movement, reflected by the areas of work in which women were encouraged or discouraged, and the fact that Jessie Newbery was designing for a craft considered essentially feminine in character only reinforces this. Thus a double standard existed not only in contemporary attitudes towards work produced by women, but also in the sexual structure of the Arts and Crafts movement as a whole. The *Studio* critic quoted above continued by saying that

Top: *Jessie Newbery: Cushion cover in linen embroidered with coloured wools, designed and executed 1899.* (PHOTOGRAPH: VICTORIA & ALBERT MUSEUM, LONDON)

Above: *Jessie Newbery: Detail of a cushion cover designed and executed by her; rose motif, appliqué on linen, with satin and needleweaving stitches in green, cream and pink silks and a border of drawn thread work, c. 1900. The elongated, slightly geometric, conventionalised style of the Glasgow Group is clearly in evidence here, producing a very particular variant of European Art Nouveau.* (PHOTOGRAPH: VICTORIA & ALBERT MUSEUM, LONDON)

'It is pleasant to remember that [Jessie Newbery's designs] happen to be for a craft which has been pre-eminently the province of women from time immemorial; but they may take their place as examples of well-applied art, with no question of sex, and no attempt to evade criticism by a spurious chivalry which is often but a covert form of insult.' Another writer on the Glasgow School of Embroidery emphasised the same point:

Plying the needle is peculiarly a woman's occupation, suited to her temperament, attuned to her delicate touch, adapted to the sexual arrangement by which she is assigned a more secluded leisure . . . and if in the new order of things it became half forgotten, crowded out of recollection by some less womanly employments and pursuits, the matter might well form a subject for inquiry, but it would be ruled out of court as offering inadequate excitement for a restless age . . . it might be undeterminable whether the new direction of womanly activity is an effect or the cause of lessened interest in the higher domestic arts, but for many and obvious reasons the recent revival of the art of embroidering, so remarkably demonstrated at Glasgow, will be heartily welcomed by all interested in the progress of art and the position of women.[78]

At first Jessie Newbery taught embroidery mostly to students as an extra subject or as an accomplishment, or to girls who hoped to use the skill to earn their livelihood. However, changes were under way that would transform the importance of embroidery teaching when, around 1900, the Scottish Education Department issued regulations for the further training of teachers which made provision for embroidery as an important element in the normal school curriculum. This broadened the field and women teachers throughout Glasgow and the west of Scotland took classes for the instruction of embroidery to children in primary and secondary schools. Many of these women attended Saturday morning classes, where 'there sit about a hundred young women, drawn from the teaching staffs of the Board Schools in the West of Scotland, sacrificing well-earned leisure weekly in the interests of the advancement of a scientific system of art education'.[78] The system of this embroidery instruction was devised by Ann Macbeth, 'Professor of Embroidery' at Glasgow School of Art and 'now working with a magnetic enthusiasm quite irresistible, laying the foundations of a scheme in needleworking that may ultimately develop into a national art',[78] with her assistant Margaret Swainson. Their innovatory method placed great emphasis upon the individual creativity of each pupil, allowing decorative design to grow naturally from the functional elements of the craft:

starting with the first simple stitches made by a child of six, taking note of the developments of plain needlework and the simple elements of decorative design, and making use of such construction lines as seams and hems, to ornament with dots and stitches and other patterns, proceeds later, as the child develops to womanhood, to teach her to correlate drawing and stitching, and finally to produce her own designs.[78]

Ann Macbeth advocated the use of simple inexpensive materials, such as linen, cotton, crash and many of the

125

cheaper fabrics produced by modern production methods, in preference to the more costly, but 'really less artistic', silks and satins so popular with the previous generation of art-embroiderers. A key element in the new scheme was the understanding of the development of a child's eyesight:

The whole system of instruction in sewing in the infant department of schools has been wrong . . . Myopia is prevalent amongst younger girls at school; it is largely caused by setting them the task of making white stitches on a white garment before the eye has reached its proper focussing power, at the age of eleven to twelve. In the system inaugurated by Miss Macbeth the garment is white, but the stitches are coloured, and each row is in a different harmonising colour; the youthful eyesight being thus carefully preserved, while the colour sense is at the same time being cultivated.[78]

The secret of the individual character of much of the art work at Glasgow was the emphasis upon originality of design; copying and imitation were greatly discouraged in students from the start, although a thorough knowledge of traditional designs was considered essential. In addition loan collections of embroidery demonstrating the Glasgow methods were available, and were sent to schools throughout the British Isles and occasionally abroad; by this means the influence of the Glasgow School of Embroidery spread, and provided the foundations of modern embroidery teaching. Ann Macbeth and her staff travelled widely, lecturing and giving classes for teachers in most of the major cities of England and Scotland, including London.

Other agencies in Glasgow were also active in encouraging artistic embroidery; classes were established by Women's Co-operative Guilds, and the Ladies' Art Club held regular exhibitions of applied art in which needlework was a prominent feature. They all worked either in close association with the Glasgow School or under its inspiration. Of all the methods of embroidery used at Glasgow, the most characteristic was the stylised simplicity of appliqué, which was exploited particularly for conventional floral designs, and

Simplicity was also called for in figure work, regarded by Ann Macbeth as 'the highest and most difficult achievement of the craft'. Any slavish copying of a painting was regarded as highly undesirable and it was not considered necessary to treat flesh tints with intricate shading of different tones: 'better to treat the face, for instance, by means of simple and dignified outlines in suitable, neutral tint'. Many figure panels, treated in this way, were executed by Ann Macbeth and her students. They display a breadth of treatment and linear simplicity far removed from the laborious efforts of Phoebe Traquair or many of Walter Crane's elaborate figure panels.[79]

From the earliest years of the Victorian period, and the revival of artistic embroidery, ladies were encouraged to improve their abilities as amateurs, but more importantly for this discussion, were advised and even channelled into the craft when there was a need for dignified remunerative employment for a lady. Needle-

Top: *Ann Macbeth: 'Let Glasgow Flourish', banner designed and worked by her, illustrated in the* Studio, *1910. Presented by the City of Glasgow to the City of Lyons.*

Above: *Ann Macbeth: Detail of an embroidered tablecloth designed and executed by her, Appliqué and satin stitch in silks on linen, c.1900. Ann Macbeth was one of the most influential embroiderers of the period, her ideas on teaching needlework having provided the foundations for all modern methods of teaching the craft.* (PHOTOGRAPH: VICTORIA & ALBERT MUSEUM, LONDON)

work must have been by far the most widespread woman's craft profession in the nineteenth century, with many hundreds of poor, anonymous fingers struggling to earn a living with the needle. Those who, because of their class, had access to a helpful organisation like the Royal School of Art Needlework were definitely at the tip of the iceberg, below which the swelling crowds of eager competitors were too numerous to count. But while artistic embroidery provided large numbers of ladies with a means to independence, laudable in itself, nevertheless the nature and practice of the work reinforced traditional, oppressive notions about women, channelling them into socially acceptable and therefore narrow and conservative patterns of work and so of self-identity.

Above: *May Morris, Jane Morris and Lily Yeats: Embroidered hangings for William and Jane Morris's Elizabethan four-poster bed at Kelmscott Manor, from a photograph by F. H. Evans.* (PHOTOGRAPH: WILLIAM MORRIS GALLERY, WALTHAMSTOW, LONDON)

Night dress case, designed and executed by Lucy Faulkner. Lucy Faulkner and her brother and sister, Charles and Kate, worked with the Morris firm from the beginning, Charles having been a founding director. This was probably a personal rather than a sale item. (PHOTOGRAPH: WILLIAM MORRIS GALLERY, WALTHAMSTOW, LONDON)

Below: *Embroidered wall-hanging executed by the women of the Battye family, design and silks supplied by Morris and Co.* (PHOTOGRAPH: WILLIAM MORRIS GALLERY, WALTHAMSTOW, LONDON)

Left: *Jessie Newbery: Velvet dress decorated with an appliqué panel on the bodice; the rather casual stitching on this piece suggests that it may have been either an early, experimental student work, or that it was intended for a theatrical production.* However, it was not uncommon for Arts and Crafts embroiderers to produce designs for dresses and for embroidered panels to decorate them; the dress styles frequently followed the lead of the Aesthetic dress movement of the 1870s towards simplified quasi-mediaeval designs, which rejected the over-fussy and highly uncomfortable styles demanded by contemporary fashion. *A Dress Designers' Exhibition Society was recorded in the* Art Workers' Quarterly *(Vol. IV, 1905), and it was clearly attempting to reform taste and craftsmanship in clothes; work by Elaine T. and Louise Lessore was commended.* (PHOTOGRAPH: GLASGOW SCHOOL OF ART)

Below: *Candace Wheeler: Printed silk* chiné à la branche *depicting waterlilies, made for Associated Artists,* c. 1885. (PHOTOGRAPH: METROPOLITAN MUSEUM OF ART, NEW YORK)

ARTISTIC EMBROIDERY IN AMERICA

Although many types of embroidery were practised in America in the nineteenth century, such as white work and Berlin wool work, after the influential exhibit of the Royal School of Art Needlework at the Philadelphia Centennial of 1876, artistic embroidery rapidly became the vogue there. Candace Thurber Wheeler was the key figure in this development; her personal reaction to the 'magnificent tent ... constructed of purple velvet hangings, and ornamented with a superb collection of ... embroidery and needlework'[80] crystallised her life and pointed her in the direction of her future fulfilment. Born in 1827, Candace Wheeler was already in her late forties at the time of the Philadelphia Exhibition, but her maturity meant that she was well prepared for her later blossoming.

She had been brought up on a farm in Delhi, a small settlement in Central New York, on the uplands of the Delaware Valley; her family ran a dairy farm and sold skins, and as a child she was familiar with domestic industries such as the spinning and weaving of home-grown flax, cheese and butter-making, meat curing and candle dipping—activities which had almost completely died out in England during the previous century—which gave her a background useful to her later craft work. After her marriage in 1844 to Thomas M. Wheeler, a surveyor, civil engineer and architect, she began moving in New York artistic circles, meeting the most renowned painters of the day, including John La Farge, George Inness and William Chase and the men of the Hudson River School. Through them her artistic training began as she watched them painting and sketching, and learnt the basic principles of colours and of oil glazes. She lived among a wealthy élite, and on her journeys abroad met G. F. Watts, Edward Burne-Jones, William De Morgan (in whose studio she worked on ceramic experiments) and Lawrence Alma-Tadema; she also studied for a time in the studio of a Dresden professor of painting. In 1876 she suffered the tragic loss of her eldest daughter, and the co-incidence of this and the Philadelphia Exhibition spurred her to look for new interests:

Although ... I was apparently absorbed in family life, and country life, and social life ... these things had in themselves elements of wider forms of usefulness; so that now when the

loss came which changed my whole attitude toward life . . . I was not unprepared.[81]

Candace Wheeler suddenly realised that 'the common and inalienable heritage of feminine skill in the use of the needle' could be converted into 'a means of art-expression and pecuniary profit'.[82] On 24 February 1877 five people, including Candace Wheeler, met together to form the New York Society of Decorative Art,

which became the parent of like societies in every considerable city or town in the United States. By its good fortune in having a president who belonged by right of birth, and certainly of ability and achievement, to the best of New York society, the movement enlisted the sympathy and interest of the influential class of New York women, while there was waiting in the shadow a troop of able women who were shut out from the costly gaieties of society by comparative poverty, but connected with it by friendships and associations, often, indeed, by ties of blood.[83]

It is interesting to note the different emphasis in the attitudes of Candace Wheeler and her associates; she found the South Kensington class distinctions, for example, 'malodorous'. The new society would not be based upon the idea of one class helping another, on the contrary it would make 'daily . . . breaches in the invisible wall of prejudice and custom which had separated . . . well-bred women from . . . money gaining enterprise',[84] thus helping to eliminate the notions of philanthropy, and eradicate the traditional stigma attached to paid work for ladies. In addition, the Society of Decorative Art introduced a new and even more radical notion into their aims—that of the importance of work and creativity as a means to psychological independence for women:

Not indeed to prevent starvation of the body, but to comfort the souls of women who pined for independence, who did not care to indulge in luxuries which fathers and brothers and husbands found it hard to supply. So, from what was perhaps a social and mental, rather than a physical, want, grew the great remedy of a resuscitation of one of the valuable arts of the world, a woman's art, hers by right of inheritance as well as peculiar fitness.[85]

Candace Wheeler here introduced the most positive attitude to embroidery as a woman's art to be found in the Victorian period; its closest echoes can be found only in feminist writings today, where the importance of reclaiming traditional women's art forms, and reassessing both them and the rigid classification of the arts which has traditionally placed women's arts at the bottom and male-dominated 'fine' art at the top, are widely under discussion. In the last sentence quoted above Candace Wheeler imparts a new dignity to needlework and to women as its makers by comparison with other writers of the period, who subtly advocate embroidery for women as a means of containing them within socially acceptable craft areas, introducing an element of restraint and condescension from without, whereas Candace Wheeler's discussion reasserts women's rights to control their own history and destiny.

Embroidery was the most important area of activity for the Society of Decorative Art:

Embroidery became once more the most facile and successful of pursuits. Graduates from the Kensington School were employed as teachers in nearly all of the different societies, and in this way every city became the center of this new-old form of embroidery, for what is called 'Kensington Embroidery' is in fact a faraway repetition of old triumphs of the British needle.[86]

Many American women took the opportunity on visits to Europe of taking classes in embroidery at South Kensington, and thus the production of high-quality embroidery spread. But the Americans soon broke away from the style of their English predecessors and English models and designs rapidly disappeared, with the exception of specialist designs like those of William Morris, and American women 'boldly took to the representation of vivid and graceful groups of natural flowers, following the lead of Moravian practice and of flower painting, rather than of decorative design'.[87] Unlike its English counterpart, Moravian embroidery in the United States designated a type of silk embroidery; silks were naturally a more suitable material for the representation of flowers, and in America they soon replaced the English crewel wools. The revival of embroidery gave new impetus to women designers:

American girl art students soon found their opportunity in the creation of applied design, and before embroidery had ceased to be a matter of representation of flowers in colored silks, the flowers grew into restrained and appropriate borders, of proper and correct space decoration, and the day of women designers for manufacturers had come.[88]

Under its influential president Mrs David Lane, the Society of Decorative Art set up a board of managers which included many famous New York women: Mrs Cyrus W. Field, Mrs Abram S. Hewitt, Mrs Bryant, Mrs August Belmont, Mrs William Astor, Mrs Hamilton Fish, and Mrs Louis C. Tiffany. General Custer's widow, seeking profitable employment in New York, was engaged as assistant secretary. The aims of the Society were ambitious and comprehensive:

1. To encourage profitable industries among women who possess artistic talent, and to furnish a standard of excellence and a market for their work.
2. To accumulate and distribute information concerning the various art industries which have been found remunerative in other countries, and to form classes in Art Needlework.
3. To establish rooms for the exhibition and sale of Sculptures, Paintings, Wood carvings, Paintings upon Slate, Porcelain and Pottery, Lacework, Art and Ecclesiastical Needlework, Tapestries and Hangings, and, in short, decorative work of any description, done by women, and of sufficient excellence to meet the recently stimulated demand for such work.
4. To form auxiliary Committees in other cities and towns of the United States, which committees shall receive and pronounce upon work produced in or in the vicinity of, such places, and which, if approved by them, may be consigned to the salerooms in New York.

5. To make connections with potteries, by which desirable forms for decoration, or original designs for special orders, may be procured, and with manufacturers and importers of the various materials used in art work, by which artists may profit.
6. To endeavor to obtain orders from dealers in China, Cabinet Work, or articles belonging to Household Art throughout the United States.
7. To induce each worker thoroughly to master the details of one variety of decoration, and endeavor to make for her work a reputation and commercial value.

The society meets an actual want in the community by furnishing a place where orders can be given directly to the artist for any kind of art or decorative work on exhibition.

It is believed that, by the encouragement of this Society, the large amount of work done by those who do not make it a profession will be brought to the notice of buyers outside a limited circle of friends. The aggregate of this work is large, and when directed into remunerative channels will prove a very important department of industry.

The necessary expenses of the Society for the first, and possibly the second, year will be defrayed by a membership fee of Five Dollars, as well as by donations; but after that time it is expected that all expenses will be met by commissions upon the sale of articles consigned to it.

The contributions of all women artists of acknowledged ability are earnestly requested. By their co-operation it is intended that a high standard of excellence shall be established in what is offered to the public, and, by seeing truly artistic decorative work, it is hoped many women who have found the painting of pictures unremunerative may turn their efforts in more practical directions.

All work approved by the Committee of Examination will be attractively exhibited without expense to the artist, but in case of sale a commission of 10 per cent will be charged upon the price received.[89]

The American style of art embroidery tended to be more colourful than its English equivalent, and a pictorial emphasis characterised the choice of subject. One of the earliest contributors to the Society was Mrs William S. Hoyt of Pelham, whose needle had produced a group of figures in mediaeval costume, worked in a style of stitching which linked the cross-stitch tapestries of the German school with the woven tapestries of France, on a base of a fabric of corded texture. Mrs Oliver Wendell Holmes Jnr. of Boston produced a series of landscape pictures, which she also exhibited in a picture gallery in Boston; she chose bits of weavings and silks for her medium, and used them 'as a painter uses colors upon his palette':

A stretch of pale blue silk, with outline hills lying against it, made for her a sky and a background, while a middle distance of flossy white stitches, advancing into well-defined daisies, brought the foreground to one's very feet. Flower-laden apple branches against the sky were lightly sketched in embroidery stitches, like the daisies. It was a delicious bit of colour and so well managed as to be as efficient a wall decoration as a water color picture.[90]

Mrs Weld of Boston sent in a picture created in much the same way; these women, with Miss Carolina Townshend of Albany and Mrs Dewey of New York, all contributed to the formation of a characteristic and progressive art needlework in America. Candace Wheeler, however, bemoaned the fact that the four main Societies, in New York, Boston, Philadelphia and Chicago, which were all under the direction of English teachers, had been less original in their development than might have been expected, and over-reliant on English models. While the Decorative Art Societies took most of the credit for the revival of high-class artistic embroidery in America, other groups were also important—the Women's Exchange, the Needlework Societies, the Household Art Societies and the Blue and White Industries. In Chicago Mrs Potter Palmer, wife of the multi-millionaire, and a great society queen and avid collector, fostered the establishment of a Needlework and Textile Guild, while in Litchfield, Connecticut, Mrs Emily Noyes Vanderpoel also encouraged the development of artistic needlework. She was herself an accomplished needlewoman and designer, and prompted the Litchfield Historical Society to build up a fine collection of needlework and lace.

By 1879 a School of Art Needlework was well established at the Museum of Fine Arts in Boston, and in that year a publication, *Designs in Outline for Art Needlework*, edited by Lucretia Peabody Hale, was advertised by the School. Here the price of tuition was $5 for six lessons or $8 for twelve, and private lessons were $2 an hour. On Mondays and Thursdays there were free lessons; other classes met on Tuesdays and Fridays, and there was a session on Wednesday for those taking only one lesson a week. Materials and designs were furnished by the School at a moderate price. Familiar names in embroidery appeared on the list of the board of managers: Mrs G. Hammond, Mrs W. B. Rogers, Mrs W. G. Weld, Mrs J. W. Wheelwright, Miss L. P. Hale (who wrote several books on art needlework), and Mrs C. G. Loring. The Committee on design included the following women members: Mrs W. G. Weld, Mrs J. P. Marquand, Miss W. R. Ware, Miss Susan Hale, Miss Annie Dixwell, Miss F. W. Cushing and Mrs J. W. Wheelwright.

Embroidery was well under way at Cincinnati, too, at an early date; specimens of decorative needlework were shown by the School of Design, under Ben Pitman and his daughter Agnes, in the Cincinnati Room of the Women's Pavilion in the Philadelphia Centennial of 1876, before the influence of the Royal School of Art Needlework exhibit at the Centennial could have taken effect. In 1879 the Women's Art Museum Association of Cincinnati rented two rooms on the second floor of a building on the corner of 4th Street and Home Street, to be fitted for the instruction of decorative arts, and embroidery was taught there by Mrs Anthony. Most of the women instructed were from the upper and middle classes of Cincinnati society, and the women running it, as in all the various American needlework organisations, were from wealthy circles. Although many of these organisations were in part or wholly philanthropic—aiding needy gentlewomen or working women—there was not the same sentiment behind the movement as there was in England. Many of the

Candace Wheeler: 'The Miraculous Draught of Fishes', needlewoven tapestry based on the Raphael cartoon in the Victoria and Albert Museum, exhibited in the Woman's Building at the Chicago Columbian Exposition of 1893. From an illustration in Art and Handicraft in the Woman's Building, *(ed.) Maud Howe Elliott, 1893.*

American women were joyfully finding a constructive outlet for their energy and talents; in a society built upon the value of the pioneering spirit, where even women's grandmothers had started from nothing in a new country, wielding shot-guns or axes where necessary as well as the needle, there must have been strong pressures for women to push forward some new frontier, here an artistic one, and make something of their lives.

New ventures were the aim of Candace Wheeler once the Society of Decorative Art was thoroughly established; she wrote that 'While the success of this Society was a source of great satisfaction to me, I had in my mind larger ambitions, which, by its very philanthropic nature, could not be satisfied, ambitions towards a truly great American effort in a lasting direction.'[91] In 1879 Louis Comfort Tiffany offered her a partnership in an organisation he was setting up to 'serve industry, apotheosize most of the handicrafts, bring the cult of art into the finest homes of the country, and raise the level of taste in the industrial arts'.[92] CandaceWheeler had already met Tiffany when his help had been enlisted by the Society of Decorative Arts, where he and Lockwood de Forest opened a class for underglaze china painting; now she was to form a fourth partner with Tiffany, de Forest and Samuel Colman. The latter was a Hudson River painter whom Candace Wheeler already knew; he was a specialist in colour decoration, textiles and Oriental art. Lockwood de Forest was an expert in carved and ornamental woodwork and Oriental colour and design. Louis Tiffany's own special interest was in the development of new forms of glassware. All their specialisations were, however, united towards the central aim of the firm, which was called Associated Artists at Candace Wheeler's suggestion, to produce artistic and unified interior decoration. In this way Candace Wheeler was one of the first women to work as an interior decorator, opening up a profession in which

many women were to follow. Her job at Associated Artists was to supervise the production and design of embroideries, needle-woven tapestries and loom weaving:

As I was the woman member of this association of artists, it rested with me to adapt the feminine art . . . to the requirements of the association . . . It meant the fitting of any and every textile used in the furnishing of a house to its use and place, whether . . . curtains, portières, or wall coverings. I drew designs which would give my draperies a framing which carried out the woodwork, and served as backgrounds for the desired wreaths and garlands of embroidered flowers.[93]

The embroidery rooms were in the lofts of their Fourth Avenue premises, and production included hangings of opalescent plushes, embroideries in gold and silk, friezes embroidered on plush, wall-hangings, panels of appliqué and mantel lambrequins; in the production of every article fitness for purpose, colour and largeness of idea were the guiding principles. The first major commission undertaken by the embroidery department, but involving the whole group, was for the drop-curtain of the new Madison Square Theatre, which opened in February 1880. The curtain depicted a realistic scene of a woodland vista, and was an unusual treatment of appliqué. Tiffany supervised the design, Colman the colour and de Forest the materials while Candace Wheeler directed the execution. The landscape was carried out in velvet and plushes for the trees, shadowy silks for the perspectives and iridescent stuffs for the misty-blue distance. Following this success, Associated Artists decorated the Veteran's Room and Library of the Knickerbocker Greys' new armoury building on Park Avenue, for the sum of $20,000. They set out to provide an atmosphere which would have meaning to the future occupants of the rooms, and would embody the ideals of the veterans. With her lush hangings, portières and curtains Candace Wheeler suggested the days of knights and romantic warfare, evoking chain-mail and slashed doublets; her embroideries were heavy with banded plush, sparkling with steel and brass, and rings of gold and silver embroidery. The four partners always tried to find a theme or motif in their decorative schemes which related to the owner or purpose of the rooms on which they were working.

Perhaps the most famous of Candace Wheeler's productions for Associated Artists was the set of bed-hangings for Lily Langtry's London hotel bedroom:

Then one day appeared Mrs Langtry in her then radiance of beauty, insisting upon a conference with me upon the production of a set of bed-hangings which were intended for the astonishment of the London world and to overshadow all the modest and schooled productions of the Kensington [school], when she herself should be the proud exhibitor. She looked at all the beautiful things we had done and were doing, and admired and approved, but still she wanted 'something different, something unusual'. I suggested a canopy of our strong, gauze-like, creamy silk bolting-cloth, the tissue used in flour mills for sifting the superfine flour. I explained that the canopy could be crosses on the underside with loops of full-blown, sunset-coloured roses, and the hanging border heaped with them. That there might be a coverlet of bolting-cloth

lined with the delicatest shade of rose-pink satin, sprinkled plentifully with rose petals fallen from the wreaths above. This idea satisfied the pretty lady . . . and when her order was completed, she was triumphantly satisfied with its beauty and unusualness. The scattered petals were true portraits done from nature, and looked as though they could be shaken off at any minute.[94]

Candace Wheeler continued searching for ever more ambitious, truly American styles of embroidery; her great challenge was to perfect a type of needle-made tapestry, and in March 1882 she filed her first English patent for her invention of 'Important improvements in Needle Woven Tapestry and in Fabric Therefor', and followed it with two patents in America. The method was used for a series of tapestry pictures for Cornelius Vanderbilt the Younger, which were designed by her daughter Dora and entitled *The Air Spirit, The Water Spirit, The Winged Moon, The Flower Spirit* and *The Birth of Psyche*; they were finished in time for an Art Loan Exhibition in December 1883.

By this date Candace Wheeler had decided to break away from the group at Associated Artists, which had in any case become fragmented since de Forest was spending most of his time in the Far East, and Colman was established at Newport. She took the name of Associated Artists with her, and the company remaining was called simply Louis Tiffany and Co. She established the business again in an old four-floor, brown-stone building at 115 East 23rd Street. It was to be conducted exclusively by American women for the decoration of American interiors and she collected a 'unique little band of accomplished American gentle-women',[95] including her daughter Dora who was both a designer and a talented painter and had trained in William Chase's 10th Street Studio as well as in Germany and Paris. Rosina Emmet was her second assistant designer, who like Dora had studied with Chase, and also at the Academy Julien in Paris, and who had begun her career as a china painter. The two younger women furnished the figure subject designs, while Ida Clark, who had trained mostly with Candace Wheeler, produced the more conventional designs. No girl was hired unless she had a special talent for composition, and knew how to draw. Concerned as she was with the study of ancient fabrics, Candace Wheeler devoted her time to producing appropriate fabrics for the modern market, in addition to the firm's work of embroidery and embellishing such fabrics. She believed in an indigenous American design, which would suit the temperament and needs of the people. To this end she used American flora and fauna for patterns, designs based on traditional American patchworks—'Moorish' styles which were merely patchwork designs raised to a higher level of artistic taste, and other themes derived from the particular characteristics of her particular patrons. She was responsible for making considerable improvements in the quality of American textile design in general, and for creating a high reputation for women designers who were producing the new designs.

By the early 1890s Associated Artists were tackling almost as wide a range of work as the firm had done under Tiffany. Candace Wheeler's greatest moment came with the Columbian Exposition of 1893 in Chicago, for which she was made Director of the Applied Arts exhibit in the Woman's Pavilion, and Colour Director of the building itself. In keeping with the sky and water outside the great window of the library room in the Pavilion, she decorated it in modulations of blue and green. A ceiling decoration was painted by her daughter Dora, Associated Artists designed and manufactured a dozen chairs and a sofa for the room, and four large oak chairs and several library tables were borrowed from Sypher and Co. Busts of famous women executed by women were included, and Rookwood and hammered brass vases added the final touches of detail. In order to select the Applied Arts exhibits, Candace Wheeler held a Preliminary Exhibition in New York in March 1893, and from it she selected over 450 articles for the Chicago Exposition. The display of course included examples of work by Associated Artists, the prize item being a needle-woven tapestry copy of Raphael's *Miraculous Draught of Fishes*, which was shown under glass in the north wing of the Women's Pavilion. On a summer visit to London, Candace Wheeler had studied the cartoon in the South Kensington Museum:

I had two photographs, as large as possible, made from the cartoon, and one of them, being very faintly printed, copied exactly the color; the other was ruled and cut into squares, and was again photographed and enlarged to a size which would bring them, when joined, to the same measurements as the original cartoon. These, very carefully put together, made a working drawing for my tapestry copy, and the lighter photograph, which had been most carefully water-colored, gave the color guide for the copy. It was interesting to find the perforations along the lines of the composition still showing in the photographed cartoon, and we made use of them by going over them with pin pricks, fastening the cartoon over the sheet of silk canvas woven for the background, so that there was no possibility of shifting. Prepared powder was sifted through the lines of perforation and fixed by the application of heat, and then we had the entire composition exactly outlined upon the ground. After that the work of superimposing color and shading by needle weaving was a labor of love and diligent fingers during many months.[96]

Among the themes used by Associated Artists and designed by Dora Wheeler for the needle-woven tapestries were ones based on American history and the legends of the North American Indians, like Minnehaha and Hiawatha. They concentrated on American subjects wherever possible:

Fifteen years ago, no American manufacturer thought of buying an American design for his carpet, or wall-paper, or textile. The usual thing to do was to buy a yard of French or English material, and reproduce its color and design. To-day the manufacturers all agree that the most popular designs they can furnish are made by our native designers, who are, to a very large extent, women.[97]

At the turn of the century, when she was in her early seventies, Candace Wheeler handed over the business to her son Dunham Wheeler, and concentrated her energies on writing down all her ideas on embroidery,

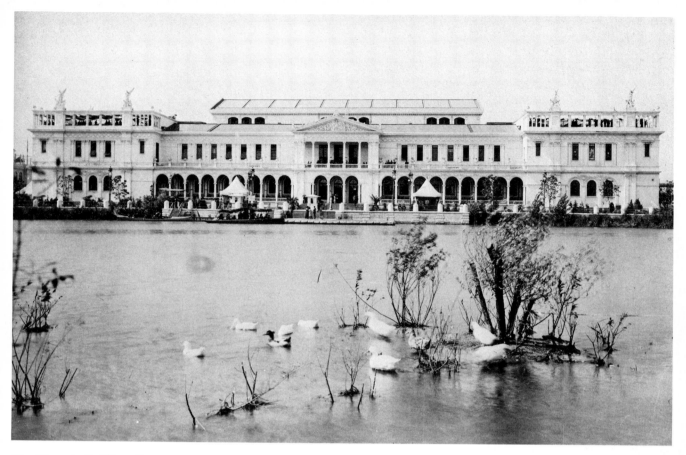

The Woman's Building, World's Columbian Exposition, Chicago, 1893; Sophia Hayden, Architect. Candace Wheeler was one of the women responsible for the design and decoration of the interior.
(PHOTOGRAPH: CHICAGO HISTORICAL SOCIETY, CHICAGO, ILLINOIS)

interior decoration and design, and to delighting in her garden in Onteora in the Catskills; on her eightieth birthday she announced that she was moving to the warmth of the south, to Georgia. After 1907 Associated Artists closed its doors, and she blamed her son for its failure. However, times were changing, and with it American taste, which was in fact largely responsible for the closure of the company, like so many others of its type. But embroidery lived on, and she was able to conclude in 1921:

Embroidery has become a dependence and a business for thousands of women, and it is this which secures its permanence. We may trust skillful executants who live by its practise to keep ahead of the changing fancies of society and invent for it new wants and new fashions. And this, because their chance of living depends upon it, and it promises to be a permanent and growing art. It may, and will, undoubtedly, take on new directions, but it is no longer a lost art. On the contrary, it is one where practice has attained such perfection that it is fully equal to any new demands and quite competent to answer any of the higher calls of art.[98]

The revival of American Blue and White work is the last major area in artistic embroidery in that country which must be discussed. Conceived by two young painters, Margaret C. Whiting and Ellen Miller, the Deerfield Blue and White Industry was established in the town of that name in Massachusetts in 1896. Both women had studied in New York and settled in Deerfield

with the express idea of reviving the traditional early eighteenth-century embroidery which had flourished in New England in colonial times. Although this was an artistic revival, it was perhaps associated more closely with the Colonial revival than the Arts and Crafts movement. The women set themselves up in an ancient house called Godfrey Nims Homestead, which became the centre of the Industry and was where all the embroideries were made:

The two revivalists found a sympathetic understanding of their objective and full co-operation was extended to them by their neighbors. At that time, too, other artists joined the community inspired by George Fuller's landscape paintings of Deerfield ... Deerfield Academy ... was fostering and continuing the finest values of the pioneering spirit through its able director, Mr Frank L. Boyden. Thus a beautiful unity of interest existed in the town which enabled Miss Whiting and Miss Miller to proceed with the establishment of a group of Deerfield women to embroider together for the creation of the blue and white needlework.[99]

The two women sought patterns and ideas in the surviving embroidery to be found in the community:

In every homestead were to be found bits of old needlework, scraps of lace made in later and more peaceful years, secrets in old notebooks, early dye formulas. All provided a wealth of ideas full of interest to these two women who, fired with zeal, proposed to take the helm and steer American needlework out of the doldrums of bad taste and poor design, back into its former glory by building an interest in the fundamentals of good design as expressed in the simpler examples of early American blue and white embroidery.[99]

The traditional embroidery was worked in crewel

133

wools, but the women substituted flax for the thread, and imported Russian linen for the earlier homespun wool foundation. Designs were derived from early colonial bedcovers, embroidered in the mid eighteenth century; although cruder than their early English equivalents, the patterns were often charming and distinctive. Margaret Whiting copied traditional examples for re-use, concentrating on early, simple ones, rather than the atypical, more sophisticated designs from the late eighteenth century. Flax was used to prevent destruction by moths—a hazard which had destroyed many of the old embroideries—although the traditional wool was easier to use, and Margaret Whiting explained that mistakes were harder to hide with the flax. Her fine art training gave Miss Whiting a particularly good sense of design in re-using the old patterns, which she did extremely well. She also made a series of careful experiments on suitable dyes to recreate the old colours, even turning to old formulas for clues; the blue colour was particularly sensitive, the atmosphere alone being enough to affect changes in tone. 'The blues finally achieved are absolutely identical with the colorings of the eighteenth-century pieces, and provoked deep admiration from women everywhere when embroidered into the new designs.'[99] In addition to the indigo, other colours were tried, and eventually dyes produced from madder, fustic and bark, supplemented by some imported colours, were included in the range.

The industry flourished for twenty years, and 'Deerfield Blue and White' became famous all over America; however, problems of importing the linen were created by the advent of the First World War, and eventually the industry died out in 1925. It was evidently a craft practised by the local housewives and probably working women, run by two trained and competent middle-class women, and although its aims were patriotic rather than philanthropic, the Deerfield Industry seems to have been similar to Langdale in England in its organisation.

NOTES

1. Rosie Parker, The Word for Embroidery was WORK, Spare Rib, no. 37, July 1975, p. 41.
2. ibid. p. 42.
3. Catherine Hall, The History of the Housewife, Spare Rib, no. 26, June 1974, p. 10.
4. Parker, op. cit., p. 42.
5. ibid.
6. Quoted in ibid., p. 44.
7. Anonymous, un-dated sampler, probably nineteenth century, reproduced in Gleeson White, The Sampler, Studio, Special Number, vol. 5, Winter 1896–7, p. 69.
8. Sampler by Sarah Vincent, 1827, in the possession of Ruth Pavey, London.
9. Parker, op. cit., p. 44.
10. Lady Marian Alford, Needlework as Art, London, 1886, p. 54.
11. Parker, op. cit., p. 44.
12. ibid., p. 43.
13. George Wallis, Machine Embroidery, Journal of the Society of Arts, 1859, summarised in Barbara Morris, Victorian Embroidery, London, 1962, p. 73. Wallis was then Head of Manchester School of Design.
14. See Ivy Pinchbeck, Women Workers and the Industrial Revolution 1750–1850, London, 1930, pp. 209ff.

15. Parker, op. cit., p. 44.
16. Lee Holcombe, Victorian Ladies at Work, Newton Abbot 1973, p. 14.
17. The Female School of Design, Journal of Design, September 1851, p. 30 and The Female School of Art, Art Journal, 1861, p. 158.
18. The Royal School of Art Needlework, Magazine of Art, 1882, p. 219.
19. Lady Marian Alford, op. cit., p. 396–7.
20. ibid.
21. Lady Marian Alford, Vice President's Report to H.R.H. the President and Council, 1875; quoted in Morris, op. cit. p. 115.
22. The Royal School of Art Needlework, op. cit., p. 220.
23. Morris, op. cit., p. 115.
24. Art-Needlework in connection with Furnishings, Furniture Gazette, vol. 5, 1876, p. 205.
25. The Royal School of Art Needlework, op. cit., p. 220.
26. London County Council Education Committee Minutes, London, 1908, p. 13.
27. The Royal School of Art Needlework, op. cit., p. 220.
28. ibid.
29. A.W.N. Pugin, On the Present State of Ecclesiastical Architecture in England, 1843; quoted in Morris, op. cit., pp. 85–6.
30. Quoted in Morris, op. cit., p. 87.
31. Parker, op. cit., p. 44.
32. Philip Henderson, William Morris, His Life, Work and Friends, London, 1967, p. 36. Webb also worked in Street's office at this time.
33. ibid. Morris, op. cit., p. 95 gives the source as a note from Jane Morris to J. W. Mackail, Morris' first biographer. The piece now hangs at Kelmscott Manor.
34. Morris, op. cit., p. 95.
35. ibid., p. 96.
36. Philip Henderson (ed.), Letters of William Morris, London, 1950; letter of 10 March 1869, p. lxi.
37. Henderson, op. cit., p. 50.
38. Morris, op. cit., p. 96.
39. Quoted in ibid., p. 97.
40. Morris & Co., 1861–1940, Arts Council catalogue, 1961, p. 15.
41. Georgiana Burne-Jones, Memorials, London, 1904, vol. 1, p. 213.
42. Letter to his sister of 10 March 1869, quoted in Morris, op. cit., p. 97.
43. Morris, op. cit., pp. 99–100. Morris' letter to Mrs Holiday is quoted from P. Henderson (ed.), Letters of William Morris, London, 1950.
44. Morris, op. cit., p. 100.
45. Henderson, op. cit., p. 156.
46. Morris, op. cit., pp. 99. The design was illustrated in Lewis F. Day, William Morris and his Art, Art Journal, Easter Annual, 1899.
47. Morris, op. cit., p. 110.
48. G. H. Wood, The Course of Women's Wages during the 19th Century, from B. L. Hutchins and A. Harrison, History of Factory Legislation, London, 1903, Appendix p. 65.
49. Art Needlework, II, Magazine of Art, 1880, pp. 180–1.
50. Dorinda, Needlework for Ladies, London, 1883, p. 116. For a reprint of the entire register, see Morris, op. cit., pp. 193–207.
51. Art Needlework, II, op. cit., pp. 181–2.
52. ibid.
53. Dorinda, op. cit., p. 115.
54. Parker, op. cit., p. 43, with a quotation from John Berger, Ways of Seeing, London, 1974, p. 83.
55. Parker, op. cit., p. 43, with a quotation from George Paston (pseudonym for Emily Morse Symonds), Little Memoirs of the 18th Century, London, 1901.
56. Parker, op. cit., p. 44.
57. Quoted in ibid.
58. May Morris Decorative Needlework, London, 1893, p. 22.
59. The Royal School of Art Needlework, op. cit., p. 219.
60. Furniture Gazette, 21 August 1880, p. 109.
61. Dorinda, op. cit., pp. 117ff.
62. Morris, Victorian Embroidery, op. cit., pp. 118–19.
63. Barbara Russell, The Langdale Linen Industry, Art Journal, 1897, pp. 329–330. Fleming was actively encouraged by Ruskin, who since 1870 had been promoting the revival of handweaving.

64. *ibid.*, p. 330.
65. *ibid.*, p. 331.
66. *ibid.*, p. 332.
67. K. Parkes, The Leek Embroidery Society, *Studio*, vol. I 1893, pp. 136–40.
68. Morris, *Victorian Embroidery, op. cit.*, p. 120.
69. *ibid.*, p. 68.
70. Quoted in *ibid.*
71. Studio-Talk, *Studio*, 1903, vol. 29, pp. 125–6.
72. E. B. Strange, Some Aspects of the Work of Mary L. [*sic*] Newill, *Studio*, 1895, vol. 5, pp. 60–63.
73. *National Gallery of Scotland Catalogue*, 1957, p. 273.
74. Morris, *Victorian Embroidery, op. cit.*, p. 145.
75. *ibid.*, pp. 147–8.
76. Glasgow International Exhibition—Part II, *Studio*, 1901, vol. 22, p. 169.
77. Gleeson White, Some Glasgow Designers and Their Work, *Studio*, 1898, vol. 12, p. 48 and p. 51.
78. J. Taylor, The Glasgow School of Embroidery, *Studio*, 1910, vol. 50, pp. 124–7, p. 128 and p. 131.
79. Morris, *Victorian Embroidery op. cit.*, p. 159.
80. Candace Wheeler, quoted in M. B. Stern, An American Woman First in Textiles and Interior Decoration—Candace Wheeler, *We the Women*, New York, 1963, p. 273.
81. Quoted in *ibid.*, p. 277.
82. Quoted in *ibid.*, p. 273.
83. Candace Wheeler, *The Development of Embroidery in America*, New York and London, 1921, pp. 109–110.
84. Quoted in Stern, *op. cit.*, p. 278.
85. Wheeler, *op. cit.*, p. 107.
86. *ibid.*, p. 110.
87. *ibid.*, p. 111.
88. *ibid.*, pp. 111–12.
89. *ibid.*, pp. 112–14.
90. *ibid.* p. 116.
91. *ibid.* p. 121.
92. Stern, *op. cit.*, p. 280.
93. Wheeler, *op. cit.*, p. 122.
94. *ibid.*, pp. 123–4.
95. Sterne, *op. cit.*, p. 288.
96. Wheeler, *op. cit.*, pp. 133–4.
97. Candace Wheeler, Applied Arts in the Woman's Building, in Maud Howe Elliott (ed.), *Art and Handicraft in the Woman's Building*, New York, 1893, p. 64.
98. Wheeler, *op. cit.*, pp. 142–3.
99. Georgina Brown Harbeson, *American Needlework*, New York, 1938, pp. 153–4.

4 Lacemaking

Lace collar in Honiton pillow lace, designed by Lewis F. Day, c. 1900. Probably made in Honiton, this example shows the combined talents of traditional lace-makers and an Arts and Crafts designer; many well-known designers used their skills to help in the lace revival by providing new, appropriate designs for the medium. Others concentrated on reintroducing good traditional designs which had died out through lack of use and of expert lace-makers to produce them. (PHOTOGRAPH: VICTORIA & ALBERT MUSEUM, LONDON)

IN THE NINETEENTH CENTURY, lacemaking was a craft practised predominantly by poor working-class women and girls, although like embroidery it had traditionally been a pastime of the aristocracy since the Middle Ages. Like embroidery too, it had its origins in the church:

During the early ages, lace was entirely made in the convents, exclusively for the Church and its ministers, and little of it therefore was known by the laity; indeed, severe were the restrictions imposed by the bishops on the nuns who worked for other than ecclesiastical purposes.

At the period of the Renaissance, when art was gradually emancipating itself from the Church, the making of lace still remained in the convent, but the nuns teaching the art to their lay pupils, the knowledge soon spread to the outside world, and lace-making formed the principal occupation of the ladies of the day. In feudal times it was the custom for knightly families to send their daughters to the castles of their suzerain lords, there to be trained in all female accomplishments. Here the lady *châtelaine* presided over the work, and taught the 'maidens' who surrounded her the gentle and noble art of the needle, their labours beguiled by the 'chansons à toile', as the ballads composed for the occasion were termed.[1]

Lacemaking was at that date no 'vulgar trade' and the surviving seventeenth-century Venetian pattern books were probably published solely for the use of noble-women:

The richness of the complicated patterns, the dedication of the books to queens and other high-born ladies, prove they were for the use of such as these rather than for manufacture, and confirm the conclusion that lace was not then a commercial speculation, but an agreeable occupation in which ladies employed their hours of leisure, and at the same time provided themselves with a new ornament for their dress.[2]

True lacemaking, needle lace and bobbin lace, were both well-established trades in their country of origin, Italy, by the fifteenth century. The best lace traditionally came from Venice, and with its spread to France became of great economic importance to that country, as also to Belgium. In the second half of the seventeenth century, Louis XIV's minister Colbert took great trouble to attract skilled Italian lacemakers to France, to encourage the growth and perfection of the craft there. The first settlers came to Alençon, and by the end of that century a distinctive style, known as *point d'Alençon* had evolved—a needle-made as opposed to a bobbin lace. By the end of the seventeenth century the number of lacemakers in the district had risen to 9,000, and many other lacemaking areas had sprung up throughout France.

Lacemaking had spread rapidly to Belgium, and bobbin lace was being made there as early as the 1580s; Antwerp was an important centre of the lace industry, and in Brussels it was already a large-scale industry by the early sixteenth century. Pillow or bobbin lacemaking was unknown in England until the middle of the sixteenth century, although lace of other sorts had been made from at least Anglo-Saxon times. In early times its production was limited to ecclesiastical needs, and did not constitute an industry as such, and the term 'lace'

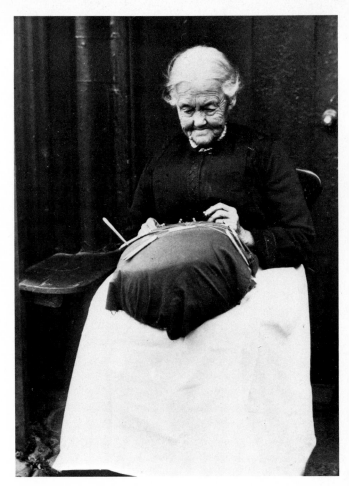

Mary Slater, Honiton lace worker, c. 1900. (PHOTOGRAPH: THE OLDE LACE SHOPPE, HONITON, DEVON)

probably indicated drawn thread or cut work. In the 1560s the exodus of refugees from religious persecution in the Low Countries meant that many lacemaking Protestants settled in England, bringing their skill with them, and passing it on to the local people. Two chief areas of lacemaking grew up, in Devon, and in the Midland counties of Buckingham and Bedfordshire.

In both areas lacemaking was essentially a cottage industry, practised by the agricultural classes, and particularly by women, to supplement meagre land-labouring wages or, in Devon, an income from fishing. By the eighteenth century lace schools were wide-spread, but even in the nineteenth century they offered little in the way of teaching beyond the training in pillow lacemaking. The 'school' was generally just a room in a cottager's house set aside for the purpose, where up to thirty children, mostly girls, were crowded in for lessons. The hours were usually from 6 am to 6 pm in summer, and 8 am to 8 pm in winter; charges varied from 2d to 6d a week per child, and sometimes an extra ½d or 1d was charged for boys, who were more reluctant to learn than their more docile sisters. Even in winter, fires were not used to avoid soiling the lace, and many women used 'dicky pots' to keep warm—unglazed earthenware vessels shaped like chamber pots, into which were put glowing embers, the whole being placed beneath the woman's skirts to keep her warm from below. This was only one of the practices of lacemaking which were considered injurious to health; the posture

required by the craft, particularly when begun at such a tender age, also posed problems:

An awkward posture had to be adopted by the worker to accomodate the cushion and in the 1860s one lace-buyer in the Thame area noted that lacemaking caused 'the shoulders and neck [to] ache so'. She noted also that 'lacemakers [complained] a good deal of pain in the side ...'. However, particularly harmful was the practice adopted by some of wearing a 'strong wooden busk in their stays to support them when stooping over their pillow-laces; this, being worn when young, while the bones [were] yet soft, [acted] very injuriously to the sternum and ribs causing great contraction of the chest'.[3]

Children of five or six worked for between four and eight hours a day, graduating by the age of twelve to fifteen years up to twelve or even sixteen hours a day in some cases. In the close and airless atmosphere of the schools, many children rapidly became pale and sick; many fell victim to consumption. The Factory Act and Education Act placed increasing limitations on the activities of the lace schools, which gradually declined; but Inspectors were often lax, and people infringed the laws. In addition, laws like the 1867 Workshops Regulation Act, although they eased the hours and conditions of female and child labour, did nothing to affect the lot of the many women working from their homes.

One writer in 1900 speculated on the folly of teaching lacemaking to boys, referring to the eighteenth-century English schools:

It is interesting to note that boys were taught the handicraft as well as girls, and many men when grown up followed no other employment, which seems to us an economic mistake, as there are so many trades suitable for men, so few for women as home workers.[4]

In fact, few men stayed voluntarily in the trade, most when old enough going into the fields as agricultural labourers or to sea as fishermen; the pay was too poor to attract them except where there was no alternative. In winter, when the seas were too rough for fishing, the Devonshire men frequently returned to lacemaking for ready cash. But emphasis was placed on the suitability of the craft for women, and its practicality, in that it did not involve the woman going outside the home for her income, was stressed. As with the grinding labour of 'sprigging' and embroidery on point net, women were helpless in their inability to organise against their conditions, and though in the lace trade there was less isolation—women often worked in groups, both for friendship and to economise on lighting in winter—they were at the mercy of their agents. Agents both collected made-up lace to be sold in London, and supplied new thread to the workers. Even when the price of lace was low, they still charged high prices for thread, threatening to refuse to buy a woman's lace if she stopped using her agent's thread. The truck system of payment was also widely used to exploit workers, who were often paid as much as fifty per cent in kind; this payment in kind often took the form of credit at the agent's shop, which would over-charge for ordinary goods. The larger agents from London simply deducted the cost of materials from the lacemakers' earnings, often charging one third or more of their entire income. Thus the women were not well placed to bargain for reasonable wages, or to assess the market value of the materials.

In the eighteenth century, lacemaking was still a pastime of the upper classes. 'Point lace was worked at this time by the upper classes all over England; they learnt the art in France, where so many girls amongst the upper middle classes were educated in the 18th century. This lace was generally worked by the wearer for her own use and was never an article of commercial value.'[5] By the nineteenth century such women had, on the whole, become the great patrons of the craft, attempting through their interest to reverse the declining fortunes of the hand-lacemakers:

Early in the 19th century royal favour was sought for the laceworkers in Devonshire, who had been much distressed by the introduction of machine-made net, and Queen Adelaide gave an order for a complete dress to be made of Honiton sprigs; these were mounted on machine-made ground, so that both industries were benefitted, for it was realized that the struggle between manual labour and invention could only have one result, and it would be useless to attempt to bolster up a dying industry such as that of the hand-made net.[6]

Mechanisation of the craft had begun as early as 1809 with the invention by John Heathcoat of a machine which could produce a net which was similar to bobbin-made mesh. He took out a fourteen year patent on it, and began production in a factory near Loughborough in Leicestershire. By 1815 he also had a factory at Tiverton in Devon, and when in 1816 Luddite rioters wrecked most of his machinery in Loughborough, he moved the remnants of the factory to his Devon premises. It was hardly surprising that the hand-workers resented the coming of these machines, which were a fore-taste of the doom overtaking their trade. By 1822 over 1,500 workers were employed at the Tiverton factory, and the following year, when his patent expired, many rushed into the production of machine-made nets. Competition pushed the prices down further, and hand-net makers quickly became extinct.

In 1837, the Jacquard system was incorporated into net-producing machines, enabling patterns to be worked into the net; thus began the rise of machine embroidery which was to put the hand-workers out of business. The centre of the machine trade was at Nottingham, on the edge of the hand-needlework area of the Midlands, and its presence had a disastrous effect on the local workers. The lacemaking population of this area declined rapidly: by 1891 there were only just over 3,000 where forty years earlier there had been over 26,000. The Midlands district had always concentrated on the cheaper and less skilled types of lace, making mostly trimmings; unlike the more advanced art of Devon lace, they never attempted to compete with the fine European laces. The lacemakers tried to compete with the machine-made product by working ever cheaper and coarser laces; but their attempts were futile. As many writers suggested, the only way to resist extinction was to exploit the advantages of the hand-made over the machine-made, improving quality

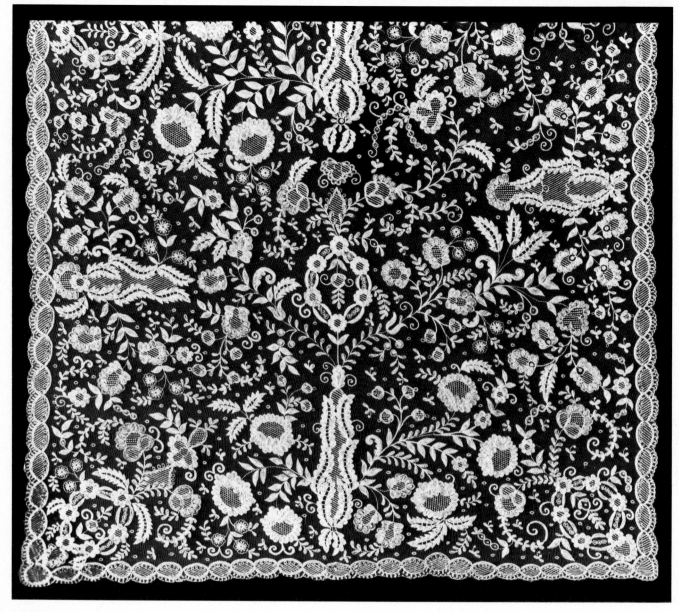

and design and selling the result expressly as an expensive art fabric.

However, because of the scattered nature of the lacemaking industry, it was difficult to control the quality of hand-made lace, and patterns often deteriorated with frequent use and copying by workers who had no knowledge of drawing. The designs were also often out of date and unfashionable by as much as twenty-five years. Mrs E. Treadwin of Exeter was one of the few lace dealers to be concerned with quality and to exercise some control over the taste of her workers; she produced 'standard pieces up to which her workers have to work. She rather complained that taste in the workers had not been cultivated for the benefit of manufacture. The wholesale trade has encouraged hastily-produced laces of poor quality'.[7]

Mrs Bury Palliser was another to bemoan the loss of quality; she saw fruitless competition with the machines as responsible for the decline:

Ever since the Great Exhibition of 1851 drew attention to the industry, different persons have been trying to encourage both better design and better manufacture, but the majority of people have sought a livelihood by meeting the extensive

Detail of a panel of machine-made net, embroidered with cotton thread. Made by a surviving worker of the tambour lace industry at Coggeshall, Essex, late 19th century, width 29 in. The net, which is of hexagonal mesh, is closely covered with a pattern of leafy stems bearing large and small flowers, springing from wreaths and ornamental devices; the intervening spaces are semé with small circles. There is a repeating narrow border all round of oval compartments, and the edge is slightly scalloped. (PHOTOGRAPH: VICTORIA & ALBERT MUSEUM, LONDON)

demand for cheap laces. Good patterns, good thread and good work have all been thrown aside, the workers and small dealers recking little of the fact that they themselves were undermining the trade as much as the competition of machinery and machine-made lace, and tarnishing the fair name of Honiton throughout the world, among those able to love and appreciate a beautiful art.[8]

The craft suffered from a dearth of good designers at a time when the Victorians were becoming increasingly aware of the importance of good design. In both design and quality the English laces were hard put to compete with the French and Belgian products. The lack of designers was particularly evident in slack periods in the craft:

On my visit to the pillow lace districts, I was told that in more prosperous times lace-buyers employed pattern drawers or designers; but since the decline of the manufacture, they have discontinued to do so; and I had great difficulty in finding a designer for pillow lace—I only succeeded, indeed, in obtaining the names of two.[9]

These designers were well-known to concern themselves only with good quality lace, so that 'the greater quantity of lace is made from very inferior parchments'. The patterns were made by pricking the relevant pinholes into a suitably sized piece of parchment. Another serious problem faced by lacemakers was the frequency with which dress fashions changed, causing the rapid rise and fall in popularity of different styles and types of lace, often leaving the lacemaker with unsaleable goods or ones which had to be adapted with new variations.

High quality, skilled lace was traditionally the province of the best Devon lacemakers, and although declining demand and increased mechanisation made inroads into the craft, it seems to have been less desperately hit than the Midlands area, as its products still retained values not found in the machine-made

Jacquard Power Looms: Stuff-manufacture. In 1837 machines using this system were incorporated into net-producing machines (which had come in early in the century), enabling patterns to be worked into machine-made net. This was the beginning of the end of both embroidery on net and traditional lacemaking. (PHOTOGRAPH: VICTORIA & ALBERT MUSEUM, LONDON)

lace. Following Queen Adelaide's example, royal commissions came every few years to Devon; Queen Victoria's patronage of Honiton lace for her wedding dress in 1840 'inaugurated a revival of Honiton lace which had taken advantage of the possibilities of machine-made net as a foundation[10] in the same way as Brussel's appliqué lace.' Victoria's daughters, the Princess Royal, Princess Alice and the Princess of Wales, were all married in Honiton lace of naturalistic designs, featuring national flowers. Other attempts to improve design standards included the use of copies from older types of lace, and Mrs Palliser recorded that in the 1870s Devon lacemakers began to restore and re-make ancient lace:

It is curious to see the ingenuity they display in re-arranging the old 'rags'—and such they are—sent from London for restoration. Carefully cutting out the designs of the old work,

141

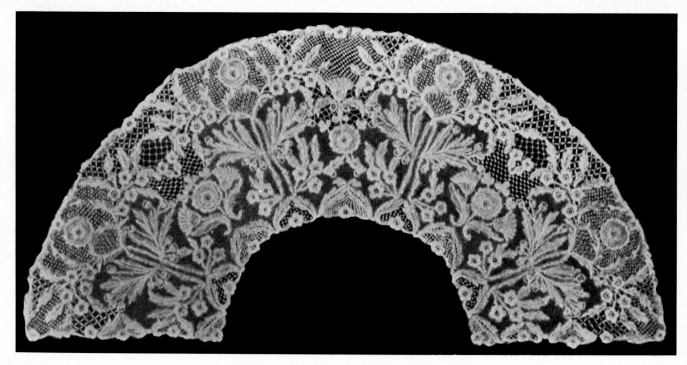

Fan of Honiton lace. Designed by Mrs Charles Harrison and executed by the Diss Lace Association; exhibited at the Exposition des Arts Décoratifs, Paris, 1914.

they sew them upon a paper pattern of the required shape. The 'modes' or fancy stitches, are dexterously restored, and deficient flowers supplied, and the whole joined together on the pillow.[11]

Despite Mrs Treadwin's enthusiastic work in the Devon lace industry, by the 1880s the decline continued steadily and good work could only be obtained through constant supervision. Intermittent work meant that lacemakers lost their technique through lack of practice, and Mrs Treadwin emphasised that her best workers were those who had been trained at the lacemaking schools she herself had set up in the 1850s. The numbers of workers had dwindled to a fraction of their earlier total.[12] Although on a very reduced basis, the industry continued to the end of the century, after which it became the pastime of a few interested craftswomen. By the 1890s the industry had been taken over from Mrs Treadwin by younger women:

There are, happily, a few isolated exceptions to this depressing state of affairs. Mrs Fowler, of Honiton, still has a small lace school where only the finest work is done and the old stitches and *vrai réseau* [genuine net ground] are taught; Miss Herbert, of Exeter, also encourages the old traditions; and Mrs Audrey Trevelyan [great niece of Lady Trevelyan] has introduced with some success graceful Italian and French designs at Beer and Seaton.[13]

Miss Radford of Sidmouth was another concerned with the survival of the art, and she, Mrs Fowler and Miss Trevelyan showed work and won prizes in 1893 at the Chicago Exhibition, thus promoting a brief revival of interest in Devon lace, particularly on the American market.

Many public-spirited ladies involved themselves in the lace revival, trying to assist workers to improve their lacemaking: 'A prominent worker in this field was Mrs Effie Bruce-Clarke who, in addition to reviving old patterns, designed new ones herself and encouraged art students to provide others. She showed the results of her

work at the various Home Arts and Industries Exhibitions of the late 1890s.'[14] The Diss Lace Association was set up to encourage lacemaking in Norfolk, where the craft had been introduced in the 1840s by two philanthropic women, Miss Stanley, daughter of the Bishop of Norwich, and Miss Chamberlain. Here they taught Honiton lace and their work achieved some recognition, but it was never more than a minor cottage industry in this area.

Sporadic attempts by ladies to support the art had begun as early as the 1870s, and even by the 1880s, despite the air of doom, lacemaking was still the largest surviving rural craft; concerted organisation started in 1891 with the formation of the Midland Lace Association in Northampton, and others soon appeared both in the Midlands lacemaking areas, and later in Devon. Schools sprang up in association with the revival, where girls were taught the craft after normal school hours, and it was hoped in this way to introduce new blood into an industry practised mostly by ageing women. The committee of the Midland Lace Association 'encouraged its workers to divide their days, so as to perform household duties in the morning and supplement their husband's small wages by two or three hours work at the pillow every afternoon. In this way adults were soon making 3s per week "without in any way interfering with their domestic routine".'[15] Many of the women were in fact supporting their husbands by their lacemaking:

There is undoubtedly a considerable class of persons to whom it is an immense boon, to whom its disappearance would be an insuperable loss ... There are hundreds of women between sixty and ninety years of age quite unfit for any other kind of

work who keep themselves by it in independence; any lace buyer can count up a large number of women who keep their husbands as well—husbands past work, crippled or blind, or bedridden ... But it is not only the aged who are glad of the work, the mother of the family finds it a great help ... There is no other industry so convenient for the home.[16]

The aims and results of the lace associations were certainly worthwhile; the craft was given a new lease of life, and the beauty and standards of its products were improved. In addition, the evils of the old truck system and poor wages which had been fostered by lace dealers were largely eliminated, and the workers' insecurity was removed by regular employment and payment of cash wages in advance, without the intervention of a middleman and the consequent loss of earnings. Their aims included, significantly: to 'provide employment in the country and prevent migration to the large centres'.[17] In the long run, however, low wages and the prospect of only part-time employment proved unsatisfactory attractions to the young workers on whom the future of the lace industry depended.

While the organisers of these associations did clearly improve conditions for the workers in their pay and under their surveillance, they also created problems; exacting standards were demanded of the women:

All workers sending their lace to the ... [Buckinghamshire Lace Industry] must always attach a slip of paper to the lace sent, on which is clearly written the name and address of the workers, also the length and price of the lace sent. Good measure must always be sent, and if a small extra piece is added that can be cut for a pattern it helps to increase orders.

Parchments are provided for the worker on application, and prizes for the different width laces, kerchiefs, borders, etc. will be given annually.

The best threads, gimp and pins for the making of Buckinghamshire Point or half-stitch laces, also linen threads for Torchons, are now obtainable from Miss M. Burrowes, Moreton, Manor House, and it is preferred that all threads etc.

Buckinghamshire Bobbin Lace, adapted from a traditional design by Miss M. Burrowes, executed by the women of the Buckinghamshire Lace Industry. Shown at the Exposition des Arts Décoratifs de Grande-Bretagne et d'Irlande, Paris, 1914. The Buckinghamshire Lace Industry was founded in 1893, centred at Maids Moreton under the chairmanship of Miss Burrowes (author of Buckingham Lace, *no date), following the success of the Midland Lace Association which had begun two years earlier. Among its numerous patrons the Lace Industry counted four duchesses, and its aim was to 'revive the industry of beautiful old Buckinghamshire pillow lace which is rapidly dying out'. Its insistence on high standards meant that it soon became self-supporting, employing over fifty full-time workers and generally paying them more than private lace dealers. Miss Burrowes, who lived at the Manor House, Maids Moreton, supplied materials and patterns where needed.*

should be obtained from the same, for all the orders given by the above are too often inferior and mixed threads have been used which spoil the lace. The best and finest pins only must be used, at $2\frac{3}{4}$d a sheet, the commoner ones ruining the parchment.[18]

Because so many of the women workers were advanced in years, such standards often proved difficult and painful to meet: 'Tired eyes did not take easily to difficult patterns, no more than did aged minds and bodies, fatigued by years of toil, take readily to meeting production targets for goods of closely defined quality.'[19] Pathetic and ashamedly apologetic letters from old women survive to give poignant proof of the demands they were often incapable of meeting:

'What am I to do next, I carnt do much now as I am such a poor thing.'

'Please I set a wide lace, I done one down. But I could not see to set up, it is so close. I new I should not be asked to do it. I am sorry I could not do what you wanted, but you see I am over eighty years old, I can't help it.'[19]

Many old lacemakers had no choice but to work for the associations till they dropped; there was no provision

for them when they were unable to continue at the pillow, which usually stood between them and death in the workhouse. Many were the only surviving experts in the craft in their localities, and the associations clearly pressed some into employment who were too old. Geoff Spenceley emphasises the degree to which the lace associations, like many other philanthropic organisations, 'looked towards individual treatment as the answer to social ills'. They did not fight for old-age pensions, which were seen by many reformers as the only comprehensive solution to the problem, but rather sought to encourage self-help in the aged and dying; curative as opposed to preventative measures, which thus remained safely within the accepted social structure. Similarly, the inherent class positions were maintained:

Not once were the lacemakers asked to participate in organization or give their say on policy, and the suspicion cannot be avoided that these dependent old ladies were viewed by many of the Associations' organizers, not so much as helpless victims of old age, as the vehicle by which public acclaim and social position could be achieved.[20]

One area where widespread lacemaking was a nineteenth-century introduction was Ireland. Although it did exist prior to this date it was not in general production until after the famine of the late 1840s, when philanthropic ladies and religious orders taught the skill to peasant women to enable them to earn extra money. The types taught included needlepoint and pillow lace, but particularly popular was crochet lace. The major disadvantage of this industry was that it was in amateur hands, and 'no amount of devoted enthusiasm on their part could take the place of the expertise needed to ensure the success of a luxury industry of this kind'.[21] All the funds earned were passed on to the makers, and two societies were established in London and Dublin to encourage the sales: the Irish Work Society of 233 Regent Street, London, and the Ladies' Industrial Society of 76 Grafton Street, Dublin. Between the 1850s and the 1880s the fortunes of the new industry varied, but it was sufficiently well-established to survive in times of general hardship. During the 1880s, as in many of the craft industries, efforts were made to improve the quality and prosperity of Irish lacemaking. Alan Cole of the Department of Art at South Kensington was encouraged to take an interest in the venture, and in 1884 a committee was set up under his chairmanship to promote the revival of Irish lace. Their most important move was to commission new patterns and designs, for as elsewhere, this aspect of the craft was considered the most deficient. But many of the organisations were still run by amateurs or philanthropists, and when a particular activist died, or was forced to break off her interest, the result was frequently the complete collapse of that organisation.

The groups run by religious orders had fewer problems in terms of steady duration, and important centres of needlepoint lace were established at the Presentation Convent in Youghal, County Cork in 1852, and the Convent of the Poor Clares at Kenmare in

Two fans and a handkerchief of Honiton bobbin lace, fans executed by the lace-makers of Honiton under the direction of Ann Fowler, handkerchief designed by Miss D. Ward, executed by Ann Fowler and exhibited at the Exposition des Arts Décoratifs, Paris, 1914. Mrs Ann Fowler was granted a royal warrant as lacemaker to Queen Victoria, Queen Alexandra and the Princess of Wales successively. One of her major achievements was the rediscovery of the technique of hand-made ground-net lace. She was awarded numerous exhibition medals for her work, both in Europe and America.*

County Kerry in 1861. Much of the finest lace in Ireland came from Youghal, and it was instrumental in spreading the production of lace to many other centres in Ireland. During the 1880s the convent had among its numbers a Sister Mary Regis, who became an excellent lace designer and raised the standard of work such that they had a very creditable showing at the 1893 Chicago Exhibition. Interestingly, the Youghal industry, which employed about seventy workers was 'organised on the basis of a co-operative society with the workers directly concerned in the administration. All the Youghal lace was sold through the Irish Lace Depot in Dublin.'[22] The Poor Clares, unlike Youghal, always used linen thread, and they too had several good designers who concentrated on reproducing seventeenth-century styles of lace from Venice and France, or used them as inspiration in creating their own designs.

Lacemaking is a craft which sits uneasily beside the other crafts of the Arts and Crafts Movement; its revival was already under way, and yet its decline foreseen and inevitable, before that movement began.

An experiment in linen appliqué on net, for a curtain; made at the Convent of Mercy, Kinsale, 1889, from a design adapted by Emily Anderson *of Cork from an eighteenth-century French brocade.* (PHOTOGRAPH: VICTORIA & ALBERT MUSEUM, LONDON)

Carrickmacross 'lace': cutwork applied to a machine net, part of a collar, 19th century. This type of Irish 'lace'—in fact an embroidery made in the hand—was produced by making a design in Indian ink on stiff paper, over which a machine made net was placed, and over the net a fine muslin. The three were tacked firmly together, and the pattern traced with close sewing stitches taken through both net and muslin, and also over a thicker outlining cord, after which the work was released from the design. The muslin was then cut away outside the outline and fancy stitches worked on the net ground. Great care was needed to avoid cutting the net. (PHOTOGRAPH: VICTORIA & ALBERT MUSEUM, LONDON)

Portion of a needle-point lace flounce worked under the direction of the Convent of Poor Clares, Kenmare, from a design by Miss Julyan, Dublin School of Art, late 19th century. Irish Point, 'which was founded upon Italian models, was first introduced into Ireland by the Sisters of the Presentation Convent, Youghal, County Cork, as a means of alleviating the distress caused by the Great Famine of 1846–50. Produced entirely by the needle, it is at once the most difficult to make and by far the most beautiful of all Irish laces. The richness of its designs and the remarkable variety of its stitches ... have extorted admiration from all quarters. Irish Point is now made throughout the whole of that part of Ireland which extends from Wexford to Kerry, but that produced at Youghal is considered the best'. (Thomas Wright, The Romance of the Lace Pillow, 1919, p. 249). (PHOTOGRAPH: VICTORIA & ALBERT MUSEUM, LONDON)

Attempts to introduce 'good design' in the Morris sense into lacemaking were more fraught and complex than in most other crafts; lacemaking was a home-based industry with geographically isolated workers, and in the course of production lace might pass through the hands of several intermediaries, who were less accessible and therefore less easily 'improved' than workshop workers. Their training was traditionally so limited as often to exclude reading and writing, let alone the rudiments of drawing or design. There was therefore no cultivated eye to select from and refine upon existing patterns, but an ignorance which often debased them. The numbers of cultured upper- and middle-class women involved in the craft were few, by comparison to embroidery, making their possible artistic influence inevitably superficial. On the other hand, lace was a difficult medium to design for, and before the 1890s a trained designer with a working knowledge of the craft of the pillow would have been a rare find. By 1905 at the latest, practical lacemaking and design were being taught side by side at the Female School, Bloomsbury, but by that date the craft was past saving, and even the Female School lace classes folded in 1906 due to lack of support.

Lace was shown regularly at many Arts and Crafts exhibitions and designs for lace fans were extremely popular; but it nevertheless was not seen as a major artistic craft of the movement, and designs for it by the leading figures of the movement are not common. It was an important source of income for many poverty stricken agriculturally based women, both in England and Ireland, but the wages earned were in fact very low; when demand was slack, payment rates were reduced, and this was a partial cause of prostitution among lacemakers in the early 1840s. In the early 1860s a girl of eight who was a 'nice little lacemaker and working nine hours a day' might expect to earn 1s. 6d to 2s. 6d ($7\frac{1}{2}$ to $12\frac{1}{2}$p) a week, while an adult would average 1s. or 1s. 6d (5 to $7\frac{1}{2}$p) a day;[23] working six days a week a lacemaker could thus earn about 6s. or 9s. (30 or 45p) a week, or rather more than the average spinner at the Langdale linen industry in the 1890s. One writer in 1900 found it surprising that the craft was dying out:

It is strange that in our country, where the classes are so much interested in the welfare and well-being of the masses, and where protest is continually being made against the growing tendency of women to leave their homes and seek work outside the home circle, the industry of lace-making has never been taken up by some wealthy enthusiast who could place the industry upon a solid artistic and business basis, without which industrial enterprise can never flourish.[24]

Caring lady amateurs were not enough, and it is symptomatic of the social changes that were taking place by 1900 that the writer above regrets the slow break-up of the traditional woman's rôle, here in a craft which enabled her to run the home and work as well, absorbing every spare minute of her time.

Like embroidery, lace was a status fabric, and although the fashionable use of it varied throughout the century, it, or its machine-made substitute, were constantly in demand. Traditionally only available to the middle and upper classes, mechanisation brought a more widespread use of lace. By the 1870s Honiton or Brussels lace were a must for wealthy brides, and even the less wealthy classes were encouraged to appreciate the value of real lace:

Laces of excellent quality may be had at far lower prices than is usually supposed; and I strongly advise young girls, instead of buying every mode in collars, ruffles and sleeves in common lace, to purchase a few lengths of *real* lace, which they can alter and arrange as the fashions change. If a girl who has a limited sum to spend will examine her account book for the last year, she will find that neckties, collars, chemisettes and sleeves of 'patent lace', of imitation 'Point Duchesse', and other novelties have cost as many pounds as would have purchased some *real* lace that would have been always elegant, *distingué*, and of value.[25]

In America lacemaking was frequently mentioned as part of the art needlework revival; it was taught in many places where embroidery appeared, and ladies like Mrs Emily Noyes Vanderpoel encouraged the production of both needle and bobbin laces in her writings and in her help to the Litchfield Historical Society in building up a collection of fine examples of lace as well as embroidery. Much of the lacemaking in America in the nineteenth century, however, seems to have remained at the level of a popular ladies' accomplishment:

A vogue which continued from the 19th century into the early 1930s was the fashion for making Honiton lace handkerchiefs. One of these handkerchiefs made by Susan Catherine Palmer in Baltimore in 1900 is in the possession of her daughter, Mrs Carroll R. Williams, who describes it as follows: 'It is of delicate workmanship. When I was growing up, the making of these handkerchiefs was a fashionable accomplishment with which matrons occupied their leisure hours while sitting at ease, on summer days during the period devoted to afternoon teas.[26]

Organisations like the Society of Decorative Art included lace in their lists of women's craft work sold and promoted, and they were concerned with increasing the professionalism of products, and raising women's work above the amateur level to new standards of quality and design.

NOTES

1. Mrs Bury Palliser, Lace, *Magazine of Art*, 1878, pp. 179–80.
2. *ibid.*, p. 180.
3. Pamela L. Horn, Pillow Lacemaking in Victorian England, *Textile History*, vol. 3, December 1972, pp. 104–5, and quotation from *First Report of the Children's Employment Commission*, Parliamentary Papers, 1863, vol. 18, p. 256.
4. Mrs F. Nevill Jackson, *A History of Hand-Made Lace*, London, 1900, p. 131.
5. *ibid.*, p. 40.
6. *ibid.*, p. 52.
7. Alan S. Cole, *Report to the House of Commons on the Present Conditions of the Honiton Lace Industry*, 1887, p. 2; quoted in Patricia Wardle, *Victorian Lace*, London, 1968, p. 135.
8. Mrs Bury Palliser, *History of Lace*, London, 1902, pp. 415–6.
9. Octavius Hudson, Report on Lace-making, *The First Report of the Department of Practical Art*, 1853, appendix VIIe, p. 368; quoted in Wardle, *op. cit.*, p. 157.

10. Jackson, *op. cit.*, p. 26.
11. Palliser, *History of Lace, op. cit.*, p. 412.
12. Cole, *op. cit.*; cited in Wardle, *op. cit.*, p. 154.
13. Jackson, *op. cit.*, p. 54.
14. Wardle, *op. cit.*, p. 161.
15. Geoff Spenceley, The Lace Associations, *Victorian Studies*, vol. 16, 1973, p. 439. See this article for a thorough study of the lace associations.
16. C. Channer and M. E. Roberts, *Lacemaking in the Midlands*, London, 1900, pp. 62–3; quoted in *ibid.*, p. 447.
17. North Buckinghamshire Lace Association pamphlet, quoted in *ibid.*, p. 442.
18. Buckinghamshire Lace Industries pamphlet, quoted in *ibid.*, p. 440.
19. Spenceley, *op. cit.*, p. 448.
20. *ibid.*, p. 449.
21. Wardle, *op. cit.*, p. 174.
22. *ibid.*, p. 179.
23. Horn, *op. cit.*, p. 107.
24. Jackson, *op. cit.*, p. 54.
25. *The Young Englishwoman*, July 1870, p. 374.
26. Georgina Brown Harbeson, *American Needlework*, New York, 1938, p. 164.

NOTE TO CAPTIONS

*See J. R. W. Coxhead, *The Romance of the Wool, Lace and Pottery Trades in Honiton*, 1973, p. 29.

5 Jewellery
and Metalwork

Frances Macdonald: the 'Honesty' mirror, 1896–7, beaten tin, 28¾ × 29 in. In this still early work Frances Macdonald shows only the vague remnants of the influence of Toorop, from whom she had derived much inspiration around 1893–4. By 1896 her dramatically elongated figures and motifs were moving towards the more personal, mysterious fairy-tale style which characterised her mature work. (PHOTOGRAPH: STIRLING MAXWELL COLLECTION, GLASGOW MUSEUMS AND ART GALLERIES)

W OMEN'S TRADITIONAL INVOLVEMENT in jewellery and metalworking was in the main a peripheral one; the Goldsmiths' and Silversmiths' Guilds were particularly exclusive and women were rarely admitted as apprentices. However, Ambrose Heal in his *The London Goldsmiths* (1935) gives ample proof that women were involved in the practical side of the craft and although they were a very small minority of the total number of metalworkers cited by him, there was nevertheless a significant group of such women. Of the centuries spanned by Heal, from 1200 to 1800, the majority of women metalworkers appear in the final 150 years. It is evident that many of them—working both in silver and gold—were involved in partnerships with husbands or male relatives; others were apparently quite independent and thus may not have been trained by a father or husband. During this period many of the rare metal crafts overlapped, so that a goldsmith, before 1700, might also have been a banker, or pawnbroker, and many of the trade shops sold the work of other craftspeople and made none themselves. There were clearly a large number of women pawnbrokers at this date, and also some who sold jewellery and gold or silver wares not made by them; however, Ambrose Heal cites several practising metalworkers who were women. He reproduces the trade cards of three women working independently in the mid-eighteenth century, and of two other women working with a husband or partner. Elizabeth Godfrey was active between 1741 and 1758 as a goldsmith, silversmith and jeweller, working under the sign of the Hand, Ring and Crown in Norris Street, St James's; her trade card reads:

E. Godfrey Goldsmith, Silversmith and Jeweller to His Royal Highness the Duke of Cumberland. Makes all sorts of Plate, Jewels, and Watches, in the newest Taste at the most Reasonable Rates. N.B. All sorts of Second Hand Plate, Watches, &c. Bought and Sold.[1]

The trade card of another goldsmith, Anne Foote (1752) notes: 'Jewellers work done at Home, after the Newest Fashion,' indicating perhaps that her shop, 'At the Ring, near the Maypole, Eastsmithfield,'[2] was too small to be used as a workshop, or that family commitments made it simpler for her to work from her home—a feature common among women jewellers of the Arts and Crafts movement. William and Mary Deards (or Deard) worked together as goldsmiths and toymen (another trade commonly linked with metalworking) at the Star, end of Pall Mall, near St James's, Haymarket after 1765. Mary Deard was particularly known as a toywoman, and her shop, originally in Bath, was recalled by Lady Wortley Montague in her *Farewell to Bath*:

Farewell to Deard's and all her toys which glitter in her shop,
Deluding traps to girls and boys, the warehouse of the fop.[3]

Another famous toywoman, Mary Chennevix, *née* Roussel, worked from the same workshop as Paul Daniel Chennevix (active from 1731 until his death in 1842), Peter Russel (possibly her brother) and other members of the Chennevix family. They worked from the Golden Door,

Elizabeth Godfrey, goldsmith, silversmith and jeweller to H.R.H. the Duke of Cumberland; trade card, 1741–1758.

The famous shop near Charing Cross ... [which] was the resort of the fashionable world in the 1730s and 40s. It will be recalled that Mrs Chennevix ... 'the toywoman of Suffolk Street', had parted with her house at Strawberry Hill to Horace Walpole in 1748.[4]

Many other women jewellers, gold and silversmiths appear in Heal's book: some were managing businesses after the death of a husband, others went into partnership, like Louisa Perina Courtauld, a practising goldsmith and jeweller in a family firm, who went into partnership with George Cowles after her husband Samuel's death. Although few in number, most of these women were active metalworkers working on an apparently equal footing with men despite their greater difficulties in obtaining a training. However, by the nineteenth century, with the increasing mass-production in and mechanisation of the metalwork trades, women were taken on to perform only the most menial tasks, such as polishing, which were no threat to the men's more skilled jobs. Button-making and the like in the great industrial metalwork centres such as Birmingham, were also trades employing women. Hair jewellery—usually memorial pieces made from the dead persons hair and extremely fashionable in the nine-

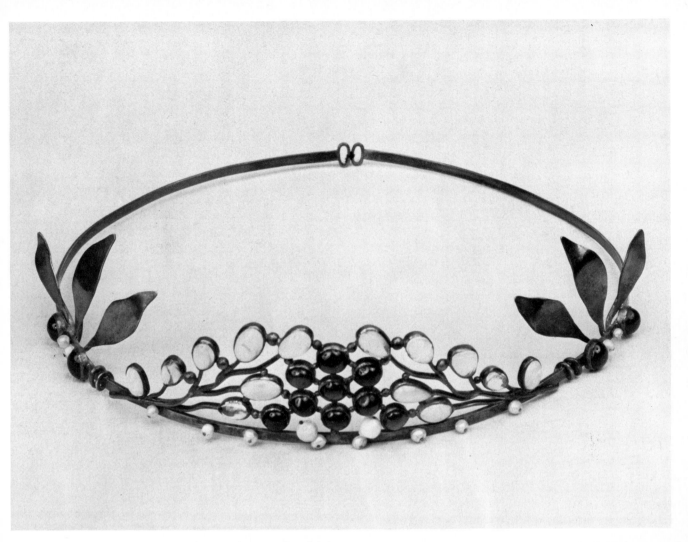

May Morris: Tiara, silver, set with pearls, opals and garnets.
(PHOTOGRAPH: NATIONAL MUSEUM OF WALES, CARDIFF)

teenth century—was a type of very fine work which was reserved for the nimble fingers of women workers. Apart from taking private lessons, the only way for a woman to become a skilled jeweller or metalworker at this period was through art school training; trade apprenticeships were even less accessible than they had been prior to the nineteenth century.

The revival of artistic jewellery, prompted by the general crafts revival, did not become widespread before the 1880s, and the most characteristic work, mostly in silver, was produced from 1890 onwards. One reason why jewellery was not so quickly influenced by Arts and Crafts ideals may be that William Morris was not actively involved in the production of jewellery, and it was left to his followers, often among the next generation, to express the ideals of the Arts and Crafts movement in this medium. Of the earlier generation, Ruskin was particularly vociferous in his contempt for fashionable Victorian jewellery, which was dominated by what he considered to be the harsh brilliance of the diamond. Aymer Vallance, a critic writing in 1902, typified this critical attitude to Victorian jewels, disdaining the use of diamonds introduced purely to flaunt 'the commercial value they represent in pounds sterling', and noting with relief that 'mere glitter and the vulgar display of affluence are gradually yielding before the higher considerations of beauty of form and colour'.[5] Pugin, who was discussed briefly in Chapter 4, Embroidery and Needlework, was similarly

influential in the craft of jewellery in his revival of Gothic styles of ornament early in the Victorian era. In particular, his revival of the art of enamelling, which had fallen into disuse at the end of the eighteenth century, was to be of profound importance in the rise of artistic jewellery.

Although none of the artist-designers in Morris' immediate circle were involved in the commercial production of jewellery, many made avant-garde designs for it and had pieces made for friends. Others, like Rossetti and Burne-Jones, were influential in their incorporation of unconventional, often Eastern, jewellery in their figure paintings, as accessories for the dramatic beauty of their female models. In addition to the influence of the mediaeval-inspired dress style shown in such paintings upon contemporary fashion (at least in artist circles), in the spread of Aesthetic dress, the jewellery seen in Rossetti's later portraits in particular was important in the dissemination of artistic taste in this field. While Morris himself did not design jewellery, his daughter May did, and she was also responsible for making most of the pieces she designed. In Rossetti's *Rosa Triplex* of 1874, a triple portrait of the young May Morris, she is shown wearing jewellery which must have belonged to Rossetti, but the necklace on the right-hand of the three figures was

153

owned by May, and according to one authority may have been designed and made by her.[6] Although she would only have been twelve years old at the time of the portrait, she was already an able craftswoman and probably not incapable of such a *tour de force*. Other jewellery by May Morris evinces a delightful simplicity of taste, typical of the best artistic designs of the period; often based on natural forms, these pieces make good use of the unpretentious 'cabuchon' stone cut, so popular in the late nineteenth century.

One of the most influential figures in the revival of artistic jewellery was Charles R. Ashbee, the architect, designer and writer who founded the Guild of Handicraft in 1888. The Guild grew out of the School of Handicraft which had been started by him the previous year at Toynbee Hall; in 1890 they moved to Essex House in the East End of London, and in 1902 the Guild's workshops were transferred to Chipping Campden in the Cotswolds while the showroom outlet for their work remained in London. The Guild survived until 1907 when economic pressures caused the venture to fold. Ashbee and his Guild were particularly renowned for their jewellery and silverwork, most of which was designed by Ashbee himself, and which had a profound influence on the artistic growth of the newly revived craft. Ashbee

stood almost alone at the beginning, when he first made known the jewellery designed by him and produced under his personal direction by the Guild and School of Handicraft in the East End. It was immediately apparent that here was no tentative or half-hearted caprice, but that a genuine and earnest phase of an ancient craft had been re-established. Every design was carefully thought out, and the work executed with not less careful and consistent technique. In fact, its high merits were far in advance of anything else in contemporary jewellery or goldsmith's work.[7]

Ashbee concentrated on the use of conventionalised natural forms, in keeping with developments in other craft fields, or worked out abstract forms which enhanced the indigenous properties of the material or were suggested by them—the ductility and lustre of the metal itself. He used mainly silver, but rather than giving it a high polish through burnishing, he preferred the more subtle qualities of a dull polish, reminiscent of old silver. This type of finish became popular among the exponents of artistic metalwork. His choice of jewels to ornament his pieces reflected the reaction against high Victorian brashness, and semi-precious stones, such as amethysts, amber and blister pearls are common in his designs. His principles became the standard for all artists in the field: 'the value of personal ornament

Nelson and Edith Dawson in their Mulberry House studio, from an illustration in The Architectural Review, *1897. The studio seen here was probably that of Nelson Dawson, which he used mainly for design work and was situated on the ground floor of their house; Edith*

Dawson's studio, on the first floor, must have looked much more practical, for it was there that she executed the enamel decorations on their metalwork and jewellery, and kept the kiln to fire them.

consists not in the commercial cost of the materials so much as in the artistic quality of its design and treatment',[8] so that the ideals inspired by the work of William Morris were carried by Ashbee into the metalwork crafts.

Despite its male-dominated history, jewellery making rapidly began to be seen as a particularly suitable artistic pursuit for women; apart from the need for manual dexterity in the intricate work—an ability traditionally attributed to women—it was a craft which could easily be practised from a small workshop in the home. Few women gained access to the heavier masculine craft of architectural metalwork and wrought-iron work, an exception was the little-documented Women Metal Workers' Company. Aymer Vallance echoed popular sentiment when he stated that 'The number of ladies who have achieved success in jewellery design proves this, indeed, to be a craft to which a woman's light and dainty manipulation is peculiarly adapted'.[9] By 1872 jewellery design was mentioned as being one of the favourite branches of designing taken up by ladies, although the emphasis in this case on design is crucial, as practical metalwork for ladies seems to have become acceptable only later in the century.[10] However, by the 1890s many women designers were producing their own jewellery.

An important figure in the development of artistic enamelling techniques, which were to be such a feature of art jewellery and metalwork, was Alexander Fisher. A national scholar at South Kensington between 1884 and 1886, he was awarded a scholarship to study enamelling in France and Italy; on his return to England he set up an enamelling workshop and his teaching at the Central School from 1896–8 was the chief source of contemporary expertise in enamelling among young jewellers. Others studied privately with him, and these included Nelson Dawson, then a painter, who worked under Fisher from about 1891. In 1893 Dawson married Edith Robinson, herself an able watercolour painter, and they later established a workshop together producing silver and jewellery. Dawson taught Edith the art of enamelling, and with her particular ability with colour, she took over all that side of their production. An article on their work appeared in the *Studio* of 1896, and her workshop was described as an artistic laboratory, with its pestle and mortar, muller and slab, and its furnace for firing the enamels. This was Edith Dawson's studio, on the first floor of their house in Chelsea overlooking, or rather on a level with, the mulberry tree from which their house took its name. Nelson Dawson's studio, where drawing and designing were carried out, was on the ground floor. They experimented with different types of enamelling, and also searched for more successful and varied colours; *cloisonné* enamelling involved the soldering of prepared wire outlines onto a base, and then the application of the enamel to the compartments between; *champlevé* exploited hollows carved out of the metal which then received the enamels. They also tried 'Limoge' or 'painted' enamel, where the colours were put on with a knife or other suitable implement in paste form. The most effective of the enamel colours were

Nelson and Edith Dawson: Waist ornament in silver with central enamel plaque, c. 1905. Marked with 'D' in an Ivy leaf. (PHOTOGRAPH: FINE ART SOCIETY, LONDON)

155

transparent, creating a jewel-like brilliance enhanced by the surface of the metal beneath; a surface roughened by a gouging tool, for example in the *champlevé* method, provided not only a key for the enamel, but its varied facets increased the scintillating light-reflective quality of the glass. The firing process was difficult and sensitive, with the colours often melting at different temperatures and causing cracking or 'floating' during firing. Nelson Dawson described an initial stage of the process upon which his wife was working, in 1896: 'My wife and I work together in this . . . Here you see the first stage—the figure in white—looking very like pâte-sur-pâte on their darker grounds'.[11]

A second article, in the *Studio* for 1901, provides little clue as to Edith Dawson's actual involvement in the work, contenting itself with half a sentence on her, in a six-page article covering them both, which comments that 'most of Mr Dawson's enamels are made by—it must be said with a welcome recognition—Mrs Dawson'.[12] Recognition would, in fact, be very welcome, and one of the major problems in researching women artists, particularly when they worked in partnership with a husband, is lack of information: discussion centres on the man's contribution, with him usually providing all the quotations cited, leaving the woman veiled in mystery. The 1901 article is a particularly blatant example of this, since despite the fact that Edith Dawson was herself a talented painter and enameller, the impression given is that she furnished nothing but the manual labour while he was the 'ideas man'—a stereotyped view of rôle patterns which in this, as in many other cases, was reinforced by the critics.

In fact it is evident that by 1897 Edith Dawson had complete charge of the enamelling work; by that date they were employing several workmen, making a greater division of labour possible. It seems likely that Nelson designed most of the pieces which were then executed either by himself or the workmen, and then enamelled by Edith; experimental work was evidently done by both the Dawsons. Although there were workmen, it was stressed that their numbers were limited 'because it would not be possible to keep in touch with these or their work' if there were too many:

The workmen are never hurried—piece work is absolutely unknown; yet it is fair to state clearly on this point that those who help in the workshops generally succeed in carrying out the work in the estimated time. In this matter it is the Dawsons' ambition to draw around them a few of the best craftsmen, and only a few, so that together there may be formed a small group in which there shall be no master, except he that can do the best work.[13]

This interesting and rather idealistic 'scheme of labour', in which 'while all have the desire for prosperity's share, none shall be led to wish to become rich', was apparently working satisfactorily; 'The Dawsons have had for a long time to refuse work, having more than they can do'.[13] It is not clear how long or how successfully this system continued, and the article of 1901 does not mention it; however, one of the hazards of a small workshop was the need to produce reasonable quantities of work in order to survive, and eventually Edith Dawson collapsed through overwork. This was mainly caused by fumes from the enamelling kiln, which were highly detrimental to the health, and which were also responsible for ill-health in another jeweller and enameller, Georgina Gaskin.

Georgina Cave France was a student in silversmithing at Birmingham School of Art, where she met a fellow student, Arthur Gaskin, whom she married in 1899. They set to work together making gold and silver jewellery which was often decorated with enamels, a specialisation taken up by Georgina. Enamelling was considered a particularly skilled and artistic job, and in larger establishments an artist was normally employed who concentrated solely on that. Both Arthur and Georgina Gaskin belonged to the Birmingham group of artists, many of whom specialised in jewellery which, because it was a mass-produced manufacture of their city, they were particularly concerned to improve. Consequently, the Gaskins' first interest was in originality and individuality of design, and technique came second, on the assumption that good craftsmanship would naturally follow. Reacting, like their contemporaries, against the flashy brilliance and regularity of diamonds, they turned to the East for inspiration, appreciating the craft of the Indian worker who cut the stone striving only to show the best it contained from the decorative point of view. In this they were influenced by the more primitive but integrated philosophy behind Eastern jewellery: in this spirit the

Gaskins first essayed the making of jewellery. Choosing simple, inexpensive stones . . . of beauty and interest, they mounted these at first very simply with lightly outlined design to set forth the stones to best advantage . . . All their work was, of course, hand wrought, and based upon simple floral forms original to themselves. At first their efforts were modest, but experience has brought certainty and assurance, and the examples of finely wrought and daintily conceived jewellery . . . represent a very notable achievement.[14]

It is interesting to note the relative cost of this type of hand-made jewellery, as this author comments that some 'dainty little brooches are not only suitable for a young girl in her teens to wear, but are quite inexpensive'. In fact much Arts and Crafts jewellery was cheap, although mass-produced articles were inevitably even cheaper; for example, a lace-pin manufactured from gold and pearls might cost between 17s. (85p) and 25s. (£1.25), while a hand-made brooch of silver and moonstones would be £3 or £4.[15] Under these circumstances it is hardly surprising that craft jewellers found it hard to survive. Many other jewellers trained at Birmingham, where a new School of Jewellery and Silversmithing was started around the turn of the century, of which Arthur Gaskin became the head in

Above: *May Hart: Seven enamels with figures, c. 1900?* (PHOTOGRAPH: BIRMINGHAM MUSEUM AND ART GALLERY)

Right: *Lydia Cooke: Jewellery and enamels, c. 1900? Two pendant necklaces, left: female figure and bird motifs; right, enamel of birds with filigree; both on decorative chains. Hair comb with raised vine leaf decoration. Enamel pendant of Virgin and Child.* (PHOTOGRAPH: BIRMINGHAM MUSEUM AND ART GALLERY)

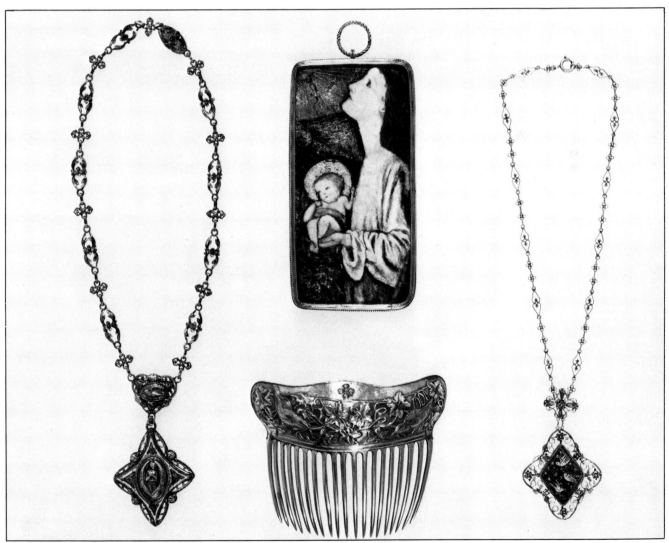

1902; among the students were a number of women, including Kate Eadie, an artist of several talents notably enamelling and jewellery, and May Hart, who also did enamelling.

One of the few companies to combine artistic jewellery with partial mass-production and commercial success was Liberty and Co. of London. Liberty's was founded in 1876 by Arthur Lasenby Liberty, who imported exotic Oriental goods and was avidly patronised by the artistic and 'aesthetic' elite of the day. He rapidly expanded into the production of high quality, well-designed, often orientally inspired merchandise, particularly fabrics, and by the end of the century had moved into the production of artistic jewellery. Despite the Celtic title of their first range, 'Cymric' silver, which was launched in 1899, not all the designs used were of Celtic origin, nor were they the first to look in that direction for design inspiration. Some of the 'Cymric' designs were of Japanese or of European Art Nouveau inspiration, and the influence of Ashbee is also present in certain designs. Many of the designers for the Liberty silver range remain unknown, but among them was Jessie M. King, who had trained at Glasgow School of Art and was also a well-known illustrator. One interesting factor in the choice of designers whose names are known is their comparative youthfulness; Jessie King was born in 1876 and

designed both silver and jewellery for Liberty in the early 1900s; 'Her approach to design is typified by the charming silver and enamel buckle . . . with its stylized bird and flower motifs'.[16] According to another designer for Liberty's, Rex Silver, they 'all submitted their designs to the firm in London. They were in no way concerned with the practical details of the manufacture in Birmingham'.[16] The commercial success of the venture seems to have been made possible by its combination of hand and machine processes; although the designers themselves appear not to have been involved in the production, nevertheless craftsmen were used: the articles themselves were mass-produced, but the stone-setting and hammered-surface texturing were probably completed by hand.

Jessie M. King was not the only important woman jewellery and metalwork designer to have trained at Glasgow; many of the famous Glasgow designers worked in this medium, in particular Frances and Margaret Macdonald. The Arts and Crafts Exhibition Society proved important as a means of publicising their ideas:

Since the production of much of the [British] jewellery was in the hands of individual artists with small workshops manned by devoted followers, the designs are mostly highly idiosyncratic and resist any rigid classification. The Arts and Crafts

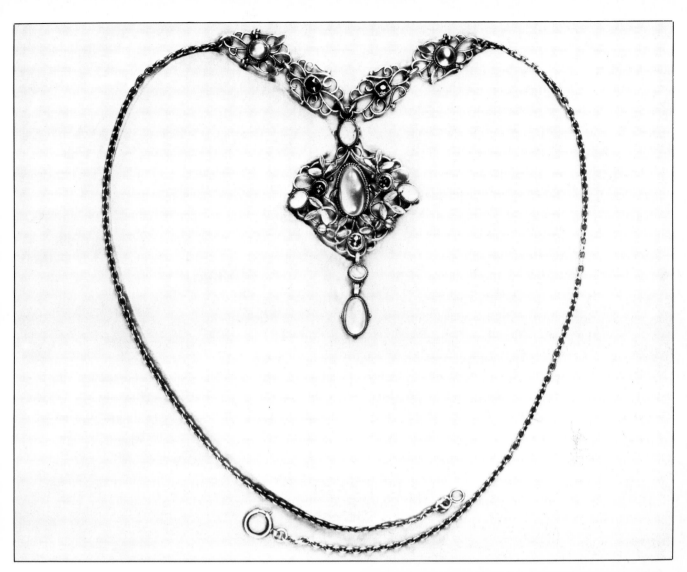

Society, founded in 1886, provided a 'shop window' for many of the Guild of Handicraft artists and the Glasgow School artists as well as a number of individual experimental figures.[17]

Thus at the Arts and Crafts Exhibition in 1896 the Glasgow metalwork designers received considerable attention for their innovatory exhibits. An article in the *Studio* devoted particular discussion to the work of Margaret and Frances Macdonald:

The Misses Macdonald show so much novelty and so much real sense of fine decoration in their works that a tendency to eccentricity may be easily pardoned. But this same tendency constitutes a very real danger; and those who are most eager in defending the posters . . . and various subjects from their hand, should be also quite candid in owning that 'the spooky school' is a nickname not wholly unmerited.[18]

The origins of the Glasgow style, and that of the Macdonald sisters in particular, was here suggested to

Above: *Arthur and Georgina Gaskin: Necklace, silver with semi-precious stones, 1910.* (PHOTOGRAPH: BIRMINGHAM MUSEUM AND ART GALLERY)

Left: *Ernestine Mills: Angel of the Annunciation, enamel.* (PHOTOGRAPH: THE FINE ART SOCIETY, LONDON)

Right: *Birmingham School of Art: Woman student metalworking—soldering, c. 1900.* (PHOTOGRAPH: COURTESY OF ALAN CRAWFORD, BIRMINGHAM SCHOOL OF ART)

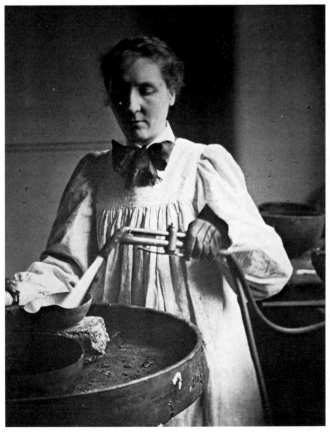

be a combination of the influence of the Japanese artist Hokusai and of the art of Aubrey Beardsley. The linear qualities were indeed important:

In each [design], lines which impress you as symbolic, and part of some strange system of magic or ritual, are the chief features, but these new combinations of lines generally reveal themselves as crowned by faces of weird import. In *The Star of Bethlehem*, by Frances E. Macdonald, a panel in beaten aluminium, and its companion, *The Annunciation*, by Margaret Macdonald, the modelling of the draperies serves to link these said lines to the rest of the figures; whereas in some designs by these artists, it is hard at first sight to disentangle the lines which belong by right to the figure, from those others which (since Mr. Beardsley set the fashion) only exist 'beautifully', with no common-place explanation of their object. The Clock in beaten silver by M. and F. E. Macdonald, and the Muffin Stand by the same ladies and George Adam, all show evidence of a very definite and not unsuccessful attempt to create a style of decoration which owes absolutely nothing to the past. In treating this work lightly one does not undervalue its evident seriousness . . .[19]

The critics of the Glasgow artists were at first, as is clear from this passage, at a loss as to how to judge their works; they were cautious and sceptical, subjecting the designers to much ridicule and misunderstanding. The writer in the *Studio*, however, despite his cynicism, prophesied great acclaim for the Macdonald sisters:

Therefore it were more wise to wait, and if one does not grasp their plan, to give them the benefit of the doubt, and conclude that possibly the fault is divided between the artists and their critics, and that sometime hence, when the sheer novelty no longer amazes, a set purpose may reveal itself. For that these decorators already prove themselves able to make beautiful patterns, of good colour, and decoration that is really decorative, may be granted. Probably nothing in the gallery has provoked more decided censure than these various exhibits . . . If the said artists do not come very prominently forward as leaders of a school of design peculiarly their own, we shall be much mistaken. The probability would seem to be, that those who laugh at them today will be eager to eulogise them a few years hence.[19]

Of the group of Glasgow artists known as the Four, Charles Rennie Mackintosh was the only one to achieve lasting, world-wide fame, while the work of Margaret and Frances Macdonald in particular has slipped into the comparative obscurity which has been the lot of so many women artists. Although during their own lifetime, as for women artists generally during the last quarter of the nineteenth century, they received fair recognition and due appreciation of their work, the twentieth century saw the disappearance of the typically Victorian category of 'female art' which had been used both by women artists and their critics as a label for this burgeoning phenomenon. No category arose to replace it, and thus there was no longer the basis for discussing women artists and their work, both of which have tended to be ignored by art historians and critics ever since.[20]

In addition to mentioning the jewellery designs of the Macdonald sisters, Aymer Vallance in 1902 refers to

Above: *Frances Macdonald: one of a pair of candlesticks, beaten brass, c. 1896; 20¼ in high, diameter of base 13 in. These candlesticks, and the 'Honesty' mirror (see above) were reproduced in an article in the* Studio *of 1896 on 'Some Glasgow Designers' (pp. 87 and 88); they were similar in style to work shown by the two women at that year's Arts and Crafts Exhibition Society, which gained them almost general hostility from the critics as being 'spooky'. The writer in the* Studio *was startled to find women doing so competently what was usually reserved for men:'Perhaps the most striking fact that confronts one at first is to find that some comparatively large and heavy pieces of wrought metal were not only designed, but worked entirely by the two sisters. Indeed with the exception of certain assistance in joinery, all the objects here illustrated are their sole handiwork' (p. 90).* (PHOTOGRAPH: GLASGOW ART GALLERY AND MUSEUM)

Right: *Constance M. Paine: Silver Casket set with a white cornelian; designed and executed by her and exhibited at the Exposition des Arts Décoratifs, Paris, 1914.*

other women jewellers of note. Miss Annie McLeish of Liverpool was commended for designs which exploited the structural, strengthening requirement of her pieces which she made into an ornamental feature; thus the way in which several parts of a piece were joined together, tying in portions pierced *à jour*, was in itself a decorative element. Because of this feature her work was likened to the iron guards of Japanese sword-handles. She was also admired for her decorative use of the human figure—as were two other lady designers, Miss Larcombe and Winifred Hodgkinson.

Commenting on the number of women to have achieved success in the field of jewellery making, several ladies were mentioned; in the production of small articles such as hatpins, graceful designs were contributed by Ethel Hodgkinson (perhaps the sister of Winifred) and Miss Swindell. Dorothy Hart was executing as well as designing her jewellery, while Miss McBean and Kate Fisher (daughter of the famous enamelling revivalist Alexander Fisher, discussed above) were producing designs in which enamelling was a prominent feature. Others to use enamels in designs inspired by natural motifs were Miss Alabaster and Edith Pickert, who usually employed a fairly thick outline of metal enclosing her coloured enamel surfaces. Another artist, Miss Rankin had her designs executed by Mr Talbot of Edinburgh, while Miss Barrie produced translucent enamel without backing 'after the Russian method'.[21]

Other fields within jewellery and metalwork design and execution in which the participation of women was encouraged were watch decoration and clock decoration (already mentioned with reference to the Macdonald sisters) and the carving of cameos. The *Art Journal* of 1872 proposed the latter as a suitable employment for ladies:

Cameo-cutting might be included in this class of work [engraving], but it is rarely followed. We hear of one young lady having succeeded well. But a £5 prize offered at the Queen Square School [Female School of Art] by G. Godwin Esq., F.R.S., has lapsed for want of competition. A few ladies are engaged in engraving stamps, monograms etc. But the most hopeful in this direction, comes to us from Sweden, where we find a lady, Mrs Lea Ahlborn, at the head of the Royal Mint, and especially famous for the perfection of her medallions.[22]

The following year, 1873, another prize was instituted for cameo-cutting by women:

We learn from the *Builder* that a silver medal, in furtherance of the will of Mr. John Stock, is this year offered by the Society [of Arts] to female artists, for the best cameos designed and executed on any of the shells commonly used for that purpose. The *Art Journal*, like our contemporary, has sought to direct the attention of females to this elegant department of Art, and has adduced evidence of its successful practice by ladies.[23]

Cameo-cutting was evidently not an entirely new field for women, and it was certainly considered particularly suitable for the delicate female touch; its equivalent in painting, the miniature, had long been acceptable as an area of art for women. Two Italian cameo engravers and stone cutters, Elena and Eliza Maria Pistrucci, were born in England, daughters of the famous gem engraver and medallist Benedetto Pistrucci, and were doubtless trained by him to the craft. It is significant that so many

skilled women artists were the daughters or wives of skilled craftsmen, showing how much they could achieve when training was readily available, and a sympathetic attitude towards their involvement existed. Eliza Pistrucci made a cameo portrait of her father and exhibited a sardonyx cameo of the death of Adonis in the International Exhibition of 1862.[24] Both of these cameo artists were of the older generation of jewellers; they died in the 1880s before the craft revival of artistic jewellery was under way, and there is little mention of cameos or women cutters of them in the Art press after the 1870s.

The general artistic improvement of jewellery and metalwork was, it was noted, dependent upon support from within the trade: 'Much good, therefore, may be expected to result from the official sanction afforded by the Goldsmiths' Company to the jewellery work of their Technical Institute, to which a number of very creditable designs owe their existence.'[25] The work of Kate Allen in designing decorations for watch-backs (a sadly neglected art) was selected for recommendation in this sphere of activity. A more unusual field of jewellery was the creation of designs for theatrical use. New trends in theatre production meant that historical veracity was by then accepted as essential to good theatre. This included every accessory, from props to clothes and jewellery. Charles Ricketts, artist and designer, was particularly concerned with theatre design after 1906, and the *Studio* of 1907–8 discussed jewellery designed by him for the stage production of *Attila* in 1907 at Her Majesty's Theatre, which was executed by Mrs Gwendolen Bishop:

The stage jewellery ... has been executed by hand with ingenuity, and a regard to beauty, by Mrs Gwendolen Bishop, out of such inexpensive materials as brass, copper, gilded leather, coloured beads etc. This was probably the first play of modern times where even the smallest jewels were made by hand, Mrs Bishop making some 130 after Mr Ricketts' designs. Apart from the scholarship and art in these designs, perfect adaptability to their purpose is their supreme merit.

As in England, the numbers of women involved in jewellery and metalwork in America seem to have been fairly limited, and restricted on the whole to a comparative élite; as with ceramics, it is evident that a number of American women metalworkers took up the craft as an upper-class pastime. Other women were trained and employed at large workshops such as that of Tiffany and Co. in New York, but they mostly remain anonymous under the master's name and influence. Two women's names have survived, however: Patty Gay and Julia Munson headed a small staff in the late 1890s making experiments into enamelling in the tradition of the English revivalist Alexander Fisher, and the French enamelling expert René Lalique. The two women worked at Tiffany's home on 72nd Street, and a repoussé copper bowl enamelled in tones of purple, brown, orange and green is thought to be by Julia Munson. In these experiments Tiffany tried to bring out the jewel-like properties of enamels, using 'judicious combinations of opaque and translucent enamels, applying them in several layers and firing each separately, thus bringing them into a soft harmony of colours. Frequently ... the final surface was iridized, giving it the vibrant quality of a prismatic gemstone.'[26] Tiffany also took note of innovations suggested by his women workers, as is recorded in this story:

One of the artists, who had little training in metals, devised a way of cushioning the sheet of metal on which she worked her repoussé. She told how Mr Tiffany preferred the effects she achieved to those of the professionally trained English chaser working next to her.[26]

Among the better-known American women metalworkers were Frances M. Glessner, Clara Barck Welles and Elizabeth E. Copeland. Frances Macbeth was born in Urbana, Ohio, and married John J. Glessner in 1870; she was one of the leaders of Chicago society in the 1880s, and thus her silverware fits into the class of that produced by lady amateurs. However, her work was of high-quality craftsmanship, and reflected the thorough knowledge and Arts and Crafts taste that she and her husband exhibited in their home and furnishings. They were close friends of the Chicago furniture craftsman Isaac Scott, who made much of their own furniture, and he may well have encouraged Frances Glessner's artistic interests. Their Chicago home on Prairie Avenue (where Frances had a metal workshop in a converted conservatory) was designed by Henry Hobson Richardson, and they also owned fabrics and rugs by William Morris, and furniture by the Herter Brothers of New York. A dish made by Frances Glessner and given by her to the women's club The Fortnightly of Chicago, shows a stark simplicity of design, enlivened by the slight surface texture of the beaten work. It was made under the direction of Mr Fogliata, the master of metalwork at Jane Addams' Hull House, Chicago.

Clara Barck Welles was another Illinois craftswoman: she founded the Kalo Shops at Park Ridge, Illinois in 1900, producing classically simple designs for silver items in line drawings, which were then followed by the craftsmen who made them. She continued to produce designs and run the shops until her retirement in 1940; her silver was popular with Chicagoans, and was renowned for its beautiful craftsmanship; she exhibited at the Art Institute of Chicago and at major museums in the East. Elizabeth E. Copeland worked both in silver and enamels, and her most characteristic work exhibits primitivistic forms 'enlivened by the colorful enamels in suggestions of natural motifs'.[26] Although she was born and worked in Boston, where she was associated with the Handicraft Shop, Elizabeth Copeland studied in London; in 1916 she was awarded a medal for excellence by the Society of Arts and Crafts in Boston. In Cincinnati, the multiple talents of Mary Louise McLaughlin included metalwork and jewellery making, while her rival in the ceramic field, Maria Longworth Nichols Storer, also moved into metalwork, making ornate Japanese-inspired stands for her pots.

NOTES

1. Sir Ambrose Heal *The London Goldsmith*, 1972 (reprint), reproduced in plate 33, facing page 164; another version in plate 32, facing page 161.

2. *ibid.*, plate 27, facing page 152. See also p. 29.
3. Quoted in *ibid.*, p. 138, n.1.
4. *ibid.*, p. 8.
5. Aymer Vallance, Modern British Jewellery and Fans, *Studio*, Special Number, vol. 12, Winter 1901–2, p. 1.
6. See Charlotte Gere, *Victorian Jewellery Design*, London, 1972, p. 142, plate 68, who puts forward this suggestion.
7. Vallance, *op. cit.*, p. 3.
8. *ibid.*, p. 4.
9. *ibid.*, p. 5.
10. Art-Work for Women I, *Art Journal*, March 1872, p. 65.
11. E. F. Strange, A Chat with Mr and Mrs Nelson Dawson on Enamelling, *Studio*, vol. 6, 1896, p. 175.
12. E. F. Strange, Some Recent Work by Nelson and Edith Dawson, *Studio*, vol. 22, 1901, pp. 169–74.
13. The Editor, Nelson and Edith Dawson, *Architectural Review*, vol. I, 1897, pp. 35–6.
14. Arthur S. Wainwright, The Jewellery of Mr and Mrs Arthur Gaskin, *Studio*, vol. 61, 1914, p. 296.
15. Cited in Gere, *op. cit.* pp. 144–5.
16. Shirley Bury, The Liberty Metalwork Venture, *Architectural Review*, February 1963, p. 111 and p. 111, n.6.
17. Gere, *op. cit.* p. 167.
18. The Arts and Crafts Exhibition, 1896 (Third Notice), *Studio*, vol. 9, 1896–7, p. 202. The 'posters' referred to doubtless include the one designed by the Macdonald sisters and Herbert MacNair *c.* 1896 for the Glasgow Institute of Fine Arts, in which the design motif of a stylised hawk-like bird appears. This poster is reproduced below, in the section on illustration.
19. The Arts and Crafts Exhibition, 1896 (Third Notice), *op. cit.* pp. 202–4.
20. For a full discussion of the selective orientation of twentieth century art history and its effect on women's art see the forthcoming book by Rosie Parker and Griselda Pollock, *The Old Mistresses*, London, 1978.
21. Vallance, *op. cit.*, pp. 5–6.
22. Art-Work for Women I, *op. cit.* p. 65.
23. Society of Arts, *Art Journal*, 1873, p. 94.
24. Gere, *op. cit.* p. 269.
25. Vallance, *op. cit.* p. 7.
26. R. J. Clark (ed.) and others, The Eastern Seaboard in *The Arts and Crafts Movement in America*, 1972, p. 23 and p. 26.

6 Woodcarving, Furniture and Interior Design

Agnes Pitman: carved chest of drawers, c. 1870–80; 5 ft high, 3 ft 3 in wide, 1 ft 6 in deep. (PHOTOGRAPH: CINCINNATI ART MUSEUM, OHIO)

THE *Studio* of 1893 noted that there were by then endeavours to 'revive an art that has been for some time unduly neglected'[1]—that of artistic woodcarving; the institution under discussion was the School of Art Woodcarving in South Kensington. This school had been established in 1879 by the Society of Arts at Somerset Street, Portman Square, with a Florentine artist, Signor Bulletti as instructor. Later that same year, because of insufficient space at Portman Square, the Royal Commissioners for the Exhibition of 1851 granted the School rooms in the Albert Hall, to which it moved in September 1879. It is not clear what form of training in this craft was available prior to 1879, but it seems likely that the only method was by a workshop apprenticeship, or perhaps through study in the studio of an acknowledged artist like Signor Bulletti. However, even in 1893, the School of Art Woodcarving was still the main centre for instruction in the craft, although small classes had sprung up throughout the country. Women evidently had opportunities to learn woodcarving, for in 1881 Miss Eleanor Rowe was appointed manager of the School and assistant teacher, though it is unclear whether or not she was trained at the School itself.

Another woman, Miss M. E. Reeks, was appointed to the teaching staff as an evening class assistant in 1882, and according to one source she did most of the teaching at the School on her own in the year after Bulletti's departure because of ill-health in 1883; two further male instructors were taken on in 1884.[2] The School 'aims at giving a thoroughly practical education to the professional carver, and to further this object, orders for carving are accepted, so as to accustom the students to work for the market'.[3] The School therefore worked on a system similar to that of the Royal School of Art Needlework, and the Female School Chromolithographic Studio, although at the School of Art Woodcarving there was no permanent workshop for graduates of the School. The School was open to amateurs as well as to students taking a professional training, and 'in the late eighties the carving of wood became a popular as well as society hobby. The School expanded very considerably until at one time as many as seventy students could be found on one day at work in the studios'.[4] This growth of interest meant that opportunities for teaching the craft also expanded, and many ex-students found employment all over the country in such teaching. In fact it is evident that this was what women trained as woodcarvers were expected to do:

In addition to teaching carving, great attention is paid to the training of teachers, and numbers are sent every year from the school to various parts of the country. For women, the opening as teachers of carving is a very good one. The remuneration varies from £1 to £5 a week, according to the energy and ability of the teacher ... For young men, in addition to the opening as teachers, there is the workshop, where they will do far better in their early years than going about the country teaching elementary wood-carving. It is only in the workshop that a thoroughly practical knowledge of the art can be obtained, yet it is better for those who can to study some three or four years in the school.[5]

There were obvious problems involved in employing women in all-male workshops, so their potential was limited almost completely to the 'teaching elementary wood-carving' referred to above rather derisively in the discussion of opportunities for men.

The School's training was thoroughly systematic, involving a knowledge of drawing, design, modelling and construction, as well as carving; it was intended as a three to four year course, with either day or evening attendance. The early examples produced by the School, perhaps because of the Italian influence of Signor Bulletti, showed an emphasis on copying from Italian Renaissance copies, themselves debased products of the early nineteenth century and conspicuous only as *tours de force* of technical skill. By the mid 1880s however, standards were high, and the School was awarded a silver medal in the Educational Section of the International Health Exhibition of 1884; Miss Reeks won a bronze medal, as did two other students, one of whom, Miss H. E. Wahab, was a woman. Miss Reeks and another student, Miss M. S. Smith, both executed works for H.R.H. Princess Louise; Mrs Hearn won second prize for women's handicrafts at the 'Woman Exhibition' for her Gothic casket. Attendance at the School numbered forty-two in 1881, and ten years later stood at 305 for the year. Out of a total of fifty-six Council Members of the school from its inception up to 1929, seven were women. After Eleanor Rowe retired as manager of the School in 1902 (she was a Council Member from 1902 to 1911), the post was taken over by Miss Reeks, who remained on the teaching staff until 1915. Miss A. C. Burton joined the teaching staff in 1904 and was still there when Grimwood wrote his book on the School in 1929. Walter Crane was Chairman of the Committee from 1911–15, and during this period:

The preponderating dilettante element was giving way to an increasing number of serious students ... It was now definitely understood that while every encouragement and assistance were to be given to students who desired to study wood-carving as a cultural interest, the School was primarily concerned in training students to enable them to enter workshops and studios as professional craftsmen, and to assist the education of those already in the 'trade'.[6]

As with other 'trades', bookbinding in particular, such measures tended to exclude or discourage women from the more active aspects of the craft and they were channelled into the most traditionally acceptable area of craftwork—teaching.

Many other women were engaged in designing for woodcarving, or for other aspects of the craft, such as inlaid work. The Home Arts and Industries Association were particularly active in this field, with women teachers and designers producing patterns for craftsmen, (usually male), to execute—an interesting but understandable reversal of the traditional rôles in many other crafts, such as embroidery, where the practical side was thought to be most suitable for feminine hands. May, wife of the painter G. F. Watts, directed a class in applied arts at Compton in Surrey, producing among other things carved panels like the one mentioned in the *Studio* of 1901, which represented

Oak settle, designed by Miss M. A. Heath and carved by W. Upton in the Leigh class of the Home Arts and Industries Association. Illustrated in the Studio, *1896 (p. 93).*

Writing-table designed by the Countess of Lovelace; inlay work designed by the Hon. Mabel de Grey, made by the Pimlico class of the Home Arts and Industries Association. Illustrated in the Studio *1896 (p. 100).*

Sidney Barnsley: oak coffer, with exposed ribbing and panelled inside, the panels painted with floral decoration by Alfred and Louise Powell (Lessore); length 5 ft 6 in, height 2 ft 0.7 in. (PHOTOGRAPH: FINE ART SOCIETY, LONDON)

the Gaelic *Blessing of the Pillow*, or invocation of sleep. This article, discussing the Home Arts and Industries Association annual exhibition at the Albert Hall, commented that the most remarkable progress of any craft had taken place in the Association's inlaid woodwork. The Hon. Mabel de Grey and the Hon. Mrs Carpenter were names which cropped up frequently in relation to artistic designs for inlaid wood, and they ran classes at Pimlico and Stepney in London, Little Gaddesden in Hertfordshire and Boulton-on-Swale in Yorkshire; they specialised in inlaid caskets, cupboards and furniture. Mrs Leopold de Rothschild ran a class at Ascot in Buckinghamshire teaching all aspects of furniture making: woodwork, carving and inlay. As is evident from the examples given here, the organisers and instructors in many of the Home Arts classes were upper-class women from wealthy backgrounds and with society connections, who were doing philanthropic, educational work among the poorer classes. The *Studio* commented in 1901 on the improvements in executive and decorative quality:

which the devotion of the good teacher has rescued from amateur methods (or lack of them) and brought successfully into line with expert craftsmanship. This result—to have trained and organised a number of unattached workers with real aptitude for applied art, and enable them to take their place in the English market with wares of distinct and individual worth—is the best justification of the Home Arts and Industries classes, and the reward (though far too scanty) of class-holders working under the Association in obscure and unpromising districts throughout the Kingdom.[7]

An article on an earlier Home Arts and Industries Association exhibition went into some detail regarding the quality of Mabel de Grey's wood inlay and design:

The tobacco box with its inlaid view of factory chimneys, a frame with a group of sheep and a dozen other items, all Miss de Grey's design, were most attractive. A beautifully proportioned writing table, designed by the Countess of Lovelace, owes its decoration to Miss de Grey. The structure of the table is severely simple, and exhibits a fine sense of proportion always rare, and exceptionally so in ladies' designs . . . but the human no less than the decorative quality of Miss Grey's work would win favourable criticism in any exhibition. On its own merits *L'Art Nouveau* in Paris would most probably award it a very distinguished place.[8]

The names of other woodcarvers appear occasionally in the *Studio*; along with a casket in French walnut by Maria E. Reeks, a screen by Miss Annie Garnett was reproduced in the issue for 1910; in 1907–8 the magazine illustrated a carved wood chest by 'Miss F. B. Adam, a pupil of Miss M. Moller, whose woodcarvings are well known to readers of The Studio. Miss Adam has undoubtedly received some influence from Miss Moller's designs, but her work nevertheless is distinctive, and the plant forms carved on the chest are very

happy in their character.' Other women produced painted or decorated accessories to the furniture design of another; one of the most famous is Kate Faulkner's gesso decoration of a grand piano made by Broadwood and Sons, and shown at the first exhibition of the Arts and Crafts Exhibition Society in 1888. In the fifth exhibition of 1896, another musical instrument, a harpsichord, was shown; it was made by Arnold Dolmetsch and decorated by Helen Coombe, and proved the most popular item on show:

one might fairly claim that by his enthusiasm in old-time music Mr Dolmetsch has annexed a new field of art to the Arts and Crafts ... of stained green wood, with charming decorations painted by Helen Coombe, it was a singularly beautiful and graceful object. For complete re-infusion of an older spirit into modern work, this delightful instrument is absolutely perfect of its class. Refinement of design is fully mated with refinement of sound.[9]

Three other examples of furniture decorated by women appeared in the 1896 exhibition; first:

A very well planned oak settle, by Mr Walter Cave, is exhibited only in a photograph ... but the six panels by Mrs Walter Cave which decorated the upper part of the structure itself are hung in the West Gallery ... They are vivid in colour as the pages of an old missal, and preserve much of the simplicity and naïve charm of antique illumination. Frank imitations of a past style as they are, criticism is disarmed, and you accept the convention they re-embody with distinct pleasure. They are a most pleasant instance of the deliberate use of archaic methods well carried out ... [10]

The *Studio* of 1896–7 reproduced all four panels of a four-fold screen by Amy Sawyer from the Arts and Crafts Exhibition:

Its harmony of colour is exceedingly sumptuous; pitched in the key of jewels, enamels, or stained glass, it almost succeeds in deluding you into believing that oil-paint can rival crystals, or the plumage of humming-birds. Yet despite its gorgeous colour, it is in no way garish or obtrusive, but is a fine piece of decoration that, pictorial as its treatment may appear, always observes the limits which separate the decorative from the pictorial.[11]

A third decorative item, a chest of acacia wood, was covered in red leather with a design added in brass-headed nails and was adapted, executed and worked by Mrs Willingham Rawnsley. This chest was also shown at the Home Arts and Industries Exhibition of the same year (1896), and was applauded in the *Studio* as a good example of a method of decoration which required only a small amount of simple though precise, handiwork. 'Those who lack the artistic skill required for carving, inlay, or painting, might do worse than revive this ancient and simple craft.'[12]

In America, artistic woodcarving seems to have got under way even earlier than in England; Cincinnati was the main centre of advanced effort in this field, as it was for ceramics. Ben Pitman, the younger brother of the famous inventor of the shorthand method Sir Isaac Pitman, had moved to America to promote his brother's invention, and settled in Cincinnati prior to the Civil War. However, his interests seem to have lain more in the direction of promoting applied arts, and it is he who was responsible for establishing instruction in this field in Cincinnati. As early as autumn 1872 examples of carved wood furniture, doors and baseboards executed by Pitman, his wife and his twenty-two year old daughter Agnes were shown at the Third Cincinnati Industrial Exposition. The following year Pitman and Agnes Pitman volunteered their services to give courses in practical art in the School of Design. Three classes a week were offered in woodcarving to any students of the School who chose to take up the study; no less than eighty-eight enrolled, most of them women. An exhibition of their work held three months later proved an astonishment to visitors, and prompted financial aid from Joseph Longworth, father of Maria Longworth Nichols:

Recognising the fact that a more liberal expenditure of money would greatly increase the usefulness of the school, Mr Joseph Longworth made two gifts of $50,000 each, the interest of which should be devoted to the support and improvement of the school of design. He said in making the gift that 'some employment ought to be provided for the idle rich as well as the industrious poor'. The carving school has shared the benefits of this contribution.[13]

The class at the school of design grew so rapidly that soon several ladies desiring a more personal or special instruction went to the workshop of Mr Henry L. Fry and his son William Henry, to study where they had the advantage of seeing the men's own work in progress. Henry L. Fry was a native of Bath in England and had studied under Grinling Gibbons; he had worked on Fonthill Abbey, built by William Beckford, and had thereby been initiated into the Gothic revival style. He had also worked on the screen of Westminster Abbey under Sir Gilbert Scott, and the Houses of Parliament under Pugin and Barry. He left London for America in 1849, when his son William, born in Bath, was nineteen. The Frys started a private class for ladies, at their request, in 1874 and it was run mainly by the younger Fry. In July 1876 Henry Fry wrote to the *Cincinnati Gazette* concerning their pupils:

We were very fortunate in our pupils. My son gave them particular attention, and they responded by faithful and diligent application, and I know that it would be a difficult matter for us to get such excellent work from ordinary skilled workmen who make ornamentation. Most of our pupils, of course, have the culture, taste, and refinement that are needed for such work, and their delicacy of manipulation and their leisure must be taken into account. Besides, the hand of a woman is better adapted and admirably organised for some of our work, better fitted for the development of the beautiful in art.[14]

Thus by 1874, only a year after Ben Pitman and his daughter's initiative, two large woodcarving classes for women were under way; many of the earliest members of the Pitmans' classes were also later famed for their work in ceramics, and they included Mary Louise McLaughlin, Laura Anne Fry (daughter of William H. Fry), Clara Chipman Newton, Jane Porter Hart Dodd,

169

Frances S. Hinkle and Julia Hall Rice (the last two were members of the Cincinnati Pottery Club from 1890). Although many of the women were taking up the craft as a pastime, the *New Century for Women*, a paper published at the Philadelphia Centennial Exhibition where many examples of Cincinnati woodcarving were shown in the Woman's Building, stated:

Much of the work thus far has been done by those who desired some special article of furniture for the decoration of their own rooms, or who wished to make a gift doubly precious to a friend by offering work of their own hands; but there are some who propose to make this work a profession, and who are willing to execute orders.[15]

Of the exhibitors at the Centennial whose work was described, the Misses Johnson were noted as having adopted carving as a profession. The exhibits were not left uncriticised; the influence in particular of William Fry was seen as unhelpful, and an example of his work, a carved cabinet in a fourteenth-century Gothic style was criticised as over-patterned:

Herein is a fault which Mr Fry's pupils have not failed to copy, and which destroys all repose in the work. It was noticeable in the women's work at the Exhibition that there was an evident disposition to cover all plain surfaces with niggling ornament, thereby detracting attention from the really fine carving with which the more important parts of the articles were wrought. This would not be worth mentioning were it not for the unfortunate example of the younger Mr. Fry.[16]

This error was apparently common in much of the work done by those women who had been taught by William Fry. The women attempted carving from both natural forms, 'handled with great vigor and precision' and figure subjects in low relief. The few attempts at under-cut work were not surprising considering the short experience of the women at that date, but their lack of strength was also put forward as a reason:

It may also be ascribed to the natural inability of women to perform the muscular part of the work. The degree in which they accomplished even this was surprising; but an explanation offered by Mr. Fry will tend to make it clear. In answer to an enquiry as to how women could drive the carving-tool by blows from the flat hand, as is common with all carvers, he said that they used wooden mallets very extensively, and became remarkably expert with them.[16]

The work of particular women at the Centennial of 1876 came in for especial applause; Louise McLaughlin produced one of the finest exhibits, a hanging cabinet of her own design with hand painted tiles in the doors made also by herself and representing ladies in the costumes of 1776 and 1876, on a gold ground. The hinges, modelled by Louise McLaughlin in wax, were cast in bronze and finely chased. Her cabinet was filled with her own paintings on porcelain and pottery. Agnes Pitman's work included a chest of drawers decorated with flowers to represent summer; the handles and escutcheons of the drawers were modelled by her and then cast in brass and nickel-plated. There were also two oak doors from the Pitmans' house, carved and inlaid with ebony by Agnes Pitman. Jane Dodd showed

an elaborate Gothic table and a carved easel, while the work of the Misses Johnson included a bedstead carved with a design of vines in black walnut and ebony, and a panel with painted decoration on a slab of slate. 'This inside of the footboard had the most beautiful and delicate piece of carving we have ever seen, representing a convolvulus in intaglio.'

While the amateur lady woodcarvers' interest was seen as possibly only a passing enthusiasm—which for many it turned out not to be—it was felt that their knowledge would provide essential help in spreading appreciation of the craft, and a basis of patronage for the future. One contemporary writer advised would-be professionals:

Those women who undertake it for a livelihood will doubtless go on and improve in the quality of their work; but ... the range of it will always be limited. With these two things are necessary to make the movement a success: First in order is the encouragement of those who have employment to bestow and the intelligence to guide it in to useful channels; for this we must look to the able architects of Cincinnati. Second, it is essential that the carvers receive study of the best models. It is also important that they be employed to work on things which are beautiful in themselves. The absence of any furniture of good design in the exhibition except that made by Mr Fry and Miss Laughlin was noticeable. The work from the McMicken school [the School of Design] showed that the art of carving had been better cultivated in that institution than the designing of furniture. When the influence of scholarly and educated designers, in full accord with the latest developments of decorative art in England and America, is felt in the school which has had its inception in Cincinnati, we may safely look for the best results of the labors of these 'idle rich', as well as 'industrious poor', women of America.[17]

This was perhaps rather too harsh a judgement on such a new venture, but it nevertheless laid down demanding standards for the women to achieve. Among the women who continued to work in wood was Laura Anne Fry, who had trained in sculpture and drawing as well as ceramics and woodcarving; pieces by her were shown at the Columbian Exposition in Chicago in 1893. Mary Louise McLaughlin, in addition to her famous experiments and achievements in the field of ceramics, continued to carve in wood as well as working in a wide variety of other materials and methods including stained glass, metalwork, jewellery making, etching, needlework, sculpture and painting. Louise McLaughlin was a prominent exhibitor in the Cincinnati Room of the Woman's Building at Chicago in 1893.

A West Coast furniture designer and decorator, Lucia K. Mathews, must be mentioned; she trained at the School of Design at San Francisco's Mark Hopkins Institute of Art, where she met her husband, Arthur F. Mathews, who was teaching there. Both were painters, but in 1906, following the terrible earthquake of that year, they built a studio on California Street which housed their Furniture Shop as well as premises for painting. At its most popular, their furniture workshop employed between twenty and fifty craftsmen producing unique pieces of furniture, mostly on commission; they were characteristically carved and incised, with

The William Morris Section at the Exposition des Arts Décoratifs de Grande-Bretagne et d'Irlande, Paris, 1914. The painted gesso decoration on the grand piano in the foreground was designed and executed by Kate Faulkner; the piano was made by John Broadwood and Sons, and was owned by Ambrose Ionides.

often stylised natural forms, and polychromed in bright colours. Arthur Mathews supervised the general designs while Lucia was in charge of the carving and colour schemes. As painters it was natural that they should introduce colour into their work, and this development was typical of other designers of the period, many of whom used colour as an alternative to the straight oak finish common in the early 1900s. The Mathews' work anticipated the designs and colours which were to be so popular in the 1920s, although enthusiasm for their own work had waned by the end of the First World War.

INTERIOR DESIGN

Women's circumscribed social rôle in the nineteenth century was a decisive factor in the growth of specific areas of architectural specialisation in which it was considered acceptable for them to practise. In particular domestic architecture, interior design and decoration were encouraged, as these provided fields where women were dealing with the needs of women, which their male colleagues considered too trifling to warrant their attention: 'Since women managed the home, the reasoning went, they therefore understood how houses functioned; if they did indeed possess a

higher moral sense, they should apply that sensibility to the design of better houses'[18] and appropriate interiors.

Social attitudes, availability of training, and work outlets all served to channel women into the 'minor' aspects of architectural work, outside the mainstream of male-dominated architectural practice. The Census of 1891 indicated that there were then twelve women architects practising in London, although these were outside the auspices of the Royal Institute of British Architects, whose ranks were closed to women until 1902. But because of the nature of women's activities, the statistics gave only a partial picture, for they excluded the large number of women engaged in interior design. Among the most important early interior designers were Agnes and Rhoda Garrett:

Two women articled many years ago to an eminent architect, now deceased, and who showed great talent for internal decorative work, and who had a good sense of colour, have had quite a successful career as decorators of houses, designers of interior panelling, chimney-pieces, and patterns of textiles.[19]

Agnes and Rhoda Garrett were 'two members of a family noted for its exceptional erudition and sense',[20] as a condescending critic wrote in 1876; Agnes Garrett was sister to the women's rights campaigner Millicent Garrett Fawcett and the pioneering woman doctor Elizabeth Garrett Anderson; Rhoda Garrett was their cousin. The two women lived and worked together in London, where they had begun their training in 1871, and set up an interior decoration business which came

to be seen as influential on a par with that of Morris and Co. in spreading new and artistic ideas of taste in the home from the 1870s. While much is known about the respected Morris firm, little information survives regarding the women's business.

In 1876 they published a book of *Suggestions for House Decoration in Painting, Woodwork and Furniture* in the Macmillan 'Art at Home' series, a series to which Lucy Faulkner was also a contributor two years later with *The Drawing Room, its Decoration and Furniture*. These books gave a wide public access to the women's innovatory ideas. In architecture, Agnes and Rhoda Garrett recommended the so-called 'Queen Anne' style, which had been pioneered by Philip Webb in Morris's Red House, and popularised by many of the Arts and Crafts movement architects. They wrote:

It is only within the last few years that architects and other competent designers have again begun to think the subject of domestic furniture and decoration worthy of their serious attention ... Much has lately been done by Architects and designers of the Queen Anne school to improve the public taste in this direction and to encourage manufacturers to introduce better designs into this branch of household art.[21]

Their critic in the *Furniture Gazette*, although uninformedly suggesting that they had no proper training, was nevertheless not entirely negative about their book, which was aimed at middle-class people of moderate means, 'the largest Class of Society':

The way our authors treat the subject of houses as they are and might be, is deserving of the highest praise, as it is systematic and careful, and the only pity is that the book is not much larger ... The Misses Garrett go from room to room describing them as they are in nine out of every ten middle-class homes, and pointing out how they might be improved ... In this manner ... each room is gone through.[22]

Although Agnes and Rhoda Garrett attempted to make good taste and artistic ideas for the home available to a broader class spectrum, they were inevitably engaged in reinforcing middle-class values, an accepted notion of the family home and woman's rôle within it. This situation was particularly unequivocal for interior designers who in practice worked almost exclusively for the wealthy; among the socially aware Arts and Crafts designers this conflict frequently resulted in a crisis of conscience such as that which prompted William Morris's outburst that he was 'ministering to the swinish luxury of the rich',[23] or Ashbee's comment on their dilemma that 'we have made of a great social movement, a narrow and tiresome little aristocracy working with great skill for the very rich'.[24] In the Victorian period, in which social status and its outward trappings were of vital importance to the consolidating middle classes, the home—centre of Social life—was crucial in reflecting the owner's taste, fashion and wealth, and thereby social rank. Professional advice in this field was generally considered essential, as few laymen could make head or tail of the extravagantly eclectic vagaries of changing taste in decoration. At the avant-garde end of the scale were the Arts and Crafts interior designers like Morris and the Garrett cousins, while the more 'popular' manifestations of artistic taste were catered for by a proliferation of art-conscious professional advisors, many of whom were upper-class women, who wrote books and columns in such popular ladies magazines as *The Queen* and *The Lady*, often setting themselves up as consultants in a field in which they had no special training.

In an article on 'Woman's Part in Domestic Decoration', Lewis F. Day criticised this dilletantism, stressing the importance of thorough art education for women attempting to enter the field of interior design:

It is the fault of the education of ladies that they realise so little what goes to make proficiency in decorative art ... Their

172

Margaret Macdonald: The Seven Princesses, 1906. Composite photograph of a frieze decoration on coloured glass, 8⅝ × 33¼ in. (PHOTOGRAPH: HUNTERIAN ART GALLERY, UNIVERSITY OF GLASGOW)

time has been spent in acquiring accomplishments which accomplish nothing ... The lamentable outcome of this unkind kindness is that when a lady, as so often happens, is reduced to want employment, she fancies that the half-developed faculties which have been wont to win the praise of friends will enable her to earn a livelihood ... It is one of the pressing questions of our time—How shall poor gentlewomen support themselves?—and many imagine that the career of art, and of decorative art especially, is open to them. So it is— or would be if they had been trained to it ... The real source of their distress and trouble is in the prejudice which men hug to themselves with more than feminine infatuation, that a man is degraded by allowing his daughters to work for their own living ... When a young woman is all at once thrown upon her own resources, with a *necessity* of earning immediately her own living, those resources seldom prove adequate, and that necessity of at once earning an income makes impossible the study that should by rights have preceded the exercise of a profession ... When one has arrived at a certain proficiency in one's craft these accomplishments begin to be valuable, but till then they are sometimes even a hindrance.[25]

Lamenting the general lack of effective training in decorative art for women, Day went on to emphasise that even the skilled amateur could be of little use to the practical decorator; most women tried too late to take up the work, they were often too old, too self-satisfied, too desperate to earn money, and ignorant of the 'slight commercial value of such labour as they have to sell'. Thus while considering women's talents in the field great, Lewis F. Day thought their chances of success small unless they were thoroughly trained early on. However, because of the minimal educational demands traditionally made upon women as a result of their social position, an inability to concentrate on serious study came to be seen as a social attribute of the feminine woman. Thus women were placed in a double bind: they could undertake no serious professional art

work without studying and training, but at the same time an aptitude for serious study and professional work was seen as conflicting with the ideals of femininity.

One of the most influential interior designers in America was Candace Wheeler, whose embroideries and needle-woven tapestries have already been discussed. In 1879, at the suggestion of Louis Comfort Tiffany, she joined with him, Samuel Colman and Lockwood de Forest to form the Associated Artists in New York, an association which would, she hoped, draw together all the arts to create a new era in house decoration: 'the first-fruits of the American renaissance that had been planted by the Centennial [of 1876], watered by the Society of Decorative Art, and that would bloom forth in Art Nouveau'. This new association:

was neither philanthropy nor an amateur educational scheme; this was a business based in the newly awakened American taste for art. What William Morris and Walter Crane had projected in England, and Eugène Grasset and Emile Gallé in France, Louis C. Tiffany proposed to accomplish in America. Mrs. Wheeler, by her own association in the scheme, could demonstrate the fact that 'woman's labour, if *well trained*, was needed in the world, and could not only make its demand but find its wages.[26]

Candace Wheeler's rôle within Associated Artists was the supervision and execution of embroideries, needle-woven tapestries and loom weaving. She was committed to the idea of rich sumptuous fabric hangings—curtains, portières and tapestries—and a style of room liberally adorned with them, to 'shut out the disagreeable...and...enclose within itself the peaceful

serenities of home'.[27] Sentiments remarkably close to Ruskin's 'temple of the hearth'. Their first commission was for the drop curtain of the Madison Square Theatre, which opened on 4 February 1880; next they decorated the Veterans' Room and Library of the Knickerbocker Grey's new armoury on Park Avenue, which was followed by the interior of the Union League Club House on Fifth Avenue. Among their most important prestigious commissions was one for the re-decoration of parts of the White House, at the request of President Chester Arthur. During the early 1880s, Candace Wheeler, in addition to her work for Associated Artists, began to experiment with wallpaper designing. Warren, Fuller and Co. had offered $2,000 in prizes for the four best designs submitted for competition, and all four were won by women—Candace Wheeler taking the first prize and her daughter Dora the fourth.

During her years with Associated Artists, Candace Wheeler developed her personal philosophy of interior decoration; fitness of purpose was crucial, as was the use of colour, which she felt to be a particularly American gift. The design should, she felt, be a reflection of the people who were to live within the interior, it should be a 'crystallization of the culture, the habits, and tastes of the family'. Interior decoration was for her like creating a picture, 'but a picture within and against which one's life, and the life of the family, is to be lived'. Beauty was considered central; she said it was 'by no means an unimportant thing to create a beautiful ... interior ... Truth and beauty are its essentials and these will have their utterance'.[28] By 1883 her work was already widely acclaimed, and she decided to break with Associated Artists and continue on her own; so

Taking with her not only her practical experience, but the name, Associated Artists, Candace Wheeler set up her own workrooms and launched upon her own business that would be conducted exclusively by American women for the decoration of American interiors ... The growth in American taste had made her work not only possible but remunerative.[29]

In a four storey brown-stone at 115 East 23rd Street, the new Associated Artists proceeded to carry out her aims of combining art and the manufacturing industry; her assistants were a 'unique little band of accomplished American gentlewomen'.[30] At the heart of the break with Tiffany may have been a difference in approach to design; while Candace Wheeler did advocate the use of conventionalised, flat design, she seems to have been more strongly in favour of a figurative, representational style, (as exemplified by the designs of her daughter and Rosina Emmet) particularly in needle-woven tapestries. The relative fitness of representational designs for decorative functions was hotly disputed in English Arts and Crafts circles,[31] and while in America a greater degree of realism in designs for applied art seems to have been accepted (particularly in art embroidery, stained glass, illustration and mural painting), Tiffany himself was clearly moving towards a highly conventionalised form of Art Nouveau.

In order to improve the general artistic quality of American industrial manufactures, Candace Wheeler began supplying firms like the great silk manufacturers,

Mary J. Newill: Design for stained glass, illustrated in the Studio, *1896 (p. 133). Like many of her colleagues in the Birmingham group, Mary Newill's wide-ranging craft skills included designs for stained glass windows.*

Cheney Brothers of Connecticut, with original, American-inspired designs; she also began experimenting with the use of cheap cloths, producing good designs that would thus be available to a wider public. She was extremely influential not only in spreading artistic taste in American interiors, but also in her efforts to improve the quality of mass-produced textiles. Candace Wheeler's Associated Artists was, however, not simply concerned with textiles for the home:

We added interior decoration to our list of accomplishments, and had much to do with making that form of art a profession for women. Women were not then and perhaps are not now sufficiently instructed in art knowledge to be equal to the interior finishing and furnishing of ... mansions ... Domestic interiors, however, fall naturally within the grasp of women, and I look forward to the time when the education and training of women decorators will fit them for public as well as for private patronage.[32]

Her comprehensive schemes for interiors included a kitchen designed by her for a one-servant house; she felt the kitchen to be the heart of the house and in need of more careful study than any other room.

Candace Wheeler had a strong moral commitment in her approach to interior design:

If decorative art was allied to architecture, it must also be subordinate to it. It must oppose things false, 'things made to sell', dishonest manufactures that demoralize the spirit of the home. It must be functional, appropriate, characteristic of the family and of the country it was intended for. It must be embedded in study and education.[33]

To this end her work at Associated Artists included a scheme for a three-year training course for women as interior decorators; she also advised the Woman's Art School of Cooper Union and lectured at the New York Institute of Artist-Artisans, where she was instructor in textiles. Like Lewis F. Day, she believed in promoting the 'serious and comprehensive study without which no professions can be worthily followed or [their] practice genuinely respected'. However, when she advised the aspiring student to 'confine yourself to conventional designs until you can used natural forms like an artist' she showed herself partly in conflict with the English Arts and Crafts ideals in acknowledging the superiority of the artist, and the use of natural, representational forms over the conventionalised decoration determined by the use of hand-wrought materials by a single artist-craftsman.

One area of decorative art closely associated with architecture which came to be seen as suitable for women both in England and America was the design and production of stained glass windows. Mary J. Newill, an artist and craftswoman associated with the Birmingham Group, has already been mentioned as being active in this field and by the late 1890s this art,

Margaret Macdonald. Two circular plaques, lead with clear and coloured glass, diameter of each approx. 7½ in, c. 1900. A writer in the Studio in 1897, evidently unfamiliar with their work, had trouble in differentiating between the sisters' work: 'It is with some relief that one finds the Misses Macdonald are quite willing to have their work jointly attributed—for actuated by the same spirit, it would be difficult, if not impossible, for an outsider to distinguish the hand of each on the evidence of the finished work alone' (p. 90). The differences in their styles became increasingly apparent from the mid-1890s onwards. (PHOTO-GRAPH: MACKINTOSH COLLECTION, HUNTERIAN ART GALLERY, UNIVERSITY OF GLASGOW)

previously dominated by men, was rapidly opening up to craftswomen. Even by this date women were not accepted in the large commercial firms, but in the small craft workshops associated with the Arts and Crafts movement, the significant contribution of women was widely acknowledged. Christopher Whall, following the inspired example of William Morris and Burne-Jones, was one of the most remarkable stained glass artists of the period, who was to be a particularly important influence on twentieth-century developments in the art of stained glass. Whall set up his firm in the 1880s, and was instrumental in the foundation of other important workshops. He also taught at the Central School of Art and Crafts, where his daughter Veronica trained; they worked together during his lifetime, and after his death in 1924 she carried on the firm until her own death in the 1950s. In addition to stained glass, Veronica Whall also carried out book illustration and mural decorations, examples of which were exhibited at the exhibition of Decorative Arts in Paris in 1914.

Below: *Wilhemina Margaret Geddes: Three panels of stained glass illustrating scenes from the life of St. Colman MacDaugh, designed and executed by her and exhibited at the Exposition des Arts Décoratifs, Paris, 1914.*

Bottom: *Birmingham School of Art: Figure composition class, c. 1900. A series of Morris stained glass cartoons on the right-hand wall would suggest that this class was engaged on designing for stained glass.*
(PHOTOGRAPH COURTESY OF ALAN CRAWFORD, BIRMINGHAM SCHOOL OF ART)

Right: *Nelia Casella: glass flower vase with ornamented motto, designed and executed by her and exhibited at the Exposition des Arts Décoratifs, Paris, 1914. This is a rare example of a woman artist involved in the design* and *manufacture of glassware; Nelia Casella's work was featured regularly in the* Studio *magazine, and at major crafts exhibitions in London and abroad.*

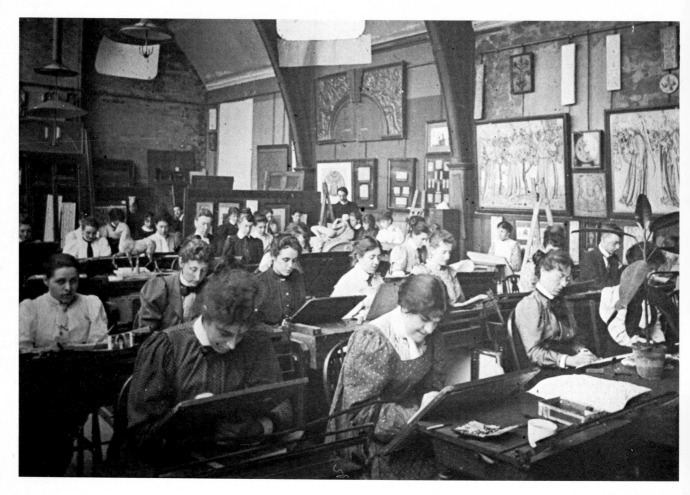

176

Several of the most talented stained glass artists of the Arts and Crafts movement were women; one of the key groups was in Ireland, the An Tur Gloine, or Tower of Glass, which was a stained glass workshop and school set up in 1903 by Sarah Purser, an artist of the Royal Hibernian Academy. She was aided by Christopher Whall, who allowed her to employ his top technician, A. E. Child, to help establish the workshop. The Tower of Glass was responsible for training some of the best young stained glass artists, among them Evie Hone, and Wilhelmina Margaret Geddes, who was to become one of the most visually powerful stained glass designers of this century, and whose work even at this early date was greatly admired. Mary Lowndes, who was involved in the campaign for women's suffrage, became a stained glass designer in the 1890s; she was co-founder, aided by Christopher Whall, of the stained glass firm of Lowndes and Drury in c. 1897, which moved into a still extant custom-built studio in Fulham in 1906. Like Wilhelmina Geddes, Mary Lowndes was a lesbian, and probably the consequent freedom from the social pressure to marry gave them greater energy and time to develop themselves and their creative work, resulting in strong, individual styles. Doubtless also, the greater degree of self-awareness often prompted by self-conscious homosexuality would have increased their awareness of the socially stereotyped 'feminine' rôle and its limitations, leading to a more sensitive, personal self-expression, if not a simple life. Clearly, in a society in which marriage

remained the key profession for women, lesbianism provided an alternative which was both unrestricting in contrast with the contemporary notion of family life, and more human, in that unlike socially sanctioned spinsterhood it acknowledged the importance of women's sexuality.

NOTES

1. E.R., The School of Art Woodcarving, South Kensington, *Studio* vol. 1, 1893, p. 56.
2. H. H. Grimwood, *The School of Wood-carving*, London, 1929, p. 21.
3. E.R., *op. cit.* p. 58.
4. Grimwood, *op. cit.* p. 9.
5. E.R., *op. cit.* p. 60.
6. Grimwood, *op. cit.* pp. 13–14.
7. Esther Wood, Home Arts and Industries Association, *Studio*, vol. 23, 1901, p. 106.
8. Gleeson White, The Home Arts and Industries Association at the Albert Hall, *Studio*, vol. 8, 1896, p. 95. Inlaid woodwork by the Hon. Mabel de Grey is reproduced on p. 97. *L'Art Nouveau* referred to was Samuel Bing's famous shop of that name on the corner of rue de Provence and rue Chauchat in Paris, which specialised in modern decorative art and also exhibited paintings; it gave its name to the *fin-de-siècle* decorative style *Art Nouveau*.
9. The Arts and Crafts Exhibition, 1896, *Studio*, vol. 9, 1896–7, p. 265.
10. *ibid*. pp. 133–4. These panels were reproduced on pp. 134–5.
11. *ibid*. p. 277. Four sketches, made especially by the artist after the four panels of the screen, were reproduced on pp. 276–7.
12. *ibid*. p. 278; reproduced on p. 279.
13. Women as Wood Carvers—The Movement in Cincinnati, *The American Architect and Building News*, Boston, 31 March 1877, reprinted in I. E. Clarke, *Art and Industry*, Washington, 1885–98, vol. 1, 1885 p. 691.
14. Quoted in *ibid*.
15. Quoted in *ibid*.
16. *ibid*. pp. 691–2. It is evident that the writer here was thinking of *ladies* rather than *women* (in Victorian terms); working-class women were of course, through necessity and training, usually as tough and as strong as men.
17. *ibid*. p. 693.
18. Gwendoline Wright, On the Fringe of the Profession: Women in American Architecture, in Spiro Kostof (ed.): *The Architect: Chapters in the History of the Profession*, New York, 1977, p. 281.
19. R. Weir Shultz, Architecture for Women, a paper read at a conference on Employment for Women held at the Caxton Hall, Westminister, printed in the *Architectural Review*, vol. 24, 1908, p. 153.
20. Garret [*sic*], Misses, on House Decoration, *Furniture Gazette*, vol. 5, 1876, p. 349.
21. Rhoda and Agnes Garrett, *Suggestions for House Decoration in Painting, Woodwork and Furniture*, 'Art at Home' series, Macmillan, London, 1876, pp. 54–5.
22. Garret [*sic*], Misses, on House Decoration, *op. cit.* p. 350.
23. Anecdote recorded in W. R. Lethaby, *Philip Webb and his Work*, Oxford University Press, 1935, p. 94.
24. From Charles Ashbee's unpublished Memoirs, in the Victoria and Albert Museum, 1938; quoted in G. Naylor, *The Arts and Crafts Movement*, London 1971, p. 9.
25. Lewis F. Day, The Woman's Part in Domestic Decoration, *Magazine of Art,* 1881, pp. 462–3.
26. An American Woman First in Textiles and Interior Decoration—Candace Wheeler, in M. B. Stern, *We The Women*, New York, 1963, p. 280.
27. Candace Wheeler, quoted in *ibid*. p. 281.
28. Candace Wheeler, quoted in *ibid*. p. 287.
29. *ibid*. p. 288.
30. Candace Wheeler, quoted in *ibid*.
31. See Chapter 3, Embroidery and Needlework, for a full discussion.
32. Candace Wheeler, quoted in M. B. Stern, *op. cit.* pp. 293–4.
33. Candace Wheeler, quoted in *ibid*. p. 295.

7 Hand-printing, Bookbinding and Illustration

Kate Greenaway: Illustration to A Day in a Child's Life, *girl and two babies. Watercolour, signed.* $7\frac{1}{8} \times 5$ *in.* (PHOTOGRAPH: VICTORIA & ALBERT MUSEUM, LONDON)

W OMEN HAD TRADITIONALLY played an active rôle in the printing trades, but by the sixteenth century were being increasingly excluded from apprenticeships, which made it difficult for them to learn the skilled aspects of the craft. This resulted in partially-trained and unskilled women trying to survive in an ever more competitive and hostile trade. 'Young printers ... were protesting against the women in the unskilled printing processes in the 1630s and had virtually excluded them by the mid-seventeenth century. It became no longer common for wives and daughters to help out the master printer.'[1] By the nineteenth century, the only means for women to enter the printing trades was by setting up their own presses. The Society for Promoting the Employment of Women, set up by the feminist 'ladies of Langham Place' in 1859, organised a series of projects to train and employ women in fields of work from which they were excluded. Among these was the Victoria Press; 'a printing business run by women trained by the Society as compositors, was successfully established, and within three years was actually named Printer and Publisher in Ordinary to Her Majesty'.[2] The *Illustrated London News* reported in 1861:

The introduction of women into the printing trade can now claim the consideration due to a successful experiment. The Victoria Press was opened in March 1860, and has therefore stood the test of one year's work, and has triumphed over all the preliminary difficulties ... The public mind, long either strongly opposed or utterly indifferent to such innovations, was in enlightened quarters beginning to feel the necessity for extending the industrial employment of women ... Miss Emily Faithfull, as one of the proprietors, undertook the sole management, and a year ago the office opened with a few girls, five of whom were apprenticed by the Society for Promoting the Employment of Women. In time these were joined by a few who had been trained by male relatives, but who could find no other outlet for their industry.

Among the publications printed by the Victoria Press was the Langham Place feminist *English Woman's Journal* which had first appeared in early 1858. The Society also helped train and place women as engravers, photographers and house decorators among other pursuits. A second women's press already referred to was The Ladies Printing Press (for the Tuition and Employment of Necessitous Gentlewomen), which was clearly intended for ladies of reduced circumstances rather than the apparently broader class aims of the Victorian Press.

The Arts and Crafts revival of the fine hand-printed book and of private presses came as a reaction to the

Printing office: The Victoria Press in Great Coram-Street, London, for the employment of women compositors, 1861. There were at least three women's presses active during the latter part of the century: The Victoria Press, The Ladies' Printing Press (for the Tuition and Employment of Necessitous Gentlewomen) and the Women's Printing Society, Limited, of 66 & 68 Whitcomb Street, London W.C. (PHOTOGRAPH: THE ILLUSTRATED LONDON NEWS PICTURE LIBRARY)

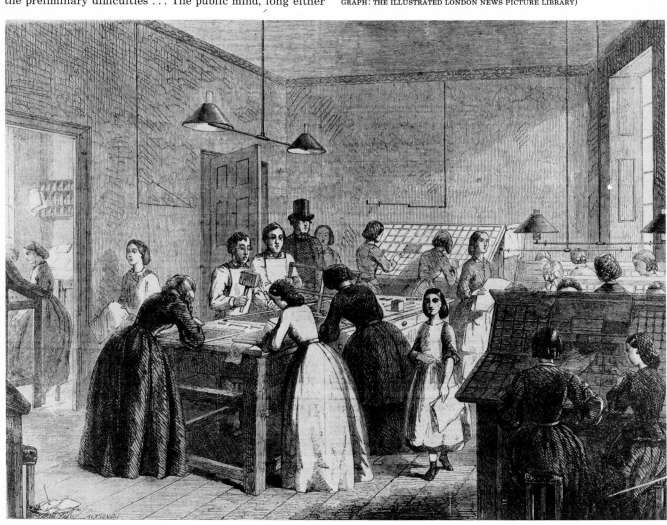

loss of craftsmanship which was the result of increased mechanisation in the trade during the nineteenth century, and of the growing split between artist/designer and craftsman so bemoaned by writers like Ruskin. However, the Arts and Crafts book, a revival which lasted from about 1890 to 1914, also had a profound effect on the standards of mechanically produced books in general. Technological advances had been essential to fill the demands of a period of increasing literacy and the need for cheap books, when ideals of self-improvement and mass education were at a height, but the resultant lowering of artistic standards was not entirely irrevocable, and many of the Arts and Crafts designers turned their talents to improving the quality of mass-produced books.

The revival of fine printing dates from the first printed book by William Morris, his own *Story of the Glittering Plain* produced in 1891 at the Kelmscott Press. The ideals of the Kelmscott Press were foreshadowed by several developments during the 1880s, in particular the influential and artistic magazine of the Century Guild of Artists, led by A. H. Mackmurdo, which was called *The Hobby Horse*. The first number, co-edited by Mackmurdo and Herbert Horne, was published by George Allen and printed at the Chiswick Press in April 1884. Other work by Mackmurdo, like his famous cover for the 1883 edition of *Wren's City Churches*, also helped foster the growing interest in artistic printing and craftsmanship in the book trades which led Morris to establish the Kelmscott Press.

The work of Henry Daniel at the Daniel Press in Oxford provided a link between the earlier traditions of private printing and the new, late nineteenth-century concern for and emphasis upon art and craftsmanship in the production of books. Daniel had begun printing at the age of nine, in 1845, but his most widely-known small hand-printed editions, especially of poetry, date from the mid-1870s, when he was Proctor and later Provost of Worcester College, Oxford. The example of his Press is significant, for in it we find already established the co-operative working relationship between the men and women of a family in the husband's Press which was to be characteristic of many Arts and Crafts movement private presses, and which harks back to the structure of printing workshops before the seventeenth century. Daniel's wife Emily and later his two daughters were all actively involved in the Press. Emily Daniel was herself entirely responsible for the setting up and printing of several of the Press's editions, like that of the *Ode on the Morning of Christ's Nativity* for Christmas 1894. Their books were usually private editions for friends, and were often prepared for Christmas or for charitable sales. Like many of the craftswomen in the field who followed her, Emily Daniel was particularly skilled in the decorative ornamentation by hand which was a characteristic embellishment of hand-printed books; she was noted for her rubrication by Falconer Madan: 'the capital letters in red which she supplies at the beginning of each poem are decked with tendrils which in some cases stray at will into and among the words, with beautiful effect'.[3] Such hand-executed decorations, in this case for the

Garland of Rachel, an anthology of eighteen poems by friends of the Daniels, printed in 1881 to mark their daughter's first birthday, were obviously only possible in very limited editions. In 1884 Emily rubricated with sensitive care the first initial letter of Henry Patmore's *Poems*, which they printed in that year. The Daniel Press books were described by Colin Franklin:

Most of the Daniel books were planned with immense care. Within their scope one looks for small type, flower ornaments, and Mrs Daniel's decorations most delicately executed in red ink on the black page. These might be lightly sketched initial letters, with tendrils curling into the type below, or white letters on a red background, or in Margaret Woods' lyrics, a beautiful miniated initial letter showing a meadow and the Oxford skyline.[4]

The true Arts and Crafts hand-produced book fell into two main stylistic categories: on the one hand the classical style with its restrained design and ornament, associated with the Aesthetic movement, and seen in its purest form in the work of Cobden-Sanderson's Doves Press; on the other the more romantically inspired Gothic, medievalistic style of work characteristic of the Kelmscott Press. In the latter, old-style gothic typefaces were adopted, with the title page and often all double-page spreads treated decoratively as a single unit. The pages were densely covered with type and ornament, initial letters and matching decorative borders; the paper was always hand-made and deckle-edged, crisp and white to complement the very black ink and often red ink used for displays in the gothic manner. The classic style concentrated on lightness and delicacy in the overall treatment, with wide margins and little ornament apart from the initial letters; type styles were classically light and legible, usually based on Italian fifteenth-century prototypes.

The Daniel Press saw perhaps a closer, more complete family co-operation in its productions than is found in the Arts and Crafts presses in general, but in several cases the women did play a crucial, active rôle in running presses with their husbands. May Morris often helped at her father's Kelmscott Press, although no particular work seems to have been credited to her specifically. In reference to the Red House years we have noted that Georgiana Burne-Jones recalled: 'Oh, how happy we were, Janey and I, busy in the morning with needlework or wood-engraving . . .',[5] but it is not clear what exactly, in the early 1860s, they were engaged upon engraving. Perhaps their work may have been linked with Morris's projected edition of *The Earthly Paradise*, for which Lucy Faulkner engraved a woodblock illustration of *Cupid leaving Psyche* in 1868; this finally abortive project had already been under way when Morris left the Red House in November 1865. The Eragny Press, founded in 1894 by Lucien Pissarro, was run jointly with his wife Esther from the start; unlike most of the private presses, they had to attempt to make a living from their books, but as late as 1903 Lucien told his father Camille that they could not survive without the allowance he gave them. Pissarro's early books were all produced at the Vale Press of his friends Charles Ricketts and Charles Shannon, both of whom

Lucy Faulkner: 'Cupid leaving Psyche', woodblock engraved for an illustration to the projected edition of Morris's Earthly Paradise, *1868.*
(PHOTOGRAPH: WILLIAM MORRIS GALLERY, WALTHAMSTOW, LONDON)

had been trained as commercial wood engravers and were in the process of reviving the traditional art of woodcutting for fine art rather than reproductive purposes. Lucien Pissarro's interest in wood engraving had begun before he left Paris in 1890; he had had a few lessons in the art from Auguste Lepère, who was himself to become involved in its artistic revival. One of the reasons for Pissarro's move to London is thought to have been a rumour that wood engraving was already undergoing a revival in England; in fact he himself became one of the main instigators of that revival. He later recalled:

So, in 1891, I made a portfolio of wood-engravings in line and colour, and soon after, a small booklet in line, colour and gold, the text of which was reproduced by means of process blocks. Having finished the preliminary work, I determined to try to print it myself with the help of my wife who had learned wood-engraving in the meantime. We knew nothing of the art of printing and had to learn it as we went along—which meant that we were faced with endless difficulties.[6]

Another source stresses even more the importance of Esther Pissarro: 'In 1892 Pissarro married Esther Bensusan, and now that he had a helper who was both skilled and talented, the possibility of designing and printing his own books came clearly to the fore'.[7] The Pissarros' particular concern with perfecting hand woodblock colour and gold printing in the illustrations

for their books meant that they faced technical problems which did not affect many of the other Arts and Crafts presses. Lucien's distinctive colour illustrations, which combined rustic French qualities with the influence of the Japanese woodcut, provided both the core and the speciality of the Press's books. But the harmonious integration of text and decoration were crucial: 'The books are an extension into text and ornament, of the mood of the coloured woodcuts'.[8] Lucien's superb use of dense, harmonising colour, so much a product of his eye and of careful, individual handling, set the tone of the books as a whole. It is not recorded to what extent Esther was involved in this creative aspect of the work; a brief account of the origin of the Eragny Press published by them in June 1903 included a 'bibliographical list of the Eragny books printed in the Vale type by Esther and Lucien Pissarro on their press at Epping, Bedford Park, and The Brook, Chiswick',[9] and the majority of the books themselves acknowledge specific debts of execution to Esther, especially for engraving after Lucien's designs and for the printing of the books. They also indicate that virtually all the important frontispiece and other illustrations were both drawn and engraved by Lucien, while the borders and initials were left to Esther to engrave. It is not clear—because the books all talk of Lucien and none of Esther—whether or not she was little more than a skilled hack-worker to Lucien. Various sources note that she was skilled and talented in her own right as an artist, but it does appear that her creativity was made subservient to the demands of Lucien's ideas.

An exception seems to have been *The Descent of Ishtar* by Diana White, printed in 1903, which seems to have been a collaboration between Esther Pissarro and Diana White. The acknowledgements note: 'The frontispiece has been designed by Diana White and engraved on the wood by Esther Pissarro . . . The book has been printed at their Eragny Press . . . finished in December 1903'.[10] An exhibition catalogue records:

The writer and artist Diana White was a friend and colleague of Esther's [*sic*] at the Crystal Palace School of Art before Esther's marriage. Pissarro and she became great friends, spending much time sketching and later painting together, and it was to her, after Camille's death, that Pissarro turned most often for advice in the matter of his art.[10]

One wonders if history has relegated the friendship between Esther and Diana White to the same level of obscurity as Esther's contribution to the Eragny Press. It is also impossible here to avoid confronting this writer's not untypical trivialisation of the women's relationship in favour of recording the two separate women's relations with the male hero, Lucien Pissarro. Pissarro's nephew recorded that it was in April 1902 that Lucien and Esther moved to 'The Brook, Stamford Brook . . . where she helped Lucien run the Eragny Press, indefatigably involved in the engraving and press work'.[11] Again the stress is on Lucien as the owner of the Press, with Esther as his hard-working assistant.

Lucien himself confirmed that he considered the nature of his wife's contribution to the work as

Esther and Lucien Pissarro, The Eragny Press: Histoire de la Reine du Matin et de Soliman ben Daoud, *by Gérard de Nerval, 1909; 130 copies printed for the Société des Cent Bibliophiles. Exhibited at the Exposition des Arts Décoratifs, Paris, 1914.*

secondary when, after fulsome records of his own development and creative achievements in printing, he ended his short survey of the Eragny Press with a brief tribute to Esther: 'I must acknowledge the valuable assistance given by my wife, both in engraving and in printing. Her energy and skill have been invaluable in the Press Room.'[12] As with so many instances of women of this period involved in husband-and-wife craft production teams, it is impossible to assess how and in what direction a particular woman's creativity would have developed had she been working for herself. *The Descent of Ishtar* is considered, along with the 1902 printing of the Bacon essay *Of Gardens*, among the most successful of the Press's small, sometimes homely, but often elegant books; they were both 'in the customary style of the press, printed in three colours which give scope for double-page borders of trailing green, mingling beautifully with the red initials and patterns of green and red flowers'.[13]

As the example of the Vale Press and the Eragny Press shows, through the close friendship and co-operation of the artists involved, there was frequent collaboration among many of the fine printers of the period. Some designed new type, others, like Florence Kingsford, did painted illustrations on vellum such as those for the Ashendene Press editions of the *Songs of Solomon* and the *Book of Songs and Poems from the Old Testament and the Apocrypha*. She was known both for her painted illustrations and decorations, and for her expert calligraphy. Florence Kingsford was also one of those artists who occasionally placed their talents at the disposal of the Essex House Press of Ashbee's Guild of Handicraft; she hand-coloured the *Ancient Mariner*,

by Coleridge, in the Press's 'great poems' series, which was printed on vellum in 1903. Another in the series, the 'most skilful and original of them all, a charming small work of art' was *The Flower and the Leaf*, a mediaeval poem once thought to have been by Chaucer:

Edith Harwood made and coloured the decorations which run happily through the pages, in quite original simplicity of form and arrangement—large initials for each new stanza, with people and flowers in greens and pinks, purple and brown. Caslon was used for all this series.[14]

Although Janet Ashbee seems not herself to have been a craftswoman, she was actively involved in organising the Guild of Handicraft, and her contribution to the Essex House Press seems mainly to have been as an editor. She edited their 1901 edition of Erasmus, *In Praise of Folly*, and the following year she worked similarly on *The Psalter or Psalms of David* from the Bible of Archbishop Cranmer, 'in honour of David the great singer'.[14]

It seems significant that the private presses were predominantly a male sphere of activity, particularly with regard to the actual setting up of presses, even if then they were run jointly with women; perhaps in consequence, there appears to have been a clear sexual division of labour in the presses, with men claiming most of the creatively original work. Among all these enterprises women only seem to have been actively

183

involved in the printing at the Daniel and Eragny Presses. On the whole women appear to have taken the lighter, more delicate tasks of embellishing or decorating, or the interpretative work of engraving the blocks after another, usually male, artist's designs. Lucy Faulkner's work, mentioned above, and that of Esther Pissarro, would have fallen into this latter category — as far as we can tell from inadequate information. The setting-up of such presses was an expensive and assertive business which, because of the ideals upon which the revival was founded, required the use of the best-quality materials and papers. In taking the more secondary rôles in this craft women seem therefore to have reinforced the broader cultural preconceptions of women's particular characteristics and abilities, something which we have seen reflected in the majority of the Arts and Crafts branches.

A welcome exception to this pattern can be cited with reference to the craft industries founded and run at Dundrum in County Dublin in 1902 by Evelyn Gleeson, and Elizabeth Corbet Yeats and her sister Lily who both returned to Ireland from London for the purpose. The Dun Emer Industries were established 'to find work for Irish hands in the making of beautiful things'; the hands were all women's, and the 'Industries originally comprised embroidery on Irish linen, the weaving of tapestry and carpets and the printing of books by hand. A bookbinding workshop was added later'. The embroidery workshop was organised by Lily Yeats and the Dun Emer Press was founded by Elizabeth Yeats in 1903 as part of the enterprise. Their brother W. B. Yeats 'acted as editorial adviser to the Press and Emery Walker, who had worked as adviser to the Kelmscott Press, The Doves Press and several other notable private presses in England, advised on typography and book production'.[15] The Press specialised in printing books by living Irish writers, and while few were illustrated, most contained decorative devices designed by, among others, Elizabeth Yeats herself. A pressmark, which was engraved on wood by Elinor Monsell in 1907 and depicted the Lady Emer, was first used in 1926. From 1908 to 1916 they published the first series of A Broadside, each issue of which contained new and traditional ballad poetry, with three wood-engraved drawings by Jack B. Yeats. The Press also 'published many hand coloured prints and greeting cards and undertook commissions to print private editions of some 30 books and booklets. Bookplates were also designed and printed at the Press, including those for John Quinn, Lennox Robinson and for members of the Yeats family'.[15]

In 1908 the Yeats sisters separated from the Dun Emer Industries, setting up the Cuala Industries at Churchtown, County Dublin, and later moving to Dublin; at the Cuala Industries they continued the two areas in which they had previously been engaged, embroidery and hand printing. The aesthetic merit of the Press's productions have been questioned by Franklin, whose brief account contains both factual errors and his own acknowledged bias; the bias seems to rest especially upon the fact that the Press was involved in a literary revival as much as a craft revival. He doubts the value both of their typography and their decoration:

Except for occasional work from Jack Yeats, of very unequal merit, these books were unadorned and should be judged by standards of pure typography ... The coloured broadsheets have some decorative charm of a primitive sort which varies in manner from Sunday school to chap-book. Yeats's sisters founded the press, and ran it on very cheap labour at Dun Emer outside Cork [sic] and in Dublin. It was more than a printing press—a craft guild, though from the record of wages paid it was hardly run on co-operative lines.[16]

In fact the Industries were probably run on lines very similar to all the philanthropically originating craft industries in England and Ireland, where middle- and upper middle-class and aristocratic parties were concerned both with giving work to poor agricultural labourers' wives and with reviving country or artistic crafts. In few of these, as we have noted, was the pay particularly good, but in general the wages were no doubt based on working-class rather than middle-class standards, and they were often only intended as a supplement to the husband's income. The Dun Emer and later the Cuala Industries, in terms of economic and class structure, should be compared for example to the Langdale Linen Industry; to see the Irish enterprise beside a cosy, middle-class, privately financed (by Annie Cobden-Sanderson) press like the Doves Press is to see it entirely out of context.

In America, Helen Marguerite O'Kane seems to have been one of the few women to work with fine handprinted books from one of the small Arts and Crafts presses; she worked mostly with the Elston Press of her husband Clarke Conwell in New York. This was one of the most successful of the many private presses that appeared around the turn of the century, inspired by the English revival, and its best designs were by Helen O'Kane; she 'designed some of the most brilliant books in America. Her style, which is her own kind of Arts and Crafts enlivened with Art Nouveau, seems to have come ... from both Morris and Beardsley.'[17] Her design for Dante Gabriel Rossetti's The House of Life which was printed by the Elston Press in 1901 after it had moved to New Rochelle, was particularly successful:

this book utilizes delicate lines that give an almost cob-web-like appearance. These fine lines would have seemed weak on white paper, so soft gray was cleverly used. The type chosen was Jenson, less bold than Satanick. Burne-Jones's influence can be seen in the facing illustration. The overall result is one of the most original and romantic books of the whole American Arts and Crafts period.[17]

Before turning to a discussion of women bookbinders, it seems appropriate to look firstly at women's important contribution to the arts of illuminating and calligraphy.

Illuminating and calligraphing were traditional occupations of educated women in the era when painting and writing were closely allied, prior to the invention of printing in the late fifteenth century. As Karen Petersen and J. J. Wilson point out,[18] one of the few alternatives to marriage and childbearing open to respectable women in mediaeval Europe was joining a

Phoebe Traquair: Photograph from the catalogue of the Second Exhibition of the Guild of Women Binders, 1898–9. Associated with the Edinburgh Arts and Crafts Club, Phoebe Traquair was a key figure in the revival of manuscript illumination and lettering.

works in black and white, with engraved borders and illustrations. All that the multiplying process could retain, it retained. Miniatures developed into our modern illustrations. The red became relegated to the title-page, headings, marginal lines, and notes—hence the rubrics, or the red-marked pages, of the Church. From the depths to which book-making had fallen in our century, the black-and-white men of the sixties— Millais, Houghton, Pinwell, Sandys, and others, rescued it. But the tide, though turned, crept slowly, till the big wave of the present decade rolled in with Beardsley on its crest. Only colour now lacks to complete, in the printed book, an evolution analagous to that which took place in the written one.[19]

This writer considered Phoebe Traquair, craftswoman, mural and tempera painter, one of the two foremost artists in the revival of illumination; she was also one of the first of her contemporaries to work in this sphere of art. As with her embroidery, her illuminated painting style was illustrative rather than purely decorative; her painted miniatures resembled those of the Italian school, although 'in a certain poetic intensity and compelling emotion she is more akin to the illuminators of the twelfth and thirteenth centuries'.[20] She began her career in lettering and illuminating with a series of poems by W. Garth Wilkinson, which eventually amounted to a book of seventy pages on vellum; she then treated poems by Rossetti, and an extract from Morris's *Defence of Guinevere*. Her work also includes transcriptions and illuminations of *Psalms I–XXV*, a total of fifty-three vellum pages, many of which she duplicated, and a small book of eight pages by herself, called *Melrose, 1886*. Ninety pages on vellum were devoted to Tennyson's *In Memoriam*, and she also produced Browning's *Saul*, and Elizabeth Barrett Browning's *Sonnets from the Portuguese*, completed in 1897 and exhibited at the Second Exhibition of Artistic Bookbindings by Women, December 1898–January 1899, where it was noted as having been 'illuminated in the manner of mediaeval manuscripts . . . for the late Duchess of Leinster';[21] although Phoebe Traquair was herself a bookbinder, in this case the binding seems to have been done by The Hampstead Bindery.

Phoebe Traquair's ideas on illumination were recorded in the *Studio*, as were her reasons for taking up the art: 'Purple and gold are delightful things to play with. Add to this a love of books, and a great desire to project feelings or emotions, and a consciousness that direct transcript from nature did not relieve me of the burden of feeling which for the moment was the master'.[20] She was particularly impressed by the illuminations of the thirteenth and fourteenth centuries as being:

truest and more vital in feeling, more restrained in execution, the essential unerringly seized, the non-essential rejected, line and colour used with greater delight in the inherent beauty of each . . . and deeper insight into the capacity of line and colour to convey emotion, quite apart from the subject represented . . . Indeed, the law of beauty in its widest sense, the absolute harmony of parts, forming a complete whole, governs the mode of expression . . . the smallness of the work making it all the more necessary for the worker to limit

convent, where most of such creative activity was carried out by women at that period. As nuns, talented women artists had access to the best working conditions, materials, training and support; illuminations survive from as early as the twelfth century which contain self-portraits of such women artists. However, from the thirteenth century onwards, secular production of illuminated manuscripts became increasingly important, and by the early fifteenth century women's participation in the art had tended to become limited to the execution of painted borders and landscape backgrounds in illuminations, revealing even at this date a degree of division of labour in which men claimed what was considered the most significant task—that of painting the human figure. This particular sexual division of labour may have been the result of an increasing exclusion of women from full secular apprenticeships, thus leaving them ill-equipped to tackle the more complex painterly problems posed by the treatment of the human figure.

Writing on the Arts and Crafts revival of illuminated manuscript making, the *Studio* summed up the importance of this early tradition and its subsequent disappearance:

We must remember that the text did not wittingly part from coloured ornament. In 1480, shortly after the invention of printing, a French press turned out *Books of Hours*, and other

himself to the vital points with a stern negation of non-essentials; all decorative art, of which illumination is but a department, being in its very nature an accompaniment . . . If I meet with a book that stirs me, I am seized with the desire to help out the emotion with gold, blue, crimson; or, is it a wall, to make it sing.[22]

Her last remark is a reference to her work as a mural painter.

Frances Kingsford has already been mentioned for her painted decorations of books for the Ashendene Press, and she was a regular exhibitor at the Arts and Crafts Exhibition Society with her illuminating and calligraphy. Among the younger generation of craftswomen, one of the most significant contributions to the art of illumination came from Jessie Bayes, artist, craftswoman and interior designer. As with many women involved in the leading circles of the Arts and Crafts movement, Jessie Bayes came from a family of artists, including her father, and her two brothers Walter, painter and critic, and Gilbert, sculptor, who at one time taught at the Sir John Cass Technical Institute with Phoebe Stabler's husband Harold, and May Hart Partridge. Much of Jessie Bayes' training must have taken place early on, in her home environment, although she did for a time attend evening classes at the Central School of Arts and Crafts, studying gilding on wood and perfecting her calligraphy—presumably under Edward Johnston, the distinguished craftsman responsible for the revival of this art in England; she is also said to have studied later at Finsbury under her brother Walter. In addition to these periods of formal training Jessie Bayes broadened her education and experience with travel on the Continent, to Belgium, Italy, France and Germany. Her ideas on the art of illumination were not dissimilar to those of Phoebe Traquair:

The idea of colour symbolizing love should be above all precious to the illuminator, since, in illuminating, colour can reach its intensest height of purity and radiance. And to me it is in its essence an intimate and loving art, and the very patience it demands can only be begotten of love.[23]

In the context of this statement it is perhaps significant to note that illumination seems to have been an art in which women predominated; both Phoebe Traquair and Jessie Bayes emphasised the importance of love and the emotions in the treatment of illuminations, added to which the patience, and the very smallness of detail and format, together create the image of an art which contemporary notions of women would appear to have rendered perfectly appropriate for women artists. Furthermore, the fact that it was work which could easily be done in the home, perhaps even without a special studio being necessary, must have reinforced its attraction to middle-class women artists. Jessie Bayes emphasised her artistic position viz-à-viz the mediaeval tradition of illuminating:

We want humbly, I believe, to follow in the traditions of the great illuminators, and we know that we cannot do that by sham mediaevalism, or by slavish imitation of their way of

The Book of Job: *Illuminated manuscript, decorated by Florence Kingsford, calligraphy by Grailly Hewitt; exhibited at the Exposition des Arts Décoratifs, Paris, 1914.*

seeing things, but rather by working in their spirit and with their sincerity and love.[23]

Jessie Bayes' colour, particularly when used in a high key, was stunningly beautiful, with subtle mauves and blues often dominating her palette. Her subjects were varied, but tended towards the treatment of themes lending themselves to fantasy, mysticism and romance. They included *The Lady of Shalott, A Madrigal* by Lapo Gianni, translated by D. G. Rossetti, Shelley's *Night*, and *Cupid and Psyche.* Her rendering of the poem *A Lovely City in a Lovely Land*, an illuminated manuscript which belonged to her friend and associate Kathleen Figgis, was praised in the *Studio*:

One cannot describe in words the charm of the miniature pictures and of the richly gilded letters and decorated capitals of this manuscript, but the owner of so exquisite a piece of work is indeed to be envied. There were glimpses of a celestial city, and of radiant beings in pale mauves and blues, who walked in the midst of a spring-like landscape, the birds and beasts also painted with loving care.[23]

Although a craftswoman of many talents, Jessie Bayes is probably best known for her illuminated manuscripts, and she came to be regarded as one of the leading authorities on the subject, lecturing widely, including at the Junior Art Workers' Guild. For her subjects she looked particularly to the legends and

Margaret Macdonald: The Christmas Story: *The Annunciation. Watercolour and pencil and gold paint on vellum/tracing paper/vellum; border sewn with gold thread. 12⅝ × 9 in. The beaten metal cover for this manuscript is illustrated on page 198 below.* (PHOTOGRAPH: HUNTERIAN ART GALLERY, UNIVERSITY OF GLASGOW)

poetry of Scandinavia, the Celts, and France, as well as to Eastern themes like the *Rubaiyat* of Omar Khayam. Much of her best work was sold in America, where friends and patrons eagerly awaited her productions, but she was also popular in England and on the Continent, where she had a wide following.

One of the most influential of all calligraphers was Anna Simmons, who took the techniques and ideology behind the revival of artistic lettering, originated by Edward Johnston at the Central School in London, back to Germany in the first decade of the twentieth century. A short account of the history of the London County Council classes in book production, in 1912, referred to the impact of Edward Johnston's teaching at the Central School:

although it has had considerable influence on the sign-writing trade in London and to some extent, in the provinces, [it] has not yet been used as much as could be wished for by English printers. German typefounders, however, have not been slow in seeing the possibilities of this revival of good letter design, and a pupil of Mr Johnston's, on her return to Germany, was set to work by the authorities to teach the new method to art teachers.[24]

This student was the German Anna Simmons, who came

to England to find the best Arts and Crafts training, and then returned to Germany, where what she had learned influenced the lettering and typography of the growing crafts organisations there, the Deustche Werkbund, and later the Bauhaus.

BOOKBINDING

Bookbinding appears to have been one of the most popular crafts, apart from embroidery and illustration, to attract women artists towards the end of the nineteenth century. Traditionally, women were actively involved in several of the workshop processes of book production, more especially the sewing of the pages and the 'forwarding'; in such tasks they seem to have formed part of a family or small group workshop, wherein specified tasks, or a division of labour, was already in practice on a minor scale.

The appeal of the craft revival of bookbinding to women was emphasised by the *Art Journal* of 1897:

Women have taken to the craft with much success, as the pages of THE ART JOURNAL can testify, and it certainly is a calling well within the compass of many women who, having taste and some skill in designing, will go through the apprenticeship necessary to acquire the technique.[25]

One of the most renowned of the Arts and Crafts bookbinders who took on students in the craft at his Doves Bindery was T. J. Cobden-Sanderson. Following the suggestion of Jane Morris that he might like bookbinding he had spent:

six months with Roger de Coverley [*sic*] to learn 'forwarding', working as an ordinary 'hand' for a while. After that he opened a workshop over Messrs. Williams and Norgate in Maiden Lane. He then converted his own drawing room into an atelier, and for seven years he worked at binding books and decorating their covers with patterns, his wife doing the sewing.[25]

In this early period, between 1886 and 1893, all the work was done by him, but he was helped by his wife Annie Cobden-Sanderson, whose money also financed the bindery and, from 1901, the Doves Press. After 1893 Cobden-Sanderson directed the bindery, but from March that year apparently no books were personally bound by him. The *Studio* review of the Arts and Crafts Exhibition Society show of 1896 lists Cobden-Sanderson's staff at that date: Douglas Cockerell, Charles MacLeish, Charles Wilkinson and Bessie Hooley. The Doves Bindery continued in existence for the whole life of the Doves Press, and although special work was carried out for private collectors, most of the bindery's work was the routine binding, from 1901, of the press's own books:

These were generally in darkish vellum without ties, occasionally in grey paper-boards with vellum backs. 'Doves Bindery' is stamped on the end-papers, and these bindings are very pleasant . . . They open well, handle easily, and the silk thread with prominent knots coming up through printed sections of the books are a feature of Doves bindings. Care and precision went into the forwarding of these simple bindings as into the same stages of more exacting work.[26]

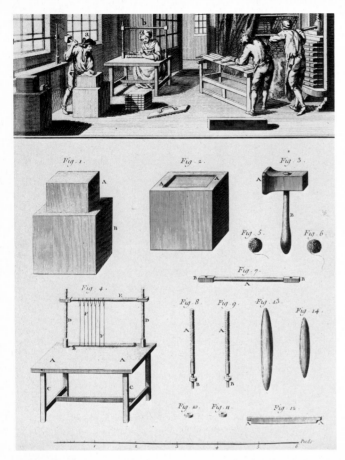

Far left: *Engraving from the* Dictionnaire des Sciences, *France, 1765, Volume VIII, Plate I Binding. A communal craft workshop is shown, with the binders' tools; there is already a clear division of labour at this date, and the woman shown works at sewing the bindings, a division echoed in the structure of the Doves Bindery (see photograph below).* (PHOTOGRAPH: VICTORIA & ALBERT MUSEUM, LONDON)

Left: *Bookbinding designed and executed by T. J. Cobden-Sanderson, founder of the Doves Press and Bindery, for* Le Capital, *(1867) by Karl Marx; binding sewn by Annie Cobden-Sanderson. Exhibited at the Exposition des Arts Décoratifs, Paris, 1914.*

Below: *The staff of the Doves Bindery, c. 1900? Bessie Hooley, the woman member of the group, holds the traditional tool for securing the pages and sewing the bindings.* (PHOTOGRAPH: VICTORIA & ALBERT MUSEUM, LONDON)

While the Central School was not directly responsible for the bookbinding trade union regulations excluding women, it is clear that the School was colluding with them in order to maintain their own policy of commitment to the teaching of strictly trade, and not 'amateur', evening classes. This attitude was further reflected in the antagonistic response by the Central School to its amalgamation with the day-time Royal Female School of Art ten years later. Such a response was additional confirmation of the widespread notion of woman as synonymous with 'amateur', regardless of the serious and professionally committed intentions of the women involved. It is evident, however, that this prejudice was the superficial manifestation of a much deeper, and fundamentally economic problem. The generally cheap valuation of female labour in the nineteenth century,[32] the convenient attitude of employers to the woman's wage simply as a supplement to the husband's, and the consequent male fear of being undercut by a large, cheap labour force of women, has already been mentioned as an important structural foundation of the capitalist economic system. A letter to the London County Council regarding Miss Wilkinson, from William R. Lethaby, then co-director of the Central School, confirms this analysis:

I have now had an opportunity of talking to Mr. Cockerell on the bookbinding matter. He tells me that there is now a strike going on in Glasgow on the employment of women, the point being not any objection to them as such, but that they cut down wages to a vanishing point. He says if a sewer did apply, she would not be admissible beyond the sewing department. He is convinced that putting a woman into the class would break it up in two days.[33]

Lethaby went on to refer to Miss Wilkinson's conversation with Mr Beckett:

the lady kept pressing the point that she was being refused because she was a woman, and Mr. Beckett replied 'no' as far as *we* were concerned she would, he thought, not be eligible because she was not in the trade. And she would urge, 'But the trade won't have women,' and Mr. Beckett replied that was a matter between the trade and women, but if they could settle the matter favourably, *we* should be very glad to take women.

Women were in fact being placed in a double bind; they had to belong to the trade in order to be accepted for classes at the Central School, but the trade excluded women; thus they had no access to this training. Significantly, the Central School was in a position to change this sexist situation, either by creating day-time classes for professional women, or by refusing to accept the trade's ruling and admitting women to the evening classes held under its jurisdiction, ignoring trade pressures; but the Central conveniently chose to support the *status quo*.

Finally the Technical Education Board's secretary went to Miss Wilkinson's residence at No. 6 Gower Street to ascertain whether or not she was a professional bookbinder, and therefore if she was admissible to the trade classes. Dr Garnett reported:

The house is strictly a private house, with no name-plates or other indication of either trade or professional work. Its appearance inside and out was that of a residence of a professional man with an income of not less than £1,000 a year. A portrait which attracted attention in the drawing-room as being far above the average painting in oils proved to be a Gainsborough. When Miss Wilkinson appeared it was with some difficulty that she could be induced to discuss the matter on other grounds than the broad question of the admission of women to the bookbinding trade, but at length it was ascertained that Miss Wilkinson carries out with her own hands all branches of the trade—sewing, forwarding, and finishing with gilding tools. Miss Wilkinson was good enough to allow the Board's secretary to visit her workshop, a room on the first floor, containing a screw-press, a hand-vice and a number of hand tools, and warmed with a gas fire, which served for heating the gilding tools. Miss Wilkinson had no work on hand at the time, and had only one book available as an example of her work. This was a 24mo volume, bound in blue morocco, with a very slight amount of gilding. Miss Wilkinson stated that she did all the work with her own hands, had no assistants, and that during the last year she bound about seven books, the orders being received from her personal friends or from friends of theirs. Under these circumstances the Board's secretary did not think it necessary to press inquiries as to payment received for the work, as the prices charged would have no bearing whatever on the issues at stake.

On the question raised by Miss Wilkinson, Mr. Lethaby states that he is anxious to have classes in artistic industries like bookbinding, silversmiths' work &c., which shall be free from the strict letter of 'trade classes', and at one time he recommended to the Board that Mr. Cockerell should be allowed to conduct an afternoon class in bookbinding entirely separate from the trade class. This proposal was rejected by the Board, lest it should introduce the amateur element into the school. Mr. Lethaby thinks that the Board is absolutely pledged to maintain the trade distinctions in 'trade classes', according to the workmen's meaning.[34]

Despite the clear proofs of her trade involvement in bookbinding, Miss Wilkinson was deemed ineligible for admission to the trade classes at the Central School, the final sentence of the above report re-affirming the power of the workmen and their union over the School in setting conditions excluding competition from women. Similarly, echoing general prejudice, the School was allowed to provide women with no alternative training

on the basis of a fear of amateurism which the School was in a position both to disprove and dispel. The report itself resounds with a peculiar form of inverted snobbery; the question as to Miss Wilkinson's personal need or desire for an independent income was discreetly avoided, and her social and economic circumstances were left to coy inference from the secretary's assessment of the income and property of the 'man of the house'; thus the Board was left to deduce that she was by implication of amateur status.

Although this particular writer, presumably referring to Cobden-Sanderson's bindery prior to the workshop established in 1893, stated that 'As a binder he had worked in the arts and crafts ideal of classless labour, as an original artist', in fact it is clear that there was not only a division of labour in the production of his bindings, but a sexual one; his wife completed what was often considered the toughest, most routine chore, the sewing, while the most creatively original work of finishing and decorating was done by him.

Another bookbinder to take on students was Sarah T. Prideaux, to whom 'belongs the honour of being the first woman book-binder in this country' and whose 'own volume on bookbinding is a standard history of the craft'.[27] Her most famous pupils included Elizabeth MacColl, Katherine Adams, who established the Eadburgha Bindery at Broadway in Worcestershire, and Miss Nathan 'whose excellent tooling is the delight of many connoisseurs'.[27] Expensive private lessons and apprenticeships with distinguished craftspeople seem to have been the only means open to women to obtain a practical training in the craft, for despite the existence of bookbinding trade classes at the Central School of Arts and Crafts, these were closed to women. The case of Miss L. M. Wilkinson, who had trained with Cobden-Sanderson and who complained about this exclusion of women, was discussed by the Technical Education Board in February 1899, and the fact that her case was taken up by Millicent G. Fawcett indicates that feminists were involved in this issue of discrimination against women, and their exclusion from a craft because of the strength of the male-dominated trades union. A letter from Millicent Fawcett of 12 December 1898 set out the facts of the case:

Miss L. M. Wilkinson applied in June last to join the bookbinding class at the Central School of Arts and Crafts, Regent-Street, under the control of the Technical Education Board of the London County Council. She was told by the secretary that women could under no circumstances be allowed to join the class, even if, as in her own case, they fulfilled the condition laid down in the prospectus of the school, of being actually engaged in the profession. Miss Wilkinson then complained to one of the members of the County Council, who said he was sure she had been misinformed, and promised to make enquiries. As a result of these enquiries she had a letter from him, saying he found the classes were open to men and women alike on the same terms, adding, 'I am glad we have no sex disqualifications, of which I was surprised to hear.'

Armed with these assurances Miss Wilkinson made another application to the secretary last week, and met with the same answer as before. She was told that the bookbinders' and silversmiths' trades were so highly organised that they could make what conditions they liked about their students, and one of the conditions on which they allowed them to take advantage of these classes was that women should be excluded, and they threatened to withdraw all their men from the school if women were allowed to join, though, as the secretary told Miss Wilkinson that these two classes were conducted at a distinct loss, the fees being nominal, it would seem as if the loss would be a greater one to the men than to the school.

In consequence of the numerous applications from women during the last year, the committee were kindly anxious to help them, and proposed to hold classes specially for them at an advanced fee; the proposal however the Board refused to sanction.[28]

Millicent Fawcett received a reply to the effect that Miss Wilkinson had not been refused entry on grounds of sex, but on the basis that she was a designer of book-covers, and so did not bind books for a living. The secretary of the Technical Education Board, Dr William Garnett, admitted that from 'the best information we have been able to obtain it appears that Miss Wilkinson is only a designer of book covers',[29] but nothing had been done to find out precisely what she did do, and Mrs Fawcett recommended: 'if he had adopted the simple plan of asking her (or anyone who knows her well) for the facts, he would have obtained the information that she is a bookbinder and not a mere designer of book covers. It would not have been beyond the resources of the London County Council to have even sent a competent person to No. 6, Gower-street, to see her work-room, if there were any reason to doubt her word or that of her friends. She does not work in another person's shop for wages, but she binds books to order in her own house, and is paid for it.'[29]

The case was further taken up on Miss Wilkinson's behalf by Lord Russell,[30] who wrote in her support to the London County Council. In order that a full statement could be put before the Committee, Mr Beckett, the curator for the Central School who had received Miss Wilkinson's applications, signed a report of his side of the case, and firstly answering to her question as to whether or not the bookbinding class was reserved for members of the trade:

He replied . . . that the class was strictly reserved to members of the trade. Miss Wilkinson then asked whether she would be excluded by reason of sex. He replied—'No, it is only a question of being or not being in the trade.' Miss Wilkinson then attempted to raise a discussion on the general question why the bookbinders' trade attempted to exclude women . . . He stated that Miss Wilkinson appeared more interested in the general question of the action of the trade union in excluding women from the forwarding and finishing departments of the bookbinding trade than in her own private case, and she appeared to hold that the school was responsible for the trade union regulations.[31]

In fact Miss Wilkinson's workshop set-up was evidently typical of the many such ventures established by middle-class women who took up the trade at this

Bookbinding Clio, *designed and executed by the Guild of Women Binders, c. 1905.* (PHOTOGRAPH: VICTORIA & ALBERT MUSEUM, LONDON)

period, enabled because of its structure to work from home; her method of sale, through commission from friends, was also a feature of many small, budding Arts and Crafts workshops. The certainty that Miss Wilkinson was a feminist, affirmed by her being championed by Millicent Fawcett, was clearly not lost on the Technical Education Board, whose reiterations of her pressing concern over the 'general' question of the exclusion of women suggest their desire to dismiss her case on that basis, and their unwillingness to confront their own support of that discrimination within the trades they were responsible for training.

The sexual division of labour apparent in the art school training both of bookbinders and silversmiths reflected existing customs in those trades, and thus the Central reinforced the discriminatory wage and job divisions which left women with low pay and menial work. Most of the students in the trade bookbinding classes would doubtless have been artisans, or lower middle-class craftsmen, who worked at their trade during the day as wage-earners; their female counterparts in the sewing section of the trade would have been unlikely to come from such a comfortable background as Miss Wilkinson, and this was clearly a further reason for excluding her from the evening classes. We have already seen how clear-cut were class and sex divisions within art education earlier in the century, and although the class divisions had not disappeared by this date, in Miss Wilkinson's case her sex seemed the overriding factor. The fact that middle-class women could only be considered for training at the Central in 'entirely separate' afternoon classes, at an 'advanced fee' reinforced these divisions, as it was widely accepted

that the real workers were those who attended evening classes, and worked in the trade during the day. Women, on the other hand, if only admitted into day classes, were considered by implication both wealthy and amateur through their not having to work during the day, while in fact they were given no choice. Thus the opportunities for book-binding training for women of all classes was limited, and their subsequent job opportunities were restricted by the trade union to the traditionally female, poorly paid sewing of the bindings. Their only possibility of a fully creative outlet in the craft was within an Arts and Crafts workshop, or in doing isolated work in the home.

It seems likely that the Women's Guild of Bookbinders was founded, in the summer of 1898, in an attempt to fill this evident need among women for solidarity and a financial outlet. The first exhibition of bookbinding by women had been held in late 1897 and, as a result of the wide acclaim it received in the press, within six months the women workers had federated themselves in the Guild, which continued to attract recruits to its ranks. This first exhibition, held at 61 Charing Cross road:

was an experiment, for although isolated examples were occasionally shewn at exhibitions of all classes of work, and received the admiration they merited, it remained to be seen whether the craft, as applied to the gentler sex, could be placed upon that commercial basis without which no lasting good could accrue to the workers as a class. The result more than justified the faith of those who believed that binding offered a sphere of occupation for women, of far more permanent benefit than many other occupations; the chief reason, above all others, being its *utility*. We all know how, at bazaars and sales of work, people will buy all kinds of ornamented fripperies because the work is women's work, and because the buying of it helps the workers. But in bookbindings the public found that women could produce what was eminently useful conjointly with what was eminently decorative; hence the immediate and, to some, surprising success that ensued.[35]

Among the earliest buyers at the first exhibition was Queen Victoria herself, adding the guarantee of success associated with royal patronage of such a venture; the exhibition was also visited by the Prince of Wales, and Princess Henry of Battenburg wrote to say 'how very much she admired the beautiful bindings'[35] which had been sent to Windsor.

At the Guild's permanent depôt at 61 Charing Cross Road, run by its sole agents Messrs. Karslake, 'week by week, all the year round, whatever is newest and best of the work finds a temporary resting-place, and a means of ready disposal. Remembering that in this case women are competing in what, until recently, was solely a man's craft, this success may without doubt be termed phenomenal.'[35] The work by the women was especially commended for its individuality and originality; there was no question with these women of a monotonous reproduction of timeworn patterns. Designs were individually thought out on the basis of the book's contents, and if a second copy of a book were bound new designs were created; this method gave particular scope

to talented designers, who were in a position to gain both by way of originality and good craftsmanship. Criticising the common use of inappropriate but fashionably rich bindings regardless of content, the work of Mrs Macdonald of the Edinburgh Arts and Crafts' Club came in for especial praise, her binding for Irving Browne's *In the Track of the Bookworm* being considered '*art*, as distinguished from *trade*'. Her inventive approach to the craft had, in this and other works, found expression in her creation of a new type of binding, based on mediaeval prototypes: 'It may safely be predicted that when this "Mediaeval" binding becomes generally known there will be a large demand for it. It is due to Mrs Macdonald to reiterate that the world owes to her efforts and initiative this new departure, which is destined to play an important part in the binding of the future.'[36] This rich style of binding and tooling was described in the exhibition catalogue; it was 'worked entirely by hand, on solid leather, and has the advantage of being exceedingly durable, improving with age, and in a year or two assuming a permanent "old-ivory" tone. The fact that continuous exposure to the strongest sunlight has only the effect of adding to the beauty of the tone is its best recommendation.'

Other bindings of this type were produced by various members of the Edinburgh Arts and Crafts' Club, including Phoebe Traquair, Mrs Douglas Maclagen, the Misses Maclagen, Miss H. W. Sym, Miss F. E. Balfour, Miss Jeanie E. Pagan, Miss Ray MacGibbon and Miss Jessie MacGibbon. Esther Wood, writing on bookbinding in the *Studio* in 1899, was less whole-hearted in her appreciation of the Edinburgh style; but

Left: *Mrs Macdonald: Photograph, from the catalogue of the Second Exhibition of the Guild of Women Binders, 1898–99. Like Phoebe Traquair, Mrs Macdonald was one of a large group of craftswomen who worked under the mantle of the Edinburgh Arts and Crafts Club, producing a large display of bookbindings for the Guild exhibitions; their productions were considered by some critics almost too ornate to be considered Arts and Crafts.*

Above: *Examples of bookbinding from Miss Bassett's class, Leighton Buzzard, the Home Arts and Industries Association; from an illustration in the* Art Journal, *1897.*

the designs of Miss Jockel, Mrs Macdonald and Mrs Traquair, while containing more ornament than was common among artistic bindings, she nevertheless considered successful. Phoebe Traquair, she wrote,

shows a powerful and fantastic imagination in her treatment of *The World at Auction* and *Religio Medici*, in which the decoration forms a curious and obscure medley of symbolism verging on the grotesque. The lettering is the most satisfactory portion of these designs; it is archaic, but congruous and clear, and its disposal round the border and along the back of the volumes harmonises with the large and leisurely spirit in which the work is approached. They are not books for hasty reference, but for quiet enjoyment in hours of ease, or contemplation in the midst of some devout and seemly ritual.[37]

Mrs Macdonald's binding of *Amor Lachrymosus* was strongly Celtic in design, as was her volume of poems by the two ladies, aunt and niece, who were intimate friends of Charles Shannon and Charles Ricketts of the Vale Press, and who wrote under the pseudonym 'Michael Field'. Miss Jockel's binding was of a more conventionalised style of decoration, and excellently worked.

None of the women of the Guild of Women Binders were directly employed by their agent in London, but Frank Karslake provided an invaluable centre where their work could be displayed and sold, and doubtless a commission was charged as was customary for such services. Isolated individuals or groups of women binders from many parts of the country were thus able to provide themselves with both an outlet for their work in the large metropolitan market, and an important sense of communal art activity under the Guild banner. In 1899 the Guild comprised sixty-seven members, including women 'connected with the Chiswick Art Workers' Guild, the Edinburgh Arts and Crafts' Club, the Gentlewomen's Guild of Handicrafts, the Kirkby Lonsdale Handicraft Classes, the Royal School of Art Needlework, besides a number of individual and unattached workers'.[38] At the show of 1898–9, the Chiswick group exhibited some examples of 'the very beautiful Niger-morocco bindings embossed on a groundwork of gold dots, with the edges decorated in gold patterns on green groundwork. It is among the most decorative of modern bindings, and any who love unfading colour on their shelves will choose it.'[39]

As this description implies, the Guild of Women Binders was committed to durability in addition to creative originality; its motto was 'Laws die, Books never'. The Guild also counted among its membership Miss Bassett, founder and instructor of the Leighton Buzzard Handicraft Class, which also seems to have been connected with the Home Arts and Industries Association. Miss Bassett's classes began c. 1892–3:

originally with the object of giving employment to a crippled

Above: *M. Sophia Smith: Photograph from the catalogue of the Second Exhibition of the Guild of Women Binders, 1898–9. Many of the women who exhibited with the Guild of Women Binders and sold their work through the Guild as members, worked in association with craft clubs and guilds all over Britain; Sophia Smith was one of the few who worked independently, probably from a small workshop in her own home.*

Left: *Miss Bassett: Photograph from the catalogue of the Second Exhibition of the Guild of Women Binders, 1898–99. Miss Bassett ran a Home Arts and Industries Association class in bookbinding, for which she supplied the designs and the training, in Leighton Buzzard. Her pupils were all crippled girls, who were thus enabled to make their own living.*

child in the town. There are now some six or seven cripples who work regularly at binding and leather work. And these are paid by the hour according to the excellence of their work. Our method of tooling leather is much the same as that adopted in the German bindings, but our speciality is that of tinting and gilding the leather after it is embossed.[40]

Their method of embossing or beating the leather was akin to that used in repoussé metal work. The Second Exhibition catalogue described her work and her philanthropy:

Miss Bassett sends a few of her exquisite worked-calf bindings, some painted in colours, and similar to the examples selected last year by H.R.H. the Prince of Wales. The fact that the work is produced by crippled girls, under Miss Bassett's own instruction and supervision, gives a pathetic as well as gratifying aspect to that lady's beneficent and kindly labours.

Sophia Smith was one of the independent bookbinders to receive special commendation in the 1898–9 exhibition; hers were cut-calf bindings 'happy in design. Her

work particularly excels in the combination of quaint and humorous figures in a harmonious whole. The execution is of the very finest.' The Kirkby Lonsdale group exhibited embossed calf bindings in admirable designs; among them was a copy of the *Crown of Wild Olive* bearing on the side a life-like portrait of John Ruskin. Other exhibitors included Constance Karslake, a designer of bindings for the Guild; she was evidently a relative, probably a sister, of Frank and Harold Karslake who ran the agency. It was clear that, while a number of the women were relying upon the craft for their livelihood, they did not wish their work to be judged by a double standard of criticism, and the catalogue emphasised:

no appeal is made to purchasers on the mere ground of the work being women's work. It is quite true that to some members of the Guild—and more especially, for example, to such as the crippled girls of Miss Bassett's class—a charitable interest is welcome, but it is also realized that unless the work is good, as well as artistic, it cannot have the desired vogue . . . Believing this, the Guild produces nothing which is not good in its technical details.

In conjunction with the work of the Guild of Women Binders, Messrs. Karslake and Co. also acted as agents for and exhibited the work of the Hampstead Bindery and the Sandringham Bindery. The Hampstead Bindery, founded on 1 January 1898, was staffed predominantly by professional men, although there was one woman, Miss Rogers, among their number. The Sandringham Bindery, probably linked to the classes of the same name affiliated to the Home Arts and Industries Association, was controlled entirely by Messrs. Karslake, most of the designs coming from Harold Karslake himself. This Bindery specialised in less expensive products than the exquisite kind from the Hampstead Bindery; the Karslakes owned all the tools, which were loaned out to the local (presumably working-class) home workers, and the Karslakes also furnished them with all the registered designs. It is not clear to what extent women were engaged in this enterprise, as the workers remain anonymous. One artist connected with this group who was widely recognised was Gloria Cardew, who coloured many of the black and white illustrations in the books exhibited; she was discovered when a student in 1897 to possess a remarkable talent for harmonious colour-schemes for book illustrations, and the *Contemporary Review* of August 1898 praised her work to excess.[41]

The *Studio* Special Number on Bookbinding in the winter of 1899–1900 brought together many of the foremost women bookbinders and designers. The work of Sarah T. Prideaux received first mention and praised as being 'very thoughtful, refined, and intelligent work, both in design and craftsmanship . . . With a sure and versatile decorative power, she unites a fine feeling for material and a deft and efficient use of tools'. Of her pupils, Elizabeth M. MacColl was known in particular for her perfection of a leather tool of her own design; she worked with her brother D. S. MacColl, and many of her decorative bindings were designed by him to exploit

the potential of this tool. Not all his designs were praised:

The cover for her Omar Khayyam, for instance, gives an unpleasing impression of fireworks, or balls of string tossed wildly about—an effect altogether out of keeping with the spirit of so dreamy and contemplative a poet. This is, doubtless, an exceptional instance of a design which does an injustice to the talent of the executant, and sets one longing for some less clever but more judicious invention of her own.[42]

This is an interesting example of a common division of talent in the Arts and Crafts, where the man is the designer—the intellectual—and the woman the executant—the manually dextrous labourer; but as this critic recognised, the division was not always to the advantage of the product, and it is evidently unfortunate that Elizabeth MacColl did not experiment with creating her own designs, familiar as she was with the possibilities and limitations of the materials.

Of all Sarah Prideaux's pupils, Katherine Adams is perhaps the best known today; she exhibited regularly with the Arts and Crafts Exhibition Society, and several examples of her work were seen at the Decorative Arts Exhibition in Paris in 1914. She bound numerous books for St. John Hornby's Ashendene Press, and her style was one of clean restraint and simplicity. In 1903 she 'bound very austerely in dark green morocco the twenty-five vellum copies of *Fysshinge with an Angle*, crowding the first word of the title into the first panel of the spine, and allowing more place and space for the full title in two lines across the front. No rods or lines and fish, or little medieval men. Once her work was welcomed rather casually, and Sydney Cockerell used to wonder whether this book or that had been "Katied" yet.'[43] Hornby mentions and illustrates some of her more elaborate designs in his *Anthology of Appreciations*.[44] The casual attitude of Cockerell to her superb work is difficult to understand considering the mutual respect usually apparent between craftsmen at this period; perhaps the fact that she was a woman is telling here.

The bookbindings by Mary G. Houston were commended warmly in the *Studio* for their 'highly poetic and imaginative work', and her name appeared regularly in that magazine. Her binding of the Kelmscott *Chaucer*, exhibited in 1899 at the New Gallery in

Top right: *Bookbinding designed and executed by Sarah T. Prideaux: P. Villon, Autres Poésies, London, 1901.* (PHOTOGRAPH: VICTORIA & ALBERT MUSEUM, LONDON)

Bottom right: *Bookbinding designed and executed by Katharine Adams, for Tutte Le Opere di Dante Alighieri, 1899, bound in blue pig skin, protected by an embroidered cover (not shown). Exhibited at the Exposition des Arts Décoratifs, Paris, 1914.*

Top left: *Bookbinding for The Germ executed by Florence de Rheims after a design by Constance Karslake of the Guild of Women Binders, c. 1900.* (PHOTOGRAPH: VICTORIA & ALBERT MUSEUM, LONDON)

Bottom left: *Bookbinding designed by D. S. MacColl, and executed by Elizabeth MacColl for C. N. Robinson, Tintinnabula (1890), early 1900s.* (PHOTOGRAPH: VICTORIA & ALBERT MUSEUM, LONDON)

195

London, was felt to be one of the most interesting pieces of the year:

Her handling of her material is at once delicate and bold, and her expression of idea and feeling by apparently simple means is of a rare order. By the insertion of a charmingly embossed panel in the binding of *The Little Mermaid* her work is associated with that of another excellent craftswoman, Miss Birkenruth.[45]

Miss Birkenruth's work was quite original in her binding of *Atlanta in Calydon*, 'pleasant both to sight and touch'. However, she was criticised for the division of the word 'Calydon', and for the lack of relation between the corner-pieces and the border decorations. Esther Wood commented that it was 'generally desirable that good executants should, by such sincere endeavours, perfect themselves in design'.

In addition to her work in numerous other crafts, Jessie M. King also produced designs for bookbinding; those reproduced in the *Studio* were all said to be executed by Herr Wertheim:

From Glasgow, amid much else that comes worthily from the hands of women designers, we get the exquisitely dainty bookbindings that bear the name of Jessie King ... It would be a pity if so distinctive and facile a talent were to spend itself in mere prettiness, and not develop more robust and versatile forms; but the inventive faculty shown even in the slight decoration of *Hanna von Anna Schober* should certainly escape a peril of that kind. The cover for the *Album von Berlin* errs a little towards poverty and discursiveness of detail, in spite of its general harmony and grace.[46]

A recent exhibition of work by Jessie King made it clear that she herself did execute many of her bookbinding designs; the *Album von Berlin*, of which there were two volumes, was a case in point, since both covers were of paper on board with the decorations executed—if not the covers made—by Jessie King. Her bookbinding designs were exhibited in Berlin, and it is evident from the name of the executant cited in the *Studio* that she collaborated with a German craftsman in some of her productions. It is not certain whether she bound any books in leather; the catalogue gives one example, *The Roadmender*, bound in gilt on green morocco and 'possibly ... by Jessie King herself: if so, it is beautifully done'.[47] *L'Evangile de l'Enface*, which was published in Paris, was rebound to a design by Jessie King by Maclehose of Glasgow; it was awarded a gold medal at the Turin Exhibition of 1902. By that year Jessie King was teaching a class in book decoration at the Glasgow School of Art, and from 1901 she designed covers for Gowans and Gray paperbacks. The single most influential book in terms of her early reputation was *The Defense of Guenevere and Other Poems* by William Morris, which was published by John Lane, The Bodley Head in 1904. For this she made ninety-five line drawings, twenty-two of them full-page illustrations to the text, the others being decorative headings and tailpieces scattered throughout the book. She also designed the binding which was gilt on red cloth.

It is evident that by 1900 bookbinding was widely accepted as a craft for women, and that many were

Bookbinding designed and executed by Mary G. Houston for the Rubaiyat of Omar Khayyam, *1899; Mary Houston's work was admired by the* Studio *in the year this binding was produced.* (PHOTOGRAPH: VICTORIA & ALBERT MUSEUM, LONDON)

actively involved in it; some like Jessie King, were also engaged in designing cloth and paper covers for the trade, for machine-bound, mass-produced books brought out by publishers who were interested in raising the artistic standards of their products. Among the most important designers in this sphere were H. Granville Fell, Talwin Morris and Alice B. Woodward; other artists more famous for their involvement in pure handicraft, such as Walter Crane, Henry Holiday, Selwyn Image, Herbert Horne, Charles Ricketts and others indebted to the pioneer work of the Kelmscott Press, also offered their services to publishers in this new effort to bring artistic book covers to a wider public. According to the *Studio*, several women famed for their book illustrations, such as Kate Greenaway and Alice Havers, also designed book covers:

Among the younger women designers, Chris Hammond may be cordially recognised as having kept the more rose-coloured vision in her illustrations to books of this [eighteenth century] period, and shown a fresh and delicate talent in her covers for *Emma* and *Sense and Sensibility*. Gertrude Bradley stands honourably among the designers for children's books, and her name will be found associated not only with covers,

but also with the inside decorations of several delightful new children's books. In Alice B. Woodward we have an artist of more robust and original quality, already acknowledged in the front rank of women designers, and gifted, perhaps, with a finer sense of composition in draughtsmanship than any of her peers. Yet another young designer of remarkable, but wholly different, endowments remains to be mentioned. The name of Althea Giles belongs properly to the Neo-Celtic school, and her cover for *The Poems of W. B. Yeats* is highly characteristic of a sombre, mystical and weird imaginative power, expressing itself through a talent still vagrant and diffuse.[48]

The fact that the *Studio* article discusses women designers of book covers in an entirely separate paragraph to men is not surprising; as with illustration, women were predominantly channelled into designing for children's books, although it was quite acceptable for men also to work in this category. Children's books were considered a sphere to which women were particularly suited by virtue of their 'nature' and biological functions; in fact certain trends of thought actually saw women as children—doubtless a result of their enforced economic and political dependence on men during the Victorian era. The frequent application of double standards of criticism to the work of men and women also encouraged the discussion of women's art in isolation.

More needs to be said concerning the involvement of women in the binderies attached to the private fine presses; the traditionally female rôle occupied by Annie Cobden-Sanderson has already been mentioned, but other women elsewhere took a more dominant position. A prospectus of October 1902 for the publication by the Essex House Press of *The Flower and the Leaf*, originally ascribed to Chaucer (John Johnson Collection, Bodleian Library, Oxford), notes:

The Essex House Bindery. The Guild desires to call the attention of the lovers of the Essex House Press Books to the Essex House Bindery now opened under Mr Ashbee's direction, and in charge of Miss Power in conjunction with the Press at Campden, Gloucestershire. Books of all sorts are at present being bound in specially prepared designs in various leathers, and also in ebony, rose, and holly wood, and in silver with enamels.[49]

Annie Power seems to have joined the Guild around 1898, for entries in the unpublished Ashbee Journals (in the library of King's College, Cambridge) refer to her from this date. It is not clear where she received her training, but she was evidently sufficiently expert to run the Bindery by 1902 and, according to the Journals, to have several 'cockney pupils' under her. Most of the workers at the Bindery were women; between 1902 and 1904 they comprised Nellie Binning, Lottie Eatley and Edgar Green; Nellie Binning was probably the wife of the compositor Tom Binning, who had worked at the Kelmscott Press until 1898, when workmen and presses were transferred to Ashbee's Essex House Press. The same may have been the case with Dick Eatley, pressman, who was probably married to Lottie; these were probably Annie's 'cockney pupils'. By 1904 Annie Power was the only worker left at the Bindery; in the

Mary G. Gibson: Leather case for a prayer book, designed and executed by her and exhibited at the Exposition des Art Décoratifs, Paris, 1914.

Ashbee Journals she is referred to as Statia Power, so it is likely that her full name was Anastasia. The Journals record that she married Gerald Loosely, an artist who lived at Chipping Campden, sometime during the spring of 1905, and from the later part of that year she was breaking her connection with the Guild, although she continued bookbinding. From the malicious remarks about Annie Power recorded by Janet Ashbee, it seems likely that conflicting personalities and jealousy were responsible for her withdrawal (see Conclusion).

A note in the *Studio* of 1905 points to the then recent introduction of bookbinding at the Dun Emer Industries, run by Evelyn Gleeson, Elizabeth and Lily Yeats: 'The Dun Emer bindery has been started so short a time that it is hardly yet possible to judge of its work; but in other sections of the exhibition some admirable work was shown from Dun Emer in tapestry and carpet weaving and embroidery'.[50] In Ireland, as in America in the initial stages, the impetus towards a revival of the Arts and Crafts was largely due to the importation by craftsmen and intellectuals from England of the ideals and methods of William Morris and his followers. In America, by the mid-1890s, artistic designs for cloth bindings had been felt to be in advance of their English counterparts; however, by the end of the century, this superior progress was considered at an end:

today it is more than difficult for them to maintain that position . . . after a careful review of the principal book-covers produced during the last few years in the United States, I am driven to the conclusion that no progress has been made, that the designs, when not comparatively feeble and ineffective, are imitative of work done on this side of the Atlantic.[51]

The work of several women did receive favourable comment; Mrs John Lane, presumably the wife of the publisher of that name, made a 'quaint and pleasant' setting of simulated Dutch tiles for *Kitwyk Stories*, a particularly appropriate choice for a book of tales of Old Holland; 'The designs are quite prettily done, and make a charming cover'. In a similar vein, the cover design by Margaret Armstrong for *Love-letters of a Musician* echoed the book's contents:

It is good in colour, the rare subordination of the two lines of floral diaper giving a pleasing effect, but the head of St. Cecilia, done on an inlay of vellum in slight relief, and the border of gold which surrounds it, seems rather forced and over-wrought. This portion of the decoration would have been better if it had been carried out in colours harmonizing more with those of the ground. It is pleasant to note that this cover bears the monogram of the designer, for the importance of signed handicraft-work cannot be insisted on too strongly or too frequently. We congratulate both the artist and her publishers on the breadth of view that permits so simple and reasonable piece of straight dealing.[52]

Another design by Margaret Armstrong, for Washington Irving's *Rip Van Winkle*, received mixed criticism.

Top: *Margaret and Frances Macdonald: Cover for* The Christmas Story, *beaten metal, 13¾ × 9⅞ inches.* (PHOTOGRAPH: HUNTERIAN ART GALLERY, UNIVERSITY OF GLASGOW)

Above: *Invitation from May Morris and Katherine Adams to an exhibition of their work, 1905. Childhood friends, May Morris and Katherine Adams remained associated in later life too, their friendship strengthened by their mutual concern for hand-crafted wares.* (PHOTOGRAPH: WILLIAM MORRIS GALLERY, WALTHAMSTOW, LONDON)

Another designer of commercial book covers discussed in the *Studio* article quoted above was Mrs Henry Whitman.

Among the producers of fine hand-crafted bindings

in America was Ellen Gates Starr; she was a close friend of Jane Addams, who had opened Hull House in Chicago in 1889 on the lines of Toynbee Hall in London's East End. Ellen Starr came to England to train, as did many of her co-patriots, and she learnt bookbinding under the able tuition of T. J. Cobden-Sanderson at the Doves Press. Her binding for William Morris's *The Dream of John Ball* and *A King's Lesson*, published by Reeves and Turner in London in 1888, was done under Cobden-Sanderson's supervision, for in the back of the book is his signed statement 'Bound and tooled by Ellen Starr under my direction at Doves Bindery, 6 May 1898'.[53] Ellen Starr was a major influence on the crafts programme at Hull House, where she was on the staff for many years 'attempting to bring some pleasure into the drab, ugly, crowded households surrounding Hull House'.[54] As a direct result of Ellen Starr's efforts the first addition to Hull House in 1891 was the Butler Picture Gallery, in which art exhibitions were organised for the ordinary people in the neighbourhood.

ILLUSTRATION

The fact that by the middle of the nineteenth century women were being encouraged to find work, at least on the illustration side of the printing trade, is borne out by the conviction with which the founders of the Female School of Art insisted upon a class for wood engraving: 'It is understood that females have frequently practised this kind of art, and it is obviously in many respects a suitable employment for them'.[55] There were those who disagreed with this, including the head of the Female School, Fanny McIan, who insisted that the trade was already overflowing with workers and that in any case it was not the place of a government School of Design to train students in what was usually considered an uncreative, purely manual activity. The Female School in fact insisted on a basic training in drawing for its trainee engravers, whose rôle it was to interpret the artist's idea into cuts on the woodblock. This emphasis on women in the wood engraving craft is further reinforced by the lists of Special Craft Classes begun under Henry Cole at Marlborough House in 1852; these included a wood engraving class 'at present, for females only' and the same for a class in chromolithography.[56] Henry Cole reported on the progress of the wood engraving class, in 1853:

The instruction consists in the practice of drawing on Wood, Engraving on Wood, and preparations for printing Wood Blocks. Students are not admissible to this class until they have acquired the power of drawing from the round. They who produce a certificate of having passed satisfactorily through the six first, the tenth, and fourteenth stages of the course of instruction, are admitted on payment of a fee of 30s. per quarter [£1.50], or 5L. [£5] a year, paid in advance. All other persons are admitted on payment of 50s. [£2.50] per quarter, or 8L. [£8] a year, paid in advance. Some considerable changes have been lately made in this class. The hours of attendance have been increased from four hours to about thirty hours per week. The fees have been raised from 2s. to 10s. [10p to 50p] a month, and the result thus far is, that pupils have increased one-third in number.[57]

One of the reasons for the large numbers of women employed in wood engraving was evidently the cheap labour:

Black and white illustrations were far cheaper [than colour] to produce and as there was an ample supply of drudges capable of cutting acceptable, if usually deplorable, wood-blocks at very low rates, the insatiably increasing demand for, for example, juveniles was met largely from this source where even the shoddiest material found a ready sale.[58]

Despite the fact that the Select Committee had noted in 1849 that there was a superfluity of good wood engravers, it was still encouraged as an area of artistic employment for women; the *Art Journal* seemed ill-informed on the numbers when it noted in 1872:

Engraving again is an Art little practiced by, but quite possible for women; and attractive from the fact that it may be done at home. Enough has been done, and still is done by women in engraving on wood, stone, glass, and metals, to show that it is practicable. Formerly ladies were employed on the staff of the *Illustrated News*. Now, there is not one at work there, and it is difficult to hear of them anywhere, although we know that wood-cuts are still largely used. The students at the Queen's Institute, Dublin, are, however, employed in the illustration of periodicals in that city.[59]

Although the Female School class in wood engraving had been transferred, with its instructor Miss Waterhouse, to Marlborough House in 1852, other classes of a similar type were later reintroduced at the Female School, in order to provide a practical training for the women. Writing and illumination classes were still available in 1906, and black and white drawing for illustration was also taught. A separate class in drawing for fashion plate illustration was offered, and these various classes, with bookbinding, constituted the main areas of non-fine art training available, emphasising their importance as career choices open to women. An important new training opportunity for women of the middle classes was instituted as part of the Female School of Art by Sir Philip Cunliffe-Owen K.C.B. in 1882; it was situated in a separate building from the Female School, at 24a Gloucester Street, Queen Square, under the name of the Chromolithographic Art Studio for Women. Students were recruited mainly from the Female School, were thoroughly trained after leaving there, and were then permitted to stay on at the Studio which took in orders, functioning like a commercial studio. When the Studio was forced to close through lack of funds in July 1904, its Committee wrote to the editor of the *City Press*:

It is with deep regret that we inform you that the Chromo-Lithographic Art Studio . . . is compelled to close its doors . . . For upwards of twenty-two years the studio has afforded instruction to students in the art of chromo-lithography, has presented a means of livelihood to numerous lady artists, and has executed work second to none in this or any other country. We need only mention in this connection the illustrations to Lord Lilford's Book on Birds [*British Birds*], which are acknowledged to be unsurpassable in excellence. Our excuse for troubling you with this letter is to explain, for

the information of persons interested in such work, that the stoppage of the studio has been occasioned by the withdrawal (for reasons which we are unable to fathom) of grants which for many years were given by the City and Guilds of London Institute, and certain companies of the City of London. . . .[60]

This support for women students had been organised, at least from 1886, by the Society for Promoting the Employment of Women; 'The City and Guilds Institute have given apprentice fees to duly qualified students, through the Society for Promoting the Employment of Women'.[61] The reasons for the withdrawal of funds were made more clear in a private letter to the manageress of the Studio, Miss Ellen Rushton:

Col. Britten called today, he said he would do all he could with City Companies—but the fact that you had incorporated yourself was against you. Still Col. B. said he would do what he could—It seems the City Guilds built up that high Building for the companies to see the Coronation [of King Edward],—which is all money lost . . .[62]

In addition to Lord Lilford's *British Birds*, the Studio produced work for *Studio* magazine, from works by Frederick Lord Leighton—his *Italian Girl* was reproduced by Miss Hake in April 1885, and J. T. Nettleship's *Battle Call* was reproduced in 1901. Work was exhibited by the Studio at the Paris Exposition Universelle in 1889, in the British section, and at a Lithographic Exhibition in London from 1 November 1898 for four months. The Studio also reproduced the Commemorative Diploma of the Colonial and Indian Exhibition of 1886; Cunliffe-Owen wrote to Miss Rushton:

I am authorized by the Queen and by the Prince of Wales to express to you as superintendent of the . . . Studio and to the ladies associated with you in the preparation of the Diploma their appreciation of the admirable manner in which this work has been so satisfactorily carried out . . . Allow me to add my congratulations and my sense of services rendered to the Exhibition by the Chromo-Lithographic Art Studio under your skilful and successful management.[63]

The *Studio* wrote of the women's work in 1902:

The Chromo-Lithographic Art Studio . . . is producing some excellent work, and among its recent successes may especially be cited a reproduction of the drawing of Monkeys by Mori Sosen now in the British Museum. This print is copied on a large scale suitable for framing and is published and sold by the Art for Schools Association. The colours and the many subtle qualities of the original have been superbly retained, and the plate is in many respects a quite notable and creditable performance.[64]

The women working in the wood engraving and chromolithographic trades discussed so far were doing reproductive work rather than themselves producing originals. There were however, numbers of women who managed to earn a living and achieve fame as original illustrators. Both the spread of Arts and Crafts movement ideals and the increasing demand for books made it a wider field with greater potential and higher artistic standards. The commitment to craftsmanship, in wood engraving in particular, revived in modern times by

Thomas Bewick in the last quarter of the eighteenth century, had found a steady line of descendants up until the work of the famous Dalziel brothers in the 1860s, who even opened a special school for training students in the techniques of drawing on wood, in order to improve their quality. However, the advance of mechanical processes during the nineteenth century meant that gradually the craftsman was eliminated from reproductive methods, in which photography was taking over. By the 1860s wood engravings could be reproduced photographically, and this resulted in the artist no longer needing to observe the special demands and limitations of the wood medium, which in turn had a disastrous effect on the quality of the images produced. It was against this loss of craftsmanship and the degradation of the printed word and image that Ruskin and Morris reacted, and in 1890 Morris founded the Kelmscott Press to revive the values of hand-production, and of quality and individuality. For illustrations of these books, a return was made to relief methods of reproduction, using woodcuts or wood engraving. As far as the hand-presses were concerned, the involvement of women in designing and engraving illustrations seems to have been very limited; most of the creative designing and drawing—as at the Kelmscott, Eragny and Essex House presses—was done by men. But, particularly with the increase in artistic mass-produced books, especially children's books, women were widely employed to produce illustrations for them; women were thought to be most able in this field, and it also seems to have been felt that women must know more about children than men, and that they were therefore better equipped to illustrate children's books. Thus women appear to have found employment more easily in the mass-produced book market than in the élite world of the hand-printed book—at least in so far as illustrating was concerned.

One of the most famous of all children's book illustrators of the period was Kate Greenaway. She was born on 17 March 1846 in London, into a family which already had strong connections with her future profession. Her father John Greenaway was a prominent wood engraver and draughtsman who worked for such periodicals as the *Illustrated London News* and *Punch*. Among her other relatives, her Aunt Rebecca was a bookbinder and her Aunt Mary a wood engraver, so that she was provided with examples of craftswomen within her immediate family, and would not have lacked encouragement. In fact the family were quick to note the talents of all their children, and were enthusiastic in promoting their careers; the family was apparently lower middle or artisan class, and doubtless had higher aspirations for their offspring. At twelve, Kate Greenaway began her art education at a class in Williams Street, near Claremont Square, Clerkenwell; her first prize was gained at that age, and she decided to make art her profession. She was soon moved to Miss Springet's School and later to the Head School of the Science and Art Department in South Kensington. In 1861 she was awarded a bronze medal, in 1864 a 'National' award for her design for tile decorations, and in 1869 she won a silver medal in the National

TOUCH WOOD.

ALL the children but one place themselves in various positions, each touching something that is wood. They keep constantly running from one wooden thing to another. The one left out runs after them, and the first she catches not touching wood takes her place.

Top: *Kate Greenaway: Watercolour illustration to the St. Valentine's Day frontispiece to the extra supplement of the* Illustrated London News, *15 February 1879. Kate Greenaway began her career as an illustrator producing extremely popular designs for greetings cards; her ideas for Valentine cards brought her early fame.* (PHOTOGRAPH: VICTORIA & ALBERT MUSEUM, LONDON)

Above: *Kate Greenaway: 'Touch Wood', a page from her 1889 Book of Games, printed by Edmund Evans.* (PHOTOGRAPH: VICTORIA & ALBERT MUSEUM, LONDON)

Competitions. At the same time as studying at South Kensington Kate attended life classes at Heatherley's in Newman Street, a private school run on the lines of the Royal Academy Schools, and later when the Slade School opened in 1871 Kate joined the classes there.[65]

Kate Greenaway's first public showing came in 1868 at the age of twenty-two when she exhibited a watercolour and six drawings on wood at the Dudley Gallery, which was to become one of her most regular exhibiting places. Her early free-lance career as an illustrator is of particular interest, as it must show the pattern followed by many less successful and now unknown women of her period. As well as exhibiting drawings regularly in the London galleries, she began producing illustrations for magazines, and in 1871 started producing designs for Christmas and Valentine cards for Messrs Marcus Ward, who were an outlet for many women illustrators, although in fact a greater number of women were employed in the manufacture of cards than in their design.[66] In Kate Greenaway's case, her earliest great success, a Valentine card designed for Marcus Ward, provides an excellent example of the way in which inexperienced young women (and probably any such designers without a famous name) were exploited financially by the companies for whom they did free-lance work; this card was said to have sold 25,000 copies in a few weeks, and Kate's share of the profits was probably no more than £3. However, she made up for this later, and fortunately she kept a book of accounts from which it is possible to assess her income—an unusual advantage in discussing women's employment in the nineteenth century. After six or seven years designing for Marcus Ward, friends advised her to ask for her drawings for designs to be returned to her; Ward not surprisingly disagreed with this idea and the connection ceased. It was at this fortunate juncture that Kate met Edmund Evans, the famous colour printer who was already working with Walter Crane,

producing high-quality illustrated books for children from his designs, and from those of Ralph Caldecott, the third of these three most renowned illustrators of the period.

Kate Greenaway had already done some illustrating for children's books before her meeting with Edmund Evans, but it had mostly been 'journeyman's' work where she was tied by the ideas of the writer; these early books included *Little Folks* for Cassell, Petter and Galpin, and *Topo* by Miss Gertrude Blood (later Lady Colin Campbell), in 1878. In 1871 Kate's earnings were just over £70, and in 1873–4 she and her father bought the lease on a house in Pemberton Gardens, where she lived until 1885. In 1877 she took a studio in College Place, Islington, and by that year her earnings had reached nearly £300. Edmund Evans later recalled his first book produced in partnership with Kate Greenaway:

About 1877–78 K.G. [as she was known to her friends] came to see us at Witley, bringing a collection of about fifty drawings she had made, with quaint verses written to them. I was fascinated with the originality of the drawings and the ideas of the verse, so I at once purchased them and determined to reproduce them in a little volume. The title *Under the Window* was selected afterwards from one of the first lines. At the suggestion of George Routledge & Sons I took the drawings and verses to Frederick Locker, the author of *London Lyrics*, to 'look over' the verses, not to rewrite them, but only to correct a few oddities which George Routledge & Sons did not quite like or understand. Locker was very much taken with the drawings and verses, and showed them to Mrs Locker with quite a gusto; he asked me many questions about her, and was evidently interested in what I told him of her. I do not think he did anything to improve the verses, nor did K.G. herself.[67]

At this time Evans tried to persuade George Eliot, who was staying nearby, to write something which could be illustrated by Kate Greenaway; she refused, although she admired her drawings, on the basis that she never wrote anything except from 'inward prompting' and could not produce work to order. No more than Kate Greenaway herself did she like working to the needs and ideas of others.

The process for reproducing Kate Greenaway's subtle, delicate watercolour drawings into satisfactory prints was not simple; Edmund Evans used woodblocks, first photographing the original drawing onto the wood and engraving it as closely as possible in facsimile. The wet impressions were then transferred to plain woodblocks—transfers—for engraving to produce all the different hues: red, flesh tint, blue and yellow. It was an expensive business, and being Kate Greenaway's first book for George Routledge and Sons, caused some difficulties:

After I had engraved the blocks and colour-blocks, I printed the first edition of 20,000 copies, and was ridiculed by the publishers for risking such a large edition of a six-shilling [30p] book; but the edition sold before I could reprint another edition; in the meantime copies were sold at a premium. Reprinting kept on till 70,000 was reached . . . We decided to publish *The Birthday Book for Children* in 1880. Miss Greenaway considered that she should have half the profits on

Frances and Margaret Macdonald and Herbert MacNair: Poster for the Glasgow Institute of Fine Arts. Lithograph on four sheets of cream paper, 93 × 40 in, printed by Carter and Scott. (PHOTOGRAPH: HUNTERIAN ART GALLERY, UNIVERSITY OF GLASGOW)

'The Lowther Arcade', (pp. 52–3) poem and illustration from London Town*, 1883, by Ellen Houghton and Thomas Crane.* (PHOTOGRAPH: VICTORIA & ALBERT MUSEUM, LONDON)

all books we might do together in the future, and that I should return to her the original drawings after I had paid her for them and reproduced them. To both these terms I willingly agreed. However, the half-share royalty only became payable after the expenses of the publication had been cleared off—that is to say, after the sale had passed a given number of copies. Consequently, as certain books never reached the limit, K.G. only received payment for the use of the drawings, which were returned to her. Such failures, commercially speaking, were *A Day in a Child's Life*, the Calendars, and one or two more.[67]

The drawings for *Under the Window* were shown at the Fine Art Society two years later, and amongst the admiring critics was Ruskin himself; he and Kate Greenaway corresponded for some time before they finally met in December 1882, and from that date a close friendship began between the two. From the date of her first work with Edmund Evans, Kate Greenaway's financial situation improved rapidly; in 1878 she earned nearly £550, and over £800 the following year; by 1881 she made over £1,500, this enormous sum reflecting the accumulated royalties for her books with Evans and Routledge. In 1885 she moved to a new house at 39 Frognal in Hampstead, which had been designed for her by R. Norman Shaw, by then a friend. Her success in both book illustrating and watercolour drawing continued; at a one-woman show at the Fine Arts Society in 1891 her work was greatly acclaimed—Lord Leighton bought two drawings, and she sold others to a total of £1,350 (£964 net to her). This was the first time that she was assigned a place among contemporary artists.

Kate Greenaway's drawings and books, although still extremely popular, have been criticised frequently for an excess of primness and for the obsessive orderliness of her children; she chose to represent them in simple, rather picturesque clothes which harked back to the fashions of the Regency period. As such clothes were

not available in the Victorian age of over-upholstery for parents and children alike, she made her own children's clothes, posing her little models in them for accuracy of detail and feeling. Her clothes in turn affected the children's wear of her period, helping to soften the stiffness and unsuitability of it. Kate Greenaway died on 6 November 1901.

The *Studio* Special Number of 1897–8 on Children's Books and their Illustrators noted that there had been a great improvement in the quality and increase in the number of such books between about 1880 and 1897; the improved quality was thanks both to the publishers and to the work of artists such as Walter Crane, Ralph Caldecott and Kate Greenaway. Other illustrators had also been of importance in this renaissance, and among them were many women of merit. Children's books in the early nineteenth century had contained an excess of moral teaching, indicating that the original function of children's books had far more to do with introducing the infant to adult society and producing a worthy, 'normal' citizen than with any kind of pleasure. Books later in the century, such as those of Kate Greenaway, were in no way free of such overtones, however subtly they were concealed. Artistic effort in the production of children's books began with those produced by Henry Cole under the pseudonym of Felix Summerley, in an attempt to raise standards in applied art in general in the 1840s; he also aimed at a lighter, more imaginative literature, as opposed to the educative moralising of earlier efforts. Among the most well-known women artists of the Arts and Crafts movement, Winnifred Smith concentrated on illustration, producing works for children which showed 'considerable humour as well as ingenuity'[68]

203

such as her two *Children's Singing Games* of 1894. Georgina Cave Gaskin, better known for her jewellery, also illustrated children's books: 'Perhaps her "A. B. C." (published by Elkin Mathews) and "Horn Book Jingles" (The Leadenhall Press), a unique book in shape and style, contain the best of her work so far'.[68] Another Birmingham artist, Celia A. Levetus, was a prolific illustrator, among her best being *Turkish Fairy Tales* (Lawrence and Bullen) and *Verse Fancies* (Chapman and Hall).

The work of Gertrude M. Bradley was admired without reservation; her *Just Forty Winks* was 'one of Messrs. Blackie's happiest volumes this year ... [it] shows that the artist has steered clear of the "Alice in Wonderland" model, which the author can hardly be said to have avoided. Miss Bradley has also illustrated the prettily decorated book of poems, "Songs for Somebody", by Dollie Radford (Nutt)'.[68] One complaint frequently directed at illustrators of children's books was that their drawings were often unsuitable for children:

In later years, Miss Alice Havers in 'The White Swans' and 'Cape Town Dicky' (Hildesheimer), and many lady artists of less conspicuous ability, have done a quantity of graceful and elaborate pictures *of* children rather than *for* children. The art of this later period shows better drawing, better colour, better composition than had been the popular average before; but it generally lacks humour, and a certain vivacity of expression which children appreciate.[64]

The work of Lizzie Lawson (*Old Proverbs*, published by Cassell) 'displayed much grace in depicting children's themes', while that of Mrs Percy Dearmer had 'a quaint straightforwardness, of the sort that exactly wins a critic of the nursery'. Rosie Pitman 'in "Maurice and the Red Jar" (Macmillan), shows much elaborate effort and a distinct fantasy in design. "Undine" (Macmillan, 1897) is a still more successful achievement.'[70] Alice B. Woodward was another well-known illustrator, who also did designs for stained glass.

Mrs Hallward, who worked as an illustrator with her husband Reginald, and did much work for the magazine *The Child's Pictorial*, illustrated almost entirely in colour and published by the Society for the Promotion of Christian Knowledge from 1887, was applauded for the merit of her drawings for the publication: 'Mrs Hallward's work is marked by a strong Pre-Raphaelite feeling, although she does not, as a rule, select old-world themes'. A drawing by another Hallward, Ella F. G. Hallward, possibly their daughter, was shown at the Arts and Crafts Exhibition Society in 1896 and elicited a powerful response from the *Studio* reviewer:

The clever illustration to *The Raven* ... by Ella F. G. Hallward, employs a striking convention of its own. One can scarcely recall any other attempt to work in white upon black which has mastered the problem so easily. To use a second outline in white is a trick that has often led artists to terrible disaster. Here it is managed so deftly and directly that you fail to observe it at first glance. Miss Hallward has won a distinct place among illustrators by virtue of this single drawing, which, it may be added, is the copyright (strictly reserved) of

Above: *Jessie M. King: 'Sorrow'; pen, indian ink and gold on vellum, $9\frac{13}{16} \times 5\frac{1}{4}$ in, signed. Exhjibited at Annan's Gallery, February 1907, and illustrated in* Art et Décoration, *1908. Jessie King made several drawings illustrating Chaucer's* Romaunt of the Rose, *of which this is one.* (PHOTOGRAPH: FINE ART SOCIETY, LONDON)

Above right: *Annie French: 'The Lace Train', watercolour, $9\frac{1}{2} \times 13\frac{5}{8}$ in, signed lower right.* (PHOTOGRAPH: FINE ART SOCIETY, LONDON)

Right: *Margaret Macdonald: Design for the Menu of Miss Cranston's 'White Cockade' Exhibition Cafés, 1911; body colour on black paper laid on card, $8\frac{1}{4} \times 12\frac{1}{4}$ in, signed. A dramatically contrasting design by Jessie King for Miss Cranston's Lunch and Tea Rooms, (probably for a menu decoration) from around the same date, is also now in the Hunterian Art Gallery, University of Glasgow.* (PHOTOGRAPH: HUNTERIAN ART GALLERY, UNIVERSITY OF GLASGOW)

Mr H. S. Nichols. Would that the reservation prevented imitators from attempting weak versions of the difficult convention it employs.[71]

In an article on the Glasgow School of Art in 1901–2, the *Studio* discussed some of the prints and drawings of the senior pupils of the school; Miss Susan F. Crawford showed, in the School's annual exhibition:

four charming etchings, one of the bridge at Ayr being a notably fine example of this versatile lady's art ... Annie French's *The Doleful Lady Eleanor* and the same lady's illustration to the *Ballad of the Banish Man* were quaint and fanciful. Miss Dorothy C. Smyth's *Card Party* was both effective and original, and Miss Jessie M. King sent some of her characteristic work full of delicate imagination. Miss Ann Macbeth's *Sleeping Beauty*, a work of great charm of colour and treatment ... [was] one of the most pleasing works in the room.[72]

Jessie M. King, in addition to her jewellery designs already discussed, was also well known for her black and white illustrations.

Another artist famed for her black and white work was Mary J. Newill; a Birmingham trained artist, she was also a talented embroiderer and designer. The *Studio* of 1895 admired her work sufficiently to devote a whole article to her, although they got her name wrong, and the writer provided no background information on her. Mary Newill's black and white drawings were discussed first:

Among these drawings are especially some studies of trees quite remarkable for their vigour of line and complete mastery of a convention which by its apparent simplicity tempts many to disaster. The largest of these would provoke admiration wherever exhibited. Not merely is its detail full of interest, it preserves also the broad masses so skilfully balanced that the whole design becomes a notable work of art ... To select the essentials of a landscape and treat them in this way, is by no means an easy task; and without forgetting many admirable other instances of successful accomplishment, one may claim that Miss Newill has succeeded in keeping the truth of things seen, expressed in purely artificial convention to a degree that deserves very appreciative recognition.[73]

Her ability to use washes, though an entirely different technique, was no less accomplished; she produced atmospheric effects with a delicate perception of tone and value. Despite the variety in her technical ability, her work was in no way imitative:

Miss Newill has the courage of her convictions, and keeps in each case rigidly within the limits of the style she elects to work in. Whether you rank her work as first-rate or less highly, it is obviously the result of a personal effort to set down what is before her, not merely in the way of a dull copyist of the mannerisms of others, but with a vivid sense of the importance of selection that promises a brilliant future. And this selection she employs in strict accordance with the limitations of her material ...[74]

Thus when using the style of the early woodcut, Mary Newill reduced her forms to simplicity and concerned herself more with pattern than with the imitation of nature. In her wash drawings, either colour or monochrome, she by contrast studied the appearance of nature as seen, not 'an interpretation to fulfil the dual purpose of illustration and decoration ... The study of a conifer ... shows that the larger study was not due to a happy accident, but the result of knowledge and trained sight.'[75] ... In her embroideries she worked, again in contrast, in an entire mosaic of colour. She also produced a design shown in this article which was probably for a stained glass window:

Above: *Celia Levetus: Bookplate design, illustrated in the* Studio, *1896. Celia Levetus trained at Birmingham and this example shows her personal variant of the strong style of illustration, derived from wood engraving, which was popularised by Mary J. Newill.*

Right: *Eleanor Fortesque-Brickdale: 'The Lovers' World'; watercolour and body colour on paper, 44 × 26 in, signed. The artist's own description of this work reads: 'Here you may see disclosed the mysteries of Spring, the Springtime of Youth, of the World, of Love. As a flower-sheath drops and shows the bud, so has Love unfolded and shown to this girl Life, Song, Colour, and Music. With clasped hands, an action suggestive of an awakening after sleep, she moves amid Spring-flowers. The Spirits of the Scented Flowers cense her with their sweet odours. It is the moment of nature's High Mass—the Wedding Bells ring for her half-dreaming ears, all happy Birds sing in the May-blooming trees; Butterflies, the colours of Nature's palette, fly in clouds. The Rainbow promises all Hope, the White Dove all Peace, and the Brown Turtle-Dove all Constancy. Over her head is the Dream-Ring, The Veil and the Wreath of Myrtle—Myrtle the Crown of Life, as Laurel is the Crown of Fame, and Cypress the Crown of Death. The Honey of Kisses is here, and the new Blush of Love is here. The World sings'. In addition to her detailed brilliantly-coloured, almost Pre-Raphaelite watercolours, Eleanor Fortesque-Brickdale was a prolific book-illustrator and stained glass designer.*

In the decorative panel with a motto ... we see the final
reduction of fact to symbols, so happily carried out that the
quasi-realistic border of carillons is the only jarring note not
merely in this panel, but in the group of Miss Newill's work
here presented.[75]

Many of the American women illustrators whose work
was exhibited at the Chicago Columbian Exposition in
1893, seem to have been working in a 'realist' rather
than an Arts and Crafts decorative style. Thus for
example, the well-known daughter of Candace Wheeler,
Dora Wheeler Keith, who was a painter, illustrator and
designer of her mother's huge figurative tapestries,
worked in a pre-Arts and Crafts style. Alice Barber
Stephens, another talented woman illustrator from the
East Coast, had studied wood engraving under Edward
Dalziel in England and at the School of Design for
Women in Philadelphia, and with Thomas Eakins at
the Philadelphia Academy of Fine Arts; she also work-
ed in a style which had been untouched by the con-
ventionalising and decorative qualities of the Arts and
Crafts movement. The work of Jessie Wilcox Smith, who
also studied under Eakins at Philadelphia and who is
best known for her illustrations of children's books
such as *Little Women* by Louisa M. Alcott, was far more
decorative in style, and closer to the new developments
in book illustration in England. Her speciality was the
depiction of children, and she produced many popular
cover designs for magazines.[76] Jessie W. Smith was a
friend of and collaborator with another interesting
illustrator, Elizabeth Shippen Green, yet another pupil
of Eakins, and also of Howard Pyle at the Drexel
Institute, as was Jessie Wilcox Smith herself. Jessie was
nicknamed 'The Mint' thanks to her considerable
financial success in her work, to which she was
completely dedicated. Jessie and Elizabeth Shippen
Green lived together with Violet Oakley; Elizabeth's
work was far more strikingly *Art Nouveau* in style,
showing the influence of European painting trends as
well as English illustrative ones.

*Elizabeth Shippen Green: ' "Poor Little One!" she murmured, resting
her cheek on the brown hair.' Illustration for 'The Real Birthday of
Dorante',* Harper's New Monthly Magazine, *June 1911. Charcoal, 14¼
× 17⅞ in, with monogram.* (PHOTOGRAPH: LIBRARY OF CONGRESS, CABINET OF
AMERICAN ILLUSTRATION)

Left: *Jessie M. King: 'She Threw her Wet Hair Backward from her Brow'; pen and indian ink on vellum. 9¾ × 7⅗ in, monogram 'JMK'. One of the set of drawings and decorations for the 1904 Bodley Head edition of* The Defense of Guenevere and other Poems *by William Morris.* (PHOTOGRAPH: HUNTERIAN ART GALLERY, UNIVERSITY OF GLASGOW)

Above left: *Agnes Raeburn: Poster for the Glasgow Lecture Association; lithograph on cream paper, 39¾ × 25 in. Printed by Carter and*

Pratt, Glasgow. (PHOTOGRAPH: HUNTERIAN ART GALLERY, UNIVERSITY OF GLASGOW)

Above: *Jessie Wilcox Smith: 'Tom reached and clawed down the note after him'; illustration for Charles Kingsley,* The Water Babies, *1916. Charcoal, watercolour and oil on board, 23¾ × 17¾ in, signed.* (PHOTOGRAPH: LIBRARY OF CONGRESS, CABINET OF AMERICAN ILLUSTRATION)

NOTES

1. Sheila Rowbotham, *Hidden From History*, London, 1974, p. 2.
2. Lee Holcombe, *Victorian Ladies at Work*, Newton Abbot, 1973, p. 16.
3. Falconer Madan, *The Daniel Press. Memorials of C. H. O. Daniels . . .*, The Daniel Press 1921; quoted in Colin Franklin, *The Private Presses*, Chester Springs, Penn., 1969, p. 28.
4. Franklin, *op. cit.* pp. 25–6.
5. Georgina Burne-Jones, *Memorials*, London, 1904, vol. I, p. 213.
6. From Lucien Pissarro's short outline *History of the Eragny Press*, reprinted in Franklin, *op. cit.* pp. 95–6.
7. *The Gentle Art of Lucien Pissarro*, Gallery L'Art Ancien, Zurich, 1974, p. 8.
8. Franklin, *op. cit.* p. 100.
9. *The Gentle Art of Lucien Pissarro, op. cit.* p. 38.
10. *ibid.* p. 39.
11. John Bensusan-Butt, Recollections of Lucien Pissarro in his Seventies by his nephew . . ., reprinted in *Lucien Pissarro*, catalogue of an exhibition of drawings, Anthony d'Offay Gallery, 1977, p. 6.
12. Reprinted in Franklin, *op. cit.* p. 98.
13. *ibid.* p. 101.
14. *ibid.* pp. 77–8.
15. Liam Miller, *A Brief Account of the Cuala Press formerly the Dun Emer Press founded by Elizabeth Corbet Yeats in MCMIII*, The Cuala Press, Dublin, 1971 (n.p.).
16. Franklin, *op. cit.* p. 121.
17. Susan Otis Thompson, The Arts and Crafts Book, in Robert Judson Clark (ed.), *The Arts and Crafts Movement in America 1876–1916*, Princeton University Press, 1972, p. 107.
18. Karen Petersen and J. J. Wilson, *Women Artists: Recognition and Reappraisal from the Early Middle Ages to the 20th Century*, New York, Hagerstown, San Francisco, London, 1976, p. 12.
19. Modern Manuscripts, in *Studio*, Special Number, vol. 5, Winter 1896–7, pp. 54–5.
20. *ibid.* p. 51.
21. *Second Exhibition of Artistic Bookbindings by Women*, exhibition catalogue p. 23, no. 122. The exhibition was held from December 1898 to January 1899 at 61 Charing Cross Road, London.
22. Modern Manuscripts, *op. cit.* pp. 51–2.
23. J. Quigley, The Art of Jessie Bayes, Painter and Craftswoman, *Studio*, vol. 61, 1914, p. 269.
24. *Book Exhibition* catalogue, Central School of Arts and Crafts, 13 May 1912, pp. 6–7. The catalogue contains a short account of the history of the London County Council classes in book production.
25. Fred Miller, Art Workers at Home. Bookbinders, *Art Journal*, 1897, pp. 14–15.
26. Franklin, *op. cit.* p. 109.
27. Modern Bookbindings and their Designers, *Studio*, Special Number vol. 8, Winter 1899–1900, pl 4. The book referred to was her *An Historical Sketch of Bookbinding*, London, 1893; and see Bibliography.
28. *Minutes of the Technical Education Board*, London County Council, T.E.B./10, 6 February 1899, p. 79. I am very grateful to Godfrey Rubens for bringing this case to my notice.
29. *ibid.* p. 80.
30. Lord Russell, 11th Duke of Bedford, 1858–1940; first Mayor of Holborn, 1900.
31. *Minutes of the Technical Education Board, op. cit.* pp. 80–81.
32. 'In 1866 the average wage (*not* earnings) for men (in 38 industries) was 24s.7d. [£1.23] a week; for women (in 23 industries) 12s.8d. [63p] i.e., 51.5 per cent. Female domestic servants earned an average of £18 a year in London and £16 in other parts of England and Wales.' Given in Yvonne Kapp, *Eleanor Marx*, vol. 2, London, 1976, p. 85, n. ‡.
33. *Minutes of the Technical Education Board, op. cit.* p. 81.
34. *ibid.* p. 82.
35. *Second Exhibition of Artistic Bookbindings by Women, op. cit.* p. 3.
36. *ibid.* p. 4.
37. Modern Bookbindings and their Designers, *op. cit.* p. 45.
38. *Studio*, vol. 16, 1899, p. 51.
39. *Second Exhibition of Artistic Bookbindings by Women, op. cit. p. 4.*
40. Miller, *op. cit.* p. 17.
41. Quoted in *Second Exhibition of Artistic bookbindings by Women, op. cit.* p. 7.
42. Esther Wood, British Tooled Bookbindings and their Designers, in Modern Bookbindings and their Designers, *op. cit.* p. 44.
43. Franklin, *op. cit.* p. 55.
44. St John Hornby, *Anthology of Appreciations*, London, 1946.
45. Modern Bookbindings and their Designers, *op. cit.* pp. 44–5.
46. *ibid.* p. 45.
47. *Jessie M. King 1875–1949*, catalogue, Arts Council Exhibition, Scottish Committee, London, December 1971–January 1972, no. 127, p. 43.
48. British Trade Bookbindings and their Designers, in Modern Bookbindings and their Designers, *op. cit.* pp. 31–2.
49. Franklin, *op. cit.* p. 76 has incorrectly transcribed the name of Miss Power, transposing it into 'Powell'; thus all his references to the woman who organised the Essex House Bindery indicate incorrectly that she was Louise Powell. I am very grateful to Alan Crawford for kindly making available to me his notes concerning Anastasia Power made from the unpublished Journals of Charles and Janet Ashbee, which Charles Ashbee donated to the library of his former college, King's College, Cambridge.
50. Studio-Talk: Dublin, *Studio*, vol. 33, 1905, p. 364; on the exhibition of the Irish Arts and Crafts Society.
51. Edward F. Strange, American Bookbindings, in Modern Bookbindings and their Designers, *op. cit.* p. 47.
52. *ibid.* pp. 48–54.
53. Quoted in Robert Judson Clark, *The Arts and Crafts Movement in America 1876–1916*, Princeton University Press, 1972, p. 116. The book, illustrated in this catalogue, no. 152, now belongs to Josephine S. Starr.
54. Doris Cole, *From Tipi to Skyscraper—A History of Women in Architecture*, Boston, 1973, p. 59.
55. *Report of the Council of the School of Design, 1842–3*, vol. 29, 1843, p. 6, para. 11. See also Chapter 1, Design Education for Women.
56. H. Cole and R. Redgrave, *Addresses*, London, 1853, p. 71. Joint classes for men and women were held in 'Woven Fabrics and Paper Hangings' and 'China painting'. Male-only classes were held in metalwork, with no 'at present' proviso—they were 'open only to male students'; it seems that these practical classes were unsuccessful and died out fairly rapidly.
57. *ibid.* section 7, p. 27.
58. D. H. Muir, *Victorian Illustrated Books*, London, 1971, p. 6.
59. Art-Work for Women I, *Art Journal*, March 1872, p. 65.
60. Press cutting preserved in the archives of the Central School of Art, London.
61. Chromolithographic Studio Information Sheet of 1886, preserved in the archives of the Central School of Art, London.
62. Unpublished letter (n.d., *c.* 1904) from Longingham? (signature illegible), preserved in the archives of the Central School of Art, London.
63. Copy of a letter from Sir Philip Cunliffe-Owen to Miss Rushton, 11 October 1886, preserved in the archives of the Central School of Art, London.
64. *Studio*, vol. 24, 1901–2, p. 300.
65. Ruth Hill Viguers (ed.), *The Kate Greenaway Treasury*, London, 1968, p. 301, using as source M. H. Spielmann and G. S. Layard, *Kate Greenaway*, 1905, states that she attended 'the newly opened London Slade School, then in charge of Professor Legros and his assistants'. The Slade School was under Edward Poynter when it first opened in 1871; Legros took over only in 1876.
66. See Art-Work for Women I, *Art Journal*, 1872, p. 65 and Women's Industries—Valentine Making, *Queen*, 8 October 1887, pp. 435ff, 'in which the supple fingers and neatness of women become of sound marketable value'.
67. Quoted in Spielman and Layard, *op. cit.* pp. 57–8.
68. Children's Books and their Illustrators, *Studio*, Special Number vol. 5, 1897–8, p. 57.
69. *ibid.* p. 42.
70. *ibid.* p. 58. It seems likely that Rosie Pitman was related to the family of Sir Isaac Pitman, whose younger brother Ben settled in America prior to the Civil War and who, with his daughter

Agnes, was so influential in the development of art woodcarving and china painting in Cincinnati.

71. The Arts and Crafts Exhibition, 1896, *Studio*, vol. 9, 1896–7, p. 280.
72. Glasgow—Annual Exhibition of the School of Art, *Studio*, vol. 24, 1901–2, p. 284.
73. E.B.S., Some Aspects of the Work of Mary L. [*sic*] Newill, *Studio*, vol. 5, 1895, p. 56.
74. *ibid.* p. 59.
75. *ibid.* p. 60.
76. See S. Michael Schnessel's recent monograph *Jessie Wilcox Smith*, Studio Vista, London, 1977. More generally, see *A Century of American Illustration*, Brooklyn Museum, 1972.

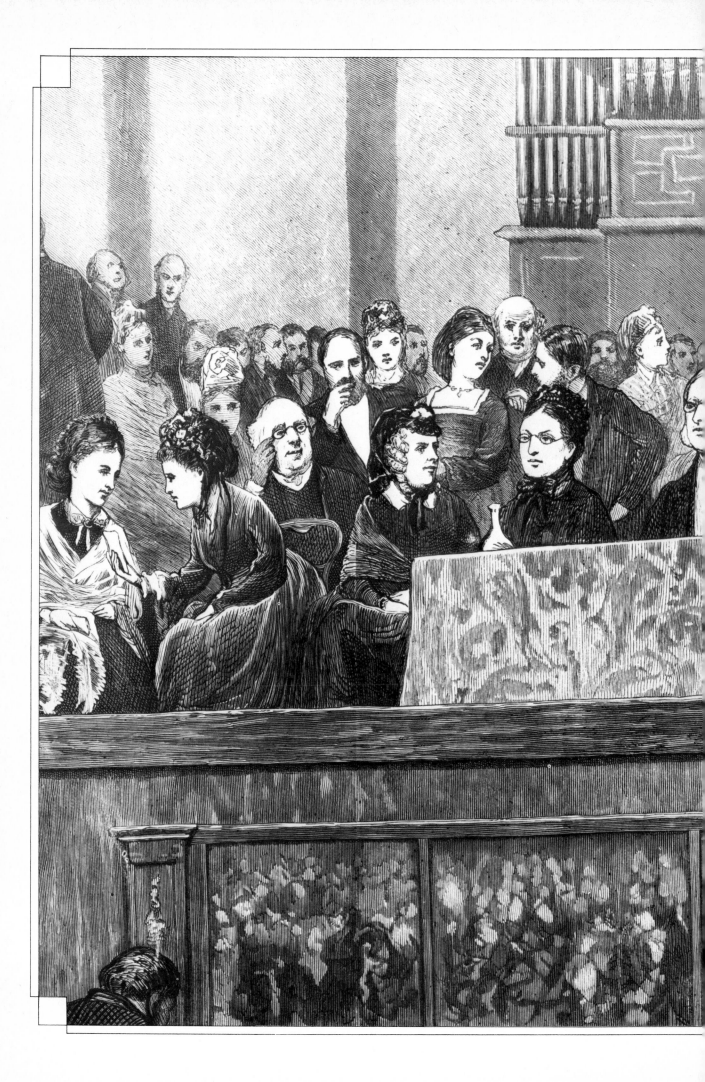

Conclusion: Feminism, Art and Political Conflict

Women's Rights—A Meeting at the Hanover Square Rooms; Rhoda Garrett addressing the meeting, standing, right. The women seated on the left are (from left to right) Millicent Fawcett, Mrs Mark Pattinson, Ernestine Rose, Lydia E. Becker. Engraving from The Graphic, *25 May 1872.* (PHOTOGRAPH: THE ILLUSTRATED LONDON NEWS PICTURE LIBRARY)

RISING SOCIALISM was a powerful force in England during the 1880s and 1890s[1] and not only was it an underlying theme but often an overt factor in the ideology behind the Arts and Crafts revival. Many of the leading members of the Arts and Crafts movement were also leading socialists, in particular William Morris himself who in 1883 joined the Democratic Federation (later the Social Democratic Federation), and was in 1889 a founder member of the Socialist League, May Morris, Walter Crane (first President of the Arts and Crafts Exhibition Society), who joined the Socialist League in 1884, A. H. Mackmurdo, who had socialist leanings, and Charles Ashbee:

A young architect who was at Toynbee Hall in the mid 1880s, became impatient with the work of the Settlement, flirted with Socialism, drew back but went off to form a Guild and School of Handicraft. Influenced by Morris he wanted to integrate art with craftsmanship, thinking it better to design trade-union banners than to hang in the Royal Academy. Unlike Morris, though, he saw a revival of craft skill as a substitute for social revolution and earned Morris's hearty contempt for his pains.[2]

T. J. Cobden-Sanderson followed a personal line in mystical socialism, while Annie Cobden-Sanderson was his more active radical counterpart, becoming involved in militant suffrage agitation. Henry Holiday, Lucien and Esther Pissarro were radicals, William Lethaby a socialist, and many other Arts and Crafts people were associated with leading Fabians like Sidney and Beatrice Webb. Of the founding members of the Morris firm, Charles Faulkner and Philip Webb supported Morris's political stance, Faulkner himself being a signatory of the Socialist League manifesto of 1887.

In *How I Became a Socialist*, Morris wrote of the universal importance of art in the socialist revolution:

Yet it must be remembered that civilization has reduced the work of man to such a skinny and pitiful existence, that he scarcely knows how to frame a desire for any life much better than that which he now endures perforce. *It is the province of art to set the true ideal of a full and reasonable life before him*, a life to which the perception and creation of beauty, the enjoyment of real pleasure that is, shall be felt to be as necessary to man as his daily bread, and that no man, no set of men, can be deprived of this except by mere opposition, which should be resisted to the utmost.[3]

He concluded in 1883: 'Both my historical studies and my practical conflict with the partisanism of modern society have *forced* on me the conviction that art cannot have a real life and growth under the present system of commercialism and profit-mongering'.[4]

Certain ideals were common to both early socialism and the Arts and Crafts movement; a missionary concern to improve the condition of man and the quality of life, to make culture and art available to everyone, and to reunite artist and craftsman, designer and artisan. As early as 1877 Morris had stated: 'I do not want art for a few, any more than education for a few, or freedom for a few'. His contact with socialism during the 1880s changed his early idealistic hatred for the machine, which was so common in Arts and Crafts

ideology and had its origins in the ideas of Ruskin and Carlyle. By 1888 he could say:

I have spoken of machinery being used freely for releasing people from the more mechanical and repulsive part of necessary labour; and I know that to some cultivated people, people of the artistic turn of mind, machinery is particularly distasteful, and they will be apt to say you will never get your surroundings pleasant so long as you are surrounded by machinery. I don't quite admit that; it is allowing machines to be our masters and not our servants that so injures the beauty of life nowadays. In other words, it is the token of the terrible crime we have fallen into of using our control of the powers of Nature for the purpose of enslaving people, we care less meantime of how much happiness we rob their lives of.[5]

During the 1880s, 'the boundaries between [the] ... moral, aesthetic and political revolt were still fluid'[2] and the ideals and practice of many who were involved in the Arts and Crafts revival reflected a general cultural reaction against Victorian life and ethics. Before the foundation of the parliamentary-oriented Independent Labour Party in 1893, revolutionary socialism represented a quasi-religious belief to which one was converted, creating a new person, a new life, committed to working—through fellowships, clubs, missionary work, poetry and songs—for a new kind of community. Thus the parallels at this period between the beliefs of many craftsmen and socialists provided a strong unifying force.

Although comparatively little is known about the early relationship between socialists and feminists, it seems clear that many socialists were hostile to the rising feminist movement and to demands for women's suffrage. H. M. Hyndman, leader of the first marxist organisation in Britain, the Social Democrat Federation, seems to have been completely dismissive of feminism, while John Bruce Glasier, of the Socialist League and later the Independent Labour Party, regarded with patronising irony attempts to raise the feminist issue in the Glasgow Branch of the Socialist League. Recalling a party after one of Morris's lectures to the Branch in the winter of 1886, he wrote:

Towards the end of the evening Mrs. Neilson, a member of the Ruskin Society and our first woman recruit, surprised us with a little preceptorial address, in which she gently rebuked us for the warlike tones of some of our Socialist utterances, and pressed upon us her view that only by the extension of the franchise to women could Socialism ever be obtained, as men were far too stupid and selfish ever to do away with a system that satisfied their fighting and predatory instincts. This was, I believe, almost the first definitely anti-militarist note, and the first sound of the new women's agitation that any of us had yet heard. She amused us greatly by admonishing Morris quaintly against becoming conceited because of his genius and the hero-worship of his Socialist comrades! Morris in reply playfully assured her that were she acquainted with his experiences for but one week as editor of *Commonweal*, or as a member of the Council of the League ... she would have no anxiety lest his personal vanity should become unduly inflated. I cannot recollect whether he alluded to her remarks about the militarist spirit and women's enfranchisement—a

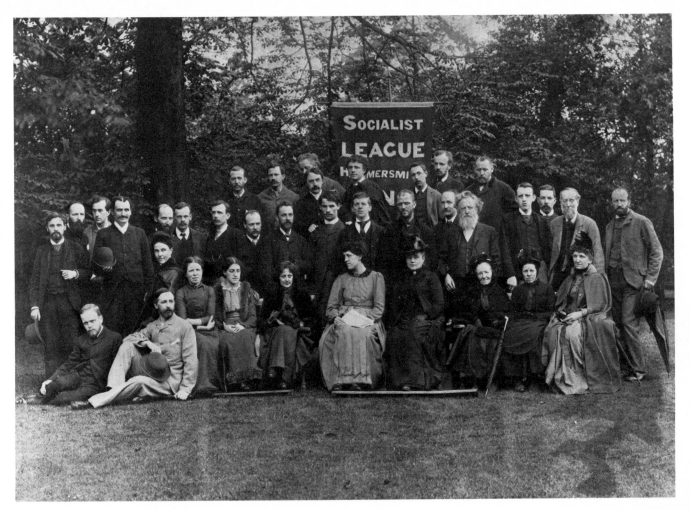

telltale forgetfulness on my part. But I doubt if any of us realised the prophetic importance of the precepts thus pitched upon us by the first women's utterance in our midst.[6]

Because of his close ties with the Marx-Avelings, both as friends and socialists, it is of course extremely unlikely that Morris at least was unaware of the feminist movement, for it was in that year that Eleanor Marx and Edward Aveling published their paper, *The Woman Question*, and it would undoubtedly have been discussed among them. However, Glasier's recollections give some indication of the attitudes of the Socialist League, and more particularly of the Morris circle, to women. Although May Morris was active in the Socialist League, her manner among her male colleagues was noted by Glasier as subdued: 'I had heard so much about her beauty and her activities in the movement. She resembled her mother, I thought, more than her father in face, and was strikingly handsome. Her manner was quiet, and she was, I observed, inclined rather to ask questions or listen than to offer opinions of her own. She worked at a piece of embroidery as she sat with us.'[7] His references were consistently to 'our male selves' chatting over the important political events of the day; the women were shown in typically feminine rôles while the men were involved in the politics: while Jane Morris did some embroidery on the settee by the fire, 'Jenny, the eldest daughter, now came in, and we were served with a cup of tea, after which Morris took me downstairs to the library to have a smoke and talk about League business before supper'.[8] Thus, despite

Photograph of the Hammersmith Branch of the Socialist League, 1886; William Morris is the large, white-bearded character standing centre row, right; the central bare-headed, seated woman is Jenny Morris, and second from her right is May Morris; the woman seated between them looks slightly like Eleanor Marx. (PHOTOGRAPH: VICTORIA & ALBERT MUSEUM, LONDON)

the revelations of contemporary writings like that of Engels on *The Origin of the Family, Private Property and the State* (1884) and the Marx-Avelings' *The Woman Question* and the work of the German August Bebel from which it sprang, there seems to have been no questioning of sexual rôles within the immediate Morris circle.

Hannah Mitchell, a working-class feminist and socialist, recalled that 'Mrs. P. [Pankhurst], and her followers found some of their bitterest opponents among the Socialists',[9] stressing that, because of lack of support for the feminist cause on the part of male socialists, she frequently felt torn between her two allegiances. Many socialists seem to have felt that if women (ie, middle-class women) gained the vote it would simply strengthen the political right wing; as if in confirmation of this, the most vocal of the suffragist leaders, particularly Mrs Emmeline and Christabel Pankhurst, who were therefore seen as representative of feminism as a whole, were clearly to the right politically. By most radicals the suffrage movement was seen as a strictly middle-class affair, potentially reinforcing the *status quo* they wished to overturn; Engels wrote in 1886: 'The foremost English champions of the formal rights of women . . . are in a large measure

215

directly or indirectly interested in the capitalist exploitation of both sexes'.[10] This was also the attitude of Eleanor Marx in *The Woman Question*, while in the early 1890s she expressed it more personally: 'Fine-lady suffragists of the Mrs Henry Fawcett type are quite of the opinion that the poor should keep their place, and if common women as well as common men were to get votes there's no knowing what use they might make of them . . .'.[11] However, it is clear that even at this period, and even among radical intellectuals, the extent of grass roots involvement in feminism and women's suffrage was obscured behind the myth-making ideas of a few leaders; only recently has the history of working-class women's activism in the feminist movement begun to be uncovered.[12]

While Eleanor Marx did recognise that all women, regardless of class, were oppressed within a capitalist society, her political activism, like that of virtually all her socialist contemporaries, was directed towards the working classes. Although she emphasised that 'Both the oppressed classes, women and the immediate producers, must understand that their emancipation will come from themselves' and acknowledged that 'the one has nothing to hope from man as a whole, and the other has nothing to hope from the middle class as a whole',[13] she was unable to take that idea to its logical, personal conclusion. She did show concern for the plight faced by large numbers of middle-class women when she stated in July 1885:

The fact is that women are driven to prostitution—not only women of the working classes. Governesses are often supposed to teach two or three languages and other 'accomplishments' and dress respectably on six shillings a week . . . Nearly all women obliged to earn a living have to choose between starvation and prostitution, and this must go on so long as one class can buy the bodies of another, whether in the form of labour power or sexual embraces.[14]

By contrast to widespread consciousness of the situation of governesses and working-class women—the relative anonymity of middle- and upper-class women dependent for a meagre livelihood on their own exertions seems to have obscured their plight and their large numbers from social agitators. Despite Eleanor Marx's conviction that, as Bebel stated: 'We must seek the real cause of woman's enslaved position in her economic dependence upon man, and that her "emancipation" means nothing but economic freedom',[15] she seems only to have applied the theory to a very limited section of her own class of women.

One of the most crucial questions brought into the open by Eleanor Marx, and one which caused a severe rupture among late nineteenth-century feminists, was that of women's sexuality:

Many feminists argued that women had suffered so much from men's sexual desires both physically and psychologically that the aim should be to make men as spiritual as women had been forced to become by Victorian morality. So there was a clear division between advocates of birth control like Annie Besant and sexual radicals like [Edward] Carpenter and [Havelock] Ellis on the one hand, and feminists like Millicent Fawcett on

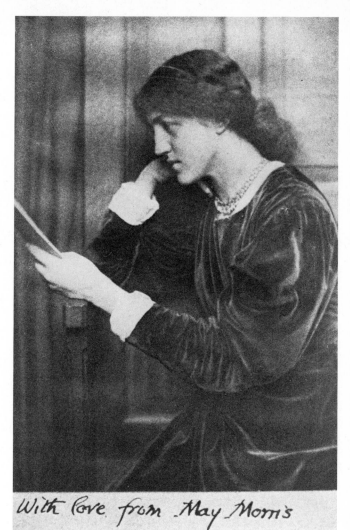

May Morris: Photograph taken by Frederick Hollyer, c. 1886, dedicated by May Morris. (PHOTOGRAPH: WILLIAM MORRIS GALLERY, WALTHAMSTOW, LONDON)

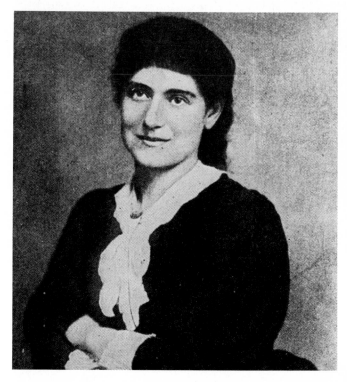

Eleanor Marx: Photograph taken c. 1880. (PHOTOGRAPH: RADIO TIMES HULTON PICTURE LIBRARY)

216

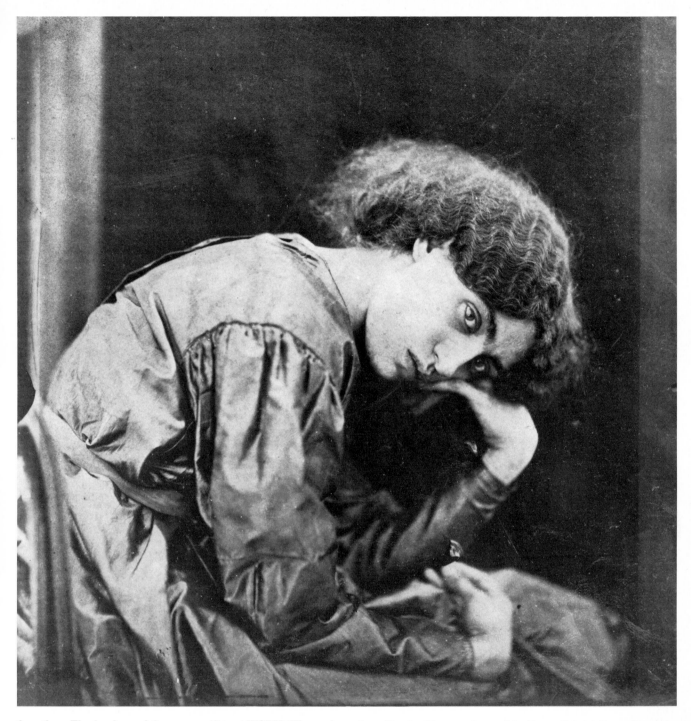

Jane Morris: Photograph posed by Dante Gabriel Rossetti, c. 1865.
(PHOTOGRAPH: VICTORIA & ALBERT MUSEUM, LONDON)

the other. The leaders of the more militant WSPU [Women's Social and Political Union] in the 1900s were equally suspicious of sexual radicalism. Christabel Pankhurst was prepared to use direct action but she had no sympathy for a growing current in the feminist movement which was asserting active female sexuality and discussing demands which related to the biological situation of women as women.[16]

The Marx-Avelings felt that it was only within the agitation against the Contagious Diseases Acts that feminists touched on the question of women's sexuality, and women like Rhoda Garrett, who was the most effective of all the early women's suffrage speakers, was also an officer of the Repeal Society, and thus placed in a difficult position at a time when most suffragists wished to keep the two issues separate for fear of 'disgracing' women's suffrage. The Marx-Avelings were against

women's oppression in marriage; 'Our marriages, like our morals, are based upon commercialism' and the double standards of Victorian morality which denied female sexuality: 'How is it that our sisters bear upon their brows this stamp of lost instincts, stifled affections, a nature in part murdered?'[17] Divorce, which was advocated by some radicals, was seen by them to disadvantage women under the present system wherein few women were in an economic position to benefit from it: 'the annulling of the union would be to him freedom; to her, starvation for herself and her children'.[18]

The economic dependence which many socialist writers, starting with Engels, considered the key to women's oppression, was felt simply to be the result of the development of private property: 'The pre-

217

dominance of the man in marriage is simply a consequence of his economic predominance and will vanish with it automatically',[19] Engels wrote in 1884. There seems here to have been no belief in the need for a struggle to change oppressive personal relations between men and women, nor any questioning of the traditional sexual division of labour in those relations, which still saw women as responsible for child-care. However, economic independence for women was to a great degree dependent precisely upon a radical transformation of that traditional sexual division of labour and its psychological ramifications, even within the socialist utopia which Engels envisaged. On a practical level, women's right to control their own biological destiny and their sexuality, was of profound and immediate importance in the struggle for economic independence, which necessitated freedom from the crippling commitments of childbearing. Thus the demands for contraception and abortion first voiced by Annie Besant, and taken up more widely during the 1900s, formed an essential pre-requisite for any radical change both in sexual relations and the sexual division of labour in the family. It is relevant that a significantly large number of women involved professionally in the Arts and Crafts movement remained unmarried or childless, and that many of those who did marry married fellow craftsmen, which enabled them to continue their creative work.

From another viewpoint, the Arts and Crafts movement can be seen as an area of remunerative activity which—unlike many others—did in fact permit married women with family commitments to pursue an independent, though sometimes only semi-professional, career; many crafts could be carried on in the home, often without the need for a special workshop, and here the sexual division of women's labour within the Arts and Crafts movement—their choice of particular crafts—shows a distinct bias which relates to that fact. The affiliation of women to certain Arts and Crafts organisations seems also to have been circumscribed to some degree both by their physical ties and their traditional rôles; the Bromsgrove Guild of Applied Art provides an interesting example of this.[20] At first centred on Birmingham and comparatively fluid in organisational structure, when Walter Gilbert's Guild settled in Bromsgrove in 1897 it became more tightly organised around a small group of craftsmen working in traditionally male-dominated crafts: metalwork (particularly wrought-iron work), stained glass, plasterwork and woodcarving. Significantly, prior to the Guild's departure for Bromsgrove, its products had been more widely varied including crafts particularly associated with women—who were then actively involved in it. Thus when the Guild established itself in Bromsgrove, physical ties seem to have limited women members, as did the Guild's development of and specialisation in markedly 'masculine' pursuits.

An underlying characteristic of the Arts and Crafts revival, and indeed of contemporary socialism, appears in this tendency described in relation to the Bromsgrove Guild. This, the notion of 'brotherhood', seems to have had its origins in the Gothic revival and in the Pre-Raphaelite Brotherhood founded in 1848; similarly, in their early years at Oxford both Morris and Burne-Jones had dreamed of setting up a monastic order to conduct, in Burne-Jones' words, 'a Crusade and Holy warfare against this age'.[21] By the time of their final year in Oxford 1855, the 'Order had become a secular brotherhood of friends devoted to literary and artistic pursuits, and its mouthpiece the *Oxford and Cambridge Magazine*'.[22] This tendency towards male bonding, which reflected contemporary social practice, was the logical result of a social structure which discouraged intellectual equality for women and restricted the forms of social intercourse between the sexes to a rigid formula, which was, however, hardly acceptable to all:

But I would ask some share of hours that you on clubs bestow
Of knowledge which [you] prize so much, might I not something know
Subtract from meetings amongst men, each eve an hour for me
Make me companion of your soul as I may safely be
If you will read I'll sit and work, then think when you're away
Less tedious I shall find the time, dear Robert of your stay.[23]

This fifteen-year-old girl found expression for her dissatisfaction through the traditional medium of the sampler.

Thus it was no coincidence that so many of the Arts and Crafts Guilds, founded on the Victorian vision of those mediaeval institutions, were male-organised and male-dominated, or as in the case of the powerful Art Workers' Guild, were exclusively male 'clubs'. The resulting sense of 'otherness' which craftswomen must have felt in the face of this fundamental aspect of the movement, and the ensuing conflicts of sexual and professional identity it caused, can only have served to further alienate women attempting to reconcile the opposing ideals of woman and artist. The example of the homosexual Charles Ashbee's Guild of Handicraft is particularly indicative of the problems faced by craftswomen trying to integrate themselves into the ideologically masculine movement; in 1909 Ashbee summed up his ideals of craft brotherhood:

So it comes that when a little group of men learn to pull together in a workshop, to trust each other, to play into each other's hand, and understand each other's limitations, their combination becomes creative, and the character that they develop in themselves takes expression in the work of their fingers. Humanity and craftsmanship are essential.[24]

It was the arrival of the bookbinder Annie Power at the Guild in Campden which prompted a discussion in the Ashbee *Journals* of the problems of craftswomen working in predominantly male workshops. Annie Power had been with the Guild in London since about 1898, and her presence as the only single woman caused her to be a focus of attention; she moved to Campden with the bindery in August 1902. It is significant that the reflections concerning her in the *Journals* are in the hand of Ashbee's wife Janet who, doubtless disturbed by her own circumstances, adopted a moralising and malicious stance with regard to Annie Power, who had a love affair with Fred Partridge while he was engaged to the Birmingham jeweller May Hart:

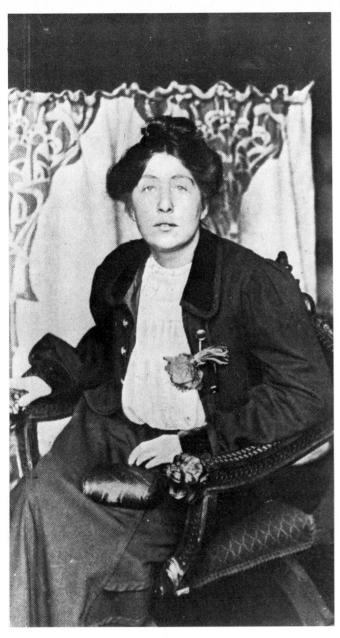

Sylvia Pankhurst: Photograph from Sphere, *5 May 1906.* (PHOTOGRAPH: THE ILLUSTRATED LONDON NEWS PICTURE LIBRARY)

It does seem hard that he should lose a good berth, and we should lose one of our best jewellers because of 'the way of a man with a maid'. Its one thing to introduce female labour at the Guild, and another to solve the problems that arise from this step.[25]

Janet Ashbee talks strangely as if an all-male community were somehow asexual—despite her evident knowledge to the contrary—and as if married women like herself were non-sexual, unthreatening creatures untouched by such issues. Soon after her marriage to the Campden artist George Loosely, Annie Power severed her connections with the Guild, a move hardly surprising in view of Janet Ashbee's hostility towards her:

I think at marriage a woman either plunges into something new, or reverts with double intensity to something one has foresaken. I plunged, Statia [Anastasia Power] is reverting. All the bourgeoisie, the conventionality, the desire to stand well with the powers that be, the assertiveness and the touch

of vulgarity which combined to set me against her at first meeting, are now showing through. She reminds me of Ann in Bernard Shaw's *Man and Superman*, who made for her prey with a partly unconscious huntress's instinct, and married him almost despite himself. But she has not Ann's charm. She has lost her supple swinging buoyant cameraderie, her breezy boyishness and the generous good nature which redeemed much that was crude and uncultured.[26]

Ashbee himself was unsympathetic towards feminism, and was openly mocking towards one of his sisters, Elsa, who was actively involved in women's suffrage.

Women's position in the Arts and Crafts movement was not only the result of external, practical constraints and rôles imposed by Victorian society; ideological constraints were evidently even more limiting. It is clear that the sexual division of labour in the Arts and Crafts movement was not simply a product of the problems faced by women in integrating domestic and work life, but also of the necessity for them to break through these ideological barriers, in particular the conflict between 'woman' and 'artist' as social rôles, and similarly also that between 'ladies' and 'work'. The stereotyped masculine characteristics of ambition and success also created problems for women striving to achieve a professional life; the feminine stereotype discouraged any artistic creativity other than 'dabbling', although it was more favourably disposed to the crafts and to nominally 'manual' pursuits. This attitude was widely reinforced in the Arts and Crafts movement through women's involvement as the executants of designs by men. Although in their general social and political aims a large section of those active in the Arts and Crafts movement were radical, yet there was a general blindness to the oppression of women within the movement, and often an open hostility to such questions. In its sexual division of labour—both in terms of traditional 'feminine' crafts, and in the split between designer and executant, the movement recreated in microcosm the broader social attitudes of the day. It also reflected general trends of employment in which working-class women (with the exception of those in the textile industry) were still largely exploited as outworkers, where they could more easily fulfil the dual functions of both producers of goods and reproducers of the labour force, combining paid outwork with unrewarded domestic labour. Within the Arts and Crafts movement many middle-class women workers were in a similar position; home work for most working ladies was essential, both from the point of view of domestic commitments and from the socially imposed necessity of hiding their need to earn a living. The resulting obscurity in which they worked hid them not only from contemporary socialist agitators for the working classes, but also from later social historians and writers on the Arts and Crafts movement. Thus women's necessity to work in secret obscured not only the extent of middle-class women's labour, but also it effectively reinforced and reproduced social prejudices against their working. Socialist condemnation of idle middle-class women was unable to take into account these factors, which placed many women in straits

Some of the 770 Banners carried during the March of Suffragists from the Embankment to the Albert Hall, from the Illustrated London News, *17 June 1908. The banners carried were on show at Caxton Hall the previous week; a great many of them were designed and executed by the Artists' Suffrage League. 70 were large in size, 700 smaller.* (PHOTOGRAPH: THE ILLUSTRATED LONDON NEWS PICTURE LIBRARY)

similar to those for example of the peasant lacemakers, who were forced to rely on fluctuating taste and fashion for a meagre and insecure income.

Thus, while the Arts and Crafts movement—both in England and America—did provide a crucial sphere of work and thereby autonomy and personal creativity for large numbers of middle-class women, their rôle within it was circumscribed by contemporary stereotypes of women—thus helping to maintain and perpetuate them. Despite the enormous extent of women's involvement, the movement remained traditionally structured, and led mostly by men; but it did give many women the vital economic independence which freed them to struggle towards a new, self-defined identity both socially and politically. However, the hostility between broad-based feminism and growing socialism had by the end of the nineteenth century created a split in radical thinking, which was manifest in the often pro-socialist, patriarchal Arts and Crafts movement, and which has remained sadly unresolved up to the present day.

NOTES

1. See Stephen Yeo, A New Life: The Religion of Socialism in Britain, 1883–1896, *History Workshop Journal*, no. 4, Autumn 1977.
2. Sheila Rowbotham and Jeffrey Weeks, *Socialism and the New Life*, London, 1977, p. 15.
3. Quoted in Raymond Williams, *Culture and Society 1780–1950*, Penguin, 1963, p. 155: Williams' italics.
4. From a letter to Andreas Scheu, an Austrian refugee and fellow-socialist, 5 September 1883, quoted in Asa Briggs, *William Morris; Selected Writings and Designs*, Harmondsworth, 1968, p. 32.
5. How We Live and How We Might Live, 1888, quoted in *ibid.* p. 179.
6. J. Bruce Glasier: *William Morris and the Early Days of the Socialist Movement*, 1921, pp. 40–1.
7. *ibid.* pp. 47–8. Glasier is referring to a visit to Kelmscott House, Hammersmith, Whitsun 1888, for the Annual Conference of the Socialist League.
8. *ibid.* p. 46.
9. H. Mitchell, *The Hard Way Up*, London, 1977, p. 126.
10. Letter of 5 July 1886, quoted in Yvonne Kapp, *Eleanor Marx*, vol. 2, 1976, p. 85.
11. Quoted in *ibid.* p. 559.
12. See Mitchell, *op. cit.* and the forthcoming work of Jill Liddington and Jill Norris, outlined in Rediscovering Suffrage History, *History Workshop Journal*, no. 4, Autumn 1977, pp. 192–202.
13. Eleanor Marx and Edward Aveling, *The Woman Question*, 1886, reprinted in *Marxism Today*, March 1972, p. 82.
14. Quoted in Kapp, *op. cit.* pp. 87–8.
15. Quoted in her review of the English translation of Bebel's *Woman—Past, Present and Future*, in the August 1885 Supplement to *Commonweal*; quoted in *ibid.* pp. 83.
16. Rowbotham and Weeks, *op. cit.* pp. 17–18.
17. Marx and Aveling, *op. cit.* p. 83.
18. *ibid.* p. 85.
19. Quoted in Rowbotham and Weeks, *op. cit.* p. 21.
20. I am grateful to Alan Crawford for bringing this information to my attention.
21. Quoted in Gillian Naylor, *The Arts and Crafts Movement*, London, 1971, p. 97.
22. Naylor, *op. cit.* p. 97.
23. From a sampler dated 1840; quoted in Rosie Parker, The Word for Embroidery was WORK, *Spare Rib*, no. 37, July 1975, p. 44.
24. Quoted in Naylor, *op. cit.* p. 167.
25. Entry in the Ashbee *Journals* for 28 February 1903. I am grateful to Alan Crawford for passing on to me the references to Annie Power in the unpublished *Journals*, in King's College Library, Cambridge.
26. Entry in the Ashbee *Journals* for 6 July 1905.

Appendix 1: Biographical Notes on Selected Craftswomen

Adams, Katherine British b. 1862
Bookbinder
Childhood friend of May and Jenny Morris, trained under Sarah T. Prideaux; her bindings are associated with several Fine Presses, particularly the Ashendene Press. She established the Eadburgha Bindery in Broadway, Worcestershire, which she ran from 1909–15 with two women assistants, and from 1945 on her own.

Addams, Jane American
Founder of Hull House, Chicago, opened 14 September 1889, which was inspired by Toynbee Hall, a pioneer university and crafts settlement, and Ashbee's Guild of Handicraft, in London's East End.

Ashbee, Agnes British
Bookbinder
Sister of Charles Ashbee. Her sister Elsa Ashbee, born 1873, was an active suffragist; she was educated at Miss Beale and Miss Buss's School and at Girton College, Cambridge.

Banks, Eliza S. British Active *circa* 1874–1884
Pottery designer and decorator
Worked for Doulton's of Lambeth, London and was one of the earliest exponents there of the *pâte-sur-pâte* painting method.

Barlow, Florence E. British Active *circa* 1873–1909
Pottery decorator and designer
The dates refer to the period when she worked at Doulton's of Lambeth, London. Best known, after 1878, for her *pâte-sur-pâte* painting on stoneware, especially of birds. Sister of Hannah, Arthur and Lucy Barlow, who also worked briefly at Doulton's, *circa* 1882–85.

Barlow, Hannah Bolton British Active 1870–1913 (Doulton's: 1871–1913)
Ceramicist, sculptor
Trained under John Sparkes and the French artist Jean-Charles Cazin at Lambeth School of Art, London, from 1868. She worked from 1871–1913 at Doulton's of Lambeth. Exhibited terra cotta reliefs and sculptures at the Royal Academy 1881–90. Specialised in *sgraffito* drawings of animals on raw clay. Between 1871 and 1874 she and her brother Arthur produced over 9,000 original pots.

Bayes, Jessie British 1890–1934
Woodcarver, painter, calligrapher, illuminator and interior decorator, gesso worker and gilder
Sister of Gilbert and Walter Bayes. Exhibited at the Royal Academy from 1908. Ran a workshop producing craftwork and decorative schemes for interiors of chapels and houses; her assistants included Kathleen Figgis, and her sister Emmeline Bayes.

Burden, Elizabeth British
Embroiderer
Sister of Jane Burden; worked on many of the Morris embroideries and taught at the Royal School of Art Needlework during the 1870s.

Cobden-Sanderson, Annie British
Bookbinder
Worked at her husband T. J. Cobden-Sanderson's Doves Press, which she financed. Daughter of the political reformer Richard Cobden. Suffragist and active member of the Women's Social and Political Union.

Coleman, Rebecca British d. *circa* 1884
China painter
Seems to have worked mainly on a freelance basis; sister of china decorator William S. Coleman and Helen Cordelia Coleman (Mrs Angell). Renowned as a colourist and for studies of heads.

Copeland, Elizabeth E. American b. Boston
Silversmith and enameller
Studied in London. Associated with the Handicraft Shop, Boston.

Daniel, Emily British Active from 1880
Fine printer, illuminator and bookbinder
Set up and printed books at her husband's Daniel Press; decorated initial letters and rubrics in their books, and occasionally bound special copies.

Davis, Louisa J. British Active *circa* 1873–94
Stoneware designer and decorator (at Doulton's of Lambeth)

Dawson, Edith (née Robinson) British Active *circa* 1900–14
Painter, metalworker and enameller
Married Nelson Dawson 1893. They founded the co-operatively run Artificers' Guild in 1901; by 1903 it was in financial difficulties. She abandoned metalwork in 1914.

Dodd, Jane Porter Hart American 1824–1911
Woodcarver, china painter
Worked with Maria Longworth Nichols (later Storer) at Frederick Dallas' Hamilton Road Pottery in Cincinatti, Ohio.

Edwards, Emily J. British Active *circa* 1871 d. 1876
Pottery decorator and designer
After Hannah Barlow, one of the earliest women artists at Doulton's of Lambeth.

Edwards, Louisa E. British Active *circa* 1873–90
Pottery designer and decorator with Doulton's of Lambeth

Faulkner, Kate British d. 1898
Embroiderer, gesso decorator, wallpaper designer, china painter
Worked for William Morris from 1861; sister of Lucy and Charles Faulkner, one of the founders of Morris, Marshall, Faulkner & Co. Also designed wallpaper for Jeffrey & Co., 1883.

Faulkner, Lucy British
Embroiderer, designer, wood engraver, china painter, writer
Worked for William Morris from 1861; sister of Charles and Kate Faulkner. Published *The Drawing Room, its Decoration and Furniture*, (Macmillan) in 1878. Married Harvey Orrinsmith *circa* 1861.

Fortesque-Brickdale, Mary Eleanor British 1872–1945
Painter, illustrator, stained glass designer
Studied at Crystal Palace School of Art under Herbert Bone from 1889, then at the Royal Academy Schools; in 1897 won a prize for the Decoration of a Portion of a Public Building. Began exhibiting at the Royal Academy in 1896; travelled frequently on the Continent. First major exhibition at Dowdeswell's, London, in June 1901. A friend and contemporary of Byam Shaw, whose influence can be seen in her early work, she taught in his school, founded in 1911.

France, Georgina Cave British 1868–1934
Silversmith, jeweller, enameller, writer and illustrator of children's books, bookbinder
Trained Birmingham School of Art; as early as 1893 was producing designs for silver; worked occasionally for the Bromsgrove Guild of Handicraft. Belonged to the Birmingham Group. Married Arthur Gaskin 1894.

French, Annie British 1872–1965
Designer, illustrator, watercolourist
Studied at Glasgow School of Art from 1896–1902; taught design there in the Ceramics Department from 1909–1912. In 1914 she married George Woolliscroft Rhead and settled in London.

Fry, Laura Ann American 1857–1943
Woodcarver, ceramicist, designer, sculptor
Daughter of the noted wood carver and teacher William Henry Fry; she trained in drawing, sculpture, woodcarving and china painting at the Cincinnati School of Design from 1872 to 1876. She continued her training in Trenton, New Jersey, studying the art of throwing, decorating and glazing pottery, and later studied in England and France. One of the leaders of the Cincinnati women's decorative arts movement in the 1870s and 1880s, she was the first employee of the Rookwood Pottery in 1881; in July 1884 she introduced the use of the spray atomizer for applying slip to moist pots. She left Rookwood in 1887 and in 1891 became Professor of Industrial Art at Purdue for a year, a job she returned to in the 1890s. Between 1891 and 1894 she worked on the decorating staff of the Lonhuda Pottery in Steubenville, Ohio.

Gere, Margaret British 1878–1965
Painter in tempera and watercolours
Half sister of Charles Gere; trained at Birmingham School of Art from 1897, and at Slade School of Art, London from 1905. Member of the Birmingham Group. Visited Florence, winter 1901, and made tempera copies after work of Piero della Francesca

Glessner, Frances M. (*née* Macbeth) American 1848–1932
Silversmith
Studied at Hull House, Chicago.

Green, Elizabeth Shippen American 1871–1954
Illustrator
Studied at Philadelphia Academy of Fine Arts with Thomas Eakins, and at the Drexel Institute in Philadelphia with Howard Pyle. Noted for her colourful and decorative drawings of children. Collaborated with her friend Jessie W. Smith.

Greenaway, Kate British 1846–1901
Designer, and illustrator of children's books
One of the most prominent artists in the revival of artistic coloured book illustration.

Hayden, Sophia American b. 1870
Architect
Graduate of the Massachusetts Institute of Technology, class of 1890. Won the national competition of designs by women for the Woman's Building at the Chicago World's Fair, 1893.

Hart, May British
Jeweller, metalworker and enameller
Trained at Birmingham School of Art; did some of the enamelling for Charles Ashbee's jewellery and silverwork. Married Fred Partridge, one of Ashbee's silversmiths. Taught at the Sir John Cass Technical Institute, London.

Jacobus, Pauline American 1840–1930 Active *circa* 1880–1911
Ceramicist
Founded Pauline Pottery in Chicago, Illinois.

King, Jessie Marion British 1875–1949
Watercolourist, illustrator, bookbinder and book cover designer, fabric and costume designer, china decorator, writer, batik artist, jewellery and wallpaper designer
Trained at Glasgow School of Art. In 1902, along with others of the Glasgow group, she exhibited at the Turin Exhibition of Decorative Art, where her design for a book cover (executed by Maclehose of Glasgow) won her a gold medal. By 1902 she was an instructor in Book Decoration at Glasgow School of Art. In 1908 she married E. A. Taylor. Remained active until her death.

Kingsford, Florence British Active *circa* 1890s
Illuminator, bookbinder
Married Sidney C. Cockerell; she worked for the Ashendene and Essex House Presses and was a regular contributor to the Arts and Crafts Exhibition Society shows.

Koehler, Florence American 1861–1944
Artist-craftswoman, designer, jeweller
A leading figure in craft revival in America; lived and worked in Chicago. From 1900 her style of jewellery was fashionable in aesthetic and intellectual circles. More Art Nouveau than English Arts and Crafts in design. (See Charlotte Gere, *European and American Jewellers*, 1975.)

Lee, Frances E. British Active 1877–94
Pottery designer and decorator with Doulton's of Lambeth
Specialised in finely incised and carved, conventionalised foliage and flowers, sometimes combined with *pâte-sur-pâte* painting.

Lewis, Esther British Active 1877–97
Pottery designer and decorator with Doulton's of Lambeth; watercolourist
Specialising in landscapes, she was one of the most accomplished of all the Doulton painters.

She was also a successful exhibitor at Howell and James' Gallery in Regent Street, London. From a similarity in the script of their signatures, it seems likely that Esther was also a sister of Florence and Isabel, (who are known to have been related); this seems confirmed by the fact that all three left Doulton's in the same year, probably all were beneficiaries of the legacy mentioned below with regard to Florence Lewis.

Lewis, Florence E. British Active 1874 until her death in 1917
Pottery designer and decorator; painter and watercolourist
Trained at Lambeth School of Art; John Sparkes introduced her to Henry Doulton *circa* 1874, and she worked full-time at Doulton's of Lambeth until 1897.

In addition to her own work as a designer and painter, she was greatly influential in that for several years she directed a group of around seventy young women who were training as painters. She retired from full-time employment when she came into a legacy in 1897, but continued to do freelance work. She gave more time to her oil painting and water colours, which she exhibited regularly at the Royal Academy and elsewhere. She also travelled extensively on the Continent. A dessert and tea service which she had painted with primroses was purchased by Queen Victoria in 1887. She published a book on *China Painting* (Cassell & Co.) in 1883. The work of her sister Isabel was good, but less original.

Lowndes, Mary British
Stained glass artist
Co-founder of the Arts and Crafts stained glass firm Lowndes and Drury in 1897.

Lupton, Edith D. British Active *circa* 1876–90 d. 1896
Pottery designer and decorator with Doulton's of Lambeth
Early incised work influenced by the Barlows; later concentrated on *pâte-sur-pâte* painting, and carved and perforated decoration.

Thought to have retired *circa* 1890, but continued to do freelance work until her death.

Macbeth, Ann British 1875–1948
Designer, embroiderer and illustrator
A prominent member of the Glasgow School, she trained at Glasgow School of Art and taught embroidery there from 1900. She was particularly influential in her dissemination of new methods in the field of embroidery education.

Macdonald, Frances British 1874–1921
Stained glass artist, embroiderer, designer, illustrator and illuminator, enameller
Studied at Glasgow School of Art and was one of The Four (Herbert MacNair, Charles Rennie Mackintosh and Margaret Macdonald); later taught enamelling and gold and silversmithing at Glasgow. At the Turin Exhibition of Decorative Art in 1902 she showed jewellery and two silver repoussé panels. The Glasgow Jeweller Agnes B. Harvey was among her pupils. Married Herbert MacNair in 1899.

Macdonald, Margaret R.S.W. British 1865–1933.
Designer, embroiderer, metalworker, stained glass artist, illustrator and illuminator, carried out gesso reliefs and painted on gesso
Most of her jewellery was made in collaboration with her sister Frances: like Frances, she exhibited at the Art and Crafts Exhibition Society shows, at Turin in 1902, and at the Vienna Secession Exhibition of 1900. She also studied at Glasgow School of Art, where she met Charles Rennie Mackintosh; they married in 1900, and her influence can clearly be seen in the work of her husband from the time of their marriage.

Mathews, Lucia K. (*née* Kleinhaus) American 1870–1955
Painter, furniture and woodwork decorator and woodcarver
Studied at the Mark Hopkins Institute of Art, San Francisco. Set up a furniture workshop in San Francisco with Arthur F. Mathews in 1906.

McLaughlin, Mary Louise American 1847–1939
Ceramicist, woodcarver, writer
In 1877 discovered the secret of Limoges underglaze painting. Studied drawing, woodcarving and china painting at the Cincinnati School of Design, 1873–77. Organised the Women's Pottery Club in Cincinnati in 1879.

Mills, Ernestine Evans (*née* Bell) British 1871–1959
Metalworker and enameller
Studied at the Royal College of Art and the Slade School of Art; studied enamelling with Alexander Fisher.

Remained active throughout her life, winning a silver medal at the Paris Salon as late as 1955.

Morris, Jane (*née* Burden) British
Embroiderer, wood-engraver
Wife of William Morris; worked for Morris and Co.

Morris, May British 1862–1938
Designer and embroiderer, wallpaper and fabric designer, jeweller
Taught by her father, William Morris. Took over the firm's embroidery department in 1885. Her jewellery, designed and made by her, included bead necklaces strung in interesting combinations of colour and texture. Lectured in the USA in 1910 on embroidery, jewellery, costume and pattern designing. Taught embroidery at the Central School of Arts and Crafts, London.

Munson, Julia American
Metalworker and enameller
With Patty Gray headed a small staff of Tiffany's experimental enamelling workshop from late 1890s.

Newbery, Jessie R. (*née* Rowat) British
Designer, embroiderer, metalworker
Trained at Glasgow School of Art, and later taught embroidery there; married the School's director, 'Fra' Francis Newbery, in 1889.

Newton, Clara Chipman American 1848–1936
China painter
Organising 'Secretary' of the Rookwood Pottery, Cincinatti, Ohio 1881–84; founder member of the Cincinatti Women's Pottery Club in 1879.

Newill, Mary J. British 1860–1947
Embroiderer, designer, illustrator, stained glass artist
Trained at Birmingham and later taught there, especially embroidery. Member of the Birmingham Group, and originator in the early 1890s of the style of illustrative drawing evocative of wood cuts which became associated with that Group.

Nourse, Mary Madeline American 1870–1959
China painter
Decorator at Rookwood Pottery, 1891–1905; niece of Mary Elizabeth Nourse.

O'Kane, Helen Marguerite American Active from 1900
Designer and illustrator
Worked with her husband Clarke Conwell on his Elston Press, designing the decorations for their fine hand-printed books.

Payne, Edith (*née* Gere) British 1875–1959
Metalworker, gesso worker, gilder, watercolourist
Half-sister of Charles Gere; trained at the Birmingham School of Art. Member of the Birmingham Group. Married Henry Payne in 1903.

Perry, Mary Chase American 1868–1961
Ceramicist
Founded the Pewabic Pottery *circa* 1903 in Detroit, Ohio; famous for her experiments with irridescent and lustre glazes.

Peter, Sarah Worthington King American 1800–77
Social leader, philanthropist and promoter of education for women
In 1844 organised the Philadelphia School of Design for Women (now the Moore Institute) and promoted an association in the same city for the advancement of tailoresses. In 1853 returned to her home state, Ohio, where in Cincinnati she founded the Art Museum with a group of interested women—which became the Women's Museum Association. She made trips to Europe to collect masterpieces and copies for this Association. The Women's Museum Association also fostered what became the Cincinnati Academy of Fine Arts. Her final efforts were in connection with the art exhibits at the centennial exhibition of 1876 in Philadelphia. (See *Dictionary of American Biography*, vol. 14.)

Pissarro, Esther (*née* Bensusan) British d. 1951
Illuminator, printer, designer and wood engraver
Married Lucien Pissarro in 1892 and with him ran the Eragny Press, London. Trained at the Crystal Palace School of Art.

Pitman, Agnes American 1850–1946
Ceramicist, woodcarver
Daughter of the craftsman and woodcarver Ben Pitman, with whom she helped establish craft classes at the Cincinnati School of Design; also taught at her father's Phonetic Institute there.

Poillon, Clara L. American 1850–1936
Ceramicist
A leading figure and co-founder of the Poillon Pottery in Woodbridge, New Jersey, *circa* 1901.

Powell, Louise (*née* Lessore) British
Embroiderer, dress designer, china painter and furniture decorator
Decorated books made by the lettering expert and bookbinder Alfred Fairbank. Her sister Elaine T. Lessore was also an embroiderer and another sister, Thérèse, a painter, was married to the painter Walter Sickert. She married the architect, Alfred Powell; they painted pottery (overglazed earthenware and both underglaze and lustre from about 1904 to 1939). They had their own pottery, first at Millwall, then later at Red Lion Square, London; she also worked for Wedgwood. She painted furniture made by various members of the Cotswold School, such as Ernest Gimson.

Power, Annie British
Bookbinder
From 1903 she ran the Essex House Bindery at Charles Ashbee's Guild of Handicraft, and trained workers there. Married Gerald Loosely in 1905; continued an active bookbinder.

Prideaux, Sarah T. British
Bookbinder and printer
The first woman bookbinder of the Arts and Crafts revival, she was active from 1890 at the latest; she taught many of the younger bookbinders, in particular Katharine Adams. Her writings on bookbinding, including histories of the subject, are standard texts; in 1900 she and Katherine Adams printed a Catalogue of books bound by her to that date. Sarah Prideaux worked at 37 Norfolk Square, London.

Purser, Sarah Irish
Stained glass artist
An artist of the Royal Hibernian Academy, in 1903 she founded the Tower of Glass (An Tur Gloine), a stained glass workshop combined with a school for the craft. Some of the most influential women stained glass artists of the period trained there, including Wilhelmina Geddes and Evie Hone.

Raeburn, Agnes R.S.W. British 1872–1955
Watercolourist, designer and illustrator
Studied at Glasgow School of Art with her sister Lucy from about 1890–4, and was one of the group centred round the Macdonald sisters and Mackintosh, known as The Immortals. Elected a member of the Royal Society of Painters in Watercolours in 1901; excelled as a watercolourist.

Robineau, Adelaide Alsop American 1865–1929
Ceramicist
Founded *Keramic Studio* magazine (later *Design*) with her husband in 1899. Began producing her own pottery *circa* 1901; associated with the University City Pottery in New York for eighteen months, 1910–11.

Simmance, Eliza British Active 1873–1928
Pottery designer and decorator with Doulton's of Lambeth
Specialised in a wide variety of often combined decorating techniques, influenced by Art Nouveau. Preferred to be called Élise.

Smith, Jessie Wilcox American 1863–1935
Cover designer and illustrator
Studied with Thomas Eakins at the Philadelphia Academy of Fine Arts, and with Howard Pyle at the Drexel Institute. Best known for her illustrations of children's classics; was a tremendous popular success. Collaborated with her friend Elizabeth Shippen Green, with whom she lived and worked along with a third artist and illustrator, Violet Oakley. She was devoted to her career.

Smith, Pamela Coleman American b. *circa* 1877
Painter and illustrator
Moved to England in 1899; associated with Walter Crane, the Craigs, W. B. Yeats and others. Published her own craft magazine *The Green Sheaf* in 1903–4.

Sparkes, Catherine British Active from early 1870s
China painter

Produced a large painted Doulton tile panel for the 1876 International Exhibition at Philadelphia. Regularly exhibited her work at Howell and James' Annual Exhibitions of China Painting, London. Wife of John Sparkes, Head of Lambeth School of Art, she apparently worked freelance for Doultons.

Stabler, Phoebe British
Sculptor, ceramicist, metalworker and enameller
Worked in the Carter, Stabler and Adams partnership producing decorated and domestic ware at Poole Pottery. Each piece was hand-thrown and decorated; they were mostly designed by Harold and Phoebe Stabler or by John Adams and his wife Truda. Harold Stabler (1872–1945) had been in charge of the Keswick School of Industrial Art 1898–9; from about 1900 he taught at the Sir John Cass Technical Institute, London, and at the Royal College of Art, 1912–26. He and Phoebe Stabler designed and executed pottery figures at their Hammersmith studio, some of which were later produced in editions by Carter, Stabler and Adams.

Starr, Ellen Gates American 1859–1935
Bookbinder
Friend of Jane Addams; trained in London under T. J. Cobden-Sanderson. Active in setting up and running the craft programme at Hull House, Chicago.

Storer, Maria Longworth Nichols American 1849–1932
Ceramicist and metalworker
Founder of Rookwood Pottery, 1880 in Cincinnati, Ohio.

Traquair, Phoebe Anna (*née* Moss) British 1852–1936
Illuminator, calligrapher, bookbinder, painter, mural painter, embroiderer, metalworker and enameller
A woman of particularly broad accomplishments and talent, she was a prominent member of the Edinburgh Arts and Crafts Club and the Guild of Women Binders and was a member of the Royal Society of Painters in Water Colours.

Valentine, Anna Marie (*née* Bookprinter)
American 1863–1947
Ceramicist
Decorator at the Rookwood Pottery 1884–1905; studied at Cincinnati Art Academy 1885–98 and also studied with Rodin in Paris. Married Albert R. Valentine in 1887.

Wardle, Elizabeth (*née* Wardle) British 1834–1902
Embroiderer
Founded the Leek Embroidery Society in 1879 and the Leek School of Embroidery *circa* 1881. She married her cousin, Thomas Wardle, in 1857 and had fourteen children. Thomas Wardle, whose silk firm provided most of the technical knowledge behind Morris's specially dyed fabrics and silks for embroidery, was knighted for his services to the silk industry in 1897. George Wardle, who was associated with the Morris firm from the 1860s and became manager after Warrington Taylor's death in 1870, was Thomas Wardle's

brother. Many of Elizabeth Wardle's daughters were involved in embroidery production.

Watt, Linnie British Active (at Doulton's of Lambeth) 1875–90
Painter, pottery designer and decorator, faïence artist. Specialised in rustic scenes and figure painting. She exhibited paintings regularly at the Royal Academy, London.

Watts, Mary British
Painter and designer, architect, architectural ceramicist
Organised classes at Compton, near Guildford in architectural and garden ornaments for the Home Arts and Industries Association, which became a 'developed industry' the Terracotta Home Arts. Designed the Watts Chapel in 1896 as a memorial to her husband, the painter G. F. Watts.

Welles, Clara Barck American 1868–1965
Silversmith and designer
Started the Kalo Shops at Park Ridge, Illinois in 1900.

Whall, Veronica British b. 1887
Stained glass artist
Daughter and fellow-worker of her father Christopher Whall, one of the most influential of the revivalists of stained glass design. Trained at the Central School of Arts and Crafts, where her father taught stained glass design.

Wheeler, Candace American 1827–1923
Textile designer, tapestry expert, interior designer
One of the founders in 1879 of Associated Artists, New York.

Yeats, Elizabeth and Lily Irish
Designers, embroiderers, bookprinters and binders, tapestry-weavers.
With Evelyn Gleeson founded the Dun Emer Industries in 1903; continued from 1908 as the Cuala Press.

Appendix 11:
A Comparative Note on Women's Wages

This appendix (based on the retail price index) is intended to give an indication of the real value of women's wages and the relative prices of their work in the period of the Arts and Crafts movement. Where known, wages and prices have been included in discussions in the text.

£1 in *circa* 1885 = £17.74 today (and 5.6p then = £1 today)

£1 in *circa* 1895 = £19.82 today (and 5p then = £1 today)

also

£1 in *circa* 1883 was equivalent to $4.80 at that time.

Select Bibliography

Alford, Lady Marian, *Needlework as Art*, Sampson Low, Marston, Searle, and Rivington, London, 1886

Art-Work for Women, I, II, III, *The Art Journal*, 1872, pp. 65–6, 102–3, 129–31

Aveling, Eleanor Marx, and Edward, *The Woman Question*, Swan Sonnenschein, Lowney, and Co., London, 1886

Beazeley, Elizabeth, Watts Chapel, reprinted in *The Anti-Rationalists*, ed. Nikolaus Pevsner and J. M. Richards, Architectural Press, London, 1976

Bell, Quentin, *The Schools of Design*, Routledge and Kegan Paul, London, 1963

Briggs, Asa (ed.), *William Morris, Selected Writings and Designs*, Penguin Books, Harmondsworth, 1968

Burne-Jones, Georgiana, *Memorials of Edward Burne-Jones*, (two volumes), Macmillan, London, 1904

Catalogue of an Exhibition of Doulton Pottery from the Lambeth and Burslem Studios, 1873–1939, Part II, Richard Dennis; held at the Fine Art Society, New Bond Street, London, 1975

Catalogue of an Exhibition of Doulton Stoneware and Terracotta, 1870–1925, Part I, Richard Dennis; held at 141 Kensington Church Street, London, 1971

Centenary Exhibition of Works by Eleanor Fortesque-Brickdale, 1872–1945, Ashmolean Museum, Oxford, December 1972–January 1973

Clarke, Robert Judson (ed.), *The Arts and Crafts Movement in America 1876–1916*, exhibition catalogue, Princeton University Press, Princeton, New Jersey, 1972

Cole, Doris, *From Tipi to Skyscraper—A History of Women in Architecture*, Brazillier, Boston, 1973

Davidoff, Leonore, *The Best Circles*, Croom Helm, London, 1973

Day, Lewis F., The Woman's Part in Domestic Decoration, *The Magazine of Art*, 1881, pp. 457–463

E.B.S., Some Aspects of the Work of Mary L. [*sic*] Newill, *The Studio* Vol. 5, 1895, pp. 56–63

Elliott, Maud Howe, (ed.), *Illustrated Art and Craft in the Woman's Building of the Columbian Exposition, Chicago*, Goupil and Co., Paris and New York, 1893

Evans, Paul, *Art Pottery of the United States*, Scribner's, New York, 1974

Eyles, Desmond, *The Doulton Lambeth Wares*, Hutchinson, London, 1975

Faulkner, Lucy, *The Drawing Room, its Decoration and Furniture*, Macmillan, London, 1878

Frackelton, Susan Stuart, *Tried by Fire*, D. Appleton and Co., New York, 1886

Franklin, Colin, *The Private Presses*, Dufour, Chester Springs, Penn., 1969

Garrett, Rhoda, *The Electoral Disabilities of Women*, a lecture delivered in the Corn Exchange, Cheltenham, 3 April 1872, printed at the 'Telegraph' Office, Cheltenham, 1872

Garrett, Rhoda and Agnes, *Suggestions for House Decoration in Painting, Woodwork and Furniture*, Macmillan, London, 1876

Gere, Charlotte, *Victorian Jewellery Design*, William Kimber, London, 1972

Glasier, J. Bruce, *William Morris, and the early days of the Socialist Movement*, Longman, London, 1921

Hall, Catherine, The History of the Housewife, *Spare Rib*, 26, June 1974, pp. 9–13

Harbeson, Georgiana Brown, *American Needlework*, Coward-McCann, New York, 1938

Henderson, Philip (ed.), *The Letters of William Morris*, Longman, Green and Co., London, 1950

Henderson, Philip, *William Morris, his life, work and friends*, Thames and Hudson, London, 1967

Holcombe, Lee, *Victorian Ladies at Work*, David and Charles, Newton Abbot, 1973

Houghton, Walter Edward, *The Victorian Frame of Mind, 1830–1870*, Yale University Press, New Haven, 1957

Jackson, Emily Nevill (Mrs F.), *A History of Hand-Made Lace*, L. U. Gill, London, 1900

Jessie M. King, 1875–1949, Catalogue of the Arts Council of Great Britain Exhibition, London, 1971–72

Kapp, Yvonne: *Eleanor Marx*, (two volumes), Lawrence and Wishart, London, 1972 and 1976

Lewis, Florence E., *China Painting*, Cassell, London, 1883

Macdonald, Stuart, *The History and Philosophy of Art Education*, University of London Press, London, 1972

Mackail, John William, *The Life of William Morris*, New Edition, (two volumes), Longman, London, 1901

Massé, Henri J. L. J., *The Art Workers' Guild, 1884–1934*, Oxford, 1935

McLaughlin, Louise M., *China Painting*, Cincinnati, 1877

McLaughlin, M. Louise, *Pottery Painting under the Glaze*, R. Clarke and Co., Cincinnati, 1880

McLaughlin, M. Louise, *Suggestions to China Painters*, R. Clarke and Co., Cincinnati, 1884

Mitchell, Hannah, *The Hard Way Up*, Virago, London, 1977

Morris, Barbara J., *Victorian Embroidery*, Herbert Jenkins, London, 1962

Morris, May, *Decorative Needlework*, Hughes and Co., London, 1893

Morris, May (ed.), *Collected Works of William Morris*, (24 volumes), Longman, London, 1910–15

Morris, May, *William Morris: artist, writer, socialist*, (two volumes), Basil Blackwell, Oxford, 1936

Muir, Percival Horace, *Victorian Illustrated Books*, Batsford, London, 1971

Naylor, Gillian, *The Arts and Crafts Movement*, Studio Vista, London, 1971

Palliser, Mrs Fanny Bury, *History of Lace*, Sampson Low and Co., London, 1902 (revised edition)

Parker, Rosie, The Word for Embroidery was WORK, *Spare Rib*, 37, July 1975, pp. 41–45

Peck, Herbert, *The Book of Rookwood Pottery*, Crown Publishers, New York, 1968.

Petersen, Karen, and Wilson, J. J., *Women Artists: Recognition and Reappraisal from the Early Middle Ages to the Twentieth Century*, Harper and Row, New

York, Hagerstown, San Francisco, London, 1976

Pevsner, Nikolaus, *Pioneers of Modern Design*, Penguin Books, Harmondsworth, 1960

Pinchbeck, Ivy, *Women Workers and the Industrial Revolution, 1750–1850*, Routledge, London, 1930

Prideaux, Sarah Treverbian, *Bookbinders and their Craft*, Zaehnsdorf, London, 1903

Prideaux, Sarah Treverbian, *A Catalogue of Books Bound by S. T. Prideaux between 1890 and 1900*, with 26 illustrations, printed by Sarah T. Prideaux and Katherine Adams, London, Spring 1900

Prideaux, Sarah Treverbian, *Exhibition of Bookbindings*, with introductory remarks on the history of bookbinding by Sarah T. Prideaux, Burlington Fine Arts Club, 1891

Prideaux, Sarah Treverbian, *An Historical Sketch of Bookbinding*, Lawrence and Bullen, London, 1893

Prideaux, Sarah Treverbian, *Modern Bookbindings: their design and decoration*, Archibald Constable and Co., London, 1906

Purnell, Thomas, Woman, and Art, *The Art Journal*, 1861, pp. 107–8

Quigley, J., The Art of Jessie Bayes, Painter and Craftswoman, *The Studio*, Volume 61, 1914, pp. 261–70

Rowbotham, Sheila, *Hidden from History*, Pluto Press, London, 1974

Rowbotham, Sheila, and Weeks, Jeffrey, *Socialism and the New Life*, Pluto Press, London 1977

Samuels, Raphael, The Workshop of the World, *History Workshop Journal*, 3, Spring 1977, pp. 6–72

Schnessel, S. Michael, *Jessie Wilcox Smith*, Studio Vista, London, 1977

Second Exhibition of Artistic Bookbindings by Women, 61 Charing Cross Road, December 1898–January 1899

Smith, Walter, *Art Education*, James Osgood, Boston, 1873

Sparrow, Walter Shaw, On Some Water-colour Pictures by Miss Eleanor Fortesque-Brickdale, *The Studio*, Volume 23, 1901, pp. 31–44

Spenceley, Geoff, The Lace Associations, *Victorian Studies*, Vol. 16, 1973, pp. 433–52

Spielmann, Marion Harry, and Layard, George Somes, *Kate Greenaway*, Adam and Charles Black, London, 1905

Stern, Madeleine Bettina, *We the Women*, Schulte, New York, 1963

Thompson, Edward Palmer, *William Morris, Romantic to Revolutionary*, Lawrence and Wishart, London, 1955

Wardle, Patricia, *Victorian Lace*, Herbert Jenkins, London, 1968

Watson, Walter R., Miss Jessie M. King and her Work, *The Studio*, Volume 26, 1902, pp. 177–78

Wheeler, Candace T., *The Development of Embroidery in America*, Harper & Bros., New York and London, 1921

Williams, Raymond, *Culture and Society 1780–1950*, Penguin Books, Harmondsworth, 1963

Woolf, Virginia, *The Three Guineas*, Harbinger, New York, 1966

Wright, Gwendoline, On the Fringe of the Profession: Women in American Architecture, in *The Architect: Chapters in the History of the Profession*, ed. Spiro Kostof, Oxford University Press, New York, 1976

Yeo, Stephen, A New Life. The Religion of Socialism in Britain, 1883–1896, *History Workshop Journal*, 4, Autumn 1977, pp. 5–56

PERIODICALS SOURCES
Architectural Review
The Art Journal
Art Union
Art Workers' Quarterly
The Englishwoman's Journal
Furniture Gazette
Journal of Design
Journal of the Society of Arts
The Lady
The Magazine of Art
The Queen
The Studio
Victorian Studies

FORTHCOMING PUBLICATIONS
Crawford, Alan, and Bury, Shirley: *A Critical Biography of C. R. Ashbee*

Crawford, Alan (ed.), *By Hammer and Hand: The Arts and Crafts Movement in Birmingham.*

Parker, Rosie, *A Feminist History of Embroidery*, Women's Press, London

Pollock, Griselda, and Parker, Rosie, *The Old Mistresses: Women, Art and Ideology*, Oresko Books, London

Index

Page numbers in italics refer to illustrations